Fictionalizing Anthropology

Fictionalizing Anthropology

Encounters and Fabulations
at the Edges of the Human

STUART MCLEAN

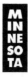

UNIVERSITY OF MINNESOTA PRESS
MINNEAPOLIS • LONDON

Permission to quote from *Transfer Fat* by Aase Berg, translated by Johannes Göransson (Ugly Duckling Presse, 2012), is granted by the publisher.

Copyright 2017 by the Regents of the University of Minnesota

All rights reserved. No part of this publication may be reproduced, stored in a retrieval system, or transmitted, in any form or by any means, electronic, mechanical, photocopying, recording, or otherwise, without the prior written permission of the publisher.

Published by the University of Minnesota Press
111 Third Avenue South, Suite 290
Minneapolis, MN 55401-2520
http://www.upress.umn.edu

The University of Minnesota is an equal-opportunity educator and employer.

Library of Congress Cataloging-in-Publication Data

Names: McLean, Stuart, author.
Title: Fictionalizing anthropology : encounters and fabulations at the edges of the human / Stuart McLean.
Description: Minneapolis : University of Minnesota Press, [2017] | Includes bibliographical references and index.
Identifiers: LCCN 2017005481 (print) | ISBN 978-1-5179-0271-1 (hc) | ISBN 978-1-5179-0272-8 (pb)
Subjects: LCSH: Anthropology—Philosophy. | Ethnology—Philosophy. | Literature and anthropology. | Art and anthropology.
Classification: LCC GN33 .M35 2017 (print) | DDC 301.01—dc23
LC record available at https://lccn.loc.gov/2017005481

UMP LSI

Contents

Prologue		vii

Part I. Anthropology: A Fabulatory Art

1	An Encounter in the Mist	3
2	*Talabot*	21
3	Fake	34
4	Anthropologies and Fictions	45
5	Knud Rasmussen	49
6	The Voice of the Thunder	67
7	Metaphor and/or Metamorphosis	73
8	"They Aren't Symbols—They're Real"	88

Part II. In Between

9	Liminality: An Old Story?	99
10	The Dead Have Never Been Modern	114
11	The God Who Comes	127
12	Between the Times	132
13	Anthropology ≠ Ethnography	147
14	Fabulatory Comparativism	156

Part III. Gyro Nights: Inhuman Culture / Inhuman Nature

15	Islands before and after History	165
16	Papay Gyro Nights	169
17	The Time of the Ancestors?	187
18	In the Beginning Were the Giants	202
19	Tiamaterialism	218
20	Blubberbomb	224
21	A Globe of Fire	241
22	Nighttime	248
	Afterword: Anthropology Is Art Is Frog	259
	Acknowledgments	265
	Notes	269
	Bibliography	305
	Index	327

Prologue

ONCE UPON A TIME . . .

Not in the time of calendars, chronicles, or clocks, not in the time of history . . .

No land, or sea, or sky. Darkness. Fire and ice, condensing into a giant body. His name is Ymir. Or is he a he? The name means something like "two-fold being."[1] One leg copulates with the other, and a boy-child is the result. A giant and giantess spring from his armpits. Then it's over. A new race of beings emerges from the ice—the race of humanly proportioned, bilaterally sexed and gendered gods led by Odin. The fecund, hermaphroditic giant is cut down to size. Odin and his brothers, Vili and Vé, kill Ymir and partition his body to fashion the earth, sea, and sky:

> From Ymir's flesh the earth was made,
> And from his blood, the sea,
> Mountains from his bones, trees from his hair,
> And from his skull, the sky.
>
> And from his eyelashes the cheerful gods
> Made earth in the middle for men;
> And from his brain were the hard-tempered clouds
> All made.[2]

Although the verses comprising the surviving corpus of Eddic poetry, along with the prose summary composed by historian Snorri Sturluson,

were first written down in Iceland sometime in the thirteenth century, more than two centuries after the settlement's official adoption of Christianity, they have often been cited as evidence of an older, pre-Christian vision of the cosmos that the earliest Norse settlers brought with them from pagan Scandinavia.[3] The world these stanzas invoke, however, is older still—older than humans and the gods they worship. Indeed, the familiar deities of the Norse pantheon appear here as latecomers, usurpers of another, earlier dispensation. And what about the giants? On the one hand, their overthrow and displacement is the precondition for the establishment of a new order of gods and humans, the polymorphous bisexuality of Ymir's originary body being subdued and partitioned to provide the foundation for the more fixed and clearly delineated forms of the presently existing world. On the other hand, the giants are acknowledged to be older than the gods who vanquish and replace them, and as such they retain powerful associations with magic, poetry, and wisdom. It is to them that even Odin is obliged to turn to acquire knowledge of past and future events.[4] In the Eddic poems, for example, the description of the chaos and darkness that precede creation is uttered by the Voluspa, a seeress, herself the descendant of giants, who can remember before recorded time and who is able also to see far ahead, beyond Ragnarok, the doom of the gods, when "the sun turns black, earth sinks into the sea/The bright stars vanish from the sky," only for a new earth to rise up from the ocean, home (eventually) to a new generation of gods and humans.[5]

What is one to make of these verses and their protagonists, who variously inhabit and remember a world prior to both gods and humans—a world fashioned, moreover, from the bodily substance of a being who was himself solidified out of the contending elements of a primordial chaos? Such origin stories, in Northern Europe and perhaps everywhere, are among the earliest subject matters of poetry. But who—or what—is speaking here? Should we trust the words of the seeress, or is she herself just another latecomer?

WHAT IF . . . ?

Fire and ice? How about melting ice caps, rising temperatures, seas, and CO_2 levels, nuclear accidents, oil spills, e-waste, floating plastic garbage patches, along with climate change deniers vociferously ensconced at the

highest levels of politics? Add to that burgeoning economic inequality, ethnic, religious, and free-market fundamentalisms, wars, genocides, more than 65 million refugees, the prospect of border walls, immigration bans and mass deportations, and the world of the early twenty-first century starts to look no less precarious (or potentially transitory) than that of the Eddic creation narrative. As the latter reminds us, myths tell not only of origins but also of endings. Recent proclamations of the advent of the Anthropocene as a distinct geological epoch call attention both to the ever-increasing impact of human populations (some conspicuously more than others) on planetary ecosystems and to the now all too thinkable possibility of a world that is no longer habitable by humans. Journalist Alan Weisman has written of "the world without us" in a work of speculative nonfiction that imagines the future of the earth in the aftermath of the sudden disappearance of the human species. Weisman pictures, among other things, the flooding of cities like New York, the gradual reoccupation of onetime human dwellings by plants and animals, and the combustion of abandoned petrochemical refineries, expelling quantities of hydrogen cyanide and other toxins into the atmosphere, creating a chemical nuclear winter and potentially causing surviving species to mutate in ways that might decisively alter the course of evolution.[6] Yet he suggests too that such thought experiments, disconcerting as they are, may be a necessary part of crafting livable human futures.[7]

Could the capacity to imagine not only our connectedness to other kinds of beings but also the possibility of our radical absence from the scene be a prerequisite of thought and creativity, not least in our present and much discussed state of ecological emergency? As the biological and physical sciences continue to remind us, humans, like the seeress, and like Odin and his followers, are late arrivals, recently emerged into a universe that existed long before them and that will continue to exist long after their disappearance.[8] At the same time, science studies and the various "new materialisms" current across humanities disciplines alert us to the fact that even the social and cultural worlds that humans often pride themselves on creating have never been exclusively human. Rather, they are dependent on and inflected by a multitude of other than human presences, including animals, plants, geological formations, weather systems, and a range of humanly manufactured artifacts fashioned from a variety of materials—materials possessed of their own density and

x *Prologue*

dynamism, and as such irreducible to the uses to which humans attempt to put them.[9]

What becomes of the human in a universe that is always more than human? What becomes of anthropology? For one thing, the encounters across difference that anthropology deals with can no longer be understood only as encounters between differently constituted human worlds. Also implicated in such encounters are the other than human materialities out of which human worlds are constructed and by which they are inevitably carried beyond themselves. No longer confined to the registers of the social, cultural, or linguistic, difference inheres in the very fabric of reality. How, then, might anthropology engage the immanence of human imagining, thought, and practice to a world that preexists and surpasses them? Might this involve suspending anthropology's sometime claims to be a social science, whether of a *geisteswissenschaftlich* or a positivist variety, and instead turning to the exploration of its affinities with art and literature as a mode of engaged creative practice carried forward in a world heterogeneously composed of humans and other than humans? Perhaps anthropology stands to learn from art and literature not as evidence to support explanations based on an appeal to social context or history but rather as distinct modes of engagement with the materiality of expressive media—including language—that always retain the capacity to exceed and destabilize human intentions. Taking its cue from art and literature as much as from the sciences, anthropology might understand itself less as the study of an objectified humanity than as the open-ended, performative exploration of alternative possibilities of collective existence—of new ways of being human and other than human.

Henri Bergson and later Gilles Deleuze called it "fabulation": the making of fictions sufficiently vivid and intense to be capable of intervening in and reshaping reality.[10] This involves not the representation of a world assumed to be already given, independent of its figuration through texts, images, or other media but rather the participatory carrying forward of material world-forming processes in which human acts of creativity are always already implicated. Think again of the dismembered body of the giant Ymir, which furnishes the material substance of the universe fashioned by his successors—a universe that presumably includes not only the poet of the Eddic verses but also the verses themselves. Presumably too, both poet and verses will share the fate of the Eddic universe (or at

least of its current iteration), as sun, moon, and stars vanish and the earth sinks beneath the sea. Today the world or worlds that anthropology evokes seem no less poised on the brink of catastrophe. Yet this book insists that faced with the encroachment of these seeming finalities, anthropology's most radical potential consists—and has always consisted—of its capacity to undermine conventional distinctions between documentary and fiction. By collapsing the representational distance on which such distinctions depend, reality—and not just human beings' culturally circumscribed representations of it—is rendered open to questioning and, potentially, refashioning. Anthropology, in other words, is a fabulatory art that plays not only at the interstices between human worlds (the more familiar spaces of ethnographic encounter or intercultural comparison) but also at the thresholds of emergence or dissolution of the human, where the travails of human world making unravel into the becoming of a universe that has, finally, no need of humans to observe, interpret, or affirm it.

Does such a claim signal a turning away from a reality that has become intolerable and a concomitant withdrawal into writerly self-absorption? Or might it point us in the opposite direction, plunging us back into the viscosity, mess, and proliferation of what is? Readers will have to decide for themselves, but there can be no doubt that the stakes of posing the question "what if?" have never been higher. What if the material universe's very indifference to our inextricable involvement in it were a potential source of hope—a hope that things might turn out differently and perhaps better? What if the "real" world routinely invoked by our politicians and media as the limit of human possibility were but one possibility among many? What if these multiple realities were also the same reality—the reality of difference? What if making manifest this unity in multiplicity and multiplicity in unity were precisely the difference that anthropology makes? What if invention, undertaken as a collective project, were the most powerful rejoinder both to the constraining pretend-pragmatism of much mainstream politics and to the dogmatically asserted "alternative facts" of populist, right-wing demagoguery?[11] What if giants, shape-shifters, and the hosts of the dead as well as biopower, neoliberal governance, and technoscientific assemblages? What if poetry? What if . . . ?

.

I

Anthropology

A Fabulatory Art

one

An Encounter in the Mist

Now imagine yourself as a shepherdess on a farm in Iceland in the early 1980s. The farm in question, Hali, is situated in the district of Suðursveit on the southeastern coast of Iceland, on a narrow strip of land with the sea on one side and mountains on the other. Further along the coast to the southwest is the Jökulsárlón Glacier Lagoon, today one of Iceland's most popular tourist sites, where the Breiðamerkurjökull glacier, an outlet of the larger glacier of Vatnajökull, deposits icebergs that drift slowly toward the mouth of the lagoon and out into the ocean. The farm itself was once home to the writer Þórbergur Þórðarson (1888–1974), the author of essays, poems, and a series of autobiographical writings recounting his childhood and adolescence there, including long, dark winter evenings spent reading aloud stories from the sagas. Today, however, is an autumn day; there is work to be done, and no time for reading. The shepherdess finds herself sitting on a ledge partway up a mountain, clutching a stray ewe that has wandered from the flock. Her companions have left her there to wait while they search for more missing sheep. She has a clear view of the farmstead, and beyond it the coast and the surrounding blue-gray waters of the North Atlantic. Books, of course, are not the only way to find out about the history and secrets of a place. The shepherdess has already learned from her companions that the surrounding landscape is densely layered with stories and associations. Every rock and cave has a name, each with an explanation attached. Some of these refer to previous human inhabitants, like Papýlisfjall, named after the *papar*, the Irish monks who eked out a solitary existence here before the arrival of the

first Scandinavian settlers in the ninth century. Others evoke presences of a different order, like the ravine Klukkugil, said to owe its name to a troll, Klukki, who once resided there. Monks and trolls have both left their traces on Suðursveit's rocky terrain in the form of stories that are told and retold by those who traverse these mountain paths, generation after generation. We have learned to call it "cultural memory," but whose memory is it?

Suddenly the weather begins to change. The temperature drops, and a thick fog rolls down from the upper mountains. The shepherdess is prepared for the cold and the drastically reduced visibility, but less so for the accompanying sense of disorientation. As the farm buildings and their surrounding topography disappear, a new and alien-seeming reality begins to take their place. At that moment, the outline of a human-like, male figure appears through the mist. He presses close to her, then disappears. What just happened?

As it turns out, even the shepherdess is not what she seems. In fact, she's an anthropologist. To be precise, she's Kirsten Hastrup, currently a professor of anthropology at the University of Copenhagen, but at the

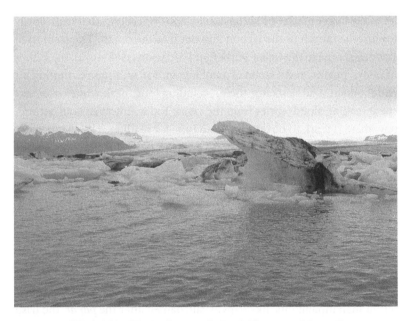

FIGURE 1. Jökulsárlón Glacier Lagoon, Iceland. Photograph by author.

time a postdoctoral researcher, recently graduated from Oxford and conducting fieldwork on an Icelandic farm, where she took on a variety of roles, including milkmaid and shepherdess. As the encroaching fog dissolves the recognizable contours of the landscape she has studied, lived, and worked in, finally obliterating all points of spatial reference, the shepherdess-anthropologist describes herself as experiencing doubt, anxiety, and then an unexpected moment of certainty concerning the figure that appeared in the mist: "I knew instantly that it was a man of the 'hidden people' [huldufólk] who visited me in the small space of vision left to me and my ewe by the fog."[1]

The Hidden People

"There is no doubt in my mind any more that there are two nations living in this country—the Icelandic nation and this invisible nation," declares an off-screen male voice, while the camera pans in succession over black sand beaches, ice floes, mist-shrouded mountains, and the shimmering colors of the aurora borealis. "This is a parallel world," announces another voice, this one female, also off camera.

In the 2006 documentary film *Huldufólk 102*, by the Trinidad and Tobago–born and now U.S.-based filmmaker Nisha Inalsingh (http://www.nishainalsingh.com/), present-day Icelanders tell stories of the *huldufólk*, or hidden people (sometimes identified with elves). The *huldufólk* are a distinct, magically gifted race of beings living alongside humans, although usually invisible to them. They are associated in particular with rocks, stones, caves, and other geological features. As such, their relationship to humans is ambivalent. If treated well, they can be a source of assistance around the home or farm, but they are equally capable of causing illness or bad luck if, for example, the location of their dwellings is not taken into account in the siting of new houses and roads. Inalsingh's film gives the impression that the hidden people in contemporary Iceland are anything but hidden at the level of public discourse—in fact, everyone, from children to the elderly, seems to be talking about them. Hastrup found that her own informants on the farm at Hila also told stories about the *huldufólk*, pointing out places where they had been known to reside in the past, including rocky hills and ravines cutting into the even surface of the infields.[2] Þórbergur Þórðarson had previously written about such sites and about the doings of the *huldufólk* during his

own childhood in the late nineteenth and early twentieth centuries. The *huldufólk* are also well documented in written sources from the medieval period onward, and in later collections of folktales like those compiled by pioneering nineteenth-century folklorist Jón Árnason.[3] By the 1980s, however, residents of Hila were uncertain whether the hidden people were still to be found in the vicinity of the farmstead. Several people suggested that they had last been sighted around ten years previously—this being roughly the time when electricity had been introduced on the farm, chasing away the shadows and darkness that might previously have facilitated their concealment. Nonetheless, as Hastrup goes on to point out, a map of Reykjavík issued in 1988 by the town planning department makes mention of the dwelling places of *huldufólk*, *álfar* (elves), *ljósálfar* (light elves), *gnómar* (gnomes), and *dvergar* (dwarves) in order that planners might respect and avoid them.[4]

Icelanders, however, are not the only ones talking about the hidden people. References to the *huldufólk*, elves, and other beings are also found in the pages of English-language newspapers and magazines like the *Guardian* and the *New York Times*, fueling a surge of interest on the part of visitors to Iceland. Terry Gunnell, professor of folkloristics at the University of Iceland in Reykjavík, complains that each year, the beginning of summer is marked by

> the arrival of foreign journalists wanting to ask me about elves and their imagined image of Icelanders ... little elves with pointy ears dancing around rocks every Friday night. And their interest says as much about their nostalgia and their loss in their worlds of the mysterious and the supernatural and the wonderful. And they are coming to Iceland because this is something they grew up with as children with the stories.[5]

Telling stories is one thing, but those who make the journey to Iceland in search of the real thing are, it seems, the dupes of their own childhood reading of fairy tales and of a parochially modern, Western sense of living in a "disenchanted" present, from which *huldufólk* and their like have long been banished.[6] If the foreign journalists and their readers are drawn to Iceland in the hope that they can make good such a loss in this European outpost in the North Atlantic, their quest is, according to Gunnell, ultimately revealing only of themselves. It is perhaps not surprising,

then, that Hastrup's own claim to have met one of the hidden people face to face has been met with skepticism or outright dismissal from many of her peers, not least from Icelandic anthropologists, one of whom has written that her description of the incident "give[s] priority to stories of the past and to idiosyncratic personal experience rather than actual social practice in the reality of Icelanders."[7] Yet Hastrup has continued to insist on the reality of her experience in the mist, refusing to account for it in other terms—for example, as a hallucination brought about by disorientation, fear, or "too much reading."[8] What, if anything, actually took place in the fog? Did Hastrup really see the *huldumaður* (man of the hidden people)? Or is that the wrong question? If it is the wrong question, then what does that say about anthropology and its relationship to the world or worlds in which anthropological research and writing are carried out? Are distinctions between truth and fiction as we are accustomed to formulate them of help here, or are they a hindrance? Or might anthropology's most subversive potential consist precisely in its capacity to call such distinctions into question?

By Hastrup's own admission, she was steeped in what was, by the late twentieth century, an extensive literature on Icelandic folklore and history. But how might the beings inhabiting Iceland's rocks, caves, waterfalls, glaciers, and volcanoes have been imagined by its first Scandinavian settlers, the voyagers who began to arrive from Norway in the ninth century, in many cases bringing with them Irish and Scottish slaves acquired en route?[9] Like the Irish monks who preceded them, these settlers were newcomers to a landscape that had long existed without human inhabitants. What means were available to them for making sense of their new surroundings? Later commentators have suggested that the pre-Christian Norse cosmos was conceived along two axes, vertical and horizontal.[10] The vertical axis was represented by the world tree, Yggdrasil, reaching from the sky down to Hel, the underworld of the dead.[11] The horizontal axis was envisioned as a series of concentric zones with Ásgarð, the home of the gods, at its center, encompassed by Miðgarð, the world of humans, and beyond it Útgarð, the abode of giants and other nonhumans. Following Iceland's adoption of Christianity in 1000 CE, the horizontal (though not the vertical) axis of the pre-Christian cosmos appears to have persisted in a modified form as a distinction between the zone adjacent to the farmstead—*innangarðs* (within the fence)—and *útangarðs* (outside

8 An Encounter in the Mist

the fence), which lay beyond it, or, in more general terms, as Hastrup suggests elsewhere, between the "social," or the realm governed by law, and the "wild."[12] The latter was the abode of outlaws, banished and stripped (temporarily or permanently) of the protection of the law, as well as a variety of other-than-human presences, many of them thought of as preexisting the arrival of the first human settlers.[13] In literary sources from the thirteenth century onward, and more conspicuously still in later folklore, both outlawed humans and figures such as elves and *huldufólk* came increasingly to be assimilated into a broader category of *útilegumenn* (outlying men) that also encompassed *landvættir* (spirits of the land), *tröll* (trolls), and *jötnar* (giants).[14]

The realm of *útangarðs*, lying beyond human settlement and the purview of law, with its variegated population of *útilegumenn*, has often been seen as finding one of its quintessential manifestations in the *ódáðahraun* (lava field of misdeeds) occupying Iceland's humanly uninhabited center.[15] More than 1,200 miles in extent, stretching from the Vatnajökull glacier northward to the mountains of the Mótvatn region, and with an active volcano, the Askja caldera, close to its center, it is an area shaped and reshaped over millennia by earthquakes, volcanic eruptions, and geothermal activity, as well as by the interplay of fire and ice evoked so powerfully by the Eddic creation story. It is in this inland lava desert that the eponymous protagonist of the saga of Grettir the Strong (composed in the fourteenth century but set in the eleventh) takes refuge after the sentence of banishment is passed upon him. Here he encounters a variety of other outliers before returning briefly to human society to defeat a giant troll and a malevolent ghost, both of which, it is implied, he is able to meet on equal terms because of his own outcast status.[16] The same region was used centuries later, in 1969, by NASA to prepare U.S. astronauts for the first moon mission by exposing these would-be otherworldly travelers to the least terrestrial seeming of available earthly surroundings.[17]

Like Hastrup's purported encounter with the *huldumaður*, her insistence on the continuity of dualistic spatial categories from the medieval period to the present has drawn criticism from other anthropologists of Iceland, who have argued that her account is "overdetermined by the anthropologist's conceptual structures and underdetermined by evidence."[18] Yet the very starkness of the proposed contrast between inside

An Encounter in the Mist

and outside suggests the possibility of a different reading. Hastrup refers to the Icelandic distinction between the social and the wild as a local variant of Lévi-Strauss's core opposition between nature and culture—an opposition that she follows Lévi-Strauss in understanding as "the creation of culture."[19] But need such a claim be understood as granting culture the upper hand? Could the repertoire of stories about hidden people, elves, giants, and other *útilegumenn* also be understood as attempting to do exactly the opposite—to acknowledge a reality existing before the human bestowal of significance upon it? Giants in particular are associated both in the Eddic poems and in Snorri Sturluson's prose summary with the earliest beginnings of the universe, before the appearance of the race of anthropomorphic gods led by Odin and their human worshippers. Indeed, in the cosmogonic narrative preserved in fragmentary form in these sources, the body of the giant, Ymir, provides the raw material for the shaping of the world that gods and humans subsequently inhabit. Most conspicuously among the company of *útilegumenn*, giants appear less as human projections onto the blank screen of nature than as condensations out of the primordial matter from which everything in the universe is fashioned, including humans and (presumably) the stories that humans tell. Might the stories that the first Icelanders spun about the environment in which they settled have been prompted by the often intransigent materialities of that same environment, with preexisting Scandinavian and Celtic conceptions of the cosmos acting as decidedly secondary influences? Taking our cue from the Eddic accounts, could *huldufólk*, *álfar*, *jötnar*, and the literary and folk narratives in which they feature be understood as imaginative distillations out of the same processes that produced their physical setting? If so, what, if anything, does it mean to believe in these stories?

Inalsingh has described her film *Huldufólk 102* as dealing with "the Icelandic belief in the hidden people," a formulation echoed in much anthropological and folklore scholarship. Such instances of belief, it is usually implied, can be unambiguously disentangled from the actual, existing circumstances of people's lives, at least by the researcher (or filmmaker), if not always by the people he or she studies. What this often amounts to, as Jeanne Favret-Saada once remarked, is a gesture of distanciation whereby the imputed falsity or credulity of others' beliefs about ghosts, spirits, or witches functions as the "mirror image" of the

academic observer's self-proclaimed detachment and objectivity.[20] Yet as Favret-Saada herself discovered in her efforts to research contemporary witchcraft practices in the Bocage of western France, it was precisely the sought-after distance that was collapsed by the fieldwork encounter. Not only were her prospective informants unwilling to share details of their lives with her until she herself was "caught" by being recognized as a potential unwitcher, but also the very conventions of academic discourse that had formed the basis of her own training—namely that language was a neutral representational vehicle for conveying information—proved hopelessly inadequate for the situation in which she found herself. In witchcraft, she discovered, words were not simply a conduit for information. Rather, they were a repository of magical force capable of producing material effects in the world—capable of healing, harming, or, on occasion, killing.[21]

A similar abolition of representational distance surely marks Hastrup's encounter with the *huldumaður*. Sitting down later to describe in writing what had befallen her shepherdess-fieldworker alter ego, Hastrup confronts what she recognizes to be the ethnographer's perennial dilemma: turning experience into text. When the fog cleared and she was rejoined by her companions, she recalls, "the only thing that remained clear in my mind was the real experience of the materialization of the unreal." What she had hitherto conceived of as existing at a remove from her—as the beliefs of her Icelandic hosts and coworkers, and thus from her own perspective unreal—becomes, in the moment of the encounter, an unassailably real part of her own experience. The challenge of rendering fieldwork experience into ethnographic text thus becomes a matter of rendering justice to what she calls "the empirical unreal." The challenge is not least a creative and writerly one, demanding a continuous struggle against the tendency of form to solidify into convention, with the result that texts begin to aspire to resemble not "life" as revealed through ethnographic fieldwork but "genre" as exemplified by other, similarly fashioned texts.[22] Instead (quoting Paul Stoller), she suggests that ethnographic descriptions need to be framed in such a way that readers are "carried into new and thought-provoking worlds."[23] What, however, is the status of such worlds relative to the ones anthropologists and their audiences are taken to inhabit? What is their relationship to the texts or other artifacts through which they are made manifest?[24]

Hastrup invokes Roland Barthes's distinction between the would-be self-effacing "writer" who acts as the supposedly transparent medium for a reality assumed to exist external to the text and the "author" whose relationship to a particular world is self-consciously embedded in the texts he or she writes.[25] An author, she writes, would not doubt that Icelandic peasants have a direct firsthand experience of *huldufólk* and would have no hesitation in showing that, as an ethnographer, he or she had been present in a space of shared experience ("in the ethnographic unreality"). The difference between writerly and authorial accounts, therefore, is one that is located "between a narrative of Icelandic sheep-rearers which relates their 'belief' in 'hidden people' living in the mountains, and another which states that the Icelandic rocks are populated by *huldufólk.*" The former distanciates itself from "LIFE" (the life that the ethnographer shares with his or her informants), and the latter admits "the momentous conjunction of conceptual universes which is an integral part of the experience of coevalness in the field."[26] But perhaps the crucial point is that the conjunction at issue ceases in such moments to be thinkable or describable as one between differently constituted "conceptual universes." If we are to take seriously the abundantly documented association of the *huldufólk* and other *útilegumenn* both with a space beyond the reach of law and human influence and with a time prior to the arrival of Iceland's first human inhabitants, then we are surely bound to ask whether what was encountered in the mist was simply another ("cultural") world of human experience that differed in specifiable ways from the researcher's own or an other-than-human reality that precedes and subtends the differential fashioning of human worlds. The latter possibility forces us to give new consideration to the relationship between anthropological texts and the worlds they purport to describe. Most importantly, it challenges us to conceive of that relationship otherwise than in terms of representation.

So what's wrong with representation? Like many of the thinkers who feature in the following pages, I have learned to be suspicious of this notion that is so much part of our Western epistemic common sense. "The epoch of representation is as old as the West," writes Jean-Luc Nancy, invoking a genealogy extending back at least as far as Plato and the beginnings of Western philosophy and including a range of assumptions about relations between originals and copies, subjects and objects,

selves and others.[27] Perhaps too, as Michel Foucault has argued, representation stands in a particular relationship to such characteristically modern forms of knowledge as biology, philology, and political economy and the societal transformations that accompanied their emergence.[28] Then there's political representation, of the kind (allegedly) practiced in so-called Western so-called democracies; how does that fit into the story?[29] Nonetheless, its lengthy and complex genealogy notwithstanding, it seems that most of the time when we talk about representation we at least think we know what we mean—or do we? Texts, paintings, statues, films, photographs, images "in" the mind: all are routinely talked about as representations of a reality existing independently of them. Representation seems always to involve a gap or disjuncture, as though the representation and the one who represents (the subject) could be cleanly and unequivocally separated from the thing represented (the object). As Tim Ingold has suggested, such a view implies that the capacity to construct representations involves taking a step out of the world. Humans, in other words, are seen as able to represent the world insofar as they have separated themselves from "nature" and acceded instead to a transendent (and distinctively human) realm of "culture."[30] It is striking, however, that doubts and questions about representation have begun to manifest themselves with increasing frequency in a moment when human and planetary futures have never seemed less certain and when long-habituated distinctions between nature and culture are everywhere unraveling to disconcerting effect. Eduardo Kohn, in his extraordinary book *How Forests Think* (2013), takes to task both Saussurean linguistics and much humanities and social sciences scholarship for conflating representation with the symbol, understood as a sign associated with a particular referent on the basis of a set of shared conventions, and thus with language as a form of communication deemed to be unique to humans. Instead, drawing on the semiotics of Charles Sanders Peirce and on biological anthropologist Terrence Deacon's explorations of emergent dynamics, Kohn argues that other forms of representation are to be found more widely among other living beings, like the animals and plants of the Ecuadorean Upper Amazon, where he conducted ethnographic research. These other forms of representation include icons (based on likeness or resemblance) and indices (signs that "point" to their referents). Furthermore, symbolic representation itself, for all its much-touted distinctiveness, remains nested

An Encounter in the Mist 13

within and thus dependent on these other modalities. Conceiving of representation beyond a human-centered preoccupation with language and "languagelike properties" becomes for Kohn a way of dislodging Western anthropocentrism and thus a step toward the "permanent decolonization of thought" called for by Eduardo Viveiros de Castro.[31]

Is there not, however, a danger that identifying icons and indices as forms of representation (albeit with a provenance extending beyond the human) imposes its own limitations? Characteristic of representation, in Nancy's view, is precisely a preoccupation with the limit—hence the West's desire to represent both itself and its "outside" (variously coded as the East, the other world, or the other than human). This gesture is aimed at eliminating other potential sources of creativity by forestalling the emergence of whatever is not already given according to the order of representation itself.[32] Of course, Nancy himself is arguably using the term "representation" in the restricted, symbolic sense criticized by Kohn and others, yet in locating it in terms of the West's hegemonizing project, thus broadly conceived, he reminds us too that its influence may be more pervasive and tenacious than we suppose. Is it possible to think about signification without recourse to the notion of representation? Might, for example, giving serious consideration to iconicity and indexicality prompt us not to extend the purview of representation but instead to question even the representational status of symbols? Is representing the world what humans and others do, or just what some humans think they do? Rather than saying that dogs, stick insects, and wooly monkeys represent the world to themselves as much as humans do (albeit differently), could we say that they and humans do something else (if "do" is the right word)? I make no claim here to answer these questions, nor to have freed myself definitively from the shackles of representation, nor yet to provide a fully articulated alternative vocabulary in the manner of Peircean semiotics. Nonetheless, what follows is an attempt at least to disturb the seeming self-evidence of representation and the explanatory frameworks that it appears to make available.

If anthropological texts, as Hastrup for one maintains, should be thought of as distinguishably different from the ethnographic realities (and unrealities?) that they reference, then should that difference be understood in terms of a representational gap between sign and referent, a gap secured (according to academic convention) by social and linguistic convention,

or of immanent participation in a material universe (including an assortment of more elusive and intangible presences) that encompasses and therefore exceeds both of them? The encounter in the mist with the *huldumaður* seems strongly to imply the latter. Like Favret-Saada, caught by the witchcraft she set out to study, the shepherdess-anthropologist is seized by a reality that can neither be relied on as objectively given nor reduced to the status of a cultural or linguistic construction—a reality of geologic prehistories, flows, becomings, and molten indeterminacies that seems indeed to render superfluous any accredited distinction between fact and belief, reality and representation.

"NONE OF MY FRIENDS . . . BELIEVE ANY SUCH THING"

Might a self-described author of literary fictions have dealt with matters differently? *Names for the Sea* is the title of a 2012 memoir by English novelist Sarah Moss, who spent the 2009–10 academic year teaching creative writing at the University of Iceland in Reykjavík in the immediate aftermath of the 2008 financial collapse precipitated by the risk-taking of Iceland's recently deregulated banking sector. Moss's decision to accept the offer of a teaching position was, she writes, influenced by her long-standing fascination with the sub-Arctic—not the ice and snow of the polar cap, but the island communities of the North Atlantic:

> It's not the real, white Arctic, the scene of centuries of bearded latitude competitions, that sets me dreaming, but the grey archipelago of Atlantic stepping stones. Scilly, Aran, Harris, Lewis, Orkney, Fair Isle, Shetland, Faroe, Iceland, southern Greenland, the Canadian maritimes; a sea-road linking ancient settlements, traveled for centuries. The Arctic is just over the horizon, the six months' darkness always at the back of the mind, the summer-long day impossible to believe in winter and impossible to doubt when it comes. Here, just below the earth's summit, there are towns and villages, a tangle of human lives in the shadow of Arctic eschatology.[33]

She had, she writes, encountered references to the "Hidden People" and the assertion that "Icelanders believe in elves," but after several months, she felt able to declare, "It's so obvious to me that none of my friends and students here believe any such thing."[34] What forced her to reconsider,

however, was an encounter with the volatile physical geography that both supports and occasionally threatens the lives of Iceland's human inhabitants. Nearing the end of her stay, her plans to leave were put on hold by a series of eruptions of the Eyjafjallajökull volcano, beginning in late March and intensifying during April, sending out an ash plume to a height of 30,000 feet along with 250 million cubic meters of tephra, forcing the closure of European airspace and resulting in the largest disruption to regional air traffic since World War II. Forced to remain longer, Moss decided to take the opportunity to see more of the country. Although skeptical about elves and other creatures, she was, by her own admission, curious about ghost stories of the kind she had encountered in the sagas and latter-day collections of folklore, and she decided to ask around for contemporary examples. At the suggestion of her department head, she reluctantly agreed to meet with Þórunn, a woman in her sixties, known both for her skills as a medium and for her ability to communicate with the *huldufólk*. The meeting took place at Þórunn's mountain house, a wooden chalet several hours' drive from Reykjavík along gravel roads, looking out across a lava field toward the erupting volcano.

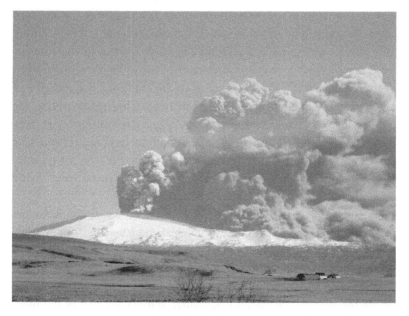

FIGURE 2. Ash plume from Eyjafjallajökull. Photograph by Árni Friðriksson.

Þórunn told Moss that there were several kinds of supernatural beings residing in the vicinity. She distinguished between elves ("fun, and colorful") and the hidden people ("more like the working class, just thinking about their livestock and how to get food"). She added that such beings usually interfered minimally with the built environment (although they could cause bad luck if the location of their dwellings was not taken into account when building a new house or road), but they did have some capacity to influence geological processes, including volcanic eruptions: "When there are eruptions in the land, on the earth, then they can make a difference."[35]

As Þórunn spoke, Moss noticed that the ash cloud issuing from Eyjafjallajökull, visible behind her shoulder, had grown perceptibly larger, reminding her that "there are farms round the other side of the mountain that will be uninhabitable for years to come, villages where the children have not set foot outside for weeks. In earlier centuries there have been eruptions that have depopulated half the island." Þórunn said that the elves were not able to cause or fully control volcanic eruptions, although they were able to influence them: "They can have a little to say about it." Moss asked her whether such beings were exclusive to Iceland, with its distinctive physical geography. Þórunn replied that she had seen them elsewhere, although they looked different in other places—Hawaii, for example, where she had gone on a holiday. The beings she encountered there were "more lightly dressed than the Icelandic ones, but just the same." Was it significant, Moss asked, that both Iceland and Hawaii are volcanic islands? Þórunn paused to consult her guide among the hidden people (who was standing close by but was visible only to her), then reported back: "He's telling me that both Iceland and Hawaii have connections to the middle of the earth, where there is a floating, something floating like lava.... It's like the hidden people are connected to the lava, but not every kind of lava. Just this kind."[36]

It is striking that in their accounts of the hidden people, both Kirsten Hastrup and Sarah Moss, an anthropologist and a novelist, respectively, refer back to geological time and to volcanic activity occurring beneath the earth's apparently solid, humanly inscribed surface. The hidden people, it seems, are evocative not only of a timescale that stretches long before the arrival of Iceland's first human settlers but also of the magmic upheavals that have shaped and continue to shape the contours of

present-day Iceland. As such, they offer a vantage point from which the seemingly fixed forms of the physical landscape can be seen as no more than the temporary slowing or abatement of violent earth processes continuing to unfold unseen in the tellurian depths, breaking cover intermittently in the guise of eruptions, lava flows, tephra clouds, and ash plumes. The repertoire of stories relating to *huldufólk*, trolls, giants, and land spirits are not least the products of successive human efforts to imagine a world without (before or after) humans. They offer a reminder that, in Nigel Clarke's words, the social life of humans unfolds on a "volatile" planet—one that, notwithstanding the manifestly increasing environmental impact of the human species, can never be wholly reduced to or encompassed by human projects and understandings.[37] For all the evident magnitude of twenty-first-century humanity's ecological footprint, as signaled by proclamations of the Anthropocene as a distinct geological epoch, seismic upheavals, tidal waves, volcanic eruptions, and meteorite strikes retain the capacity to take us by surprise, to disrupt the futures that we plan and enact.[38] The *útilegumenn* of Iceland's central lava desert are an imaginative manifestation of just such a possibility. They force us to ask whether the cultural-historical mediation of nature that remains an article of faith for much anthropological (and other) scholarship is not itself mediated by the suprahuman temporalities of, for example, evolutionary biology, geology, and cosmology.[39]

When I first read Hastrup's description of her encounter in the mountains, I was troubled by her use of the terms "reality" and "unreality." These seemed to imply that the question of what should or should not be counted as real was already settled. Perhaps they still imply as much, yet they also alert us to the fact that the real (and not simply our descriptions of it) is precisely what is at issue here. As the mist obscures the reassuringly knowable world delineated by anthropological and historical scholarship, distinctions between reality as given and people's culturally specific representations of it become impossible to draw with certainty. Hastrup writes that anthropologists in the field cease to be simply themselves—subjectivities shaped by a particular context and history—and become instead objects of an alien reality—or, as she puts it, "third person" characters in a discourse governed by others.[40] If, for Hastrup, this involves simultaneously the subjectival experience of the phenomenality of an alien reality and an awareness of one's own becoming

18 *An Encounter in the Mist*

an object in and for that reality, then the reference to the third person suggests that even more might be at stake.

THIRD PERSON

Where does anything begin? In the middle, perhaps? From one extremity of Europe to another, not far from where Europe confronts Africa across the Strait of Gibraltar and the Alboran Sea. A bookish narrator, searching for the exact location of a celebrated Roman battle (the Battle of Munda, 45 BCE), takes a vacation from the library to wander in the mountains of Andalusia. He comes across a bandit asleep in the sun beside a spring that follows a gorge descending from the peaks of the Sierra de Cabra. A scholar and an outlaw—this time they both live to walk away, so there's a story to tell. They will meet again, for the last time, in a prison cell as the bandit, Don José, awaits execution. His lover, Carmen, the devil girl, the wild gypsy, the story's turbulent raison d'être, lies dead by his hand. Sentence has been passed and waits only to be carried out. Everything is decided. It remains only to recount what has already happened. To discover the might have beens, the paths not taken, it is necessary to work backward. What lies upstream of the facts? What is there before the branching and bifurcating of ways, before the decisions that produce this world rather than that, this story rather than another? Might literature know something about this that science (and social science) can't?

Philosopher Michel Serres summarizes the plot of Prosper Mérimée's novella, *Carmen* (first published in 1845, and the source for Georges Bizet's arguably much better-known 1875 opera), to illustrate the importance of what he calls the third person.[41] Linguist Émile Benveniste had previously distinguished between the first and second persons, defined and deployed in relation to each new speech act, and the third person, which is excluded from the community of interlocutors ("I," "we," or "you") and which may not even refer to a person at all. Benveniste writes (himself adopting the impersonal form of the third person), "One should be fully aware of the peculiar fact that the 'third person' is the only one by which a *thing* is predicated verbally."[42] Linguistic anthropology has often emphasized the importance of such pronomial shifters in orienting and enabling human communication.[43] The concerns of both Benveniste and Serres, however, extend beyond the human. The third

person partakes simultaneously of exclusivity and inclusivity. It can encompass not only specific excluded others—the hidden people implied in any two-way exchange—but also externality in general, the world as such in the impersonality of its taking place: it rains, it hails, it snows, it thunders—the meteorological fluctuations that bring fog down from the mountaintops on a clear day, creating the conditions under which a representative of the hidden ones might show himself to an unsuspecting shepherdess-fieldworker. More expansively still, for Serres, it is also the third person that gives and articulates Being, as rendered in the French expression for "being there": *il y a*.[44]

Serres attaches great importance to such third spaces—spaces of transition and transformation, of aberration and incalculability, the middle where everything commences. Such are the spaces of the parasite, of the ineradicable noise that accompanies and enables meaningful communication, of the departures and castings off that inaugurate new projects and pathways, and of the tortuous and elusive Northwest Passage between the institutionally divergent knowledge cultures of the sciences and the humanities. Serres describes himself as occupying such a tertiary zone, that of the "instructed third" (*Le Tiers Instruit* being the original, French-language title of *The Troubadour of Knowledge*): a left-hander taught to use the right, or, as he calls it, "completed"; a self-described descendant of Gascon peasants turned sailor turned mathematician turned philosopher; a traveler passing always through the middle, the undecidable. The third person and third space are at once between and antecedent to the oppositional differentiation of subject and object or of self and other, effecting an opening to the universe in all its turbulent generativity.

Understood in these terms, Kirsten's third-personification in the mountains of Iceland appears to be more than a matter of intersecting or overlapping frames of cultural reference. Let us remember that the figure in the mist is an emissary not only from an alien cultural world that is nonetheless in some measure discursively knowable and describable, but also from a realm beyond the sway of human influence—the great lava field of misdeeds with its population of *útilegumenn*, including the giants who, in the account of the creation of the universe preserved in the Norse Eddic poems, are identified as emerging out of primordial chaos and darkness, and thus as predating both the anthropomorphically conceived

gods of the more familiar Norse pantheon and their human worshipers. Considered thus, the mythopoeic beings who populate the lava field of misdeeds are more than the human projection of meaning onto an inanimate nature. They are a conduit for the insinuation into culture of material presences that exceed the self-described realm of the human. The fieldworker's supposed objectification by an Icelandic cultural reality is also her interpellation by an other-than-human materiality that subtends the making and unmaking of human worlds, including those of the shepherdess-anthropologist and her Icelandic coworker-informants. The *huldumaður* functions here not just as an image embedded in specific and localized histories of signification and verbal art but also as the discursively formulated manifestation of a reality irreducible to discursivity—a reality that is at once the constituent stuff of our cultural imaginings (as indeed of our bodies, thoughts, affects, and sensations) and imbued with an inhuman vitality of its own that forever exceeds our cognitive or representational grasp. To recognize this is less a matter of respecting or accurately representing the beliefs of others than of acceding to a truth that demands not only to be documented but also to be poetically affirmed—a truth, that is, of becoming.

two

Talabot

Now picture yourself at the theater, seated in one of several rows of seats bordering a narrow performance space. The scenery is minimal, just a ramp and platform assembly at either end of the playing area. Most of the lighting is provided by flashlight bulbs suspended overhead from two electrical cords. The shepherdess-anthropologist is joined onstage by a variety of other characters. Some of them—her late father, and figures encountered during her fieldwork in Iceland—appear directly connected to her story. Others are less obviously so. One is Knud Rasmussen, early twentieth-century Danish anthropologist and Arctic explorer. Another is Antonin Artaud, playwright, poet, actor, director, and sometime asylum inmate. Yet another is Che Guevara, iconic revolutionary, medical doctor, and onetime director of the National Bank of Cuba. Most curious of all is a self-identified trickster, wearing a Balinese theatrical mask of the kind that inspired Artaud and suckling an effigy of a child filled with sand.[1]

Talabot is the name of a theatrical production devised and staged by Italian-born director and theater scholar Eugenio Barba and members of Odin Teatret, an experimental theater company based in Holstebro, Denmark, that Barba founded in 1964.[2] It was inspired in part by Barba's reading of Hastrup's work, including the essay "The Challenge of the Unreal," in which she describes her encounter with the *huldumaður.*[3] Hastrup and Barba first met in 1986 at a conference hosted by Odin Teatret. Both would recall being struck by their similarities to and differences from one another. Barba would later write that Hastrup's work as

an anthropologist resonated with his own long-standing fascination with diasporic characters, a fascination reflected in the dramatis personae of *Talabot*: "It was an example of the type of person who had chosen of her own will to leave her country of birth and unfold an activity among foreigners, as for instance the explorer, the revolutionary, the doctor, the missionary and many theater people."[4] The same concern with the displaced and marginalized would also inform Barba's conception of a Third Theater occupying another kind of third space, distinct from both traditional theater and the avant-garde and located on the fringes of or outside recognized centers of cultural production.[5] Barba, however, distinguished his own "theater anthropology" in its search for the "pre-expressive" substrate of all theatrical action from the more particularistic studies undertaken by many cultural anthropologists.[6] Hastrup for her part recalls being fascinated by the unabashed universalism and transcultural scope of Barba's work and by its effort to identify generative principles underlying diverse genres and performance traditions, again contrasting with the dominant approaches of her own discipline. Nonetheless, she saw affinities between Barba's explorations of the performer's "presence," a notion extending beyond simple physical presence to include affect and energy, as well as the techniques of their deployment— and her own reflections on the anthropologist's presence in the field.[7] Out of this initial meeting came further exchanges, then an invitation from Barba to collaborate on a creative project. Barba and members of Odin Teatret met with Hastrup, and they agreed that she would write a hundred autobiographical episodes, each no longer than a page, detailing episodes from her life. These were to include her childhood and student years, the death of her father, her marriage, the birth of her children, her fieldwork in Iceland, the emotional distress attendant on her return to Denmark and the breakup of her marriage, and, finally, her personal and professional recovery. They would constitute part of the verbal fabric of the performance and would offer inspiration for individual scenes. Other sources included the masks and costumes of the Italian commedia dell'arte, the lives and writings of Rasmussen, Artaud, and Guevara, and a psalm written by Danish poet B. S. Ingermann (1789–1862), which opens and closes the performance.

Talabot was created by the company in Chicxulub (Yucatán, Mexico) and first performed in 1988 at Holstebro in the Blue Room, the smallest

of the company's performance spaces, laid out on this occasion to accommodate around 100 spectators. The production went on to tour Europe and South America over the next three years. The name "Talabot" evokes a number of associations. It is the name of the Norwegian cargo vessel on which Barba made his first voyage as a merchant seaman in 1956; the name of a French engineer, Paulin François Talabot, involved in the planning of the Suez Canal; and a verb in the Mayan language of Yucatán meaning "to reach the seashore" (*tal'bot*) or "to come to agitate the body" (*talah bot*). The actors use multiple languages: Hastrup and her father speak English, Che Guevara speaks Norwegian, and Artaud combines heavily accented English with fluent Italian. All of the actors play multiple roles, and at different times they don masks resembling those of the commedia dell'arte, but broken in several places and held together with strips of rawhide.[8]

Barba would later liken the construction of the play—its concatenation of episodes drawn from disparate times and places—with the techniques of modernist literature and cinema, including the fascination with Chinese and Japanese ideograms that informed both Ezra Pound's poetry and the cinema of Sergei Eisenstein. In contrast to the linear, sequential logic imposed by a phonetic, written script, ideograms, like the juxtapositions of Pound's *Cantos* or Eisenstein's use of montage, offered instead the possibility of "the construction of meaning through the conjunction and clash of distant concepts . . . adjoining and interlacing dissimilar elements . . . creating a new reality of thought and perception."[9] For Barba, theater shared the capacity to join together dissimilar elements to tell stories articulated on the basis of a simultaneity of events: "A story through words, both written and oral, must necessarily organize events one after another, following the vector of time. A story which takes shape in theater can on the contrary show two or more different events at the same time and in the same place."[10]

Talabot juxtaposes scenes from a variety of times and places, including Hastrup's childhood and university days and episodes from twentieth-century history:

- With much shouting and gesticulation, Artaud repeats parts of his lecture to the Sorbonne of April 6, 1933, "The Theater and the Plague," in which he likened theater to an epidemic unleashed on the social body: "It releases

conflict, disengages powers, liberates possibilities, and if these possibilities and these powers are dark, it is not the fault of the plague or of the theater, but of life."[11]

- Che Guevara, wearing the costume of a commedia dell'arte Capitano, is led to his death by firing squad, only to be resurrected to the strains of the song "El Cóndor Pasa."[12]
- A young Kirsten Hastrup addresses a group of fellow student protesters. "All power to the imagination!" she shouts.[13]

The trickster, meanwhile, maintains a presence betwixt and alongside the action, sometimes hovering on the margins, sometimes seizing center stage.[14] The program notes to the production describe the trickster, played by Odin Teatret actress Iben Nagel Rasmussen, as a metamorphic figure, "a grotesque character . . . [that] can transform itself from man into woman and from human being into animal. It creates and destroys, gives and receives, cheats and is cheated, bringing with its tricks disorder into the order of things." The trickster's interventions include songs, dances, and sometimes mocking introjections and commentaries on the other characters. At one point the trickster recites a litany of the atrocities of the twentieth century—wars, genocides, coups d'état, assassinations— ending with the declaration (in Danish) that "it must be hard to be a human being."[15] After the performance, on the way out of the theater, a postcard in a sealed envelope was handed to each of the spectators. It showed an image of the trickster dancing around the mound of garbage accumulated over the course of the performance and piled beneath a tree, the branches of which were tangled in burned barbed wire. On the other side of the postcard was printed a quotation from Walter Benjamin's "Theses on the Philosophy of History" (1940) describing the "Angel of History" (a figure drawn in turn from a painting by Paul Klee):

His face is turned towards the past. There where we see a chain of events, he sees one single catastrophe which piles up wreckage upon wreckage throwing it at his feet. He would prefer to remain, awaken the dead and put back together what has been laid waste. But from paradise a storm still blows, so violent that his wings become entangled and the Angel can no longer fold them together. The storm pushes him irresistibly toward the future on which he turns his back, while in front of him the mountain of wreckage rises toward the sky. This storm is what we call progress.[16]

Hastrup would later identify the trickster as Kirsten's twin in the play: "As clown and storyteller respectively, Trickster and Kirsten achieve their identities by exploiting the ambiguities of their cultural and social position."[17] Yet her account of her own involvement in the production reveals one crucial point of contrast. If, as Lewis Hyde has suggested, the figure of the trickster is characterized precisely by not being anchored in a particular species identity, a particular way of being in the world (unlike humans and most other creatures), then this is perhaps why the trickster's serial transformations can be undergone without any corresponding sense of loss or disorientation.[18] Such, however, appears not to be the case for the anthropologist. If the encounter with the *huldumaður* amounted to a forceful manifestation of the unreal, as a result of which the familiar, taken-for-granted world appeared suddenly dubious and uncertain, Hastrup experienced her involvement in the making of *Talabot* as a gradual undermining of her own sense of self. As members of Odin Teatret asked her questions about her life and the written accounts of it she had prepared for them, taking notes on her responses, she became increasingly aware that her own aims in describing her life did not coincide with the company's aims in eliciting such descriptions: "My life history was already implicated in Odin's search for a main character." She recalled that a number of anthropology's most celebrated informants—like Tuhami, who features in Vincent Crapanzano's ethnography of that name—had died when their time as research subjects came to an end. She found herself wondering about her own fate when the play was over. This sense of self-dispossession intensified as work on the production progressed and Hastrup, invited to attend a rehearsal, was able to see herself portrayed onstage by another woman, in this instance Odin Teatret actress Julia Varley. While being moved sometimes to tears by the portrayal as well as by the skill of the company as a whole and the precision with which they had grasped what she took to be the essence of her story, she remained acutely aware that the figure on stage was "not-me":[19]

Seeing myself performed by another woman in a strange context forced me to question my authenticity. I became an invention even to myself. Consequently, the traditional categories of thought broke down. Self or other, I or she, subject or object, were dichotomies of no relevance. Losing my identity implied a complete loss of confidence in the world. My childhood fear of darkness came back upon me.[20]

A further change took place when Hastrup, seated in the audience, saw the production again on opening night. The audience included a number of colleagues, students, and family members, many of whom were unfamiliar with the details of her story, and she was able to observe their reactions as the performance unfolded. The effect was a partial closing of the gap she had previously sensed between herself and the figure of Kirsten portrayed on stage: "She was no longer not-me, but had become not-not-me." Hastrup watched the performance several more times, including the last night of its run at Holstebro, after which she saw the

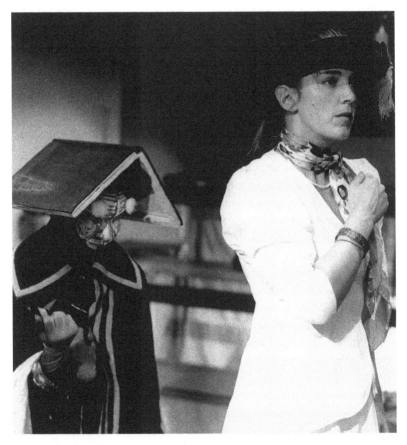

FIGURE 3. Trickster (Iben Nagel Rasmussen, left) and Kirsten (Julia Varley, right). Odin Teatret Archives. Performance: *Talabot*. Director: Eugenio Barba. Photograph by Jan Rusz.

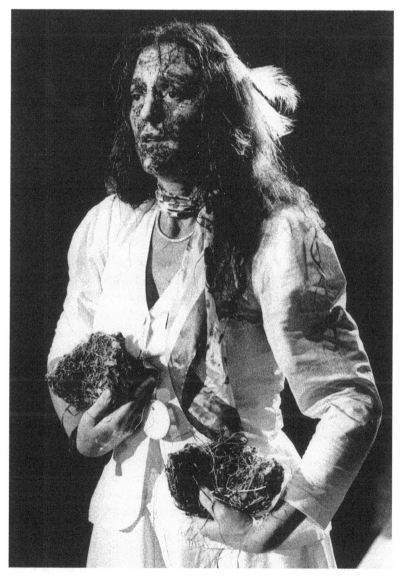

FIGURE 4. Kirsten (Julia Varley). Odin Teatret Archives. Performance: *Talabot*. Director: Eugenio Barba. Photograph by Jan Rusz.

group pack up their costumes and masks in preparation for embarking on a tour of Europe and South America. The company's departure gave rise to a new sense of loss and abandonment, the result not only of having been "fieldworked upon" but also of a sense that with the shift from "not-me" to "not-not-me," her own reality had been usurped by that of the character bearing her name—a character who would now travel the world in her absence.[21]

In the end, Hastrup did find a way to return from the oblivion to which Odin Teatret's appropriation of her story threatened to consign her. In reassembling her personal and professional life, she found herself able to "write back" by exploring her own participation in the making of *Talabot* and the ways in which the experience had transformed her understanding of herself and of anthropology. In particular, she describes herself as led to a new awareness of the importance of fictionality and performance in the crafting of identities and the shaping of human worlds and of anthropology itself as "a forceful practice of intersubjectivity" that engaged with and transformed collective life rather than standing apart from it. Anthropological encounters, like theatrical performance, involved simultaneously the threat of symbolic violence and the possibility of encountering new worlds. They did so by occupying a space in which the real and the fictional could not be clearly and unequivocally distinguished. The same blurring of accredited boundaries was at work both in the shepherdess-fieldworker's encounter with the *huldumaður* and in the oscillation between estrangement and identification that characterized the anthropologist-spectator's relationship to her theatrical namesake.[22]

The Plague

How might such a zone of nondistinction appear from the vantage point of some of *Talabot*'s other protagonists? Perhaps it might look like a plague epidemic, sweeping through a city, spreading chaos and destruction. Plague victims experience an upheaval of bodily fluids, as though the fluid were trying to escape through the skin; the pulse alternately races, then slows to the point of being imperceptible; black, pus-filled buboes form under the armpits and around the anus and genitals; the skin rises in blisters around them "like bubbles under the surface of lava."[23] Yet for all its evocations of the magmic surging of body fluids—

recalling the upheavals of Iceland's volcanic center, home to the fractious company of *Útilegumenn*—Artaud's lecture "The Theater and the Plague," on which Odin Teatret's production of *Talabot* draws, references a collective disturbance that is at once physical and psychic: not only the accumulation of dead and dying bodies, but also alternating delirium and apathy; the neglect of roads and sewers, and eventually the disposal of bodies; deranged victims, not yet dead, running howling through the streets; random and profitless acts of looting; necrophiliac orgies. Artaud asks: could this letting loose, this proliferating disorder of individual and social bodies, be the beginning of theater? Theater for Artaud consisted in its essence not in the reassurances of enframed spectacle, character, plot, and socially sanctioned meaning, but in an outpouring of dark and violent forces. As such, it promised to restore to both performers and audience a visceral sense of their own participation in the tumult of a planetary and cosmic life that exceeded and overflowed the more narrowly bounded lives of both organisms and social collectives.

If, decades later, the play that Odin Teatret fashioned from fragments of Artaud's and other texts would be received with enthusiasm by both critics and the public (including Kirsten Hastrup, who attended each of the initial performances), Artaud's original lecture met with a very different response. The occasion is described in the diaries of French-born writer Anaïs Nin, who was present in the audience. Artaud was introduced to a crowded room by psychoanalyst and homeopathic doctor Réné Allendy, the popular success of whose lectures on "New Ideas" at the Sorbonne had attracted many of those present. Nin describes Artaud's appearance as he took his place at the front of the hall: "He looked tormented. His hair, rather long, fell at times over his forehead. He has the actor's nimbleness and quickness of gestures. His face is lean, as if ravaged by fevers. His eyes do not seem to see the people. They are the eyes of a visionary. His hands are long, long-fingered." Artaud began his lecture:

> But then, imperceptibly almost, he let go of the thread we were following and began to act out dying by plague. No one quite knew when it began. To illustrate his conference, he was acting out an agony. "*La Peste*" in French is so much more terrible than "The Plague" in English. But no word could describe what Artaud acted on the platform of the Sorbonne. He forgot about his conference, the theater, his ideas, Dr. Allendy sitting

there, the public, the young students, his wife, professors, and directors. His face was contorted with anguish, one could see the perspiration dampening his hair. His eyes dilated, his muscles became cramped, his fingers struggled to retain their flexibility. He made one feel the parched and burning throat, the pains, the fever, the fire in the guts. He was in agony. He was screaming. He was delirious. He was enacting his own crucifixion.[24]

People gasped, then began to laugh; eventually everyone was laughing. Then they began to hiss, and one by one, they began to leave, banging the door, talking loudly, protesting as they did so. Artaud continued to the end, when the hall was emptied of all but a small group of friends. Afterward he asked Nin to accompany him to a nearby café ("Everyone else had something to do"). As they walked through the darkened streets, it became clear to her that Artaud was hurt by the audience's reaction. He told her, "They always want to hear *about*; they want to hear an objective conference on 'The Theater and the Plague,' and I want to give them the experience itself, the plague itself, so they will be terrified and awaken. I want to awaken them. They do not realize *they are dead*."[25] Like the plague he evokes, Artaud's lecture-performance sought to overturn familiar distinctions between death and life, awakening his audience from a convention-bound existence that amounted to a living death by exposing them to the simultaneously creative and destructive force of a more expansive life. His attempt—and, from the audience's point of view, his failure—consisted of his refusal to be content with conventional representation. Rather than talking about the plague as an object that could be held at a safe remove from the audience's experience, he sought to enact it, to render it viscerally present through words and gestures.

TRICKSTER

Nin's description suggests powerful affinities between Artaud and another of *Talabot*'s protagonists, the trickster (Iben Nagel Rasmussen), a figure whose Balinese mask evokes a performance tradition that would exert a strong influence on Artaud's work and who would reappear in a number of Odin Teatret's subsequent productions.[26] In addition to tricksters' lack of a fixed and determinate identity or "way," Lewis Hyde sees them as characterized by what he calls joint work. All systems, Hyde suggests, insofar as they present themselves as immutable or eternal, are vulnerable

to transformation precisely at their joints or interstices. Joints are thus places where movement can be introduced into whatever appears static. Although some joints (those made by a stonemason; those made by joining together plates of the skull) are intended to be static, contributing to the creation of a stable form, tricksters are concerned in particular with moving joints, or with introducing movement into the seemingly immobile, thus recalling Artaud's vision of theater as the violent reanimation of a collective life sunk into the deathlike fixity of routine and habit.[27] Barba would later describe *Talabot*'s trickster in strikingly similar terms. The trickster, he writes, was a half-human, half-animal figure of indeterminate gender who shadowed the other characters on stage, mimicking their passions and suffering without partaking fully in any of the contexts in which the latter unfolded. As such, the trickster existed apart from the main narrative of the play, which consisted of the events of Hastrup's biography and of twentieth-century history. Instead, the trickster was identified with montage or with the ideogram-like construction of the work as a whole, a juxtaposition of elements from heterogeneous times and places. Indeed, Barba admits that he himself (if not necessarily the audience) saw the trickster as belonging to a "secret story" that surfaced in an elliptical and fragmentary way in the interstices of the more easily recognizable one, a story pertaining not to any linearly unfolding sequence of events but to the generative possibilities of simultaneity, contiguity, and juxtaposition understood to inhere in the in-between spaces that the trickster characteristically inhabits.[28]

Anthropologists, who have had a great deal to say over the years about tricksters, have pointed sometimes to the resemblance between their own role and the interstitial joint work that Hyde and Barba associate with such figures.[29] Some anthropologists have even fancied themselves as tricksters and envisioned the possibility of a trickster anthropology.[30] Comparison with Artaud's Sorbonne lecture—and the audience reaction it elicited—suggests, however, that such an undertaking must go beyond interstitial meddling and boundary crossing, that it must engage further the trickster's manifest capacity to scramble the conventionally real and the conventionally fictive. Take, for example, Paul Radin's classic recounting of the Winnebago trickster cycle. For Radin, the trickster evokes both the emergence of classificatory order and its dissolution, both primordial undifferentiation and the future promise of differentiation.[31]

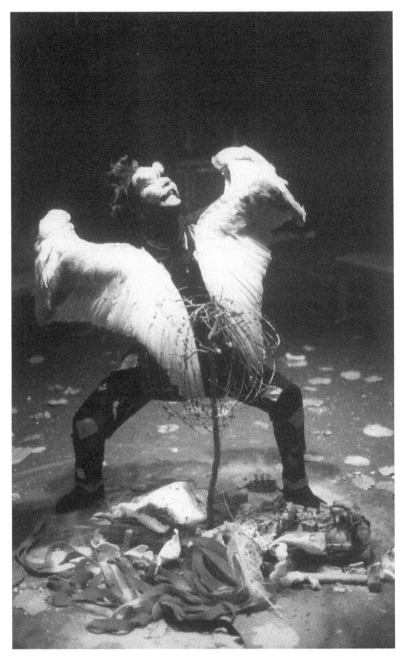

FIGURE 5. Trickster (Iben Nagel Rasmussen). Odin Teatret Archives. Performance: *Talabot*. Director: Eugenio Barba. Photograph by Jan Rusz.

The Winnebago trickster, like all tricksters, is a figure who effaces divisions between appearance and reality. At one point he disguises himself as a woman, using an elk's liver and kidneys to fashion a vulva and breasts, over which he puts a woman's dress (one of several given to him by a woman who had earlier mistaken him for a racoon). He lets a fox have intercourse with him and becomes pregnant, and after the fox a jaybird and a nit. Later he enters a human village, marries the chief's son, and becomes pregnant three more times, giving birth to three boys.[32] Surely more is at stake here than the confounding of classificatory distinctions. Disguise and literal metamorphosis become indistinguishable as discarded body parts become facsimile reproductive organs that in turn conceive and give birth to actual progeny. The trickster becomes the disguises he adopts, exchanging sex, gender, and species identities in the process. The trickster does so, moreover, with an unselfconscious exuberance that far outstrips anthropologists' more tentative forays onto the shifting ground between realities and unrealities, their own and others'.

Could a state of ontic confusion, of the kind Hastrup describes in her account of her encounter with the *huldumaður* and her involvement in the making of *Talabot*, lead directly to affirmation, to a renewal of belief in the world, as Artaud had hoped and suggested in his Sorbonne lecture? Could such affirmation arise directly out of the dissolution—in effect the falsification—of one's habituated sense of self and world, pointing to a truth beyond or outside accredited distinctions between truth and falsehood? Perhaps it all hinges on how we understand the false and its relationship to truth.

three

Fake

A Paris train station. We catch a glimpse of a film crew, preparing for a shoot. A voice (off camera) says: "For my next experiment, ladies and gentlemen, I would appreciate the loan of any small, personal object from your pocket—a key, a box of matches, a coin." A small boy, aged six or seven, holds up a key. A white gloved hand takes it and the voice warns him (and us) to "watch out for the slightest hint of hanky panky." Cut to a train standing at the adjacent platform. Through the window of one of the compartments we glimpse a woman in a fur coat and hat. She lowers the window and watches. The speaker takes the key between the palms of his gloved hands: "Behold, before your very eyes, a transformation." He opens his hands and reveals, in place of the key, a coin. "What happened to the key? It's been returned to you. Look closely, sir. You'll find the key back in your pocket." The camera pans back to reveal the speaker—a large man, wearing a black cape and hat, beneath which is the immediately recognizable face of Orson Welles. From the window of the train compartment the woman says, "Up to your old tricks, I see." Welles turns toward her: "Why not? I'm a charlatan." The camera pans back again to reveal the film crew and sound technicians, along with Welles's producer and collaborator, François Reichenbach. A white screen backdrop is wheeled onto the platform. Welles positions himself in front of it and the camera begins to roll (although, of course, it's been rolling all the time): "Ladies and gentlemen, this is a film about trickery and fraud, about lies." Almost any story, Welles tells us, "is almost certainly some kind of lie." But not this one. Welles makes the viewer a promise:

"during the next hour everything you'll hear from us is really true, based on solid fact."

F for Fake, released in 1974 and the last feature-length project that Welles completed before his death more than a decade later, presents itself as a documentary film about charlatans, fakers, and forgers. And there are many of them. There's Elmyr de Hory, Hungarian-born art forger extraordinaire, whose works, painted (as he puts it) "in the style" of Picasso and others, are said to have hung undetected in reputable galleries and collections all over the world. There's Clifford Irving, an American journalist and de Hory's biographer, who, in the course of filming, was engaged in a hoax of his own, using forged letters, manuscripts, and tapes to convince New York publisher McGraw-Hill that the famously reclusive billionaire Howard Hughes had approached him to ghostwrite his autobiography, a claim that unraveled after a voice claiming to be the real Hughes denounced Irving at a telephone press conference. There's Hughes himself, a onetime movie mogul and aviator, who shunned public appearances during the final decades of his life and was reputed to employ a retinue of doubles to keep secret his actual whereabouts. And last but not least, there's Welles himself. Appropriately, *F for Fake* ends with its own piece of fakery as Welles recounts the story of an affair between Oja Kodar (the woman glimpsed from the train in the opening sequence) and none other than Pablo Picasso, involving, among

FIGURE 6. Orson Welles, *F for Fake* (1974).

other things, a cache of forged paintings, only to declare at the film's close that the promised hour of truthfulness has ended and that "for the past seventeen minutes I've been lying my head off."

Welles's film asks on what basis is it possible to tell the difference between a so-called original and a forgery, and who, if anyone, is to blame when the distinction gets lost. Is it forgers like de Hory and Irving? Is it the art market and the increasingly inflated prices commanded by the works of artists like Picasso? Or is it the self-styled art experts who, as de Hory notes with satisfaction, have certified many of his paintings as authentic? Could the proliferation of fakes be a product of the desire for the genuine article? Nietzsche called it the "will to truth"—this persistent, indeed millennia-old, hankering after truth as an absolute value, fixed, eternal, elevated above the shifting play of appearances. The pursuit of such an immutable truth amounted, for Nietzsche, to a repudiation of life, nature, and history in all their changefulness. The affirmation of such a "true world" in contrast to the existing one could manifest itself in a variety of ways—Plato's forms, the Christian God, or the genuflection before the supposed givenness of facts (*petits faits*) that Nietzsche found among many of his scientifically inclined German contemporaries. In each case, the will to truth involved a corresponding relegation of appearance and change to the status of illusion or falsehood. But what if, as Nietzsche suggests, the true world itself were the supreme falsehood? What if truth resided not in a transcendent realm of essences, forms, or ideas but in the world itself, understood as an artist, a continuous maker and unmaker of forms with no end other than the process of making itself—a truth, that is, not of fixity but of becoming? Falsehood would no longer stand then in straightforward opposition to truth; rather, it might assume the status of an active power, capable of overthrowing established certitudes and creating the world anew.[1]

POWERS OF THE FALSE

"Orson Welles is the first: he isolates a direct time image and makes the image go over to the power of the false," writes Gilles Deleuze in the second of his books on cinema, first published in French in 1985, the year of Welles's death. Deleuze continues: "There is a Nietzscheanism in Welles, as if Welles were retracing the main points of Nietzsche's critique of truth."[2] Welles's Nietzscheanism revealed itself both through his suspicion of any

Fake

37

attempt to judge life in the name of a higher value—a suspicion exemplified in his 1962 adaptation of Kafka's *The Trial*, Welles's favorite among his own films—and through a refusal and disruption of linear chronology, as in the uncertain, retroactively pieced together pasts of *Citizen Kane* (1941) and *Mr. Arkadin* (1955). *F for Fake* is also notable for its abrupt temporal shifts, juxtaposing images from newsreels with interviews with de Hory and Irving from various times and places, some of them recorded for an earlier, unfinished documentary film about de Hory by Reichenbach, along with footage of Welles himself sitting in his editing suite, surrounded by reels of film, splicing together these disparate fragments. The film's final sequence, recounting the story of Oja, Picasso, and the forged paintings, is introduced in Welles's voice-over as a reenactment, only to be revealed subsequently as a self-conscious deception—and thus a reenactment of events that never took place.

For Deleuze, Welles's early work prefigured a series of developments carried forward in post–World War II European cinema. The upheavals of global conflict had, Deleuze suggested, shattered the "sensory-motor schema" underpinning previously habituated experiences of space and time, enabling instead the emergence of what he called a "time image"—an image of time as such, no longer subordinated to space and movement, as in earlier forms of cinema.[3] Exemplified by Welles as well as by Italian neorealism, the French New Wave, the New German Cinema, and by figures such as Tarkovsky in the former Soviet Union and Kurosawa and the later Ozu in Japan, the time image revealed time not as a linear succession of presents but as a generative power of difference. As such its affinities lay rather with Bergson's duration, affirming the coexistence of each passing present with the past in its entirety, or with Nietzsche's eternal recurrence, which Deleuze famously interpreted as the return not of the same but of multiplicity and becoming. Eschewing the coherence of plot, character, and setting, the cinema of the time image evoked instead the dispersal of identities, the coexistence of alternative pasts and futures, and the indiscernibility of the actual and the virtual (as in the hall of mirrors denouement of Welles's 1947 thriller *The Lady from Shanghai*). For Deleuze, it was appropriate that forgers and confidence men should be among the predominant characters in postwar cinema insofar as the time image amounted to a mobilization of the powers of the false against any presumption of an already given true

world. Yet the powers of the false found their highest exemplification not in the forger, who remained invested in the outward form of truth, but in the creative artist—not de Hory or Irving, in other words, but Picasso, whose continuous self-reinventions over the course of his career testified to art's fundamental affinity with falsification, reinvention, and becoming:

> Only the creative artist takes the power of the false to a degree which is realized, not in form but in transformation. There is no longer either truth or appearance. There is no longer either invariable form or variable point of view on a form. . . . Metamorphosis of the true. What the artist is, is creator of truth, because truth is not to be achieved, formed or reproduced; it has to be created. There is no other truth than the creation of the new.[4]

What distinguished the creative artist from the forger was not a distinction between truth and falsehood but rather the capacity to invent fictions that transformed reality by measuring themselves against reality's own fiction making, against the Dionysian, metamorphic artistry of a world in continuous becoming. It was this worldly and world-altering power—a power simultaneously creative and destructive—that the time image revealed and put to work.

The (Inhuman) Art of Fabulation

According to Deleuze, the task in which creative artists and other fashioners of new realities are engaged is that of fabulation. Like the powers of the false, the notion of fabulation is rarely referenced directly in Deleuze's published writings. Yet it is arguably present throughout his work in the metamorphic guise of multiple aliases, including his much-cited claim that science, art, and philosophy are all, in their distinctive ways, creative undertakings, involving, respectively, the creation of "functions," "sensory aggregates," and concepts.[5] Gregory Flaxman writes: "Such is the paradox of fabulation which is evoked so frugally because its powers are so ubiquitous, suffusing virtually everything Deleuze writes."[6]

The term "fabulation" itself derives from Bergson.[7] In *The Two Sources of Morality and Religion* (1932), Bergson associated fabulation (or "mythmaking," as it is rendered by his English translator) with "closed" or traditional societies, which he saw as characterized by a rigid and rule-governed

sense of moral obligation and a clear distinction between insiders and outsiders. In such societies, Bergson argued, fabulation contributed to the formation and maintenance of the moral order through the creation of fictions that were sufficiently intense and persuasive to produce real effects: "A fiction, if its image is vivid and insistent, may indeed masquerade as perception and in that way prevent or modify action." In particular, fabulation made use of what Bergson saw as a universal human propensity for imputing a humanlike agency to unforeseen occurrences like storms and earthquakes, thus rendering them more familiar and less threatening: "It lends to the Event a unity and an individuality which make of it a mischievous, maybe a malignant being, but still one of ourselves, with something sociable and human about it."[8]

For Bergson, the role of fabulation was an essentially conservative one, enjoining compliance with the status quo through images of powerful beings overseeing human affairs and demanding obedience. In contrast, it was the power of fabulation to intervene in and modify reality that led Deleuze to find in it a very different potential, a potential not simply to reaffirm but also to challenge the existing order of the world: "We need to take up Bergson's notion of fabulation and give it a political meaning."[9] This might involve the creation of a "minor" language within a dominant, "major" one, subjecting the latter's familiar idioms to a series of distortions, interruptions, and transformations—like Kafka, a Czech Jew writing in German, the official language of the Austro-Hungarian empire.[10] Or it might involve the creation of "giants"—mythic images powerful enough to be projected into the world with tangible effects, providing a rallying point for collective mobilization and action.[11]

Fabulation for Deleuze is never the expression of an already formed identity (whether individual or collective). It finds its constituency not in the present but in the future, being addressed always to a people who are "missing" or "a people to come."[12] Even when it appears to draw on the past, it does so with a view to overcoming and transforming the present. In the documentary film *Pour la suite du monde* (1963), filmmaker Pierre Perrault persuades a group of Québecois islanders (residents of the Île aux Coudres in the St. Lawrence River) to revive a long-abandoned practice of building weir barriers to snare white dolphins. To do so, they are obliged to revive distant memories and fragments of local lore transmitted by their ancestors. The camera follows them as they work and

share stories. Perrault describes them as "in a state of legending" or "of legending *in flagrante delicto*" (*en flagrant délit de légender*).[13] Deleuze in turn sees this as an instance of "the pure and simple *function of fabulation*," whereby the becoming of a group of actual, existing individuals begins to "make fiction" and thus contribute to the "invention" of a people. In Deleuze's words, what is at stake is "not the myth of a past people, but the storytelling of a people to come."[14] According to Perrault, neither he—an educated Québecois who sees himself as separated from his roots—nor the islanders could have done it by themselves. Both islanders and filmmaker are transformed by the encounter of which the film itself is one of the products. Fabulation is always a collective undertaking, involving the relational becoming of an artist (or artists) and a people. Deleuze is insistent, however, that art and literature in invoking a people yet to come do not create such a people. Rather, a people creates itself through its own resources, its own struggles and sufferings. Yet the fabulatory function of art nonetheless "links up" to the creation of a people.[15] On what basis then is such a link established?

In an essay reviewing the significance of Deleuze's writings for contemporary anthropology, Joao Biehl and Peter Locke suggest that Deleuze's work serves to direct attention away from the fixity of institutions and structures and toward the ways in which these are continuously made and remade through "the desires and becomings of actual people," revealing in the process "neglected human potentials" and thus expanding the limits of understanding and imagination.[16] It is well to remember, however, that for Deleuze the capacity of artistic and literary fabulations to align themselves with and contribute to a range of human social, cultural, and political struggles always depends on an engagement with the other than human. Deleuze locates the origins of art in the marking of a territory, the differentiation of an inside from an outside. This involves more than simply the delineation of a bounded, humanly intelligible form. As Elizabeth Grosz notes, such an action also establishes a relationship to the outside, to planetary and cosmic forces that preexist and exceed human determinations.[17] The creativity of art (like that of science and of philosophy) depends on the appropriation and channeling of these other-than-human becomings, even as the latter retain the power to overflow or disrupt the uses to which humans attempt to put them. Indeed, it is precisely this excess that has the potential to generate new

becomings, new and unforeseen futures. It is toward such an outside of the human that Deleuze and Guattari gesture in their final collaboration, *What Is Philosophy?*, where they sketch out a program for a "geophilosophy" that would take as its point of reference the inhuman "earth"—prior to any act of inscription or territorialization—that is at once the condition and limit of any conceivable project of human world making.[18]

If Bergson understood myth making as originating in the projection of humanlike qualities onto (among other things) seismic disturbances and meteorological phenomena, Deleuze's fabulation always involves a surpassing of the conventionally human. The aim of art is to uncover "a block of sensations, a pure being of sensations" no longer based either on perceptions of objects or on the states of a perceiving subject and thus no longer dependent on a human-centered perspective. Art deals not in perceptions and affections (understood as subjectival states) but in "percepts" and "affects": "*Affects are precisely these nonhuman becomings of man*, just as percepts . . . are *nonhuman landscapes of nature.*" The landscapes revealed by art and literature are no longer apprehended via a subject–object relation; they no longer owe anything to those who may have experienced, perceived, or remembered them. Instead they are landscapes characterized by a vanished or radically attenuated human presence—the hills of Cézanne's Provence, the steppes of Chekhov's or Tolstoy's Russia, or (it might be added) Iceland's lava field of misdeeds, home only to those cast out from human society or to the monstrous remnants of a prehuman order. Even when ostensibly peopled—like the London streets and parks of Virginia Woolf's 1925 novel *Mrs. Dalloway*—such scenes are rendered not through the prism of a perceiving human subject but through the latter's dissolution, passing into the surroundings "like a knife through everything." These are settings in which the human becomes other—settings like the seascapes of Melville's *Moby-Dick, or The Whale* (1851), across which Captain Ahab pursues his obsession with the white whale: "Ahab really does have perceptions of the sea, but only because he has entered into a relationship with Moby-Dick that makes him a becoming-whale and forms a compound of sensations that no longer needs anyone: ocean."[19]

For this reason, Deleuze and Guattari assert that "creative fabulation" has "nothing to do" with memory, whether that of an individual or a community.[20] If fabulation contributes to the enactment of alternative

human futures, then the resources it draws on in order to do so extend beyond human experience. Fabulation deals in becomings. It does not give expression to experiences, memories, or even fantasies that any individual or group can claim as their own. Becoming involves being carried beyond not only one's present self but also the very possibility of claiming an identity. It seeks a zone of indiscernibility where the actuality of a living individual becomes indistinguishable from an impersonal virtuality: "Literature . . . exists only when it discovers beneath apparent persons the power of an impersonal—which is not a generality but a singularity at the highest point; a man, a woman, a beast, a child."[21] The indefinite article is used here to strip away the formal characteristics implied by the definite and to evoke instead the quality of the unforeseen and nonpreexistent. Literature's closest affinities lie for Deleuze not with the first two persons of I/you interlocution but with the impersonality of the third person: "It is not the first two persons that function as the condition of literary enunciation; literature begins only when a third person is born in us that strips away the power to say 'I.'"[22] The third person articulates the space not only of the missing or absent people to which art and literature address themselves but also that of what Deleuze elsewhere refers to as "a life."[23] "A life" describes a condition of pure immanence, of the kind that Spinoza, another of Deleuze's interlocutors, took to obtain between divine "substance," the infinity of "attributes" into which it determines itself and the "modes" through which it is actualized.[24] It is composed of virtualities, events, and singularities and is thus possessed of a distinctiveness that cannot be reduced to a determinate identity.[25] As such, "a life" precedes its individuation in the guise of a subject or an organism. Indeed, as Claire Colebrook has suggested, it assigns no necessary privilege to the organic but rather can be thought of as an impersonal force of difference and becoming that extends beyond biological evolution to encompass the geologic and planetary prehistory that Deleuze and Guattari's geophilosophy seeks to evoke.[26]

Brazilian writer Clarice Lispector (like Deleuze an avid reader of Spinoza) calls it the "*it*"—an inhuman, preindividual life forming the impersonal substrate of experience and subjectivity without being directly accessible to either, or indeed to language, demanding that words be used as "bait . . . fishing for whatever is not word." Variously characterized as "living and soft" and "hard like a pebble," the "*it*" is to be approached

circuitously via a succession of mythic, animal, vegetable, and mineral metamorphoses, a multiplication of analogues and personae conveying its shifting and elusive being—insects, birds, frogs, tigers, black panthers, witches, Diana the huntress, pestilential swamps, caverns filled with stalactites and fossils. Sometimes, however, one catches a more direct glimpse—for example, watching the birth of an animal:

> To be born: I've watched a cat give birth. The kitten emerges wrapped in a sack of fluid and all huddled inside. The mother licks the sack of fluid so many times that it finally breaks and there a kitten almost free, only attached by its umbilical cord. Then the mother-creator-cat breaks that cord with her teeth and another fact appears in the world. That process is *it*.[27]

Note that the "*it*" is identified not with the organism thus born into the world but with the process of its birthing—a process of which the animal itself is arguably but a contingent and passing effect. Alternatively, such a glimpse might be caught at the moment of death, or close to it. Charles Dickens's novel of nineteenth-century London, *Our Mutual Friend* (1854–55), describes the near death and subsequent revival of Roger "Rogue" Riderhood, a waterfront criminal and corpse robber, who is pulled, close to death, from the river Thames after a boating accident. Neighbors who have previously shunned him as a disreputable figure crowd about him in what they take to be the moment of this demise:

> All the best means are at once in action and everybody present lends a hand, and a heart and soul. No one has the least regard for the man: with them all he has been an object of avoidance, suspicion and aversion; but the spark of life within him is curiously separable from himself now, and they have a deep interest in it, probably because it is life, and they are living and must die.[28]

As he begins to show signs of recovery, however, the empathy of the onlookers begins to fade, and they resume their former attitudes toward the man who is no longer at death's door: "As he grows warm the doctor and the four men cool. As his lineaments soften with life, their faces and their hearts harden to him."[29] Of the incident, Deleuze writes:

44 *Fake*

> Between his life and death, there is a moment that is only that of a life playing with death. The life of an individual gives way to an impersonal yet singular life that releases a pure event freed from the accidents of internal and external life, that is, from the subjectivity and objectivity of what happens: a "Homo tantum" with whom everyone empathizes and who attains a sort of beatitude. It is a haecceity no longer of individuation but of singularization: a life of pure immanence, neutral, beyond good and evil, for it was only the subject that incarnated it in the midst of things that made it good or bad. The life of such individuality fades away in favor of the singular life immanent to the man who no longer has a name, though he can be mistaken for no other. A singular essence, a life . . .[30]

It is this impersonal yet singular life—the life of the third person, overflowing any possible actualization in the form of an individual biography—that the arts of artistic and literary fabulation engage to remake the world. To borrow once again Nietzsche's formulation, fabulation is an art that embeds itself within and carries forward the artistry of the world's own self-making. It represents the partial (and never more than partial) redirection to human ends of becomings that bear no necessary relation to the human, yet without which no humanly imagined world could ever take shape. Yet if the inhuman, anorganic life that powers fabulation becomes perceptible in moments of transition or transformation—like the birth or death of an individual organism—might it manifest itself too in ethnographic spaces of encounter between differently constituted human (and other) worlds—on a mist-shrouded Icelandic mountainside, for example—when the conventional parameters of the real are made suddenly to appear shifting and uncertain? Surely fabulation and the powers of the false are forcefully at work as Hastrup struggles to articulate "the real experience of the materialization of the unreal," no less than in the dramaturgy of Barba and Artaud, the filmic charlatanry of Orson Welles, or the ontic shenanigans of the Winnebago trickster? It would seem, after all, that anthropologists habitually put themselves in the hazardous and uncertain place of indiscernibility "between the real and the really made up."[31] Why, then, do many anthropologists often seem so reluctant to embrace the role of fabulator?

four

Anthropologies and Fictions

"This is the point where I feel myself turning away from the line between poetry and anything else, where I become a face in the other direction, shimmering," writes Carrie Lorig, a contemporary American poet.[1] In contrast, anthropologists who have discerned commonalities between their own work and that of artists and literary writers have often chosen to move in the opposite direction by seeking to reinscribe such a line. Clifford Geertz, for example, once asserted that anthropology, like literature, was all about the making of fictions—a claim he immediately proceeded to qualify by adding that he meant fictions in the etymological sense of *fictio*, or made thing. For Geertz, this followed from his own much-cited characterization of anthropology as a hermeneutic discipline, an interpretive science concerned with the pursuit of meaning rather than an experimental one in search of law. As such, ethnographic fictions were second-order elaborations, distinct from the humanly crafted worlds of meaning they sought to understand and document. Anthropologists' data were in effect their own interpretive constructions of the interpretations of their own lives produced by the people anthropologists studied. Fictions upon fictions—similar in kind to but nonetheless distinguishable from those other fictions produced by writers of imaginative literature. Geertz is thus able to contrast his own interpretation of a sheep-stealing incident in early twentieth-century Morocco with the plot of Flaubert's novel *Madame Bovary* (1856):

46 Anthropologies and Fictions

To construct actor-oriented descriptions of the involvements of a Berber chieftain, a Jewish merchant, and a French soldier in 1912 Morocco is clearly an imaginative act, not all that different from constructing similar descriptions of, say, the involvements with one another of a provincial French doctor, his silly, adulterous wife, and her feckless lover in nineteenth century France. In the latter case, the actors are represented as not having existed and the events as not having happened, while in the former they are represented as actual, or as having been so. This is a difference of no mean importance; indeed precisely the one Madame Bovary had difficulty grasping. But the importance does not lie in the fact that her story was created while Cohen's was only noted. The conditions of their creation, and the point of it (to say nothing of the manner and the quality) differ. But the one is as much a *fictio*—"a making"—as the other.[2]

But can Madame Bovary's fatal error be avoided simply by attending to the different kinds of truth claims made by academic and literary discourses? More recently, Didier Fassin has identified commonalities between ethnography and literature on the basis not only of their shared involvement in writing but also of "their common endeavour to understand human life." Fassin insists on a distinction between reality (that which exists or has happened) and truth ("that which has to be regained from deception or convention"), arguing that anthropology can be understood as an attempt to articulate the real and the true. What distinguishes anthropology from literature, he suggests, is its relationship to reality— that is, its claim to depict actual persons and events. This is at once a limitation and a strength. On the one hand, an ethnographer cannot assume the omniscience of, say, a novelist or filmmaker, being confined instead to the more limited perspective of his or her own observations. On the other hand, this seeming limitation is also the source of ethnography's authority and its capacity to intervene in public debates. It is on this basis that Fassin distinguishes between his own ethnographic study of policing in the Paris *banlieus* and the Baltimore-set television detective series *The Wire* (2002–8, itself the subject of a sociology course taught at Harvard University): "The reception of my book [*Enforcing Order: An Ethnography of Urban Policing*] by the media, youth and public, more generally; the reactions it generated among police unions, successive ministers of the interior, and several human rights organizations;

and the debates it elicited were determined by the assumption I depict reality rather than fictionalize it."[3]

Many of Fassin's examples draw on a French intellectual tradition in which, as Vincent Debaene has noted, the relationship between anthropology and literature over much of the twentieth century followed a trajectory not directly paralleled in the Anglophone world, many French anthropologists having published the results of ethnographic fieldwork in the form both of academic articles or monographs and of experimental or literary works aimed at a wider audience, Michel Leiris's *L'Afrique fantôme* (1934) and Lévi-Strauss's *Tristes Tropiques* (1955) being two notable examples.[4] Certainly this may account in part for Geertz's own later, highly critical appraisal of *Tristes Tropiques*.[5] Nonetheless, Fassin shares with Geertz at least two assumptions that are worth questioning. The first of these concerns an elision of modes and genres: it appears that literature is to be identified with narrative fiction (whether in the guise of the novel or of television drama) and anthropology with the ethnographic monograph. Might it be possible, however, to think the relationship between anthropology and literature differently by taking into account not only, say, drama, nonfiction, and poetry (all of which may claim on occasion to reference actual persons and events) but also other, non-ethnographic forms of anthropological writing, such as the comparative essay (with which the present volume seeks to experiment, and of which there will be more to say later)? Second, having established that anthropology and literature share something in common, Fassin's immediate response, like Geertz's, is to attempt to find a basis for distinguishing them. In both cases, this is done through an appeal to anthropology's claim to represent a reality assumed to be given independently of the efforts of anthropologists, literary writers, or others to depict it. Yet it is precisely such an assumption that is called into question by the powers of the false evoked by Nietzsche, Deleuze, and Welles, by the dramaturgy of Artaud and Barba, and, I would add, by the metamorphoses of figures like the Winnebago trickster. Certainly as the example of Fassin's study of French policing makes clear, there are occasions when anthropology's public impact—its claim to be taken seriously—may depend on distinguishing itself from other kinds of writing. But on what basis should such a distinction be made? Is striving for representational accuracy the only, or even the most effective, form of fidelity to the real? What if

instead anthropology were to entertain the possibility that its most radical potential to intervene in the world consisted not in describing an assumed to be given reality but in putting such a reality into question? Think of Jeanne Favret-Saada conducting ethnographic research in the Bocage of Normandy in the 1970s, finding herself caught, and obliged, as a condition of learning anything whatsoever, to enter as a practitioner and potential victim into the world of rural witchcraft that she had initially set out to study as the beliefs of others. Or of Michael Taussig, speeding through Medellin, Colombia, in a taxi in 2006, catching a glimpse at the entrance to a freeway tunnel of what appeared to be a woman sewing a man into a white nylon bag of the kind used to transport potatoes or corn to market and scribbling in his notebook: "I SWEAR I SAW THIS."[6] Like those of Hastrup, the reflections of Favret-Saada and Taussig remind us that the real that anthropology engages is often a source less of certitude than of doubt and disorientation. Rather than a restraint or limit, might not such a fictionalizing real (in Deleuze's and Nietzsche's sense) serve as an incitement to experiment, to match our fiction making against its, by lingering in those spaces and moments when realities and representations, and with them anthropology and literature (at least according to certain definitions), are rendered truly indiscernible? Perhaps it is time to inquire more closely into the status of the anthropologist as both fiction maker and purported truth teller? Kirsten Hastrup, let us remember, is not the only anthropologist featured in Odin Teatret's production of *Talabot*.

five

Knud Rasmussen

The man in the center left foreground of the photograph, trim of physique, clean-shaven, purposeful, unsmiling, could hardly seem more different from the corpulent, black-caped, self-described charlatan who introduces himself at the opening of *F for Fake*. Knud Johan Victor Rasmussen was born in 1879 in Jacobshavn (now Ilulissat) in Greenland. His father was a Danish missionary; his mother was of part Inuit descent, and Rasmussen grew up speaking both Danish and Greenlandic.[1] After a period of study in Copenhagen (including an unsuccessful attempt to make a career as an opera singer), Rasmussen took part in and led a series of expeditions to Greenland and the Canadian Arctic, beginning in 1902.[2] He would go on to become one of the founders of Danish anthropology, whose travels furnished the National Museum of Denmark with the basis of its now extensive collection of Inuit artifacts, earning him an honorary doctorate from the University of Copenhagen. The photograph of Rasmussen and his companions was taken in West Greenland before embarkation on his most ambitious journey, the Fifth Thule Expedition (1921–24), which included a sixteen-month trek across northern Canada and Alaska, the aim being, in Rasmussen's words, "to travel by dog sledge clear across the continent to the Bering Sea" and to "visit all the tribes on the way, living on the country, and sharing the life of the people."[3] From Nome on the coast of Alaska, Rasmussen took a boat to Siberia, where he hoped to complete the expedition, but he was refused entry by the Soviet authorities because the visitor's permit he had requested had not yet arrived. Rasmussen's account of the expedition

FIGURE 7. Members of the Fifth Thule Expedition, photographed in West Greenland. Clockwise from top left: Kaj Birket-Smith, Therkel Mathiassen, Helge Bangsted, Jacob Oleson, Peter Freuchen, Knud Rasmussen, and Peder Pedersen. Photograph by Leo Hansen. Smithsonian Institution Archives image 2005-8627, Records Unit 7091, Box 409, Folder 2. Reproduced by permission of the Smithsonian Institution, Washington, D.C.

was published in the form of a ten-volume *Report* and a shorter narrative aimed at a wider audience, published in 1927.[4]

Odin Teatret's portrayal of Rasmussen is, however, in many ways a critical one, associating him with the West's destruction and expropriation of indigenous cultures (a persistent theme of Barba's work) and suggesting, among other things, that the Inuit amulets that he donated to the National Museum of Denmark were obtained under false pretenses.[5] The amulets in question usually consist of animal body parts sewn inside the clothing. Rasmussen writes, "The virtue lies in the soul of the creature represented, though it is only certain parts of its body which can convey the power." A woman with a newborn child, for example, would use a raven's claw as a fastening for the strap of her *amaut* (the bag in which she carried the child on her back) in order to ensure that the child would have success in hunting in later life.[6] It was possible, however, for an amulet to be given away while its power remained at the service of the original owner, or, alternatively, both the amulet and its power could

be transferred, temporarily or permanently, to someone else if something appropriate were given in return. Rasmussen describes the difficulties he encountered in persuading the Inuit to part with their amulets:

> Amulet hunting is rather a delicate business, and I had to proceed with care. My business was to obtain, in the name of science, all that I could of these little odd trifles which are held by the wearers to possess magic power, and worn as a protection against ill. But it had to be done in such a manner that I could not be held accountable afterwards for any evil that might befall those who had parted with their treasures.[7]

Arriving at Cape Adelaide, he set out his trade goods for the perusal of the local population. These included needles, knives, thimbles, nails, matches, and tobacco ("little, ordinary everyday trifles to us, but of inestimable value to those beyond the verge of civilization"). He then explained that he had visited them on account of their amulets, of which he had heard so much. He told them that because he was a foreigner from across the sea, ordinary restrictions concerning the use and transfer of amulets and their power did not apply to him. He pointed out that the owner of an amulet could still enjoy its protection even if he or she lost it. Surely, then, the owner of the amulet would retain its protective power to an even greater degree if, by giving it away, he or she obtained in exchange some item of value. Rasmussen emphasized that he wished to buy the amulets themselves as material artifacts and not as protective charms. His audience was not immediately convinced, but the following morning, a little girl named Kuseq arrived at his hut carrying a skin bag containing all her amulets, which she had removed from various parts of her clothing. They were, Rasmussen wrote, "a pitiful collection of odds and ends, half mouldy, evil-smelling, by no means calculated to impress the casual observer with any idea of magic power." They included a swan's beak, to ensure that her first child would be a boy; the head and foot of a ptarmigan, tied together, to confer speed and endurance in hunting caribou; a bear's tooth to give powerful jaws and good digestion; the pelt of an ermine with the skull attached to give strength and agility; and a dried flounder as protection against danger in encounters with other tribes. In exchange Kuseq received beads for a necklace, two needles, and a sewing ring. She was soon followed by others, until Rasmussen's supply of trade

goods was exhausted and he had a collection of several hundred amulets. The next morning, the whole village assembled to wave farewell to Rasmussen and his companions, and "I had the satisfaction of feeling that we had left them convinced of having obtained full value for what they had given, and something over."[8]

Did Rasmussen cheat his Inuit hosts? Did he prove himself no less a charlatan than Welles, albeit one unwilling to admit to his status as such? Certainly by his own criteria he misled them with his assurances that the amulets, once sold to him, would continue to afford magical protection. That is, he appealed to what he took to be his informants' (unfounded) belief in the power of the amulets, whereas for him the amulets were inert material objects, of ethnographic interest only, devoid of magical power.[9] Nonetheless, as Odin Teatret's portrayal of him also makes clear, Rasmussen's fascination with the polar North and its peoples was a powerful and enduring one, compelling him to return throughout his life to the Arctic. By the end of *Talabot* he appears as a marginal and isolated figure, caught between worlds, neither wholly European nor wholly Inuit, belonging nowhere.[10]

For the young Kirsten Hastrup, however, Rasmussen was, as she puts it, a "mythical" figure, whose writings, which she first encountered as a child growing up in Denmark in the 1950s and 1960s, influenced her own decision to study anthropology and undertake ethnographic fieldwork. Of her initial arrival in Iceland she would later write: "I had almost become a polar explorer."[11] She recalls reading as a child Rasmussen's accounts of his journeys across the Arctic—accounts in which he unashamedly embraced the role of "explorer-hero" who "drives his dogs further ahead," willing to endure any hardship in the pursuit of knowledge.[12] Unlike Hastrup herself, whose self-doubts and personal crisis find expression both in her writings and in Odin Teatret's theatrical production based on her life, Rasmussen, at least on the evidence of his published work, appeared to be a figure whose subjectivity coincided seamlessly with his public self. At the same time, she saw Rasmussen as a figure who was able to pursue, without apparent contradiction, the vocations of scholar and literary writer. His writings included works aimed at wider as well as academic audiences, and such was their popularity that in 1929 Denmark's Royal Academy of Sciences nominated him (unsuccessfully) for the Nobel Prize in literature. That Rasmussen was

Knud Rasmussen

able to pursue his ethnographic and literary interests simultaneously was, Hastrup suggests, because he lived and wrote at a time when, at least in Denmark, there existed no clearly demarcated institutional separation between anthropology and literature.[13] It is perhaps Rasmussen's occupancy of this undefined (or not yet defined) between-space that allows his texts to invoke and on occasion to subvert the authority of a putative anthropological science. Nowhere is this more apparent than in his encounters with the spirit worlds of Inuit shamanism.

Among Rasmussen's most prolific informants was an *angakoq* (shaman) named Avva (Aua).[14] Avva hailed from Igloolik, a settlement located on an island close to the Melville peninsula in what is now the province of Nunavut. Rasmussen first encountered him on a cold, starlit night en route to Cape Elizabeth in January 1922.[15] Out of the darkness appeared a sledge carrying six men and drawn by fifteen white dogs—"the wildest team I have ever seen."[16] Avva introduced himself as the leader and invited Rasmussen and his companions to join him at his camp beside a nearby lake, where he introduced them to his wife and family. Over the course of this and subsequent meetings, Avva would recount to Rasmussen stories about the spirit world, about the fate of souls after death, and about the origins of mythic beings like Sedna, the Mistress of the Sea, the submarine-dwelling protector of the sea mammals on which Inuit hunters depended for their survival. He also described his own realization of his vocation as a shaman and his first encounters with the spirit helpers who would assist him in his work. These included his namesake, Little Avva, a diminutive female spirit ("no taller than the length of a man's arm") residing near the shore and clad in a pointed skin hood, short bearskin breeches, long black boots, and a coat of sealskin, as well as a shark spirit that swam up to him and whispered his name one day when he was out in his kayak.[17]

On a subsequent visit to Avva's camp, Rasmussen noticed that a small white flag was flying above each hut, a sign that the occupants had converted to Christianity. They assembled outside Avva's hut, and as Rasmussen approached, they began singing a hymn. Rasmussen writes: "There was something very touching in such a greeting; these poor folk had plainly found in the new faith a refuge that meant a great deal to their lives."[18] For Rasmussen, the change that has taken place is a matter of belief. Avva and his extended family have exchanged an older "heathen"

set of beliefs for a newer, Christian one, the latter understood by Rasmussen as offering greater consolation for the hardship and material privations of their existence. Avva himself tells it somewhat differently. Confirming that he has indeed become a Christian, he tells Rasmussen that he has sent away his helping spirits to join his sister in Baffin Land.[19]

THE CINEMA OF POETRY

Among the techniques that Deleuze associates with the cinema of the time image is the dissolution of distinctions between what is presented as seen supposedly objectively by the camera and what is seen from the subjective vantage point of a particular character. Instead, postwar cinema moved toward the narrative style of free indirect discourse, or what Pier Paolo Pasolini called the "cinema of poetry," whereby conventionally subjective and objective images passed back and forth into one another, refusing any appeal to a true world given independently of its cinematic visualizations.[20] Such a technique is powerfully at work in the 2006 film *The Journals of Knud Rasmussen*, based in part on Rasmussen's published accounts of his journey. The film is a collaboration between Canadian Inuit director Zacharias Kunuk and American-born producer Norman Cohn, released through Isuma, the Igloolik-based production company that Kunuk and Cohn helped found in 1990. Kunuk's earlier film, *Atanarjuat: The Fast Runner* (2001), the first feature-length film ever to be written, directed, and acted entirely in the Inuktitut language, had enjoyed considerable critical and commercial success, becoming the top-grossing Canadian film of its year and winning the Camera d'Or award at the Cannes Film Festival (where Kunuk delivered his acceptance speech entirely in Inuktitut). *The Journals of Knud Rasmussen* proved less popular, drawing criticism in some cases for its slow pace and lack of plot (in contrast to the more conventional narrative of *Atanarjuat*, based on an Inuit legend).[21] Certainly the later film is likely to be more challenging to Euro-American audiences, not only by virtue of its elliptical, often collagelike construction but also because of the way in which Kunuk and Cohn critically expand the perspectival undecidability of the cinema of poetry to encompass the fraught history of Inuit contact with white settler society, including its anthropological representatives. Kunuk's film focuses on Rasmussen's relationship with Avva, culminating in the episode of his family's conversion. Rasmussen's successive meetings and

interviews with Avva are condensed into a single sequence, set inside a snow hut, in which Avva (played by Pakak Innukshuk) speaks directly to the camera as though addressing Rasmussen. To Avva's left and slightly to his rear we see an unexplained female figure, clad in an elaborately stitched fur parka, who sits watching and listening in silence. Only as Avva's narrative progresses do we realize that she is Little Avva, the first of his helping spirits: "There are many of these that live along the shore, wearing a pointed hood and bearskin pants and their feet twisted up." (She glances down when this latter detail is mentioned.) Yet at no point does the film give us the option of regarding her as a projection of the shaman's imagination. Indeed, for the entire sequence, the only subjective viewpoint that the camera could be said to occupy is that of Rasmussen himself (for whom spirits are, most emphatically, an instance of subjective belief, not objective reality).

As to the family's conversion to Christianity, it is Avva's version of events that Kunuk's film adopts.[22] The embrace of Christianity by Avva's family is not presented as a voluntary act, as Rasmussen implies it to be. Instead, faced with the prospect of starvation as a result of their continued lack of success in hunting, Avva and his family are forced out of desperation to join a neighboring band of Christian Inuit, whose leader is only willing to share food with them if they convert. When it comes

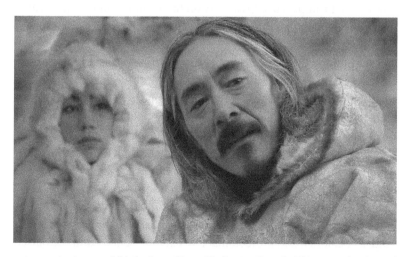

FIGURE 8. Avva and Little Avva. From Zacharias Kunuk, *The Journals of Knud Rasmussen* (2006).

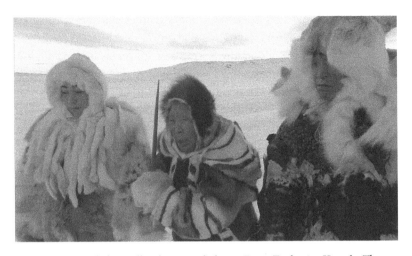

FIGURE 9. Avva's farewell to his spirit helpers. From Zacharias Kunuk, *The Journals of Knud Rasmussen* (2006).

to the act of conversion itself, we see Avva bid his spirit helpers a tearful farewell as he sends them away, while they in turn cast reproachful glances backward as they disappear into the distance across the ice.

In an interview conducted two years before the film's release, Kunuk referred to the impact of Christianity on Inuit communities and affirmed the enduring reality of the spirit presences that Christianity had sought to displace: "My next film is about shamanism, the coming of Christianity, and Inuit mythology. I believe in these spirits. I believe that the dead walk the earth."[23] Kunuk's film challenges not only the view that so-called traditional Inuit beliefs will inevitably disappear under the impact of Christianity and colonialism but also the very assumption that shamanism and spirits are beliefs and not realities. Crucially, Kunuk affords the spectator no vantage point from which to make such a distinction, propelling us instead into a cinematic universe in which spirits are real—as real as dogsleds, snow huts, fur traders, or anthropologists.

In questioning the ontological presuppositions of Western accounts of Inuit life, Kunuk's film demands too a radical rethinking of the temporalities of colonial and postcolonial pasts and presents. From the outset, *The Journals of Knud Rasmussen* usurps the assumed temporal priority of the Western ethnographic sources on which it purports to be based.

At the opening of the film, the actors portraying the principal Inuit characters are shown looking into and interacting with the camera before a freeze-frame transforms the scene into a re-creation of one of the black-and-white still photographs taken by Rasmussen at the time of his visit. The filmic (re-)enactment is thus presented as, if anything, chronologically prior to the photographic original, a gesture repeated in the closing credits when the names of cast members are juxtaposed with photographic images from the 1920s depicting the characters they play. In another incident, when a group of children is shown playing in the snow, the camera becomes momentarily visible as one of them trips over it, rendering suddenly and conspicuously contemporaneous the then of early twentieth-century settler society's increasing encroachment on Inuit life and the now of filming, and thus refusing the teleology implicit in Rasmussen's own characterization of the 1920s in the Canadian Arctic as a moment of cultural loss. Rather than accepting its own determination by the past, the film as an artifact of the early twenty-first century present undertakes to remake the past (and its relationship to the present) through a fabulatory becoming that dissolves the claims to fixity and authority of any canonical version of historical truth. As in many Isuma productions, the on-camera enactment of a range of so-called traditional Inuit practices—constructing snow huts, making sealskin tents, performing shamanic séances—becomes an affirmation of the contemporary persistence of an Inuit human and spirit world irreducible to the temporalities and explanatory logics of a Euro-American-centered global history.[24]

ANARQÂQ'S DRAWINGS

Kunuk's cinematic transformation of Rasmussen's texts makes us newly appreciative too of the ways in which the latter are themselves already cinematic, already a conjuration of and with the powers of the false. Kunuk's film renders retroactively legible those moments in Rasmussen's own writings when representation and reality appear to fuse, when anthropology, no less than cinema, appears not as the elaboration of hermeneutic fictions reassuringly distinct from the realities they reference but as an art of interstitial fabulation dedicated to the dismantling of established certitudes and the elaboration of new worlds of meaning and being. One such incident is described at length both in the expedition's *Report* and in the abridged narrative aimed at wider audiences. In

the vicinity of Igloolik, Rasmussen had previously encountered another, younger shaman named Anarqâq, who had moved to the area from King William Land. Anarqâq was a young man "of highly nervous temperament" and not particularly successful as a hunter. He was, however, extraordinarily susceptible to spirit visions, which would come upon him whenever he was alone, day or night: "His imagination peopled the whole of nature with fantastic and uncanny spirits, which appeared to him as soon as he lay down to sleep, or while still awake and wandering, tired and hungry, in search of caribou."[25] Rasmussen would comment repeatedly on what he took to be the "astonishing credulity" of the Inuit toward all communications from the spirit world, including their acceptance of what struck him as obvious recourse to trickery on the part of Anarqâq and other shamans. Like other ethnographers of the Arctic before and after him, Rasmussen had been struck by the fact that shamans not only routinely engaged in trickery but that they were generally known to do so, and that this knowledge seemed to diminish neither their own nor others' belief in their powers.[26]

On one occasion, a little boy ran into the hut, crying but unable to say why. Anarqâq immediately rushed out and disappeared from sight across the ice. More than half an hour later, he returned, his sleeves and the lining of his fur torn and his hands covered with blood. Breathing heavily and seemingly exhausted, he sank to the floor and remained there for some time, watched by everyone "with the greatest admiration and respect." When he revived, he explained that the child had been attacked by an evil spirit but that he, Anarqâq, had defeated it after a hard fight. Rasmussen was astonished at people's willingness to accept Anarqâq's version of events: "It never occurred to anyone that he could have snatched up a lump of seal's blood out of the passage, where some had been set to freeze after the day's hunting; nor did it enter anyone's head to suppose that he might have torn his clothes himself." Instead, it was taken for granted by everyone that Anarqâq had indeed saved the child's life. The boy's father was known as a skillful hunter. Anarqâq was clad in old, worn skins that had been damaged in the alleged struggle, and the father presented him with a supply of furs for a new outfit.[27]

Rasmussen's attitude appeared to change, however, when one day he asked Anarqâq to draw some of his spirit visions. Anarqâq was reluctant at first because he was afraid of offending the spirits. He finally agreed,

on the condition that Rasmussen would only show the drawings in the white man's country and not among his own people. Anarqâq had never drawn with a pencil on paper before, but Rasmussen was impressed by the seriousness and dedication with which he set about his task. Anarqâq would sit for several hours with his eyes closed, taking care to picture every detail of his vision; only then would he begin to draw. Sometimes his recollections would affect him so powerfully that he would tremble all over and be forced to abandon the attempt.

Anarqâq's drawings are reproduced, along with his explanations of them, in Rasmussen's *Report*. The original drawings are now displayed, along with other Inuit artifacts collected by Rasmussen, on the upper floor of the National Museum of Denmark in Copenhagen. It was here that I first encountered them several summers ago, on a rainy afternoon at the end of July, having wandered away from the more crowded Danish prehistory and Viking-era exhibits on the museum's lower floors. The drawings themselves are, I think, extraordinary—straightforward in technique but distinguished by a remarkable attention to detail and intensity of visualization. Seeing them, it is easy to picture Anarqâq, eyes shut, meticulously scanning every aspect of his visions before committing them to paper. Take, for example, Igtuk, or the boomer, held to be responsible for booming noises heard in the mountains. He is, according to Anarqâq, "made otherwise than all living things": his legs and arms are on the back of his body; a single, great eye is level with his arms; his nose is hidden inside his mouth; on his chin is a tuft of black hair; and below it, on a line with his eye, are his ears. His mouth opens to disclose a "dark abyss," and the opening and closing of his jaws produces the booming sound.[28]

Then there is Issitôq, or the giant eye—a gloomy helping spirit, covered in bristly hair standing straight up, each eye divided into two sections, his mouth vertical with one long tooth at the top and two shorter ones at each side. His speciality is identifying those who have broken a taboo. Anarqâq encountered him first soon after the death of his parents. Issitôq came to him and said, "You must not be afraid of me, for I, too, struggle with sad thoughts; therefore will I go with you and be your helping spirit."[29]

Some of Anarqâq's visions, however, were too terrifying to establish a relationship with. Among them was Kigutilik, or the spirit with the giant's teeth. One spring, Anarqâq was out sealing when this creature

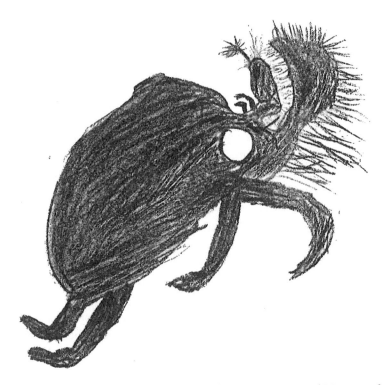

FIGURE 10. Igtuk, or the boomer. Drawing by Anarqâq. National Museum of Denmark, Copenhagen.

emerged from an opening in the ice. Its body mass was similar to that of a bear, but it stood higher, on long legs that had large bumps at the joints. It had two tails and one large ear that seemed to be joined to the rest of its body only by a flap of skin. It had teeth like walrus tusks, and its skin was mostly bare, with only a fringe of hair. It emitted a mighty roar, and Anarqâq fled without securing it as a helping spirit.[30]

The drawings appear to have had a powerful effect on Rasmussen too, prompting him to question his earlier skepticism about the genuineness of Anarqâq's spirit visions. That is, Rasmussen came to believe in Anarqâq's belief in his own powers as a shaman—and this despite what Rasmussen knew to be the frequent reliance of shamans on tricks and sleight of hand. If Anarqâq himself sometimes had recourse to trickery

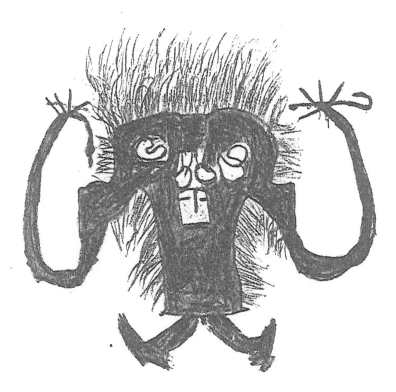

FIGURE 11. Issitôq, or the giant eye. Drawing by Anarqâq. National Museum of Denmark, Copenhagen.

(as, it appears, occurred in the case of the crying boy), there was nonetheless, Rasmussen concluded, every reason to think that he was always "honest and sincere."[31]

Rasmussen's change of attitude toward Anarqâq is all the more remarkable given that the drawings themselves—and the meticulous acts of envisioning that preceded their execution—were, from Rasmussen's point of view, depictions of nonexistent beings. We should remember that the drawings are the result of Rasmussen's own invitation to Anarqâq to draw his various helping spirits. The existence of these images in the form of drawings is thus a direct result of the ethnographic encounter. Without Rasmussen's intervention, there is no reason to assume that Anarqâq would ever have undertaken such a graphic rendering of his spirit world.

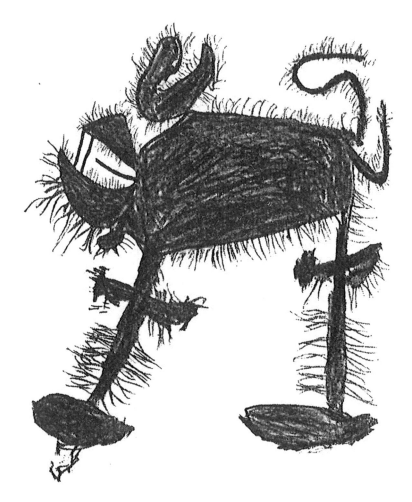

FIGURE 12. Kigutilik, or the spirit with the giant's teeth. Drawing by Anarqâq. National Museum of Denmark, Copenhagen.

What, then, is the status of the drawings? Are they another instance of the becoming real of the ostensibly unreal? Whatever else they may be, the drawings are enduringly and unassailably material presences, whether adorning the pages of Rasmussen's *Report* or suspended in a glass case, beguiling visitors to the National Museum of Denmark. For this reason, it is not enough to understand the results of Anarqâq's spirit draftsmanship as pictorial transcription of belief, whether collective or individual.

Knud Rasmussen 63

His drawings are not incursions from a pristine space of Inuit alterity but acts of manifestation that palpably unsettle the assumed contours of the real. As constitutively interstitial artifacts, they cannot be assigned unequivocally to either Inuit or Euro-American versions of what reality is. What, after all, has become of the world we thought we knew once Igtuk, Issitôq, Kigutilik, and the rest have shown themselves within it?

A Spirit Séance

Another such moment of radical indistinction between realities and representations occurred later in Rasmussen's journey. Traveling westward from the Mackenzie Delta, Rasmussen and his companions rounded Cape Barrow, which at the time was engulfed by fog, and headed for an Inuit village built out on the ice, where they were "received with great friendliness." They learned that the place was known as Agiaq and its people (forty-six of them in all, twenty-five men and twenty-one women) were known as Agiarmiut.[32] Having constructed a hut, Rasmussen's party found themselves caught in a blizzard that lasted four days. During this time, they were largely confined indoors, venturing outside only to repair damage to the snow walls caused by the storm, but they received a constant stream of visitors from the neighboring huts. On the third day, they were invited to attend a spirit séance in one of the huts: "We were given to understand that the storm child, Narsuk, was angry, and it was proposed to ascertain if possible what had been done to offend him, with a view to propitiation and that the storm might be called off."[33] The officiating *angakoq* was called Horqarnaq—"a young man with bright, intelligent eyes and little hasty movements." He looked, Rasmussen noted, "the picture of honesty," adding that "it was perhaps on that account that it took him so long to get into a trance." Before the séance started, Horqarnaq explained to Rasmussen that he did not have many helping spirits:

There was his dead father's spirit and its helping spirit, a troll from the legends, a giant with claws so long they could cut a man right through just by scratching him; and then there was a figure that he had created himself of soft snow, shaped like a man—a spirit who came when he called. A fourth and mysterious helping spirit was a red stone called Aupilalánguaq, a remarkable stone he had once found when hunting caribou; it had a lifelike resemblance to a head and neck, and when he shot a caribou near to it

he gave it a head band of the long hairs from the neck of the animal. In this way he made his own helping spirit into a shaman and increased its power twofold.[34]

Horqarnaq began by declaring modestly that he was sure he would never manage to summon the spirits, but his audience encouraged him. The men formed a circle around him, urging him on and praising his powers. At last he began to show signs of the approaching trance. His face strained; his eyes opened wide, as if staring into the distance, his breath coming in short, jerky gasps. He seemed, Rasmussen wrote, scarcely able to recognize those around him. A gurgling sound indicated that a spirit had taken possession of his body. He danced around, calling on his dead father and other spirits of the dead, whom he saw in front of him, seated among the living audience. He described them—an elderly man and woman, neither of whom he recognized—and called on members of his audience to say who they were. Finally an old woman who had been silent until that point shouted out their names—those of a man and woman from Nagjogtoq who had died recently. Horqarnaq shouted out, "That is just who it is!"—that is, they were the ones causing the storm.[35]

Outside, the blizzard continued to rage in the darkness, to the extent that the dogs, usually kept outside the snow houses, were allowed in for shelter and warmth. There was no meat left for tomorrow and no fuel: "The storm-boy weeps the women weep, the men murmur incomprehensible words."[36] The séance now entered a new phase, involving the taming of the storm god, who in this case was represented by an elderly man called Kingiuma, himself a shaman. Horqarnaq threw himself upon Kingiuma and cast him to the ground, fixing his teeth in his neck and shaking him violently "as a dog shakes another beaten in fight."[37] Horqarnaq's frenzy appeared to abate, and he stroked the prone body of his adversary as though to restore him to life, but no sooner had Kingiuma got to his feet than Horqarnaq was on him again. This was repeated three times in all, until after the third time, it was Horqarnaq who collapsed and Kingiuma who took the active part, planting his foot on Horqarnaq's chest and announcing what he could see:

The sky is full of naked beings rushing through the air. Naked people, naked men, naked women, rushing along and raising gales and blizzards.

Don't you hear the noise? It swishes like the beats of wings of great birds, up in the air. It is the fear of naked people, it is the flight of naked people.

The weather spirit is blowing the storm out, the weather spirit is driving the sweeping snow away over the earth, and the helpless storm-child, Narsuk, shakes the lungs of the air with his weeping.

Don't you hear the weeping of the child in the howling of the wind!

And look! Among all the naked crowds of fleeing ones there is one, one single man whom the wind has made full of holes. His body is like a sieve, and the wind whistles through the holes: Tju, tju-u, Tju-u-u! Do you hear him? He is the mightiest of all the wind travelers.

But my helping spirit will stop him, will stop them all. I see him coming calmly, confident of victory towards me. He will conquer, he will conquer— Tju, Tju-u! Do you hear the wind? Sst, sst, ssst! Do you see the spirits, the weather, the storm, sweeping over us, with the swish of the beat of great birds' wings?[38]

After the speech, Horqarnaq picked himself up from the floor, and the two shamans joined together in singing a hymn to Sedna, the mother of the sea:

Woman, Great Woman down there!
Turn it aside, turn it aside from us, that evil!
Come, come spirit of the deep,
One of thine earth-dwellers
Calls upon thee; prays thee to bite our enemies to death,
Come, Spirit of the Deep![39]

Then the rest of those present joined in a wailing chorus: "No one knew for what he was calling, no one worshipped anything; but the ancient song of their forefathers put might into their minds." They implored the powers to make a truce to enable their hunting and to send them food for their children. Until this point, Rasmussen had described events from the perspective of a self-conscious outsider, distinguishing scrupulously between what he as an ethnographic observer saw and what the two *angakoqs* purported to see in their trance. Suddenly, however, all of that changed:

Knud Rasmussen

It seemed as if nature around us had become alive. We saw the storm riding across the sky in the speed and thronging of naked spirits. We saw the crowd of fleeing dead ones come sweeping through the billows of the blizzard, and all visions and sounds centered in the wing-beats of the great birds for which Kigiuna had made us strain our ears.[40]

So much hangs on "it seemed"—a distancing term, but one also carrying a hint of proximity, of boundaries dissolving, partially if not completely—the crying of the storm child, the naked beings rushing to and fro in the air and through and beyond them, the contending materiality of the elements out of which these personifications are condensed. And just for a moment, through his descriptions, Rasmussen makes us see it too.

The next morning, the storm abated, the men of the village set out hunting, and Rasmussen and his companions continued their journey.

six

The Voice of the Thunder

The flood had subsided, the receding waters leaving behind an earth covered by dense forest. Across this sylvan expanse were scattered the survivors, Noah's descendants. The race of Ham wandered through southern Asia and Africa, that of Japheth through northern Asia and into Europe, and that of Shem through central Asia and onward to the east. Dispersed and isolated from one another, they began to forget. They forgot religion, the institutions of matrimony and family life, and the language that had once identified them as members of a human community. Running wild, unchecked by the authority of gods, parents, or teachers, they wallowed naked in their own filth and copulated randomly and indiscriminately, mothers giving birth on the forest floor and abandoning their offspring as soon as they were weaned. Invigorated by the challenges of forest living, their bodies too became excessive, expanding to massive proportions, giving rise later to the stories of giants preserved in mythology and folklore. Then something happened. As the giants pursued their unthinking course through the trees and foliage, they were startled by the flashing of lightning and the sound of thunder. They raised their eyes and became aware for the first time of the sky, of a realm beyond the canopy of leaves. From the moment of this revelation, however, the sky was no longer simply the sky. An interval of transcendence had opened. Confronted by an unknown expanse beyond the familiar foliage, the giants pictured it to themselves as a vast, animated body, which they called Jove. Thunderclaps and lightning bolts were henceforward the signs through which Jove communicated. By attending

68 *The Voice of the Thunder*

to his commands, the giants rediscovered religion, marriage, and the burial of the dead. Submission to divine authority enabled the giants to subdue their vast and unruly bodies, and thus finally to regain their human proportions. History had begun.

The story of the giants' awakening to self-consciousness is recounted as the origin of the "gentile peoples" by the Neapolitan philosopher Giambattista Vico (1669–1744) in his major work, *The New Science* (1725). For Vico, it testified not least to the "poetic wisdom" of the earliest ages and the metaphorical origins of human thought. In contrast to a rational metaphysics teaching that *homo intelligendo fit omnia* (man becomes all things by understanding them), Vico argued that man became all things by *not* understanding them (*homo non intelligendo fit omnia*).[1] It was Aristotle, whom Vico goes on to cite, who, in a still influential formulation, declared that metaphor (from the Greek *metaphora*, a transfer or carrying across) consisted in "applying to something a noun that properly applies to something else."[2] In the case of Vico's giants and their successors, this meant transforming the unknown into the familiar through an act of anthropomorphizing (or gigantomorphizing) projection: "The first poets attributed to bodies the being of animate substances, with capacities measured by their own, namely sense and passion."[3] The thunder-wielding Jove, Vico wrote, was soon joined by other personifications, including the sea (Neptune) and the earth (Cybele). This inaugurated the age of gods, when laws, customs, and institutions of government were understood to derive from divine commandments. It was followed by a heroic or aristocratic age, when authority was vested in a small elite. This in turn was followed by a "human" age of democratic government or enlightened monarchy, guaranteeing the equality of all before the law, which was exemplified, as Vico saw it, in the Europe of his own day. The story Vico told, however, was by no means an unconditional affirmation of human progress. Rather, enlightenment contained the seeds of its own destruction in the form of critical reason itself, the "barbarism of reflection" that Vico saw as ultimately leading to an ironic disparagement of the institutions and traditions that had hitherto held society together. Unchecked, the result could only be the collapse of civilization: "They shall turn their cities into forests and the forests into dens and lairs of men."[4] If history and thought began in metaphorical

displacement, then Vico expected the arc of their subsequent unfolding to culminate in an all too literal return to the forest.

Vico's theories were to be posthumously influential both on the later development of what have sometimes been referred to as the human sciences, including anthropology, and, equally famously, on James Joyce's final masterpiece, *Finnegans Wake* (1939), a work written in a dream language seeking to encompass all of human history and organized around Vico's proposed sequence of gods, heroes, and humans, followed by the movement of "recourse" that brings humanity back to the forest and unleashes once again the inaugurating voice of the thunder. Like Vico, anthropologists and linguists have often emphasized the importance of the role played by metaphor in the shaping of human worlds. James Fernandez, in a widely cited essay, echoes Aristotle in describing metaphor as a process of translation from one domain to another on the basis of some shared predicate. In this sense, he argues, metaphor plays a crucial role in integrating and organizing human experience, conferring order on the otherwise inchoate: "However men may analyze their experiences within any domain, they inevitably know and understand them best by referring them to other domains for elucidation. It is in that metaphoric cross-referencing of domains, perhaps, that culture is integrated, providing us with the sensation of wholeness." The success or failure of such an undertaking, Fernandez suggests, is attested by the degree to which humans are able to feel the "aptness" of one another's metaphors. He enjoins anthropologists to pay closer attention to metaphor on the basis of its seemingly ubiquitous appeal to human societies, past and present, including many of the ones anthropologists have traditionally studied. The anthropological literature on religion and folklore, he reminds his readers, "is full of those shape-shifting possessions which constitute in most dramatic form the assumption of a metaphoric identity."[5] More recently, George Lakoff and Mark Johnson, in their boldly titled study *Metaphors We Live By*, draw attention to what they take to be the pervasiveness of metaphor in everyday life, claiming that both human language and thought processes are "largely metaphorical" and that "truth is always relative to a conceptual system that is defined in large part by metaphor."[6] Like Aristotle and Fernandez, Lakoff and Johnson take the essence of metaphor to be the understanding or experiencing of one thing in terms

70 *The Voice of the Thunder*

of another, and they emphasize its importance in bestowing meaning and coherence on a world that might otherwise be lacking in both.

THE STORM CHILD

What, then, of Narsuk, the storm child, crying out in the wind's howling, thronged by the hosts of the naked and the dead? Is he a metaphor? Does he represent the human ascription of meaning to elemental forces through a gesture of anthropomorphic personification, asserting a perceived likeness between the violence of the storm and the distress of an abandoned child? Rasmussen's own investigations into the origins of Inuit religion drew much of their inspiration from the work of Swedish Lutheran theologian Nathan Söderblom, who is mentioned repeatedly in Rasmussen's ethnographic notebooks. Like his contemporary, Rudolf Otto, Söderblom sought the origins of religious sentiment in awe-inspiring *mysterium tremendum* of "the Holy," understood as the overwhelming experience of a power residing outside the self.[7] Söderblom was in turn influenced by Oxford anthropologist Robert Ranulph Marett, whose account of "animatism" or "pre-animistic religion" had sought to reach behind the individuated spiritual beings of Tylorean animism to uncover a more fundamental stratum of religious belief in the intuition of something akin to the impersonal, "vague" power referenced by the Melanesian term *mana* as described by Codrington and later Mauss.[8] The conception of such a power, Marett insisted, was both chronologically and logically prior to its depiction in the guise of personified agents:

> It is the common element in ghosts and gods, in the magical and the mystical, the supernal and the infernal, the unknown within and the unknown without. It is the supernatural or supernormal, as distinguished from the natural and normal. . . . Or perhaps another and better way of putting it, seeing that it calls attention to the feeling behind the logic, is to say that it is the awful, and that everything wherein or whereby it manifests itself is, so to speak, a power of awfulness, or, more shortly, a *power* (though this, like any other of our verbal equivalents, cannot but fail to preserve the vagueness of the original notion).[9]

For Marett, the English term best suited to express this "fundamental religious feeling" was "awe," which he saw as having one of its most notable

The Voice of the Thunder 71

sources in the elemental violence of geological and meteorological disturbances: "thunderstorms, eclipses, eruptions and the like."[10]

Among the native peoples of Greenland and the Canadian Arctic, Rasmussen uncovered what he took to be such a conception in the form of "Sila," a power (usually, but not always, male identified) associated variously with the air, the wind, the weather, the physical environment in general, or the animating "breath" of the natural world.[11] Sila (otherwise referred to as the "indweller in the wind") was identified as the defender of traditional observances and the punisher of taboo violations, and as the patron and guardian of shamans and shamanic initiations: "The shaman does not get the power from the animal [spirit], but from a mysterious 'power' in the air; at the same time it is near to them, it is so infinitely remote that it cannot be described."[12] Rasmussen's understanding of Sila was based in part on his conversations with two *angakoqs*—Igjugarjuk of the Copper Eskimos and Najagneq from Nunivak island. Najagneq described Sila in the following terms:

> A great spirit, supporting the world and the weather and all life on earth, a spirit so mighty that his utterance to mankind is not through common words, but by storm and snow and rain and the fury of the sea; all the forces of nature that men fear . . . When all is well, Sila sends no message to mankind, but withdraws into his own endless nothingness, apart. So he remains as long as men do not abuse life, but act with reverence toward their daily food.
>
> No one has seen Sila, his place of being is a mystery, in that he is at once among us and unspeakably far away.[13]

Sometimes, however, Sila was personified more concretely and in more directly anthropomorphic terms. One such personification, associated in particular with the wind, was Narsuk (sometimes spelled Narssuk), often described as an infant giant, orphaned by the death of his parents and residing in the sky. When his caribou-skin diaper became loose, Narsuk would cry out, and the flapping of his loose diaper would create storm winds. On such occasions, an *angakoq* was required to fly into the sky to fix the diaper and, if necessary, to thrash Narsuk until he calmed down.[14] In being personified as Narsuk, however, Sila was subject to a double demotion in status, being at once infantilized and subordinated

72 *The Voice of the Thunder*

to the authority of Sedna, the sea mother, the sea-dwelling mistress of the marine mammals on which Inuit hunters depended.[15] Shamans wishing to placate Narsuk were thus obliged first to summon and combat Sedna, on whose behalf Narsuk acted to punish taboo violations and other transgressions. It was just such a scene that Rasmussen witnessed and described at Agiaq in the company of the *angakoks* Horqarnaq and Kingiuma.[16]

Is Narsuk a metaphor, then, of the kind Vico identifies Jove as being? There are, I suggest, reasons to resist such an interpretation. Rasmussen's own claim to have seen and heard (or almost seen and heard) the crying of the storm child and the spirits of the dead thronging the polar night sky implies that distinctions between the metaphorical and the literal have become impossible to draw with certainty—for Rasmussen himself, no less than for the reader. It would appear that there is something more or other at stake here than the transfer of human-identified traits to meteorological phenomena. Even in Vico's account, the giants' invention of a sky god in their own image is preceded and enabled by their prior interpellation by a nonhuman other—albeit one that is immediately (mis)interpreted as the voice of an anthropomorphically conceived divinity—in the form of the voice of the thunder, breaking through the verdant closure of the forest, a voice that would later resound at intervals to disruptive effect throughout Joyce's *Finnegans Wake*:

> Bababadalgharaghtakamminarronnkonnbronntonnerronntuonnthunn-
> trovarrhounawnskawntoohoohoordenenthurnuk![17]

For Söderblom and Marett too, on whose work Rasmussen draws, the experience of "the Holy" or the intuition of a "vague power" diffused throughout the physical world is associated specifically with presences credited with existing outside the self—or outside the human realm altogether. We should therefore beware of reducing Narsuk to a metaphorical operation of human-centered meaning making. Rather, his image and the repertoire of stories and performances in which it is embedded suggest a more open-ended, two-way traffic between worlds of human discourse and what lies beyond their determinations.

seven

Metaphor and/or Metamorphosis

Given anthropologists' and linguists' frequent endorsements of the constitutive role of metaphor in the making of human worlds, it can be disconcerting to encounter the very different view put forward by Deleuze and Guattari in their study of the writings of Franz Kafka. Indeed, Deleuze and Guattari applaud Kafka precisely for destroying metaphor:

> Kafka deliberately kills all metaphor, all symbolism, all signification, no less than all designation. Metamorphosis is the contrary of metaphor. There is no longer any proper sense or figurative sense, but only a distribution of states that is part of the range of the world. The thing and other things are no longer anything but intensities overrun by deterritorialized sound or words that are following their line of escape. It is no longer a question of resemblance between the comportment of an animal and that of a man; it is even less a question of a simple wordplay. There is no longer man or animal, since each deterritorializes the other, in a conjunction of flux, in a continuum of reversible intensities . . . It is no longer the subject of the statement who is a dog, with the subject of the enunciation remaining "like" a man; it is no longer the subject of the enunciation who is "like" a beetle, the subject of the statement remaining a man. Rather, there is a circuit of states that forms a mutual becoming, in the heart of a necessarily multiple or collective assemblage.[1]

If metaphor has often been contrasted with metonymy, based, in Jakobson's words, on "association by contiguity" rather than on perceived

similarity, Deleuze and Guattari invoke the figure of metamorphosis, so prevalent in Kafka's writings, as a basis for the undoing of metaphor.[2] In eradicating metaphor, Deleuze and Guattari suggest, Kafka also dispenses with any distinction between literal and metaphorical, proper and figurative meaning. There is no recourse to another, higher level of reality, no world behind the apparent world: Josephine is a singing mouse, Gregor Samsa awakens to discover that he has indeed turned into a giant cockroach—"It was no dream."[3]

Should Deleuze and Guattari's strictures be read as yet another instance of a long-standing (Western) philosophical mistrust of metaphor? Sarah Kofman finds one of the earliest expressions of such a mistrust in none other than Aristotle, arguably the first theorist of metaphor.[4] In his *Rhetoric*, Aristotle praises metaphor as a source of value and distinction in both poetry and prose. Yet he insists at the same time that metaphors must be "fitting." By this, he means that they must correspond to the thing they signify, and that the transfer of terms must respect the claims of truth and identity. It is therefore possible to distinguish between good and bad metaphors; the latter—"inappropriate" metaphors—are those which fail to describe their object according to these criteria of accuracy, appearing instead "far fetched," "obscure," or "theatrical," like the sophist Gorgias's description of "events that are green and full of sap," a formulation that Aristotle finds to be "too much like poetry."[5] According to Kofman, however, what Aristotle describes in these and other passages is a version of metaphor that has already been tamed and subordinated to the authority of the philosophical concept as part of a larger victory of *logos* (reason, word) over *mythos* (myth, fiction) that would furnish the subsequent basis of Western philosophy.[6] Kofman suggests that the distinction between concept and metaphor, or between literal (or "proper") and figurative meaning in Aristotle's account, is linked to a series of other, similarly hierarchical oppositions: master and slave, father and child, male and female, Greek and barbarian. In each case, it is only the former—the master, the father, the male, the Greek—who has access to *logos*.[7] To these might be added the no less value-laden distinction between *morphé* (form) and *hyle* (matter) that received one of its most lastingly influential formulations in Aristotle's *Physics*, where it is asserted that the nature (*physis*) of a thing is best determined with reference to its formal properties rather than its constituent matter, a view that has come to be known

as hylomorphism. John Protevi has argued that the implications of such a view are, not least, political, suggesting a predilection for the top-down imposition of order upon the body politic rather than a confidence in the democratic self-ordering capacities of its constituent elements.[8] In the case of metaphor, it is form as a principle of identity that makes it possible to distinguish between appropriate and inappropriate metaphors. The good or truthful metaphor is that which respects the definitional boundaries of a world already differentiated into knowable and intelligible forms—a world, that is, where identity, understood in formal terms, rules over difference. Yet if some of these contrastive pairs (for example, male/female) are understood by Aristotle and his contemporaries to denote relations of ineluctable superiority and inferiority, others, such as father/child, have a more provisional status. The (male) child is at once distinguished from the adult and a potential adult—an adult in the making. Viewed in this light, as Kofman further suggests, the relation between concept and metaphor is apt to appear ambiguous. On the one hand, the language of the concept is aligned with truth and literality as opposed to figurative meaning. On the other hand, metaphorical language is credited with prefiguring and giving confused or distorted expression to truths that philosophy would later articulate with greater clarity, the indeterminate and polysemous language of *mythos* giving way to the "transparent and univocal" language of *logos*. Aristotle is thus able simultaneously to criticize his pre-Socratic precursors for their reliance on myth and metaphor and to depict them as dimly apprehending through their befuddled idioms what philosophy would later clarify and elaborate under the name of truth.[9]

Yet even philosophy is not able to leave metaphor behind definitively. Complete knowledge and perfect clarity of vision belong, finally, not to the philosopher but to the divinity, whose status in this regard the philosopher can approach but never attain. Like that of the sophists and pre-Socratics in relation to the Aristotelian philosopher, the philosopher's own knowledge in relation to that of the divinity remains a potentiality, not yet fully transparent to itself, always awaiting further clarification. The divinity, however, who is alone capable of such clarity of expression does not speak but remains aloof in its self-contemplation. *Logos* (in the sense both of speech and of reason) is for Aristotle an activity proper to humans as political animals, but to the extent that this is the case, it can

never fully rid itself of the trappings of *mythos*. If, for example, metaphor is presented as potentially detrimental to the task of philosophy in that its imputed excessiveness, obscurity, and polysemia threaten a return to a state of chaos prior to the advent of intelligible form, then philosophy can nonetheless never dispense outright with metaphor insofar as philosophical knowledge itself can never achieve the perfect transparency of expression for which it purports to strive, but rather remains entangled in the perennially less than transparent idioms associated with *mythos*. Philosophy is thus not capable of entirely subduing metaphor, which remains a potentially disruptive presence within its own discourse. Not only is metaphor needed by philosophy to articulate the philosophical delimitation of metaphor—the subordination of metaphor to the concept—but also every philosopher, in continuing to rely on metaphor, inevitably retains something of the sophist, the poet, the maker of fictions.[10] Philosophers, by this account, are producers of what Jacques Derrida, following Anatole France, would call "white mythology," their language of conceptuality seeking constantly to efface a metaphorical scene of origin on which it nonetheless remains tacitly reliant.[11]

Of course, not all philosophers have shared Aristotle's reservations about metaphor. A spectacular contrast is afforded by Nietzsche, as the initiator of a style of philosophy that was explicitly, indeed extravagantly, metaphorical, courting precisely the confusion between philosophy and poetry of which Aristotle accused the sophist Gorgias. In a much-cited passage, Nietzsche describes truth itself as

> a movable host of metaphors, metonymies, and anthropomorphisms: in short, a sum of human relations which have been poetically and rhetorically intensified, transferred and embellished, and which, after long usage, seem to a people to be fixed, canonical and binding. Truths are illusions which we have forgotten are illusions; they are metaphors that have become worn out and have been drained of sensuous force, coins which have lost their embossing and are now considered as metal and no longer as coins.[12]

Yet as Kofman points out, in his early writings (like *The Birth of Tragedy*), even Nietzsche remained attached to a vision of the world as endowed with an "innermost essence" distinct from its metaphorical

Metaphor and/or Metamorphosis 77

expressions. The latter were to be evaluated on the basis of their degree of proximity to or distance from the Dionysian "music of the world." It was, however, the art of music itself that approached most closely to this elusive essence of things, while the philosophical concept remained furthest removed from it.[13] Still, Nietzsche was insistent that metaphorical expression also involved the relinquishing of identity, the metamorphosis of the artist's self, entering into the multiplicity of the world's constantly changing forms. In later writings, it was just such a Dionysian undoing of the Apollonian *principium individuationis* that would overwhelm any possible appeal to a literal or "proper" meaning, as opposed to a merely figurative one.[14] Henceforward metaphors were to be evaluated not on the basis of their adequation to an independently existing truth (albeit one considered to be inaccessible, finally, to direct representation) but rather according to the degree to which they affirmed or denied their status as metaphors. On the one hand, there were the idioms of truth, of the philosophical concept—metaphorical through and through, yet bent on concealing their own metaphoricity. Unlike Aristotle's, Nietzsche's metaphor did not operate in a world already differentiated into discrete species and genera. Instead, it was metaphor that was responsible in the first instance for distinctions such as that between the deed and the doer, which lay at the origin of moral concepts and contributed to the stabilization of such a true world of fixed and eternal essences out of the flux of becoming. The concepts engendered by such metaphors contributed in turn to the repudiation and forgetting of their own metaphorical beginnings, thus making it possible to claim a distinction between metaphors and concepts. The categories used to contain the universe came to assert their coincidence with a universe assumed to be already ordered in accordance with their terms. Nietzsche's method of genealogical etymology was intended, not least, to reverse this trajectory, restoring to visibility the heterogeneity of the play of contending forces that lay behind the apparent identity and unity of the concept, revealing the true world itself to be no more than an appearance, an effect of metaphor and its subsequent forgetting.[15] On the other hand, there were metaphors that were unashamed of being metaphors—metaphors that aspired not to represent the world but to match themselves against the world's own artistry, that found expression in lying, dreaming, art, and myth.[16] Unlike the philosophical pursuit of a truth independent of appearances, these expressions

had the strength to affirm themselves as nothing more or less than a play of masks and perspectives.

In a direct challenge to Aristotle's much-cited definition of man as an animal endowed with reason and distinguished on that basis from other animals, Nietzsche proposed his own characterization of humans as metaphorical animals: "The drive toward the formation of metaphors is the fundamental human drive."[17] In identifying metaphor as a drive, as instinctual, Nietzsche detaches it from the imputed human exceptionalism of reason and sees it instead as issuing from a place prior to the artificial, retroactive separation of concept and metaphor, reason, and unreason that philosophy had attempted to effect. Both the philosophical concept and metaphor, its own derivation from which the concept sought to disavow, had their origins in the instinctual realm of drives. These included the artistic drive of life itself, impelled to continuously create and destroy worlds, a process with no end or purpose external to itself and that Nietzsche likened to the activity of a child at play, an image borrowed from the Greek pre-Socratic thinker Heraclitus, whom Aristotle had criticized for his alleged violation of the principle of noncontradiction on the basis of his enigmatic claim that "everything forever has its opposite along with it."[18]

The impetus to subordinate metaphor to truth and literality was understood by Nietzsche as the project of a stunted and deficient form of life, one lacking the strength for self-affirmation and thus projecting its weakness outside itself in the guise of metaphysical fictions. This in turn resulted, Nietzsche thought, in a further impoverishment of both life and of the human capacity for metaphor, substituting a reassuringly rigid and knowable world for the molten violence of becoming:

> Only by forgetting this primitive world of metaphor can one live with any repose, security and consistency: only by means of the petrifaction and coagulation of a mass of images which originally streamed from the primal faculty of human imagination like a fiery liquid, only in the invincible faith that *this* sun, *this* window, *this* table is a truth in itself, in short only by forgetting himself as an *artistically creating* subject, does man live with any repose, security and consistency. If but for an instant he could escape from the prison walls of this faith, his "self-consciousness" would be immediately destroyed.[19]

Metaphor and/or Metamorphosis 79

The drive, however, was not definitively vanquished by the ordered world instituted through the concept's repudiation of its own metaphorical origins. Finding other channels of expression through art, literature, and myth, it continually threatened, confused, and overran the conceptual categories imposed on life: "It continually manifests an ardent desire to refashion the world, which presents itself to waking man, so that it will be as colorful, irregular, lacking in results and coherence, charming, and eternally new as the world of dreams."[20] In rupturing the stabilized order of fixed essences appealed to by the concept, the drive exposed that order itself as no more than fleeting, provisional, and, contrary to its own claims, thoroughly metaphorical. In doing so, it forcibly reminded humans of the power of their own artistry as makers of metaphors and fictions.

However, should humans be considered the only, or even the most effective, makers of fictions? It is worth remembering that Nietzsche's discussion of metaphor in his essay "On Truth and Lies in a Nonmoral Sense," is preceded by the following:

> Once upon a time, in some out of the way corner of that universe which is dispersed into innumerable twinkling solar systems, there was a star on which clever beasts invented knowing. That was the most arrogant and mendacious moment of "world history," but nevertheless, it was only a minute. After nature had drawn a few breaths, the star cooled and congealed and the clever beasts had to die. One might invent such a fable and yet he still would not have adequately illustrated how miserable, how shadowy and transient, how aimless and arbitrary the human intellect looks within nature. There were eternities during which it did not exist. And when it is all over with the human intellect, nothing will have happened.[21]

The critique of truth and the countervailing valorization of metaphor freed from the authority of literal meaning that the essay goes on to develop thus begin by invoking a cosmic timescale that outstrips the much briefer span of human existence and terrestrial life. If metaphor, as Nietzsche afterward suggests, has its origins not in thought but in the differential play of contending forces, then does this ultimately imply a provenance beyond the human realm?

Is it, then, as Luce Irigaray has suggested, a gesture of bad faith on Nietzsche's part that the rehabilitation of humanity's metaphorical drive appears sometimes as a project of asserting mastery over the world? Certainly the perishing of the ascetic ideal that gave rise to the fiction of a "true world" offers for Nietzsche the possibility of "the will for man and the earth" that humanity has so far lacked.[22] As Irigaray notes, however, such a prospect seems often to call forth for Nietzsche images of mountain peaks, tightrope walkers, or soaring eagles, whereby the earth appears as something to be looked down upon, viewed from the safety of an objectifying distance. Yet, she writes, "What a limitless world of appearances lies concealed beneath the great seas."[23] And what about the metamorphic letting go, the relinquishing of self, the being carried away that is part of metaphor's primordial violence? Water is, after all, an element strongly associated with the figure of Dionysus in Greek art and thought.[24] Does Nietzsche lack the courage of his own insights in such moments? Or of his own metaphors (at least some of them)? Perhaps it is the metaphors themselves, rather than any ascribed authorial intention, that should be given the last word. Might not Nietzsche's own igneous turns of phrase in passages like the one quoted above (the "fiery liquid" of metaphor's "primitive world") alert us to a metamorphic potentiality in metaphor that exceeds any possible human-centered project of world making, just as the ecstatic transports of Dionysus and his followers break down instituted boundaries between the human, the animal, and the divine?[25] It might be said that Nietzsche's repudiation of the distinction between literal and figurative meaning demands such a reading, irrespective of his own predilections.

It is surely no accident that, as Gregory Flaxman has noted, Deleuze's fabulation, inspired as much by his reading of Nietzsche as of Bergson, finds one of its final articulations in the geophilosophy elaborated in his last collaboration with Guattari.[26] When metaphor is recast in these terms, the distinction between metaphor and metamorphosis invoked by Deleuze and Guattari begins to break down. Reading Deleuze and Guattari's account of metaphor alongside Nietzsche's, it appears that Deleuze and Guattari's strictures may be directed less against metaphor as such than against its long-standing enchainment to identity. Might not metaphor, released from its Aristotelian subservience to literality and truth, itself appear as an actualization of the power of metamorphosis?

Metaphor and/or Metamorphosis

Furthermore, might not theories of metaphor as meaning making be predicated upon the disavowal of this more prodigious, potentially world-destroying as well as world-forming power, even as they borrow surreptitiously from its momentum?

THE MYTHIC WORLD

What might it be like, then, to live in a not yet congealed and petrified world, a world in which metamorphosis and metaphor were not yet securely subordinated to the principle of identity? Something like this, perhaps: ancestors emerge from the ground. They rejuvenate by sloughing their skins. They transform themselves from human form into animals, plants, and rocks, and back again. The sea flows from a mango tree. Flying canoes glide through the air.[27] The Melanesian ethnographies of Bronislaw Malinowski, Reo Fortune, Paul Wirz, and others would later furnish material for Lucien Lévy-Bruhl's philosophical speculations regarding the "mythic world" of the Australian and Papuan natives. According to Lévy-Bruhl, the mythic world was characterized by its "fluidity"— by a sense that boundaries between species and kinds are not yet fixed and that "anything at all can happen and at any moment."[28] The mythic world appears as one of pure and unconstrained potentiality, where categories and kinds are not yet firmly established, in contrast to the more fixed and determinate contours of the actual, existing world, to which it gives rise and in which stories detailing the exploits of mythic ancestors are recounted. Lévy-Bruhl's account of a "primitive" mentality lacking in concepts and formal logical coherence and predicated instead on "participations"—a continuum of powers and agencies encompassing both animate and inanimate beings—has been much criticized by Evans-Pritchard and others, not least for posing too sharp a dichotomy between "rational" and "non-rational" modes of thought. Yet such a contrast was arguably never intended by Lévy-Bruhl to map directly onto one between "civilized" and "primitive" populations.[29] Although he draws mostly on ethnographic studies of native Australia and Melanesia from the 1920s, Lévy-Bruhl argues explicitly that the notion of participations, like that of an origin or creation time, identified in his sources by a variety of indigenous and European names (such as *Alchera, Ungud, Dema, Urzeit*, and *Dreaming*) and populated by metamorphic ancestral beings, combining human and animal characteristics, is of much wider—indeed universal—

provenance, persisting, albeit in desacralized and attenuated form, in the stories of human–animal metamorphosis that form part of the repertoire of European folklore.[30]

A generation later, Claude Lévi-Strauss responded in an interview to the question "what is myth?" by citing his own native American informants: "If you were to ask an American Indian it is extremely likely that he would answer: it is a story from the time when humans and animals did not distinguish themselves from one another. This definition seems to me very profound."[31] More recent scholarship has often been at pains to distinguish the native Melanesian and Australian totemic classifications that form the basis of Lévy-Bruhl's work from the animistic Amerindian cosmologies that inform Lévi-Strauss's compendious writings on myth. Philippe Descola argues that while Australian totemism and the animist mythologies of, for example, Amazonia resemble one another in referring to originary beings of human and nonhuman character existing under an already extant regime of sociality, they represent entirely distinct ontological orientations. Whereas Australian myths tell of the self-propagation of already constituted classes of hybrids such that dream beings, totemic ancestors, animal species, and groups of humans are linked by preestablished relations of physical consubstantiality, Amerindian cosmogenic narratives speak rather of the introduction of physical discontinuities between species (humans, plants, animals) that once formed part of a continuum and that nonetheless retain after their differentiation a shared psychic interiority.[32]

The latter view has famously been characterized by Eduardo Viveiros de Castro as the Amerindian ontology of "perspectivism": "the conception, common to many peoples of the continent, according to which the world is inhabited by different sorts of subjects or persons, human and non-human, which apprehend reality from distinct points of view." Thus:

> Typically, in normal conditions, humans see other humans as humans, animals as animals and spirits (if they see them) as spirits; animals (as predators) and spirits see humans as animals (prey); animals (as prey) see humans as spirits or as animals (predators); animals and spirits see themselves as human, that is as anthropomorphic beings, when they are in their own habitats (which they perceive as villages) and see their own characteristics

and habits in the form of culture—food seen as human food (jaguars see blood as manioc beer, vultures see maggots in rotting meat as grilled fish); bodily attributes (fur, feathers etc.) seen as bodily decorations; collective life seen as organized in same way as human society (chiefs, shamans etc.).[33]

In contrast to Western, naturalist ontology, perpectivism is concerned not with distinguishing a distinctively human realm of Culture from the supposed universality of Nature but with distinguishing specific natures from a universal sociocultural condition in which all living beings are understood to participate. Different kinds of bodies thus assume particular importance in establishing such distinctions. The body is an envelope or clothing covering an inner personhood that humans share with other kinds of entities; it is also an assemblage of specific affects, capacities, and dispositions, which are reaffirmed and accentuated as a site of differentiation through various forms of bodily decoration and adornment. Different bodies "see" different realities (what to humans is blood is manioc beer to a jaguar, what to humans is a muddy water hole is a ceremonial house to tapirs): "Animals see in the *same* way as we do *different* things because their bodies are different from ours."[34] At the same time, if animals appear human to themselves, it is because this is the common or generic form under which subjectivity and personhood are apprehended. The possibility of seeing species both as they see themselves and as other species see them is reserved to transspecific beings who are able to travel between bodies and realities, such as shamans. The masks and costumes worn by such interperspectival voyagers are not a form of disguise or symbolism but rather are instruments making it possible to actualize the powers and potentialities of different kinds of bodies: "they are akin to diving equipment, or space suits, and not to carnival masks."[35] They are instruments, it might be said, of metamorphosis.

The finite range of distinct—though sometimes interchangeable— embodied, species-specific perspectives that perspectivism articulates is understood, following Lévi-Strauss, as originating in a preexisting mythic dispensation in which species differentiations were not yet actualized in their current form.[36] Unlike some earlier writers on myth, however, such as Eliade, Viveiros de Castro does not understand such a mythic space-time as one of simple undifferentiation and "primordial unity."[37] Rather, he understands it as a zone of intensive difference—of

84 *Metaphor and/or Metamorphosis*

difference not yet resolved into the difference between a this and a that, a subject and an object, a self and an other:

> Mythic discourse registers the movement by which the present state of things is actualized from a virtual pre-cosmological condition that is perfectly transparent—a "chaosmos" where the corporeal and spiritual dimensions of beings do not yet conceal each other. Far from evincing the primordial identification between humans and nonhumans commonly ascribed to it, this pre-cosmos is traversed by an infinite difference (even if, or because, it is internal to each person or agent) contrary to the finite or external differences constituting the actual world's species and qualities.[38]

The regime of metamorphosis is thus characteristic of myth, which is understood as a superposition of states rather than as a linearly unfolding process of change from one clearly delineated state to another. It is therefore impossible to determine whether a metamorphic human–animal being like a mythic jaguar is a bundle of jaguar affects in the form of a human or of human affects in the form of a jaguar. It is only when these precosmological "flows of indiscernibility" are actualized in the form of the presently existing world and the beings inhabiting it that the human and feline dimensions of jaguars and humans will become distinguishable from one another.[39]

Yet as the unapologetic universalism of Lévy-Bruhl, no less than the thought of Deleuze (from whom Viveiros de Castro borrows the concepts of virtuality and intensive difference), serves to remind us, any articulation of a mythic precosmos is always already an actualization proceeding out of a generative virtuality that necessarily exceeds the specifications of any given ontological scheme, whether animistic, totemic, or anything else. Surely a great deal hinges on the status ascribed here to the difference between Amazonian and Western ontologies. Debates provoked by anthropology's recent ontological turn have often centered on the question of whether ontology is simply a new object of anthropological inquiry, susceptible to being studied and explicated in the manner of "culture" or "social structure" or whether it poses a more far-reaching challenge to the very project of social scientific explanation.[40] Viveiros de Castro himself has emphatically rejected the possibility that perspectivism can be assimilated to Descola's proposed typology of "modes of

Metaphor and/or Metamorphosis

relation" (animism, totemism, naturalism, analogism), arguing that if properly understood, perspectivism is rather a "bomb" capable of blowing up any such classificatory enterprise.[41] In what, however, does the subversive potential of perspectivist ontology and the mythic realm to which it appeals consist? Beyond the destabilization of familiar conceptual categories, might it direct us toward a new awareness of more radical possibilities of human and other-than-human world making—toward a project of ontological *poesis* rather than one of comparative ontology?

Anthropologists aligning themselves with the ontological turn have sometimes argued for a recursive approach whereby anthropological concepts might be called into question and (potentially) reformulated through an encounter with the concepts of others.[42] This in turn has often been understood to require an effort, taking its cue from Lévi-Strauss's explications of *la pensée sauvage*, to elicit from mythic expressions a latent conceptuality, or, in Viveiros de Castro's words, "the uncovering of an indigenous philosophical problematic."[43] What, however, are the implications for philosophy and philosophically informed anthropology of the attempt to take indigenous thought seriously by treating its expressions as concepts in something akin, though not necessarily identical, to the Western philosophical sense? It is important to remember that Western philosophy, from its Platonic and Aristotelian beginnings, has based its own claims to truth not least on the differentiation of *logos* from *mythos*. As Jean-Pierre Vernant reminds us, in the case of Greece, this involved from the eighth to the fourth centuries BCE the progressive self-differentiation of the abstract, avowedly affect-free language of the philosophical concept from the various rhetorical features (including metaphor) associated with mythic or, in a more recent articulation, literary discourse.[44] Perhaps an engagement with myth as the expression of indigenous thought has the potential to transport us back (or forward?) beyond the terms of this long-instituted separation? Viveiros de Castro's English translator, Peter Skafish, certainly suggests as much when he argues that to approach Amerindian thought in terms of concepts necessarily entails acquiescing to the deformation of conceptuality by myth: "For conceiving Amerindian thought in terms of concepts changes not only our concepts but our very concept of concepts, pulling the concept, that is, into the orbit of myth and its much greater capacity to effect transformations of other myths but also other

discursive materials."[45] Yet it remains striking (and curious) that anthropologists associated with the ontological turn have for the most part shown a marked reluctance to engage in any kind of formal or writerly experimentation, although their tacit refusal of the Western compartmentalization of philosophical and mythic discourse might seem to point inexorably in such a direction.

The difference between the Amazonian perspectivism that provides Viveiros de Castro's principal point of reference and the Western naturalism with which he so often contrasts it could be reformulated as akin to Nietzsche's distinction between metaphors that acknowledge and affirm their own status as such and those that seek to disavow it in the name of a philosophical conceptuality purged of metaphor. In both cases, the contrast at its most basic would be one between an acceptance of immanence and a desire for transcendence—between the enactment of an acknowledged consubstantiality with a world that exceeds human purposes and understandings and a refusal to acknowledge such consubstantiality that seeks rather to establish a representational distance enabling the objectification of a world of fixed and stable forms assumed to be knowable to the extent that it is already given independently of the act of invoking it. It is something like the former that Viveiros de Castro claims to find in the later writings of Lévi-Strauss (notably the *Mythologiques* series and its successor volumes), where a conception of structure as a principle of transcendental unification is seen to give way to an emphasis on the transversal self-proliferation of mythemes and a predilection for dialectically unresolvable, asymmetrical oppositions (exemplified in the Tupinamba myth of the "impossible" twins and its variants explored in *The Story of Lynx*). In these later works, Viveiros de Castro suggests, myth is understood not as recounting the definitive supercession of a given world of Nature by a humanly fashioned realm of Culture, but rather in terms of "a labyrinth of twisting, ambiguous pathways, transversal trails, tight alleys, obscure impasses, and even rivers that flow in both directions at once."[46]

Taking my cue not only from Lévi-Strauss and Viveiros de Castro but also from Nietzsche and Deleuze, as well as the Icelandic and Canadian Inuit sources discussed in the preceding pages, I want to go further in emphasizing myth's immersive engagement with an other-than-human reality acknowledged as preexisting and surpassing human acts of verbal

Metaphor and/or Metamorphosis 87

narration. In projecting a precosmological condition out of which the presently existing world is actualized, myth can be considered as a site where Culture dreams the capacity of Nature to differ from itself. Rather than yet another metaphor in the service of human meaning making, might the figure of metamorphosis be thought of as a manifestation of that same capacity in a specifically cultural-linguistic register, such that the relationship of Nature to Culture might itself be conceived in terms of metamorphosis? Myth, like literature (and like anthropology), is a fabulatory art effecting an opening to an impersonal, inhuman "life" that encompasses not only metamorphic interchanges between humans and animals (as they come to be designated in the postmythic dispensation) but that also extends beyond the conventionally organic to encompass, for example, the volcanic prehistory invoked by Nietzsche's discussions of metaphor—a prehistory that produced both the landscape of contemporary Iceland and the figure of the *huldumaður* encountered there in the fog by the young Kirsten Hastrup. Furthermore, anthropology's own claim to such a status need not be seen to consist only in the second-order retelling of cosmogenic myths. If many anthropologists have remained attached to conceptions of metaphor derived in the last instance from Aristotle, then their accounts of the worlds of others have often worked to unsettle the very distinctions on which such conceptions are founded, revealing behind the conventionally metaphorical a latent metamorphic power that folds into human discourse the materiality of the universe's own fiction making. Michael Taussig has suggested that anthropology, folklore, and even certain branches of history continue to function as a repository of the "excess" that is at once necessary and threatening to meaning and representation: "namely the belief in the literal basis to metaphor—that once upon a time, or in distant places, human sacrifice and spirit possession, ghosts and spirits, sorcerers and witches, miracles and gods and people making devil pacts did walk the face of the earth."[47] Or might it be said that what such accounts remind us of, often despite their authors' best intentions, is the continuing possibility of encountering worlds in which reality and belief, literality, and metaphor cannot be sharply differentiated—worlds in which the real itself retains a Nietzschean power of artistry unsubordinated to the authority of a fixed and canonical truth?

eight

"They Aren't Symbols—
They're Real"

The Mueda plateau, northern Mozambique, late 1994, two years after the end of a fifteen-year civil war, following on from a ten-year independence struggle, and shortly before the country's first-ever democratic elections. A young American anthropologist who has been conducting doctoral fieldwork in the region has received an invitation to give a lecture at the Cultural Heritage Archives (Arquivos do Patrimônio Cultural, or ARPAC) in the provincial capital of Pemba. The director of the archive has asked him to address questions raised by the research topics of the other staff. In his previous encounters with the archive's staff, the young doctoral student has been struck by their apparent reluctance to analyze or interpret their material: "I wished to inspire them to move beyond the cataloguing of data and the verbatim quotation of informants that characterized their publications." Accordingly, he decides to offer a brief introduction to symbolic anthropology by way of Victor Turner's classic 1967 essay, "Symbols in Ndembu Ritual." He begins by summarizing Turner's analysis of the *nkang'a* girl's puberty ritual. He describes how the sap of the tree at the ritual's center symbolizes the milk of the initiates' developing breasts; the tree itself simultaneously symbolizes the unity of the initiate and her matrilineage (and of all Ndembu more generally) and the social tensions that the ritual produces and mediates as it separates the adolescent girl from her mother's kin group. He then moves on to discuss material collected in the course of his own field research. During a previous visit, he has observed that lions seen in and around villages on the Mueda plateau are often considered to be not ordinary

"They Aren't Symbols—They're Real" 89

lions but either a sorcerer metamorphosed into a lion or else a lion made by a sorcerer. Such sorcery lions are often blamed for physical attacks on humans and domestic animals, and they are sometimes credited with causing illness through magical means. Ritual specialists are called on to render the lions vulnerable to hunters. Suspected perpetrators are sometimes lynched. Invoking Turner's theoretical framework, the speaker suggests to his audience that as Muedians consider who among themselves might envy or seek to appropriate the wealth of others, or conversely who has transgressed egalitarian norms by refusing to share their own wealth, they are led to associate such predatory behavior with their well-founded fear of lions. In Turner's terms, the lion as symbol allows them to connect the sociological and sensory poles of their experience, the latter including not only the hunt for the lion but also the (sometimes fatal) ad hoc punishments meted out to those accused of sorcery. At the same time, the elders who are often called on to counteract sorcery are seen as deriving part of their power from ingesting an array of magical substances, including the throat meat of bush lions. Lions are thus capable of symbolizing both predator and protector. As such, they testify to "a deep ambivalence about the workings of power in the social world." If power is necessary to secure the common good, including the protection of the community against predators, it is itself at the same time a potential source of predatory threat. When the talk ends, there is a long silence, followed by a series of questions from the audience about minor ethnographic points. Finally, Lazaro Mmala, a Muedan graduate of the elementary school at the Imbuho Catholic Mission and a veteran of the guerilla campaign for independence, rises to his feet and says: "I think you misunderstand. . . . The lions that you talk about . . . they aren't symbols—they're real."

Recounting the incident more than a decade afterward, the young fieldworker in question, Harry West, now a faculty member at the University of London's School of Oriental and African Studies, writes, "Years later, the words still ring in my ears."[1] West, of course, as he himself notes, is not the only anthropologist to have recourse to symbols and metaphors as a means of navigating a middle passage between skepticism and belief—illness as a metaphor for social contradiction, vampires as metaphors for colonial and postcolonial violence, sorcery more generally as a metaphor for "extraordinary powers."[2] Others, meanwhile, have

attempted to engage sorcery as a more direct challenge to the premises of Western science by claiming to have been both victims and perpetrators of magical attacks.[3] Confronted by the claim that sorcerers made or made themselves into lions, West's own aim, as he describes it, had been to steer a course between a straightforward dismissal and a no less straightforward credulity: "I neither dismissed nor adopted Muedans' way of talking about these lions; I pronounced them neither true nor false."[4] West's solution is to treat sorcery as a "discourse" composed in part of metaphors, and as such both contributing to the construction of a humanly meaningful world and pointing to the limits of that world's comprehensibility: "Through sorcery discourse, Muedans reflected upon the complex truth that the world they made sometimes eluded their grasp, sometimes turned around and made them, and sometimes became suddenly and unexpectedly responsive to their whims."[5] But does the appeal to discourse and the world-forming potential of metaphor in fact achieve the sought-after neutrality? Does the prioritization of human meaning making amount finally to a more subtle refusal of sorcery discourse's own claim that the world is imbued with powers and presences that are not the creation of humans? The response comes back from the audience: the lions are real.

West's attempts to balance the claims of metaphor theory against the seeming literality of his informants' claims about sorcery lions suggests that one of anthropology's most telling contributions to such debates might consist precisely in its capacity to unsettle the distinctions between metaphorical and literal meaning that Aristotle and his successors embrace and that Nietzsche so pointedly refuses.[6] The problem with "sorcery discourse" in West's account is, arguably, that it keeps refusing to accept its assigned status as such, instead making insistent and disruptive claims on the very constitution of the real. West finds himself obliged on at least one occasion to manipulate distinctions between the literal and the metaphorical. Toward the end of his account, he describes a conversation, taking place shortly before his return to the United States, with Chombo, the president of the local healers' association, and by reputation "the most powerful healer on the Mueda plateau." Suggesting that West's researches have exposed him to a variety of dangers, including attack by malign sorcerers, Chombo insists on "vaccinating" him to protect him. Drawing on both the vocabulary and a version of the methods

of biomedicine, vaccination in this instance involves slitting the patient's skin and inserting *mitela* (medicinal substances used in the practice of sorcery and countersorcery) mixed with the acid of a disposable battery. Alarmed at the prospect both of submitting to the proposed inoculation and of alienating a valued informant through too brusque a refusal, West searches for a way out. He decides finally that his own status as an ethnographer and his impending departure offer the possibility of nudging Chombo's understanding of what vaccination might entail in a more conventionally metaphorical direction. He begins by reminding Chombo that *vakulaula* (healers) derive their knowledge from a variety of sources, some from *mitela*, some from dreams, some from the words of ancestral spirits. He himself, however, he notes, has learned principally from the stories that Chombo and others have told him—stories that he will pass on to others in the form of written accounts on his return to America. He understands that such stories are the real source of Chombo's power as a healer. In giving his blessing to his research and sharing his knowledge with him, Chombo has thus in a sense already vaccinated him against potential dangers, rendering a more literal vaccination with magical substances unnecessary. To his relief, Chombo agrees, and they part as friends.[7]

Distinctions between the literal and the metaphorical, however, are not always so amenable to self-conscious manipulation. At an early stage in his initial fieldwork, in the run up to Mozambique's 1994 elections—the first since the ending of the civil war that brought the ruling FRELIMO party to power—West and Marcos Mandumbwe, another ARPAC researcher, found themselves chased from one of the villages on the plateau by a hostile and somewhat drunk local official. They appealed to the district administrator in Mueda, who reprimanded the official, and they were allowed to continue their work. A few days later, West and Marcos were returning by pickup from another village. During the drive back, West felt unusually tired. His head pounded. Arriving back in Mueda, he decided to go to bed before the evening meal and fell asleep immediately. He woke at around ten, shivering uncontrollably. He called out for Marcos but was unable to make himself heard. He tried to stand but collapsed on the floor, clutching the blankets around himself. Finally Marcos awoke, and he began to carry West toward the latrine. Before they could reach it, West collapsed again, shitting and vomiting. Marcos

cleaned him up and put him back to bed. After lying in a state of partial delirium for three days, he was driven into Mueda town, then to Pemba; he was finally transferred by plane to a U.S. embassy clinic in the national capital, Maputo, where the doctor who examined him suggested that in addition to dysentery he had also contracted malaria. On his return to Mueda several weeks later, Marcos suggested that they interview a *humu* (elder and countersorcerer) named Mandia, who lived in the village of Nimu. Sitting in Mandia's house, Marcos began a conversation about sorcery. Gradually, however, he began to ask more concretely about specific elements and their cures. West writes: "I realized that the subject of Marcos's interest was *my* ailment and *my* cure." Mandia asked whether West had had any "conflictual relations" with anyone before his illness. Marcos responded on his behalf by recounting the story of their encounter with the local official and what had ensued. He concluded by saying, "The problem may lie there." Mandia then offered to treat both Marcos and West with some of his *mitela*, including a white substance made from sorghum flour mixed with other ingredients, which he smeared in a vertical and then a horizontal line, resembling a Christian cross, on their foreheads.[8]

"I Became Uncontrollable Flows of Lava"

Looking back, West recalled that he found himself wondering "how I had arrived at this moment—how I had come to be sitting in a dank hut searching my recent experiences for signs of sorcery."[9] How had he come to be confronted once again by sorcery as an actual and effective presence rather than a metaphor of power or a symbolic articulation of the limits of human agency and knowledge? Once again, the possibility of distinguishing between a metaphorical and a literal understanding of sorcery appeared to be receding as sorcery was invoked as a potential explanation of recent events in his, the ethnographer's, own life. To better understand what led him to this point, let us return to his initial description of the onset of his symptoms. Awakening at night in his bed, in the compound of one of Marcos's relatives (his *likola* sister, or mother's sister's daughter, treated as a sibling), he was aware first of all of being "seized" by chills and uncontrollable trembling. He convulsed violently, pulling the covers around himself in alarm, "frightened by the apparent vulnerability of my body to the world around me." Attempting to stand,

he found himself unable to and sank to the floor, "overpowered completely by the elements in which I was suspended." He felt as though his trembling body would shake itself to pieces, dissolving into the world around it. Half an hour later, as Marcos was carrying him to the pit latrine, "something broke loose deep inside of me, erupting through my chest and out of my mouth." He collapsed. Marcos lifted him from behind, but another "eruption" followed, this time from below: "I was unable to differentiate myself from that which burst out from within me. I became uncontrollable flows of lava." Thus began the sequence of events that led him to Mandia's hut, reviewing his recent past in search of evidence of sorcery.[10]

West's near-fatal bout of dysentery and his subsequent consultation with the *humu* stands in stark contrast to the calculation attendant on his later encounter with Chombo, when he attempts to manipulate the idioms of biomedicine and sorcery to persuade the healer of the efficacy of a metaphorical vaccination through storytelling rather than the more directly physical version the latter has in mind. The sudden onset of his illness is marked not only by a loss of any sense of control (including control over bodily functions) but also by a more radical sense of self-dispossession. Racked by waves of shitting and vomiting, the ethnographic observer experiences the dissolution of any differentiating boundary between himself, his surroundings, and the flows erupting from his mouth and anus. Yet the circumambient materiality with which he feels himself forcibly conjoined retains an alien and threatening character: "Again and again throughout the night, my body met with overpowering forces from within and opened itself to flow into a hostile world."[11]

Strikingly, the language of West's account is one of bodily metamorphosis rather than the metaphorical linking of discrete domains. Indeed, identity—and with it distinctions of subject and object, self and other, human and nonhuman—is precisely what is thrown into question: "I became uncontrollable flows of lava."[12] Although West makes no mention of Artaud, the becoming-volcanic effected by his prose uncannily echoes Artaud's description of the ravages of plague in his Sorbonne lecture: the "crazed body fluids" surging "like lava kneaded by subterranean forces."[13] As Nin notes in her retelling of the occasion, what disconcerted and ultimately repelled Artaud's audience was his slippage from description into enactment.[14] It is at such moments that the classificatory

patterning of the world on which metaphor appears to depend breaks down and we find ourselves in the presence of something more akin to Nietzsche's "primitive world" of untamed metaphor, not yet subordinated to the authority of a literal, nonfigurative, "true" meaning—a metamorphic, Dionysian world that is similarly rendered through magmic, volcanic images—images that, if we are to take Nietzsche at his word, must surely be read as more than mere metaphors.

Nietzsche's lava flows and Artaud's and West's bodily eruptions direct us back both to the storm-riven skies over Arctic Canada and to Iceland, to the *óðáðahraun* (lava field of misdeeds) from which Hastrup's mysterious visitor in the mist may ultimately have issued. Like Narsuk the storm child and his attendant throng of spirits of the dead, Iceland's human and other than human population of *útilegumenn* and the lava field with which they are associated cannot be viewed simply as projections of conventionally human-identified traits onto the wild nature lying beyond the confines of village and farmstead. They gesture instead toward an elemental and geologic prehistory antecedent to the very act of naming, of classification, and can therefore be understood more suggestively as the insinuation of the generativity of an inhuman time and matter into human discourse as a constitutive alien presence, one that simultaneously grounds the classificatory order of "culture," yet in doing so renders it perennially alien to itself.

On the far side of accredited distinctions between metaphor and literality lies not the truth of adequation to an already established real but a radically different kind of truth: that of the play of fictionality as the becoming of the world. I have suggested that one role of anthropology has been to reveal this—sometimes inadvertently—by juxtaposing the often cautiously Aristotelian understandings of metaphor elaborated by its own practitioners with the frequently bolder assertions of their informant-interlocutors: sorcery lions are real. Anthropology's encounters (not only with other communities of humans but also with creatures such as *huldufólk* and lion men) remind us that the human-centered, world-forming creativity of metaphor celebrated by metaphor theorists like Fernandez and Lakoff and Johnson is steeped in, and finally overwhelmed by, a more expansive movement of creation and destruction that is its source even as it remains recalcitrantly indifferent to its operations. It is this asubjectival, impersonal, other-than-human impetus that is invoked by

Lispector's "It," Deleuze's "A Life," or Benveniste's and Serres's "third person"—and that is variously actualized in the guise of Ymir, the *huldumaður*, the Trickster, Narsuk, and the sorcery lions of the Mueda plateau. It is this that fabulation seeks to engage, not as an object of representation but as a participatory carrying forward of the world's own fiction making. Situated as it is at the interface between humanly conceived worlds and the nonhuman materials that are their indispensable precondition and unsurpassable limit, anthropology is nothing more or less than an art of fabulation, an art of third personification, an art of the between.

II

In Between

nine

Liminality

An Old Story?

The middle, as Michel Serres keeps reminding us, is where everything begins.[1] This particular middle begins by returning once more to Iceland, this time to a photograph taken in July 2009 during a visit there. Thingvellir National Park, lying twenty-three kilometers east of Reykjavík, is Iceland's first national park and, since 2004, a Unesco World Heritage Site. It is known both on account of its spectacular physical geography—including lakes, lava fields, hot springs, and waterfalls—and because it served as the setting for the world's first democratic parliament, the Althing, convened by Iceland's Norse settlers in 930 and continuing to meet annually as a legislative body until 1271, when governance was surrendered to the crown of Norway. The photograph shows the flag of the present-day Icelandic republic flying atop Lögberg (Law Rock), where, before the introduction of a version of the Latin alphabet some time after 1000 CE, the "Lawspeaker" would recite annually from memory all the laws currently in force in Iceland.[2]

That much you can learn from the guidebooks. The Althing, however, has lately reentered the discourse of contemporary social theory, thanks in part to Bruno Latour, who invokes it to remind his readers (like Heidegger before him) of the etymology of the word "thing," which referred originally, he notes, to a gathering or assembly, serving as a reminder too that the more commonly understood "things" that are our contemporary objects of knowledge and concern are, similarly, constituted by sometimes fractious combinations of unlike elements.[3] In fact (as Latour also notes), Thingvellir marks not only to the coming together of Iceland's

FIGURE 13. Thingvellir, Iceland, 2009. Photograph by author.

first human inhabitants but also a prior and still ongoing scene of encounter—namely, the meeting point of the Eurasian and North American tectonic plates, which form a fault line running through the center of Iceland and continuing beneath the Atlantic Ocean. It was a series of underwater volcanic eruptions along this joint or fissure between seventeen and twenty million years ago that eventually produced the island of Iceland as Europe's most recently formed and volatile landmass, where the earth's crust is only a third of its normal thickness and where, to the present, magma, or molten rock, continues to force its way upward from the depths, pushing the two plates (and thus the two continents) further apart. The traces of these upheavals are scattered throughout Iceland's recorded history in the form of volcanic eruptions, floods, and earthquakes and are visible today in the vicinity of Thingvellir in the great rift Almannagjá, which continues to broaden by around one millimeter a year.[4]

For Latour, the coincidence of geological fault line and political assembly serves principally as a reminder of the perennial interimplication of politics and nature. Thingvellir can also be understood, however, as a spectacular instance of juxtaposition—of montage—in the guise of the politically massed bodies of the first Icelanders and of the boundary between two of the tectonic plates comprising the earth's crust. The notion of montage has been much discussed in anthropological writings of recent decades, whether as an analytic for understanding the complex and contradictory forms elaborated in the wake of colonial encounters and burgeoning global interconnection, or with reference to emergent multisited and transdisciplinary research imaginaries, many of them drawing inspiration directly from the practices of literary and artistic avant-gardes.[5] In appealing here to geophysical processes and temporalities as well as to cultural and historical ones, I wish to extend and pluralize the concept of montage, such that it can be taken to refer not only to an audiovisual or a textual method, or indeed to a sensibility and mode of engagement with the world, but also to a principle of creation operative across distinctions between the realms of the natural and the social. Such a principle seeks to align itself not with explanatory foreclosure or recourse to an established order of significations (society, history, context) but with a generative instability that inheres in juxtaposed elements and the spatiotemporal intervals that both conjoin and differentiate them. This is the space and time of the between—of the fluid indeterminacy

that subsists and underlies the seeming stability of solid forms and out of which new configurations are continuously born, not least the geophysical, political, and cultural entity that is present-day Iceland. As Thingvellir reminds us, the process is an open-ended one, involving the simultaneous emergence and dissolution of forms, without cessation or resolution, a movement captured so powerfully by Heraclitus, in his image of the universe as a child at play, perpetually making and unmaking with no end or purpose other than the game itself.[6]

Anthropology, of course, is easily (perhaps too easily?) characterized as an in-between discipline. Not only have encounters across difference (whether conceptualized in terms of culture, language, or social positionality) been a stock-in-trade of anthropological research and writing, but also the discipline of anthropology as a whole, at least in its four-field instantiation in the U.S. academy, can be seen to have occupied an intellectual and discursive space at the intersection of the humanities, social sciences, and natural sciences. It is surely unsurprising, then, that anthropology, in the course of its still comparatively brief history as a discipline, should have had a great deal to say on the subject of betweenness. Equally unsurprising, perhaps, is the fact that much of what has been said has considered betweenness as a human-centered affair of meaning, symbolization, and social status, pertaining principally to culturally demarcated zones of transition, ambiguity, and classificatory uncertainty. Take, for example, Mary Douglas's influential account of the concepts of pollution and taboo, which argues that these have a particular affinity with whatever is deemed to be unclear or ambiguous and that they arose as an attempt to safeguard society's most cherished principles and categories against the threat of contradiction.[7] Or consider what Arnold van Gennep famously identified as the transitional or liminal phases of rites of passage, the latter encompassing a range of culturally recognized transitions, from those focusing on an individual's life course, such as puberty rites, to society-wide celebrations concerned with war, fertility, or the investiture of a new ruler.[8] Everything, it seems, begins and ends with the social. But does it have to be this way? Does classificatory order have to prevail? Does the between have to be understood in terms of what is taken to lie on either side of it? Remember Thingvellir; remember the magma rising from the depths, pushing the continental plates apart. What if the between could be thought of as a material process as much

Liminality 103

as one of symbol making? Could there be a story to be told about liminality that is much, much older than some of the ones hitherto told by anthropologists?

DOWNPOUR

It's raining. It's always raining. It's always been raining—not frogs, or cats and dogs, or men, but atoms—*primordia*—cascading down endlessly through a void. Then something happens. Or rather, it's always happening—no before or after. Atoms deviate from their downward fall by the smallest possible angle. A disturbance disrupts the regularity of the flow, introducing turbulence. Vortices form. Atoms, deflected from their downward path, encounter other atoms. Particles of different sizes and shapes conjoin to form solids, liquids, and vapors—earth, sea, and sky. Out of the earth emerge plants, animals, and human beings. Language, political institutions, and property relations make their appearance. Humans discover the use of tools and the domestication of animals. They found cities and begin to worship gods. Out of successive combinations of atoms a world is formed, a fleeting island of stability, destined in its turn to perish as its constituent particles are pulled back into the downward torrent.

From the nameless poet of the Eddic verses to a poet with not much more than a name—Lucretius—of whom little is known beyond the fact that he was the author of the first century BCE epic poem, *On the Nature of the Universe*, a treatise on physics, inspired by the atomist theories of Greek thinker Epicurus and written in verse—some 7,400 lines of it, in dactylic hexameters and divided into six untitled books.[9] Lucretius, poet and scientist, traversed, apparently without difficulty, what Serres would later characterize as an increasingly tortuous Northwest Passage between the ever more disparate knowledge cultures of science and literature.[10] In Lucretius' account, it is the *clinamen*—his term for the minimal angle of deviation in the path of an atom—that allows material creation to occur by disrupting the absolute regularity of rectilinear free fall:

> When the atoms are traveling straight down through empty space by their own weight, at quite indeterminate times and places they swerve ever so slightly from their course, just so much that you can call it a change of direction. If it were not for this swerve, everything would fall downwards

104 *Liminality*

like raindrops through the abyss of space. No collision would take place and no impact of atom upon atom would be created. Thus nature would never have created anything.[11]

Lucretius' poem evokes a spatially and temporally unbounded universe, in which combinations of atoms are continuously forming and dissolving and where transformation is the only constant. Whatever comes to exist is always already in the process of dissolution. He predicts that the present world, which he thinks likely to be only one among many created worlds, will in its turn be pulled asunder and its constituent atoms redistributed.[12] It is this emphasis on the world-forming capacities of self-organizing material processes, rather than on the actions of a divine creator, that has led a number Lucretius' latter-day readers to identify his work as a precursor not only to the theory of evolution but also to today's theorists of chaos and complexity, with their explorations of nonlinear dynamics and open systems operating far from equilibrium.[13] Indeed, for Lucretius, to exist at all is to be in a state of dis-equilibrium.

Lucretius does not rule out the existence of gods, but he insists that such beings play no active role either in human affairs or in the making of the universe. Indeed, the gods, like everything else, are themselves products of the *clinamen*, the swerve that brings about collisions between atoms and their resultant combinations. Like their Eddic counterparts, emerging out of the ice that produced the primordial giant, Ymir, Lucretius' gods are latecomers and therefore are transitory rather than eternal presences.

If the constituent elements of Lucretius' universe are solid particles, his account is arguably as much concerned with liquid flows. Lucretius' atoms are atoms in motion—solid particles and liquid flows. *De Rerum Natura* is at once a physics of particles and a poetics of flows, in which turbulence appears, condenses temporarily into a form, and then disperses. Serres writes, "The physics of Lucretius is a hydraulics."[14] It's not so surprising, then, that Lucretius should dedicate his only surviving work to the goddess Venus, "the guiding power of the universe." Venus is herself a late arrival on the scene, a daughter of turbulence, born of the foam springing from the severed testicles of her father, Uranus, when they were cast into the sea by his usurping son, Cronus. Venus is not a divinity who stands apart from the world; she is rather immanent to it,

participant in and product of its material substances and their transformations. There is no room for transcendence here, not even the familiar distance of representation, the sign standing in for the absent thing. Lucretius himself appears to have understood the act of literary composition as a direct continuation of the processes governing the formation of the material universe. He likens the atoms composing a physical body to the letters composing his own verses, not representation but consubstantiality. Serres describes his own study of Lucretius in the same terms: "My text, my body, the collective, its agreements and its struggles, the bodies which fall, flow, flame or thunder like me, all this is never anything but a network of primordial elements in communication."[15] Serres finds in Lucretius, the poet-physicist, the possibility of a "science of Venus"—a science that would know the world not by objectifying detachment from it but through an acknowledged immersion and participation in the transformations of the world's own material substance, carrying us far beyond currently institutionalized divisions between the arts, the sciences, and the social sciences.

What remains of the difference between worldly fact and literary fictions if both are condensed out of an antecedent, primordial matter? Or perhaps the movement of differentiation, the *clinamen*, the swerve, the

FIGURE 14. Sandro Botticelli, *The Birth of Venus* (mid-1480s).

power to differ or become other is what is truly antecedent—prior to any given, or indeed any possible, configuration of world or text. What remains, then, of the assumed distance between world and text on which the latter's claim to represent the former has usually been based? What might anthropology have to learn, not least about the intermingled materialities of words and things, from the verses of Lucretius and the world-forming and world-destroying powers that they evoke?

"PARTICULAR FORM BECOMES GENERAL MATTER"

Lucretius' *clinamen* offers a forceful reminder that betweenness need not be thought of in narrowly anthropocentric or logocentric terms. Another such reminder comes, more surprisingly perhaps, from anthropology's most influential theorist of the liminal: Victor Turner.[16] At the same time, no one has exposed more tellingly the hesitations and ambivalences that have often characterized anthropology's attempts to approach the topic. Turner famously defines liminality as an "interstructural situation" characterized by flux and becoming, whereas society is defined as a "structure of positions," comprising more or less fixed and stable identities and relations. What rites of passage accomplish, according to Turner, is a transition between such stable, culturally accredited states—for example, youth to adulthood, a transition that proceeds by way of a phase of structural "invisibility," when the initiate is beyond or outside of classification, but which culminates in his or her reintegration into a new, socially recognized status. Such a transition, Turner notes, may result either in the reproduction of existing structures or, on occasion, in the emergence of new ones. Of the phase of liminality itself, he writes, "Liminality may perhaps be regarded as the Nay to all positive structural assertions, but as in some sense the source of them all, and, more than that, as a realm of pure possibility whence novel configurations of ideas and relations may arise."[17]

At the same time, Turner's descriptions of liminal states suggest that they include—and are widely understood by participants to include—an irreducibly material component. He notes that that condition of neophytes during rites of initiation is frequently understood in terms of death or physical dissolution. What appears to be at stake, however, is not merely a symbolic identification with death but rather a bodily mimesis

of death. Neophytes may be forced to lie motionless for extended periods in a posture associated with burial; they may be forbidden from washing, painted black, or smeared with earth; they may be required to live in the company of masked and monstrous figures representing the dead or the undead. What these ordeals accomplish, for Turner, is a rendering down of the neophyte into an amorphous, undifferentiated stuff—as he puts it, "Particular form becomes general matter," out of which new identities, and indeed new realities, can be fashioned.[18] As such, liminal states afford one instance of what Turner calls "communitas"—a homogeneous, undifferentiated collective belonging, grounded in physical contiguity and thus distinct from Durkheimian "solidarity" ("the force of which depends upon an in group/out group contrast") and from the ordered differentiations of status, role, and hierarchy.[19] In addition to liminal states, communitas is associated with figures on the margins of society—beggars, outcasts, countercultures, millenarian movements—and with those in positions of subordination or weakness in relation to established status hierarchies, such as matrilineal kin in patrilineal societies, from whose ranks were drawn, for example, the leopard-skin priests (*kuaar twac*) whom Evans-Pritchard identified as significant wielders of sacred power (though not of political authority) in Nuer society.[20] Turner suggests that such "edgemen" (liminal, marginal, or structurally subordinate figures), to the extent that they are divested of the trappings of status incumbency and role-playing, give expression to what Bergson called "the *élan vital* or evolutionary 'life force.'"[21] Rearticulations of the social and the symbolic, in other words, appear to issue from a conspicuously embodied vital energy, often figured in terms evocative of its extension beyond the human realm. Turner notes that the Nuer leopard-skin priest (also referred to as *kuaar muun*, "priest of the earth") was understood to derive his sacramental authority, including his capacity to bestow curses that caused crops to wither, from what Evans-Pritchard refers to as his "mystical relationship" to the earth—a relationship that Evans-Pritchard often describes as much in terms of physical participation as of symbolic association.[22]

It seems that when Turner talks about liminality, or more broadly about the communitas of which it is one manifestation, a certain earthly or bodied materiality keeps asserting itself, with an insistence that resists

easy reduction to a logic of symbolization but is suggestive rather of the material commonality of sign and substance evoked so powerfully by Lucretius' flowing, cascading word atoms. With the suspension of everyday distinctions of role and status, we find ourselves in the presence not only of classificatory indeterminacy but also of a *materia prima* out of which both new symbolic classifications and transformed physical bodies appear to be generated. We are thus obliged to confront the possibility that the liminal, understood as a material process as well as one productive of new symbolic configurations, might be prior to the various differentiations it helps to organize ("the Nay to all positive structural assertions, but . . . in some sense the source of them all"). The latter suggestion is, however, one that Turner appears to back away from in many of his substantive descriptions of rites of passage, where appeals to social context, meaning, and functionality are given renewed precedence. Take, for instance, Turner's discussion of the masks, costumes, and figurines that are a feature of the liminal phase of many initiation rites. Turner notes that such objects are often characterized by grotesque distortions or exaggerations—disproportionate limbs, an implausibly enlarged phallus or breasts—or else by the juxtaposition of human and animal features. Turner rejects the view that the hybridization of human and animal characteristics that is a feature of many initiation masks (including those of the Ndembu of Zambia, who form the subject of his own ethnographic research) are indicative of the fact that their makers regard such categories as porous or interchangeable. Instead, he argues that their function is a pedagogical one, aimed at teaching neophytes the importance of certain fundamental classificatory distinctions. This is achieved by abstracting what Turner calls the factors of culture—certain key themes or motifs pertaining to the organization of society, the cosmos, and the powers animating it—and thus forcing neophytes to reflect on them and relate them to the new status they themselves will assume on their return to society. Turner writes, "Put a human head on a lion's body and you think about the human head in the abstract." The juxtaposition of human head and lion's body might, he suggests, lead the observer to think about the head as the emblem of chieftainship, or as representing the claims of the soul against those of the body. Alternatively, it might prompt reflection on lions, their habits and properties, or their metaphorical significances, or on the relationship between lions and humans.[23]

If passages like the above are apt to disappoint, it is surely because Turner appears at such moments to lack the conviction of his own boldest insights. No doubt part of the problem concerns the analytic decomposition of that which has previously been characterized in terms of the undoing of categorical distinctions. To isolate and explicate features of the liminal phase seems to entail falling back on society as an assumed structure of positions and source of explanations. The transformative power of liminality dissipates in favor of the pedagogical reiteration of the same—the promulgation of social meanings that are already formed and instituted outside the ritual context. Moreover, the cultural factors imparted to neophytes appear all too easily abstractable from the material media through which they are conveyed. Yet Turner suggests elsewhere that liminality is capable not least of effacing the distinctions between meaning and materiality that academic writing so often seeks to maintain—indeed, many of his own descriptions of liminal states, like Favret-Saada's accounts of the language of witchcraft, are evocative of just that. If rites of passage can be understood—in the terms of a more recent parlance—as material-semiotic phenomena, then the conjunction of attributes thus evoked is not merely additive but generative, such that material flows are able to exert transformative pressure on the existing repertoire of symbolic forms.

What about the man-lion itself? Does the mask or costume not amount also to a physical reshaping of reality, endowed with its own material density and specificity, and consequently its own capacity to generate perhaps unpredictable affects? In Turner's description, it is precisely the obtrusive materiality of the juxtaposition that is apt to disappear from view, to be replaced by an analysis of its possible social significances. In other words, it is society that is prioritized as an explanatory framework, as we are led away from the elusiveness of the liminal itself and back to the (allegedly) more stable and knowable terrain of social relationships and cultural significations. At such moments, it becomes hard to distinguish between Turner's approach and that of Douglas, for whom the condition of betweenness is to be understood, quite explicitly, with reference to what is assumed to be an already extant grid of socially instituted symbolic categories. But remember Lazaro Mmala, rising from the audience to inform a startled Harry West: "The lions that you talk about . . . they aren't symbols—they're real."[24]

The ambivalence that often marks Turner's account is indicative, I would suggest, of a long-standing disinclination on anthropology's part to approach the between on its own terms rather than by way of what is assumed to lie on either side of it. In the words of Brian Massumi, what seems to be at issue here is the possibility of conceiving of "the being of the middle" rather than simply a "middling being."[25] Indeed, to inquire into the between in itself, on its own terms, would necessarily be to confront the impossibility of grasping or representing it through recourse to a notionally preestablished social context. Could it not rather be argued that it is the between that simultaneously grounds and exceeds the explanatory logic of classification and social relationality, not least through its dissolving of familiar distinctions between the natural and the social, the human and the other than human? What kind of anthropology would it be that attempted not to appropriate and master this "being of the middle" as a packaged and labeled object of academic scrutiny, but rather to acknowledge it as an elusive and wayward—but nonetheless constitutive—presence within its own discourse? A fabulatory anthropology perhaps?

Vincent Crapanzano has criticized Turner for flattening the liminal by reducing it to a binary and sequential logic of before and after, structure and antistructure. Crapanzano's own interest in the between takes the form of an exploration, itself organized as a self-conscious montage, of what he terms "imaginative horizons"—moments of transition or transformation that resist articulation through familiar categories. Of such moments, he writes, "They unwittingly call attention to the artifice of our social and cultural understanding by exposing those intractable moments which step out of—and risk destroying—that understanding and its demand for cohesion and continuity."[26] While I share Crapanzano's concern with the ineffability of the between as it resists sociological or historical explanation (and recognize a strong affinity between his efforts to reconceptualize liminality and my own), I am struck too by the fact that that the between can be understood not only as a void or absence but also as a superabundant plenitude, overflowing our received explanatory categories, like the molten rock welling up from the earth's core at Thingvellir. Or perhaps it is the simultaneous plausibility of these seemingly antithetical characterizations that is a distinguishing feature of the between.

Time for a change of scene.

On the Beach

I began (in the middle) with the image of a fracture line on the earth's surface, where molten rock wells up and solidifies to form and re-form the features of the present-day physical landscape. Let me turn now to another threshold between states of matter: the beach or shoreline as a fluctuating space of separation and interchange between the dry land most of us call home and the sea covering some seven tenths of the globe.[27] The beach I have in mind is in the Orkney Islands, lying directly north of Scotland, and once a familiar port of call for Norse settlers making their way across the North Atlantic to Iceland:[28]

> And there, on the sand, glimmering, were men and women—strangers—
> dancing! And the rocks were strewn with seal skins![29]

Who are the strangers dancing on the beach? And why are the rocks strewn with sealskins? The folklore of Scotland's northern and western islands abounds in stories of selkies, or seal people, beings who dwell in the sea in the form of fur-clad marine mammals, but who, at intervals, come ashore, casting off their sealskins to assume human form and dance naked on the shore.[30] The quotation given above is from a widely recorded selkie story as retold by poet and novelist George Mackay Brown (1921–96), perhaps Orkney's best-known twentieth-century writer. A young man sits daydreaming among the dunes on the beach at twilight (another transitional moment) when the seal people appear, circling and interweaving on the sand to the accompaniment of music only they can hear. His gaze is caught by a seal girl who sits apart from the dance on the adjacent rocks. He finds her skin and hides it, forcing her to retain her human form and to return home with him and become his wife. She lives with him in his croft for several years and bears him children. Although she adapts to life on land, she continues to prefer food from the sea—herring, crab, haddock, and skate, as well as the whelks and mussels from rock pools. She learns human language, but her speech carries the traces of her former home—"something of the music of breakers in a cave mouth, or far-off horizon bell-notes, or dolphins in the flood tide."[31] When not occupied with her children or the running of the croft, she spends much of her time at the water's edge, gazing westward. Then, one day, when her husband and children are away at the annual Lammas Fair

(August 1), she finds her skin, puts it on, and resumes her former life in the sea.[32] Her husband returns from the fair to find the skin gone from its hiding place. He runs to the sea in time to catch sight of the dark shadows of seals drifting out into the open ocean. One of them calls to him, "a strange terrible cry, of love and loss, joy and longing," before disappearing beneath the waves.[33] In other versions of the story, the seal woman returns at intervals to observe her children but is careful henceforward always to keep a safe distance from the shore.

Like many accounts of animal–human metamorphosis, stories of selkies appear to play havoc not merely with classificatory distinctions between humans and animals but also, more profoundly, with some of the most cherished of our modern, Western, landlubberly ontological orientations—inner and outer, surface and depth, appearance and reality. Are the seal people seals, or people, or both, or neither? Their skins can be removed, suggesting that their underlying, human form is their true one, yet it is to their seal forms that they invariably return—unless, of course, they are thwarted by the theft of their skins. So does their authentic being reside in the skin itself? Why, then, the impetus to discard it temporarily to participate in these crepuscular dances on the sand?

Like the interstitial meddling of the trickster, I like to think of the selkies, their transformations and their shoreline dances, as playing with liminality for its own sake, dancing its possibilities, delighting in the

FIGURE 15. Selkies? North Ronaldsay, Orkney. Photograph by author.

Liminality 113

capacity to move freely between sea and land, between seal and human form. The seal people are creatures of the between. It is in the doubly liminal setting of the beach at twilight that their interstitial being is able to reveal itself most fully. Their seemingly gratuitous shoreline revels have less to do with symbolization, classificatory ambiguity, or social structure, than with a manifest delight in the plasticity and creativity of the material substance of the world. What is at stake here is not metaphor but an affirmation of metamorphosis as a material power and a quintessentially liminal phenomenon, the dynamics of which are irreducible to explanation in terms of context or functionality. If Turner's descriptions of what he terms the "fruitful darkness" of liminal states often express some intimation of this, how much more evocative is the dance of the seal people, accompanied by its secret music, with the sea breaking on the sand and rocks as day fades imperceptibly into night.[34]

The seal people's predilection for showing themselves at twilight serves as a reminder that while liminality has often been figured in spatial terms, it is also possessed of an inescapably temporal dimension. Just as the beach on which the seal people dance is a fluctuating boundary between dry land and water, solid and liquid, so twilight is a zone of transition, neither day nor night, neither fully light nor fully dark. Like the liminal phase of the initiation rites described by Turner, such moments mark the suspension of the everyday temporal order, the habituated linear succession of pasts, presents, and futures, permitting the dissolution of familiar forms and the emergence of interstitial, metamorphic beings. Among the latter are to be counted not least the dead, whose presence in Orkney's coastal waters is attested by the material evidence of countless shipwrecks and by an extensive repertoire of folktales evoking spirits of the drowned, ghost ships, and enchanted underwater realms.[35] Indeed, are not the dead, like the shape-shifting selkies and the masked figures who preside over the initiation of Ndembu youths, themselves quintessentially denizens of the between?

ten

The Dead Have
Never Been Modern

"But what do we really know of the dead? / And who actually cares?" asks
Nick Cave in his song "Dig, Lazarus, Dig" (2008), which reimagines the
biblical Lazarus as an outcast turned junkie, unwillingly restored to life
and wandering the streets of present-day San Francisco and New York.
What do we know of the dead? One answer to the question posed by
Cave's song (and suggested by the fate of its protagonist) is that we know
a lot less than we once did. Such, at least, has been the claim of some still
influential versions of the story of modernity. From Schiller's, and later
Weber's, "disenchantment of the world" to Baudrillard's more recent "ex-
tradition of the dead," the process of becoming modern, assumed to be
concomitant with, among other things, industrialization, urbanization,
the colonial expansion of Europe, and the global diffusion of capitalism,
has been repeatedly understood in terms of a severed or attenuated rela-
tionship between the living and the dead.[1] If the self-described modern
period, with is social upheavals, its armed conflicts, its military technol-
ogies, and its mass media, has produced not only death but also the spec-
tacle of death on an unprecedented scale, this has been accompanied,
so the argument goes, by a corresponding diminution in the social pres-
ence accorded to the dead. Take, for example, eminent French historian
Philippe Ariès, who, in his magisterial history of Western attitudes to
death, contrasts what he calls the "tame death" of the early Middle Ages,
when death was viewed as a culmination and thus an accepted part of life,
with the "invisible death" of modernity, which is characteristically enacted
in the confined and sequestered spaces of hospital wards, hospices, and

The Dead Have Never Been Modern 115

mortuaries, a development that he sees as indicative of modern Europeans' increasing unwillingness to extend any sort of collective recognition to death.[2]

Ariès's account also suggests, however, a contrasting vision of a bygone and very different world in which death was a familiar presence, a premodern, medieval world of artisan production and slow-paced oral narration, a world like that of Walter Benjamin's storyteller, perhaps, who has "borrowed his authority from death" and whose words reach back not only into the human past but into "natural history," the eons-long processes of rock and mineral formation that precede and underlie humanly wrought narrative art.[3] Or, delving further back into the genealogy of what would become the West, take the circuitous return voyage of Odysseus, as recounted by the artist subsequently known as Homer. Odysseus has been identified by later commentators like Marcel Detienne and Jean-Pierre Vernant as the epitome of "cunning intelligence" (*metis*) in ancient Greek culture, or, more expansively by Horkheimer and Adorno as the prototypical figure of Enlightenment rationality's striving toward the instrumental domination of a passive and disenchanted nature.[4] Nonetheless, having incurred the anger of Poseidon, god of the sea and earthquakes, his homeward trajectory is repeatedly deflected by elemental forces until he finally arrives back on the shores of Ithaca twenty years after having left them. In Horkheimer and Adorno's reading, Odysseus's wanderings across the ancient Aegean take the form of a series of encounters with adversaries embodying an archaic world of "mythic nature," indifferent or hostile to human purposes, a world older than both the combatants of the Trojan war and the Olympian gods (latecomers, like their Norse counterparts), who feature in the *Odyssey* and its companion poem, the *Iliad*, as partisan and sometimes interventionist spectators of the conflict. This archaic world is represented by figures like the Cyclops, a race of cave-dwelling, one-eyed giants, who subsist without agriculture, laws, or political institutions; by the enchantress, Circe, whose magic tames wild beasts and transforms Odysseus' followers into swine; and by the Sirens, bird women whose seductive song entices passing sailors to disaster on their rocky shores. Odysseus succeeds in defeating each of these adversaries in turn, blinding the Cyclops Polyphemus with his spear, resisting the theriomorphic enchantments of Circe, and stopping the ears of his crew against the Sirens' song, while he himself listens,

116 *The Dead Have Never Been Modern*

bound to the mast of his ship.[5] Yet even the retroactively designated hero of Enlightenment is not able to dispense definitively with the dead. Indeed, he is obliged at one point to actively summon their presence in order to ascertain his direction home. Leaving Circe's isle, Odysseus, on her advice, turns his course toward the realm of Hades, the ruler of the dead, in order to consult the blind prophet, Tiresias, about the remainder of his journey home. Odysseus's detour in pursuit of the deceased sage takes him to the furthest shore of the ocean circling the known world to the land of the Cimmerians, "covered with mist and cloud," a land of perpetual night, where the sun never rises. Beaching their ship, he and his crew proceed on foot to the entrance to Hades's kingdom, marked by a rock, beside which the river Styx flows down to the underworld. Here Odysseus sacrifices two sheep over a trench that he has dug:

> When with my prayers and invocations I had called on the peoples of the dead, I seized their victims and cut their throats over the trench. The dark blood flowed, and the souls of the dead and gone came flocking upwards from Erebus—brides and unmarried youths, old men who had suffered much, tender girls with the heart's distress still keen, troops of warriors with brazen pointed spears, men slain in battle with blood stained armour still upon them. With unearthly cries from every quarter, they came crowding about the trench until pale terror began to master me.[6]

The dead first appear as a mass, crowding about the trench, hoping to drink the blood that will temporarily restore them to speech and sentience. Only gradually is Odysseus able to distinguish particular individuals, including his former companion, Elpenor, killed in a drunken fall from a rooftop on Circe's island; his own mother, Anticleia; and finally Tiresias himself. Holding his sword extended, Odysseus keeps the other shades at bay until Tiresias has drunk of the blood and spoken.

Homer's account of Odysseus has inspired not only philosophers but also a succession of now canonical literary figures, including Dante, Tennyson, and James Joyce. In Joyce's *Ulysses* (1922), the episodic structure of Homer's epic is transposed into an account of a single day and night (June 16, 1904) in the author's native Dublin as a Jewish advertising agent, Leopold Bloom, and an impecunious student, Stephen Dedalus,

become the counterparts of the wandering Greek hero and his estranged son, Telemachus.[7] It is surely significant that the Ireland about which Joyce wrote from the vantage point of self-imposed continental European exile has often been viewed as an exception to the widespread social scientific characterization of modernity as marked by the attenuation of the social presence of the dead. In contrast to this widely assumed world-historical trajectory, Ireland has often been identified, at least by outside observers, with an excessive or anachronistic attachment to death. English Elizabethan poet-colonist Edmund Spenser, writing in 1596, complained that the Irish were given to engaging in excessive lamentations for their dead—"ymoderate wailings"—that he took as indicative of both a lack of civility and a residual paganism.[8] Four centuries later, a controversial study by Nina Witoszek and Pat Sheeran would criticize the "funereal culture" of Irish literature, past and present, for its alleged morbid fixation on the past and corresponding unwillingness to engage the present and future.[9] It is tempting, but too easy, I think, to dismiss such characterizations as tropes of colonial discourse, lingering, in the latter case, into the postcolonial present. Instead, in the second decade of the twenty-first century, as the suspicion dawns (or perhaps it dawned long ago?) that none of us has, in Latour's words, ever been truly modern, the predilection for death so frequently attributed to the Irish may present the opportunity to pose a different set of questions.[10] Rather than simply reclaiming death as a presence within the history of Ireland and of modernity (a move that, at the very least, runs the risk of stating the glaringly obvious), it might allow us to consider the dead and the powers they mobilize as an indispensable and constitutive component not only of cultural memory (whether this takes the form of academic scholarship or of artistic and literary imagining) but also of the very texture of our, or indeed any, being in the world. As such, the dead can never be truly left behind even if "we" as a society, or as even a species, decline to acknowledge their presence. Perhaps, as C. Nadia Seremetakis has suggested with reference to Inner Mani in the southern Peloponnese, the seeming tenacity of death practices in modernity's self-designated peripheries can serve to contest not only the assumed temporality of historical progress but also the very possibility of explaining death in social scientific terms.[11] Joyce is in this regard an exemplary figure, a product of one of what Michael Hechter has referred to as Europe's "internal

118 *The Dead Have Never Been Modern*

colonies," and a writer whose work is at once unimpeachably modern in its subject matter and its pursuit of formal and linguistic experimentation, yet suffused nonetheless by the presence of the dead.[12]

THE DEAD IN "THE DEAD"

Let me turn now from *Ulysses* to an earlier work by Joyce in which the dead are no less conspicuous a presence, the short story "The Dead," written in Trieste in 1907 and first published in 1914 as the concluding story in the volume *Dubliners*.[13]

Dublin, early January, some time around the beginning of the twentieth century. Irish nationalist leader Charles Stewart Parnell has been dead since 1891, and the events of the Easter Rising of 1916 and the independence struggle that followed lie more than a decade in the future. The scene is the upper floor of a house at Usher's Island, part of the quays running along the south bank of the River Liffey. The occasion is the annual dance hosted by the Misses Morkan—two elderly spinsters, Aunt Kate and Aunt Julia, and their niece, Mary Jane. Outside, snow is falling, covering the city and, as we later learn, the whole of Ireland, the heaviest snowfall in thirty years, according to the newspapers. As the snow falls, the focus of attention indoors is on the Misses Morkans' nephew, Gabriel Conroy, a "stout, tallish," bespectacled young man, by profession a teacher of languages and a graduate of what was then the Royal University (now the National University of Ireland). At the opening of the story, Gabriel arrives, somewhat belatedly, in company with his wife, Gretta, who is, we are soon to learn, a native of Galway, on Ireland's west coast. They have left their two children at home in the middle-class suburb of Monkstown in the care of a servant and are planning to spend the night at the Gresham Hotel in the city center. The evening is to prove a fateful one for Gabriel. Things get off to a bad start when a casual inquiry about the servant Lily's matrimonial prospects draws the bitter retort: "The men that is now is only all palaver and what they can get out of you!"[14] Disconcerted, he begins to worry that his after-dinner speech will likewise prove a failure, and that an allusion to the poetry of Robert Browning that he plans to include will fly above the heads of his listeners. There follows another uncomfortable altercation, this time with his colleague and university contemporary, Molly Ivors, who chides him for writing a literary column for the Unionist newspaper, the *Daily Express*, and for

The Dead Have Never Been Modern 119

declining to join a planned excursion to the Irish-speaking Aran Islands, preferring instead a cycling tour of continental Europe. Her cultural nationalist rebuke that he knows nothing of his own land and people prompts his own outburst: "I'm sick of my own country, sick of it!" resulting in Miss Ivors's premature exit from the gathering.[15] It is after the party, however, when he and Gretta are alone in their room at the Gresham, that Gabriel is confronted by the night's most disconcerting revelation—a revelation about his wife's Galway past that propels the story toward its celebrated ending. In an outburst of tears, Gretta tells him that a song, "The Lass of Aughrim," sung earlier in the night by one of the other guests, has reminded her of a young man whom she knew and loved as a teenager. The young man in question, Michael Furey, was an employee of the local gasworks. In response to her husband's initially jealous questioning, she reveals that Michael Furey has been dead for many years, a victim of tuberculosis, which at the time claimed as many as 10,000 lives annually in Ireland. But as she puts it, "I think he died for me." It was, she relates, the beginning of winter, and she was about to leave her grandmother's house in Galway to attend a convent school in Dublin. Michael Furey was ill in his lodgings and was forbidden to receive visitors, "so I wrote him a letter saying I was going up to Dublin and would be back in summer, and hoping he would be better then." The night before she left, she was in her room, packing up her belongings, when she heard gravel thrown against the window. Unable to see out on account of the rain, she ran downstairs and found Michael Furey shivering under a tree in the garden. She begged him to go home, but he declared that he no longer wanted to live. Finally she convinced him to return to his lodgings. Then, a week after arriving at the convent in Dublin, she learned that he had died and was buried at Oughterard, his family home, a small town seventeen miles northwest of Galway: "O, the day I heard that, that he was dead!"[16]

As the story ends, Gretta has cried herself to sleep. Gabriel, still awake, lies beside her on the bed, reflecting on his marriage and contrasting his own relationship with his wife with the death-defying passion of Michael Furey. Outside, the city—and indeed all of Ireland—lie blanketed by snow. What follows is one of the most widely discussed passages in modern Irish literature and decisively transfigures the naturalistic surface both of the story itself and of the collection as a whole:

Generous tears filled Gabriel's eyes. He had never felt that himself towards any woman, but he knew that such a feeling must be love. The tears gathered more thickly in his eyes and in the partial darkness he imagined he saw the form of a young man under a dripping tree. Other forms were near. His soul had approached that region where dwell the vast hosts of the dead. He was conscious of, but could not apprehend, their wayward and flickering existence. His own identity was fading out into a grey impalpable world: the solid world itself, which these dead had one time reared and lived in, was dissolving and dwindling.

A few light taps upon the pane made him turn to the window. It had begun to snow again. He watched sleepily the flakes, silver and dark, falling obliquely against the lamplight. The time had come for him to set out on his journey westwards. Yes, the newspapers were right: snow was general all over Ireland. It was falling on every part of the dark central plain, on the treeless hills, falling softly upon the Bog of Allen and, further westwards, softly falling into the dark mutinous Shannon waves. It was falling too, upon every part if the lonely churchyard on the hill where Michael Furey lay buried. It lay thickly drifted on the crooked crosses and headstones, on the spears of the little gate, on the barren thorns. His soul swooned slowly as he heard the snow falling faintly through the universe and faintly falling, like the descent of their last end, upon all the living and the dead.[17]

The two paragraphs in question have been the subject of extensive critical commentary, much of it concerned with Gabriel's seeming revaluation of his relationship to the west of Ireland from which his wife hails, and which he has so pointedly repudiated earlier in the story. I draw attention here, however, to two less frequently remarked features of the passage quoted. First, I want to note that the dead make their appearance in the guise of a crowd or multiplicity—"the vast hosts of the dead"—and that the named and individuated figure of Michael Furey emerges from and is finally reabsorbed by this undifferentiated mass, just as the figures of Odysseus's mother, and later Tiresias, emerge from and recede into the multitudes of dead who flock about the sacrificial blood in book 11 of Homer's *Odyssey*. Second, I want to mark the seasonality of this concluding manifestation of the dead, the fact that it takes place at the close of the Christmas season, in midwinter, as signaled by the ubiquitous and

The Dead Have Never Been Modern 121

much-discussed snow that falls alike on all the living and the dead, imparting to the scene at the same time a certain unassailable if elusive materiality that the dead themselves, in their "wayward and flickering existence," might otherwise seem to lack. Let us consider each of these aspects in more detail.

The Invisible Crowd

Elias Canetti, in his study *Crowds and Power*, suggests that what he calls the "invisible crowd" of the dead may be among the most ancient and the most universal of human imaginings:

> Over the whole earth, wherever there are men, is found the conception of the *invisible dead*. It is tempting to call it humanity's oldest conception. There is certainly no horde, no tribe, no people which does not have abundant ideas about its dead. Man has been obsessed by them; they have been of enormous importance for him; the action of the dead upon the living has been an essential part of life itself.[18]

Of these invisible dead, he writes, "generally it was assumed there were a great number of them," and he proceeds to give, by way of illustration, an eclectic range of ethnographic examples: the Bechuana of South Africa, who "believed all space to be full of the spirits of their ancestors"; the Chuckchi shamans of northeastern Siberia, with their "legions of auxiliary spirits," called upon in effecting cures; the belief, shared by the Sami of Northern Europe and the Tlingit of Alaska, that the aurora borealis is composed of hosts of the dead; and the Gaelic term *sluagh*, used in the Scottish Highlands to refer to massed spirits of the dead who "fly about in great crowds like starlings." He further notes that the compound term *sluagh-ghairm*, used of the battle cry of these massed dead, is the origin of the modern English word "slogan," so that, as Canetti notes (with apparent satisfaction), "the expression we use for the battle cries of our modern crowds derives from the Highland hosts of the dead."[19]

Let me add two further examples to those given by Canetti. The first of these concerns the Afro-Cuban "inspiration" known as Palo or Palo Monte. Like the better-known and more extensively researched Santo or Santeria, Palo developed during the plantation era among slaves of African descent and comprises a complex set of concepts and practices

122 *The Dead Have Never Been Modern*

relating to sorcery, healing, divination, and communication with the dead. A key concept in Palo practice is the Ba-Kongo-derived term *Kalunga*, which is often used to refer to the dead as an undifferentiated and all-pervading substance, or what Todd Ramón Ochoa calls "the ambient dead." Ochoa writes that his own understanding of *Kalunga* (and his curiosity about the role of the dead in Palo more generally) derives in large measure from conversations with Isidra, a sixty-year-old woman and Palo practitioner living in an apartment building in the El Cerro district of Havana. For Isidra, as a professional healer, the dead were a constant, albeit unpredictable, presence. The term *Kalunga*, as she used it, appeared to capture something of this very ubiquity and unpredictability:

> Kalunga, as Isidra taught it through variegated reiteration, was the great, indifferent sea of the dead. At times she referred to Kalunga plainly as "el muerto," "the dead" or, more precisely, "the dead one." Kalunga is transposed from 19th century BaKongo language and cosmology, in which . . . it referred to the sea, in the depths of which reside the dead. As Isidra used it, Kalunga was not only haunted by the dead, but was also composed of the dead and simultaneously constitutive of them; the dead were immanent to it, in the same way a broth makes a soup. Kalunga, Isidra said, comprises all the dead that could possibly exist or have existed. It is ancient beyond memory, and within it the dead exceed plurality and become instead a dense and indistinguishable mass. According to Isidra, the world and experience, all things available to perception and perception itself, are a series of condensations within this fluid mass of the dead.[20]

In Isidra's rendering, Canetti's invisible crowd becomes something more akin to a universal primordial substance, like the primal matter to which, according to Turner, initiates in Ndembu rites of passage are understood to be reduced. *Kalunga* appears to designate a polymorphous stuff, capable of manifesting itself in a seemingly endless variety of forms (what Ochoa terms "versions" of the dead) and out of which not only material bodies but also thoughts and perceptions are fashioned. In other words, it is the dead who provide, among other things, the basic material of life.

The second example that I wish to add to Canetti's list is from a setting rather closer to that evoked in the final paragraphs of Joyce's story. It comes from *The Year in Ireland* (1972), a study of Irish calendar customs

by Irish broadcaster and folklorist Kevin Danaher. Danaher is describing customs associated with the Celtic festival of Samhain (spanning the night of October 31 to November 1) and its Christian counterpart, the Feast of All Souls (celebrated on November 2). He is concerned specifically with the belief that the spirits of dead relatives could come to the aid of living family members at this time. He recalls an incident from his own childhood in County Limerick, when he had asked one of his neighbors, an elderly man known as a gifted storyteller, why he was not afraid to go into an abandoned house in the district that was reputed to be haunted. This was the man's reply: "In dread, is it? What would I be in dread of, and the souls of my own dead as thick as bees around me?"[21]

The image of the souls of deceased relatives as a swarm of bees serves also to link the depiction of the dead as a crowd phenomenon to the second aspect of Joyce's story to which I wish to call attention—namely, its seasonal setting. As Danaher notes, apparitions of the dead were often associated in Ireland with specific dates and times of year. During the winter season, these included not only Samhain and All Souls but also the Twelve Days of Christmas, spanning the period from Christmas to

FIGURE 16. "The souls of my own dead as thick as bees around me." Photograph courtesy of Francis Chung; reproduced under a Creative Commons Attribution 2.0 Generic License.

124 *The Dead Have Never Been Modern*

Epiphany. Joyce's brother, Stanislaus, refers in a memoir to the setting of "The Dead" during the Christmas period, noting that in England and Ireland, ghost stories were often told about the fire at this time of year and suggesting that "The Dead" itself can be understood as a ghost story of sorts.[22]

FROM ANOTHER WORLD

Out of the winter darkness they come: human-shaped torsos with the heads of bulls, stags, horses, goats, and birds with large clapping beaks pulled by string. They pour forth like the souls from Hades enticed by Odysseus's sacrifice of the sheep, or like the hosts of the dead whose presence Gabriel intuits as he watches the snow from his hotel window. In addition to ghostly apparitions, the Twelve Days of Christmas were widely associated—across Europe as well as among populations of European descent in the Americas and elsewhere—with performances and dances involving a variety of animal masks and costumes.[23] These include, to name but a few, the Capra (goat) and Cerbul (stag) (Romania); the Hobby Horse (England); the Krampus and Perchten (Austria); the Julebukk (Christmas goat) (Norway); the Kukeri or Survakari (Bulgaria); the Mari Lwyd (Wales); and the Zvončari (Croatia).[24] In the words of English folklorist Violet Alford, who compiled a comprehensive inventory of such animal masking practices, the dancers seemed to make their appearance "as from another world."[25] In some cases, the masked dancers were explicitly identified as spirits of the dead, who were permitted to return and mingle with the living during the suspension of the normal spatiotemporal order.[26] Other observers saw in these seasonal masquerades survivals of paganism, among them the early Church fathers, whose writings abound in condemnations of such practices on the part of their newly and imperfectly Christianized congregations. Saint Augustine, for example, wrote, "If you ever hear of anyone carrying on that most filthy practice of dressing up like a horse or a stag, punish him most severely." At least one leader of the early Church, Bishop Timothy of Ephesus, earned the crown of martyrdom in the first century of the Christian era for attempting to intervene to stop such masked revels.[27]

In addition to masked performers, European folklore abounds in stories of fantastical, composite, and metamorphic beings whose appearances were similarly associated with the period between Christmas and

FIGURE 17. Kukeri (masked and costumed figures appearing around New Year and before Lent), Razlog, southwestern Bulgaria. Photograph courtesy of Ivaneskoto; reproduced as part of the public domain.

Epiphany. In Orkney, Shetland, and much of Scandinavia, it has been said that "trows," or trolls, are especially prone to leave their underground habitations and wander abroad during the Christmas season.[28] Moving south and east, across the Balkan peninsula, in Romania, the activities of vampires (*strigoi*) and werewolves have been particularly linked to the period between Christmas and New Year.[29] In the folklore of Greece and Macedonia, beings known as Callicantzari (singular Callicantzaros) or Karkantzari (Macedonia) were often depicted as emerging from the underworld to wreak havoc during the Twelve Days.[30] According to Cambridge classicist John Cuthbert Lawson, who conducted field research on Greek popular customs between 1898 and 1900, Callicantzari were "the most monstrous of all the creatures of the popular imagination." There were, he found, "extraordinary divergences and even contradictions" between descriptions of Callicantzari from different localities, prompting him to wonder whether such variability might not in fact be one of their defining features.[31] He discovered, however, that Callicantzari were

126 *The Dead Have Never Been Modern*

generally believed to be of two kinds: a smaller one considered to be "frolicsome and harmless," and a larger, malevolent, and often deadly one given to breaking into houses, stealing food, and on occasion abducting and raping women. Nonetheless, details of their physiognomy were hard to pin down. Here is Lawson's description of the larger kind:

> [They] vary from the size of a man to that of a gigantic monster whose loins are on a level with the chimney pots. They are usually black in color, and covered with a coat of shaggy hair, but a bald variety is also sometimes mentioned. Their heads and also their sexual organs are out of all proportion to the rest of their bodies. Their faces are black; their eyes glare red; they have the ears of goats or asses; from their huge mouths blood red tongues roll out, flanked by ferocious tusks. Their bodies are in general very lean, so that in some districts the term Callicantzaros is applied metaphorically to a very lean man; but a shorter and thickset variety also occurs. They have the arms and hands of monkeys, and their tails are as long again as their fingers and curved like the talons of a vulture. They are sometimes furnished with long thin tails. They have the legs of a goat or an ass, or sometimes one human leg and one of bestial form; or again both legs are of human shape, but the foot so distorted that the toes come where the heel should be. Hence it is not surprising they are often lame, but even so they are swift of foot and terrible in strength.[32]

Consider the list of attributes: black and hairy; bald; lean; thickset; vulture's talons; the legs of a goat, ass, or human, or one human and one animal leg; lame; swift of foot. As described by Lawson, the Callicantzari seem not so much a combination of specific human and animal characteristics as a riotous affront to the very notion of species identity, not so much formless as over-endowed with a superabundance of possible forms. Indeed, Lawson adds that the Callicantzari were believed at one time to have possessed "unlimited" powers of metamorphosis and to have been capable either of adopting a fully human form or of transforming themselves into any animal shape of their choosing.

Unlimited powers of metamorphosis—the capacity to assume any form of one's choosing. Does that remind you of anyone?

eleven

The God Who Comes

The ancient Greek city of Thebes, on the southern edge of the Boeotian plain, date unspecified but sometime before the fifth century BCE. A stranger has arrived in town—or is it several strangers? Or perhaps all the strangers? Dionysus, aka Bacchus, aka the Stranger God, aka the God Who Comes, and whose coming throws the city into a state of mass delirium. The women of Thebes, adopting the guise of maenads, ecstatic followers of the god, abandon their homes and take to the forests that cover the slopes of nearby Mount Cithaeron. They wrap themselves in the skins of fawns, suckle wolf cubs at their breasts, entwine live snakes in their hair, and rush upon herds of cattle and goats, tearing them limb from limb and devouring them raw. They dance wildly and chant for the god to appear. At the same time, the surrounding landscape of mountain and forest is transfigured by the coming of Dionysus. Streams of milk and honey flow across the ground. Fountains of wine break forth from the bare rocks.

But Pentheus, the ruler of Thebes, wants none of it. He denounces the newly arrived god as a fake, an upstart who dares to challenge his royal authority. He orders his soldiers to round up those who have abandoned themselves to the rites of the stranger god. He arrests and attempts to imprison one of Dionysus's followers, who turns out to be none other than the god himself, who has temporarily adopted human form to bring about the ruin of his royal adversary. The bolts of the cell door fly open and the prisoner walks free. A sudden earthquake reduces the king's palace to rubble. Enraged, Pentheus himself takes to the slopes of

the mountain, and it is there that he meets his fate. Dionysus brings Pentheus to the attention of his women followers, led by Pentheus's own mother, Agave, who descend on him, oblivious to his cries for mercy, tearing off first his limbs and finally his head.[1]

The story of Dionysus and Pentheus has gone through numerous retellings, perhaps most famously by Greek dramatist Euripides and Roman poet Ovid. Euripides's play, *The Bacchae*, on which this summary of events is based, was first performed posthumously at the Theater of Dionysus Eleuthereus on the southern slope of the Acropolis in Athens in 406 BCE. Dionysus himself appears in the story as simultaneously individuated in the assumed persona of one of his own devotees and as diffused throughout the scene. Literary scholar Robert Pogue Harrison writes of the episode, "At the moment of his revelation Dionysos is everything and everywhere. He is the ancient primordial matter behind the phenomena of the world."[2] Everything and everywhere: the ubiquitous stranger? Some later commentators have suggested that Dionysus is a quite literal stranger, a divinity whose cult has its origins not in Greece but in Asia Minor.[3] At the opening of Euripides' play, Dionysus himself, arriving in Thebes, announces that he has come from the east, across

FIGURE 18. Drunken Dionysus transported on a chariot pulled by a centaur, followed by a bacchante and a satyr. Mosaic from third century CE, El Jem Museum, Tunisia. Photograph by Dennis Jarvis.

Asia and through Arabia, amassing en route a retinue of followers clad in deerskins and brandishing drums and tambourines. In fact, as he himself goes on to point out, the stranger god is anything but a stranger to Thebes. Thebes was home to his mother, Semele, daughter of Cadmus, the city's founder and Pentheus's predecessor. Seduced and impregnated by Zeus, she was consumed by one of his lightning bolts when his jealous spouse, Hera, persuaded her to insist that her lover show himself to her in his full glory. Zeus rescued the child and carried him to term in his own thigh, from which he was subsequently born, a decidedly queer birth usurping the maternal connection to a particular, earthly place— the birth of a stranger, one might say. Indeed, it is the guise of such a (mortal) stranger that the god adopts in returning to what would otherwise have been his natal city to punish its new ruler for denying his divinity. Despite his parentage, Dionysus is an anomalous figure among the more decorously anthropomorphic company of Olympian gods—not only a latecomer, born (in highly unorthodox fashion) of the union of a god and a mortal, but also a figure whose ecstatic transports contrast with the more modest shape-shifting episodes of his fellow Olympians, like the animal metamorphoses often resorted to by his father, Zeus, in his amorous pursuits of mortal women.

Rather than a particular stranger hailing from a particular place, Marcel Detienne suggests that Dionysus is a figure evocative of the "beyond," of an alterity that confronts and periodically usurps the everyday order of existence: "In the enclosed space of the city and beyond it, he calls up the haunting figure of the Other."[4] Certainly it is this aspect that has appealed most to many of Dionysus's modern interpreters, notably Nietzsche, for whom the god's manifestations were linked specifically to interstitial occasions when the transformative flux underlying the world's apparently stable forms was rendered momentarily visible and when a fugitive glimpse could be caught of "all nature's artistic power."[5] Nietzsche's later writings make clear that what is revealed on such occasions is not a Dionysian truth underlying the Apollonian appearance of form and order but rather the truth of appearances themselves—the truth that there is no truth beyond or behind the play of appearances, of the world's ceaseless becoming. As such, Dionysus has been identified with the primordial life force, flowing through all living things, that the Greeks termed

130 *The God Who Comes*

zoë and that Aristotle would distinguish from *bios* as a particular mode of life, such as that specific to humans as citizens of the *polis*.[6]

Dionysus has other associations too, of course: with the depths of the sea (in depictions of his festivals, his image often appears mounted on a ship drawn on wheels); with darkness and nighttime (he is sometimes referred to as the "nocturnal one" and is shown leading night dances by torchlight); and, most conspicuously perhaps, with wine and the grape harvest.[7] At the same time, as Lawson notes, Dionysus was a seasonal divinity, whose worship was concentrated in the winter months, a fact that leads him to propose the stranger god and his skin-clad retinue as possible antecedents of the later folkloric figures of the Callicantzari, who were permitted to show themselves above ground only during the Twelve Days, being confined during the remainder of the year to the underworld.[8] Chief among the festivals of Dionysus celebrated in ancient Athens was the Anthesteria, held over three days at the end of January. In addition to being a celebration of Dionysus, featuring the drinking of new wine and including a ritual "marriage" between the god and the wife of the city's chief magistrate (the *archon basileus*), the Anthesteria was a festival eliciting the participation of the entire community, in which distinctions of rank and status were suspended, as slaves drank with their masters and young men riding on wagons hurled insults at their elders.[9] Equally importantly, the Anthesteria was also a festival of souls, in which spirits of the dead returned en masse to mingle with the living. Their appearance was associated in particular with the festival's second day, known as Choes (cups or beakers), which was also the occasion for drinking competitions. These roaming dead carried with them the threat of pollution. According to Athenian lexicographer Photius, Choes was an "unclean day" when people chewed buckthorn and anointed their doors with pitch as a source of protection.[10] Yet for all its attendant perils, this same day appears to have occupied a central and perhaps unique place in the city's ritual calendar. According to historian of ancient Greek religion Robert Parker, "If one were to identify an Athenian festival day that had an emotional appeal . . . like that of modern western Christmas," it would be none other than Choes, the middle and "constantly mentioned" day of the Anthesteria festival.[11]

On the festival's third and final day, offerings in the form of a dish of grain and seeds were made to the spirits, who were still at large, and at

the close of the day, they were bidden to depart.[12] Scholars have disagreed as to whether these offerings to the dead form the more ancient component of the festival, onto which the celebration of Dionysus was subsequently grafted.[13] More telling, perhaps, however, as both Parker and German classical scholar Walter Burkert have argued, is the way in which these elements were combined, the return of the dead being thus explicitly associated with a divinity whose range of attributes characteristically included wine, theatricality, transformation, ecstatic celebration, and the temporary suspension of everyday norms and temporalities.[14] According to contemporary descriptions, the festival itself was celebrated both in people's homes and at the so-called temple of Dionysus "in the Marshes" (*Limnaion*). The exact location of this etymologically liminal setting has never been definitively established, although references in contemporary literary sources like Aristophanes's comic drama *The Frogs* (first performed in 405 BCE) suggest that it may have been associated with the entrance to the underworld, the abode of the dead.[15] Given that there are no marshes in the vicinity of Athens, Burkert suggests that the name of the temple was chosen precisely on the basis of its associations, not least with the fluctuating, disruptive intermittency that characterized the presence of the god himself: "Marshes and swamps—or, for the coastal inhabitant, the sea—are the places where things disappear and surface again miraculously. This is where victims are submerged. This is where stories appear of the god's return from the depths. This is the place where Dionysus reveals himself as god."[16]

twelve

Between the Times

One explanation for the complex of associations extending seemingly across Europe (and beyond) linking the midwinter season with the power of metamorphosis, the temporary suspension of the everyday order, and the return of the dead can be sought in the fact that, like the festival of All Souls, the Twelve Days of Christmas represented the overlay of a Christian on a pre-Christian sacred occasion, in this case the midwinter and winter solstice festivals once celebrated across much of Europe and Asia.[1] A more intriguing possibility, however, is suggested by James Frazer in *The Golden Bough* (1913). Here Frazer speculates that the Twelve Days, as well as the pre-Christian observances on which they were overlaid, originated long before Christianity as an intercalary period inserted into the regular calendar to bridge the discrepancy between the solar year and the cycle of lunar months. As such, he suggests, they were always regarded as existing outside the normal course of time, forming part of neither the lunar system nor the solar system. They thus represented "an excrescence, inevitable but unaccountable, which breaks the smooth surface of ordinary existence, an eddy which interrupts the even flow of months and years." The result, Frazer argues, was that intercalary days came to be viewed as periods of license, when ordinary rules of conduct did not apply and when customary authorities might be replaced temporarily by capricious mock rulers, like the lords of misrule or boy bishops who presided over the medieval and early modern European festivals of fools that were sometimes a feature of the Christmas season.[2]

Frazer's argument is carried further by German anthropologist Hans Peter Duerr, who insists that what he calls "times between the times," although largely unrecognized by the modern West, have been a feature of human societies in most times and places. In support of this claim, he cites a prodigious and eclectic range of examples, including the interworldly flights of Siberian shamans, the nocturnal voyagings of medieval and early modern European witches, native American peyote cults, and the Paleolithic cave sanctuaries of the last ice age, into which, it has sometimes been suggested, neophytes descended in order to undergo ritual death and rebirth from the womb of an earth goddess.[3] Of such occasions, Duerr writes:

> No matter how great the differences between these groups of people, they were all united by the common theme that "outside of time" they lost their normal, everyday aspect and became beings of the "other" reality, of the beyond, whether they turned into animals or hybrid creatures or whether they reversed their social roles. They might roam bodily through the land or only "in spirit," in ecstasy, with or without hallucinogenic drugs.
>
> "Between the times" indicated a crisis in the ordinary course of things. Normality was rescinded, or rather, order and chaos ceased to be opposites. In such times of crisis, when nature regenerated itself by dying first, humans "died" also, and as ghostly beings ranged over the land in order to contribute their share to the rebirth of nature.[4]

The lifting of the everyday temporal order grants access to a material and temporal flux of becoming underlying the seemingly solid realities of the familiar, commonsensical world. During such interludes, not only are the boundaries between past, present, and future rendered fluid and permeable but also the physical contours of the material universe likewise become unfixed and malleable—hence the association of such times both with the returning dead and with a variety of masked, costumed, metamorphic beings, and further with the power of metamorphosis itself. Where Frazer is principally concerned with human perceptions and representations of time, however, Duerr is prepared to consider these times between the times not as a "separate" reality (as Carlos Castaneda—another self-described voyager between worlds—once suggested) but as "another part of *the* reality."[5] The reality of between the times lies outside

134 *Between the Times*

or beyond everyday perception but has no less claim to be considered real. This is what Castaneda's interlocutor, Yaqui sorcerer Don Juan (a figure whose own reality—or fictionality—has been vigorously debated), refers to the *nagual* ("the part of us for which there is no description— no words, no names, no feelings, no knowledge"), in contrast to the "island of the *tonal*," or "civilization."[6] For Duerr, it is only those who have exited at least once from the *tonal*—for instance, by undergoing an initiatory trial—who are able to live subsequently within its bounds in full self-awareness, knowing that such bounds have never been anything but flimsy and provisional constructs:

> Only those people can become conscious of the "island of the *tonal*," of their own "mechanism," of their own culture, who become aware of the *nagual*. That is, their boundary. In order to become aware of their own limits, in order to become *conscious of themselves*, the initiates go where they can hear the "whispering" of the *nagual*, a whispering that is not of this world and yet is not outside this world either.[7]

According to Duerr, however, the reality of such an outside is one that the modern West has been increasingly unwilling to acknowledge. Experiences associated with psychoactive drugs or trance states induced by other means are no longer taken as indicative of a heightened sensitivity to otherwise imperceptible realities but are dismissed as illusions or distorted perceptions. Those who remain persuaded by them are classed as mentally ill. Any notion of a reality beyond the conventional bounds of knowledge and experience is explained as a projection of society or the individual psyche. In Duerr's words, "That which was outside slipped to the inside."[8]

A familiar story, one might say—one more variant of the disenchantment tale that theorists of modernization have been telling for more than a century. Certainly Duerr often seems all too prone to seek solace for the ills of the present in a romantic primitivism of the long ago and far away. Yet he remains adamant that the outside (or the between, which amounts to the same thing for him) is real—as real as Avva's leave-taking helper spirits in Kunuk's cinematic revisioning of Rasmussen's Arctic ethnography. According to Duerr, it is modern commentators who are deluded in their attempts to explain away the reality of the *nagual* in

terms of ideology or the unconscious. Duerr's account differs from both Frazer's and Turner's, first in its lesser willingness to subordinate consideration of between times to an analysis of the social contexts of their materialization, and second in its insistence on attempting to understand such episodes in terms of material processes of unmaking and remaking rather than simply as a suspension of symbolic classifications. Indeed, part of what is at stake for Duerr in such collective descents into the flux of becoming is, precisely, the very possibility of social knowledge and explanation. The reality of the between, he suggests, is at once the condition of our collective existence and that which must be repressed in order for us to convince ourselves that the world is indeed definitively knowable and explicable.

What Time Is It?

If we are to take Duerr at his word, then the repertoire of images and performances associated with between times cannot be considered simply as another way of representing time and thus, ultimately, as another human contrivance—a "projection," in the terms of the modernist vision Duerr wishes to contest. Instead, the other time, of which his numerous sources afford varied intimations, is for Duerr one that must be distinguished from any conception of time as measurable or quantifiable. Duerr's description evokes time as a force at once creative and destructive, a power both of differentiation and dedifferentiation, which simultaneously gives rise to and exceeds humanly contrived classificatory orderings of the world, including culturally calibrated systems of time reckoning. Duerr makes no mention of Bergson, but his account of times between the times is often uncannily redolent of Bergson's own lifelong effort to think the reality of time as such. Most of our efforts to represent time, Bergson suggests, signally fail to do this, substituting instead a range of concepts and categories derived from the analysis of space, resulting in notions of linearity and chronology, as well as attempts to locate events "in" time, as though in a spatial container. Not that such spatializations of time are simply an error; they are, Bergson suggests, the result of our perceptual and practical engagements in reality, through which we selectively carve out a knowable and thus seemingly manipulable world from the flux of becoming. This, according to Bergson, is the world that the sciences set out to quantify and explain. It is a world figured explicitly in spatial

136 *Between the Times*

terms, where time too is conceived on the basis of spatial categories, the passage of time being imagined as akin to a one-directional movement through space. Bergson claims, however, that such attempts to render time measurable inevitably fail to acknowledge the generativity of becoming as it implicates not only discretely conceived bodies in motion but also the entirety of the cosmos. Spatialized depictions of time, in other words, evoke a ready-made universe that humans can act on rather than a universe in the making.[9] Bergson proposes a radical alternative in the concept of duration (*durée*), referring to an indivisible, unquantifiable movement of becoming that links past, present, and future in a nondeterministic process that partakes simultaneously of change and continuity. This involves the still unsettling claim that the past, in its entirety, co-exists with the present. As such, the past is no less real than the present, albeit existing, or subsisting, not in the register of the actual but of the virtual. Our acts of memory, according to Bergson, involve detaching ourselves from the present and placing ourselves directly in the past— first in the past in general, then in a specific region of the past from which an image is drawn in accordance with the requirements of action in the present. Reality comprises not only the actuality of the present but also the virtuality of the past and future. The passage of time should be understood not on the basis of an analogy with movement through space but as a continuous differentiation between actual and virtual. Each passing present is understood as coexisting not only with its own immediate past but also with the past as a whole. The present, insofar as it is continuously passing, is constantly adding to and thus transforming the virtual past. The past, however, as a no less real counterpart to the actuality of the present, is not simply the result of the accumulation of passing presents. Rather, the virtual past that coexists with the present includes both the sum total of bygone presents and a "pure" past that has never been present. Far from being a diminished version of the present and thus derivative of it (a difference in degree), the past is different in kind from the present. Indeed, it is the preexistence of the virtual past that is the condition for the passing of the present.[10]

Is there one duration, or are there many? Bergson's first book, *Time and Free Will* (1889), entertains the possibility that there might be multiple durations, our own duration as human beings existing alongside any number of other, more dispersed or more intense durations.[11] In contrast,

in later writings, such as *Duration and Simultaneity* (1922), this emphasis on multiple times appears to give way to the claim that there is a single "impersonal time, in which all things will pass."[12] Bergson, however, explicitly rejects the philosophical choice between the One and the Many in favor of the notion of multiplicity, drawn from the mathematician Bernhard Riemann and referring to a mode of organization belonging to the many as such, without need for recourse to a principle of unity.[13] Rather than choosing between a single unified time and a plurality of times, the task of the philosopher, for Bergson, is to distinguish between different kinds of multiplicities: discrete (actual) and continuous (virtual). The former—homogeneous, divisible, quantifiable, comprising differences in degree—pertains to material objects located in space (a flock of sheep in a field being one of Bergson's examples).[14] The latter—heterogeneous, indivisible, unquantifiable, comprising differences in kind—pertain to duration. It is therefore the oneness of the impersonal time invoked in Bergson's later writings that expresses the particular (that is, virtual) character of its multiplicity. The virtual can be characterized in terms of both multiplicity and unity because it refers not to a given, circumscribed totality of actually existing entities but to a unity of becoming—a unity that both English classical scholar Jane Harrison and later Deleuze would find personified in none other than Dionysus, the stranger god, "the god of transformations, the unity of multiplicity, the unity that affirms multiplicity and is affirmed by it."[15]

In his study of Bergson, first published in 1966 and responsible to a large degree for reintroducing Bergson's work to late twentieth-century readers, Deleuze insists that the relation between the virtual and the actual is fundamentally distinct from that which has often been thought to obtain between the possible and the real. Whereas the real is directly prefigured in the possible (that is, the possible becomes real by having existence "added" to it), the actual is produced out of the virtual by a process of creative self-differentiation. Whereas the real resembles and proceeds out of the possible, the actual and the virtual are both coexistent and nonidentical. Revisiting Bergson's writings in *Difference and Repetition* (1968), Deleuze suggests that the past in its entirety is therefore nothing less than the a priori element of all time, "the in-itself of time as the final ground of the passage of time." Insofar as it exceeds what is actualized in any given present, it is the virtual past that enables the

138 *Between the Times*

surpassing of the present in the direction of an unforeseen future, introducing change, open-endedness, and unpredictability into a universe from which they would be lacking if only three-dimensional space and the actuality of the present were taken into account. Critics of Deleuze and Bergson have often dismissed the concept of the virtual as marking a withdrawal into transcendentalism and otherworldliness.[16] It is worth asking, however, what kind of this-worldly difference it might make to assert that reality includes more than the givenness of the actual. What would it take to grant durational time and space a constitutive role in our accounts of the world? What kind of realism might be adequate to such a reality? Deleuze suggests in his own writings on film and literature that the virtual is a vital resource for the arts of fabulation as they seek to remake the world. Although Bergson himself assigns fabulation an essentially conservative, status quo–maintaining function, the more radical version of fabulation envisioned by Deleuze involves not least an engagement with the virtual past not as a source of authority, identity, or tradition but a transformative power of difference to be engaged in the crafting of new presents and futures.[17]

WINTER CEREMONIAL

Comparisons have often been made between Bergson's conception of time and Joyce's writing, perhaps most controversially by painter, novelist, and critic Wyndham Lewis in *Time and Western Man* (1927), where both Bergson and Joyce are criticized for their adherence to a "Time Philosophy" that is, in Lewis's view (and contrary to its own claims), ultimately mechanistic and lifeless.[18] It is perhaps superfluous to state that my own assessment of both Joyce and Bergson is a more positive one. Before returning to Joyce, however, I want to pursue a further detour by comparing the European midwinter celebrations referenced in "The Dead" and in the folklore record with the more lavish and much longer-lasting Winter Ceremonial practiced, at least until the late nineteenth century, by the Kwakwaka'wakw (or Kwakiutl) of Vancouver Island and the Pacific Northwest and described by, among others, Franz Boas. Boas's accounts of the Winter Ceremonial, which run to many hundreds of pages (including almost half of his posthumously published volume, *Kwakiutl Ethnography*), describe a production on an altogether more lavish scale than its European counterparts. The ceremonial began in November and

Between the Times 139

lasted, without interruption, until well into the following year. Boas writes that with the commencement of the winter season, "all quarrels, all sickness, all causes of unhappiness are forgotten." At the same time, the ceremonial was a blatantly and avowedly theatrical occasion, one of the names used to describe it being linked etymologically to the Kwak'wala term meaning "to cheat or commit fraud."[19] Boas writes that the ceremonial is described as the sacred part of the year. In contrast to the secular summer, winter was the season when a variety of ancestral beings, believed to reside during summer in distant northern locations, returned to the Kwakwaka'wakw villages. These beings, with names such as Warrior of the World and Cannibal at the North End of the World, performed initiations of both men and women, and their presence provided the occasion for a succession of meticulously staged performances involving singing, dancing, and wearing intricately carved and painted animal masks and costumes, including a variety of birds, sea lions, killer whales, and grizzly bears. Just as these performances materialized ancestral beings of combined human and animal character, so the transition from the secular to the sacred part of the year was further marked by the adoption, on the part of the entire population, of different names. Many of these names were themselves passed down as an inheritance within individual lineages, giving the bearer the right to incarnate a particular lineage ancestor.[20] The Winter Ceremonial, with its elaborate stagecraft and its community-wide participation as either audience member or performer, thus furnished a setting in which ancestral beings were through performance afforded a collectively acknowledged contemporary presence. The transformations undergone by performers and initiates, including ritual alterations of status and physical transformations involved in the donning of masks and costumes, were associated with a suspension of chronological time such that the past of tribal origin myths, with their human–animal protagonists, was able to obtrude on and (at least while the ceremonial lasted) to remake the present.

One should not, of course, be too hasty in assimilating the spirits who descend on the villages during the winter season with the supernatural beings and apparitions of the dead described in European ethnographic and literary sources. Indeed, the spirits who appear during the Winter Ceremonial are not thought of as being dead at all but as residing during the summer months in the far north of the world. Nor are the spirits

FIGURE 19. Showing of Kwakwaka'wakw masks. Photograph by Edward Curtis, taken during the filming of *In the Land of the Head Hunters* (1914).

conceived of as an undifferentiated mass. Rather, they themselves, the initiations they perform, and the possessions and privileges they confer (dances, names, masks, ritual objects, and so on) are clearly specified and distinguished in terms of their associations with the particular lineages through which they are transmitted from one generation to another.[21]

Nonetheless, the effect of the commencement of the Winter Ceremonial is arguably the suspension of chronologically marked time. Stanley Walens, in a study of Kwakwaka'wakw cosmology, writes, "During the winter ceremonials, time stops."[22] According to Walens, the commencement of the Winter Ceremonial marks the dissolution of the social order that obtains during the secular, summer part of the year. This involves not only the abandonment of the practical, subsistence-related activities associated with summer such as food gathering, hunting, and fishing, but also a shift to a different principle of social organization. During the secular part of year, priority is accorded to relationships among living humans, who are connected by virtue of being, for example, kinsmen, affines, or coworkers (just as spirits are thought of as related to one another on basis of similar ties). During the sacred part of year, in contrast, bonds such as kinship and affinity yield precedence to analogies

between individuals currently living and the ancestors they incarnate through their dances and masked performances and through the adoption of names used only for the duration of the ceremonial. In thus prioritizing relationships with ancestral spirits, the Winter Ceremonial is also seen to usher in a different order of temporality. More precisely, time ceases to be understood or experienced as a linear progression from past through present to future, a mode characteristic of the practically oriented activities associated with the summer season. Instead, during the Winter Ceremonial, time ceases to be something that passes, and events cease to be thought of as related to each other in terms of a linear sequence. For the duration of the ceremonial, there is no before and after. Walens writes: "Thus, from the first blowing of the ceremonial whistles until the concluding speech, there is only a single instant. All acts during that period, though they may seem from a historistic viewpoint to precede or postdate one another, are considered to occur simultaneously."[23]

Although the spirits who appear during the ceremonial are thought of as continuing to live on elsewhere during the summer months, the fact of bringing them quite literally on stage in the form of masks, costumes, dances, and seasonally adopted ancestral names has the effect of rendering

FIGURE 20. Kwakwaka'wakw raven mask belonging to a Hamatsa secret society. Peabody Museum, Harvard University. Photograph by Daderot.

them both contemporaneous and physically contiguous with human beings of the present generation. In the same way, the practice of passing on ancestral names from fathers to sons, which is also a feature of the ceremonial, calls attention to the enduring and unchanging character of the names themselves rather than the fleeting and transitory existence of their successive bearers. The Winter Ceremonial thus accomplishes the ritual annulment of the distance separating the present from the mythic time in which these ancestors performed their world-forming actions. Thus, for all their insistence on the specificity of lineages and ancestrally derived ritual prerogatives, the Kwakwaka'wakw are also appealing to a creative, world-forming epoch that, for the duration of the Winter Ceremonial, displaces and annuls the calibrated time of the secular half of the year. The ceremonial itself thus involves a two-way traffic between differentiation and dedifferentiation—between, on the one hand, the emergence of specific lineage identities through the acquisition of distinguishing privileges and attributes, and, on the other hand, the assimilation of the present to the mythic time in which those differentiations were first produced. If much of the ceremonial appears to be marked by a particularizing assertion of clearly distinguished ancestral relationships and ritual prerogatives, then this is in fact achieved through a corresponding dedifferentiation between pasts and presents, understood in terms of a chronological sequence, as mythic time displaces secular time. It might be said that relationships between humans and ancestral spirits are able to achieve such clarity of articulation in the Winter Ceremonial precisely to the extent that the latter affords a ritually demarcated opening to something akin to Duerr's times between the times or Bergson's *durée*. As in the multifarious examples discussed by Duerr, this is less a matter of a shift from one system of time reckoning to another than of an affirmation of time as such as a virtual multiplicity—that is, as a creative power of difference out of which human (and other) worlds are continuously made and remade.

Ghost Hunting

The same interplay between differentiation and dedifferentiation is much in evidence in the ending of Joyce's "The Dead," juxtaposing as it does the named figure of Michael Furey with the anonymous "vast hosts of the dead" who encroach upon Gabriel as he watches the snow from his

hotel window. In fact, this final appearance of the dead in both massed and individuated guises has already been prefigured by a series of anticipatory references scattered throughout the text. These include, most obviously, references to deceased family members like Gabriel's parents and grandparents, as well as references to the future demise of those still living, including Aunt Julia and, by implication at the story's close, Gabriel himself, along with the dinner table discussion of the monks of Mount Melleray, who sleep every night in the their coffins, as Mary Jane puts it, "to remind them of their last end"—a phrase echoed in the story's final sentence.[24] More subtly, the dead are present in the text in the form of a dense web of historical, literary, and mythological allusions that generations of commentators have been at pains to unravel. Here are just a few examples. Richard Ellmann, in his classic biography of Joyce, points out that one antecedent for the figure of Michael Furey is to be found in Sonny Bodkin, a girlhood suitor of Joyce's partner, Nora Barnacle, who had died from tuberculosis, having stolen from his sickroom on a rainy night to bid Nora good-bye before her departure from Galway to Dublin.[25] John Kelleher, reaching further back into Irish antiquity, draws a series of parallels between the actions of Gabriel in the story and the events leading to the downfall of King Conaire Mór in the Old Irish saga *Togail Bruidne Da Derga* (The destruction of Da Derga's hostel), which include the violation of a series of taboos (*gessa*), some of which explicitly concern his relations with women.[26] More recently, poet Paul Muldoon, in his Oxford Clarendon Lectures (published in 2000), has proposed a complex series of echoes and parallelisms encompassing not only the fate of Conaire Mór but also the stories of other mythological heroes, Fin MacCumhaill and Cuchulain, along with their latter-day retellings by Irish writers such as Samuel Ferguson, Standish O'Grady, and Lady Augusta Gregory, as well as American folklorist Jeremiah Curtin.[27] Having myself no credentials as Joycean beyond an undergraduate thesis written many years ago, it is not my intention here to add further to this list. Instead, I wish to make two observations. First, it is striking that so many commentators on Joyce's work have found themselves caught up in and thus carrying forward the necromancy of Joyce's texts through the identification and naming of the dead. In this regard, it is perhaps worth mentioning the still more compendious scholarly labors expended over the years on *Ulysses* and *Finnegans Wake*. Second, although the critical

144 *Between the Times*

pursuit of Joyce's sources and allusions usually presents itself as a labor of clarification, one aimed at the identification of particular figures, whether literary or historical, it can be seen also to have had a rather different effect, whereby, as their numbers multiply, these named dead start themselves to resemble a crowd.

What, then, can literature be said to know about the dead? Let us turn to another, less frequently remarked-on group of ghosts attendant at the Misses Morkans' Twelfth Night feast. In an essay published in 2002, historian Kevin Whelan suggests that "The Dead" needs to be understood as a crucial cultural document of the Great Irish Famine of the 1840s and of its aftermath. Precipitated in the first instance by the potato failure of 1845 but exacerbated by massive disparities in wealth and access to resources, by the greed and opportunism of many landlords, and by the inadequate or nonexistent relief efforts of successive British governments, the Great Famine was a social and demographic disaster that claimed more than a million lives and drove a further two million people into exile during the ensuing decade. It wiped out many rural communities in their entirety and plunged others into a spiral of population decline that would not be reversed, in some cases, until the end of the twentieth century. At the same time, it was, as Whelan notes, a cultural catastrophe, resulting not least in the widespread loss of the Irish language, since many of those who died or who were forced to emigrate were from Irish-speaking areas.[28] Although the Great Famine is not mentioned directly in Joyce's story, Whelan argues that the cultural devastation wrought by mass starvation and emigration reveals itself in a variety of ways: through the spectral paralysis that afflicts the city and its inhabitants here and in other stories in the collection; in the Ireland-wide snow, recalling the "killing snows" of James Clarence Mangan's 1846 Great Famine poem "Siberia"; in the final images of snow drifted on the "crooked crosses" of Oughterard churchyard, evoking not only the final resting place of Michael Furey but also the numerous Irish-speaking west of Ireland rural communities for which the famine years were to sound a death knell; and, not least, in the name of the story's protagonist, Gabriel Conroy, borrowed from an 1875 novel of the same name by American writer Bret Harte, describing the deaths from starvation of a party of snowbound pioneers in the Californian Sierras, itself based on the actual fate of the Donner party, who perished in the same location during the winter of

Between the Times 145

1846–47, coinciding with the notorious Black '47, which marked the peak of Great Famine mortality in Ireland.[29]

While the focus of Whelan's essay is on reconstructing one of the least remarked-on contexts of Joyce's writing, it has less to say about the specificity of literature's (and Joyce's) modes of engagement with the dead, whether as named individuals or as an undifferentiated and anonymous mass. Yet the famine dead surely could be seen to occupy a position somewhere in between the two. On the one hand, they are an undoubted historical presence and, in recent decades at least, a frequent object of scholarly investigation. On the other hand, many of the victims of the 1840s remain unnamed and uncommemorated, piled into mass graves like those at Skibbereen (West Cork) or on Achill Island (off the coast of County Mayo), or their passing registered only by anonymously erected improvised monuments, like the stone cairns that mark the locations of burial sites and death places along much of Ireland's western seaboard and that are frequently referenced in the oral histories of the famine years collected during the 1940s by the Irish Folklore Commission.[30] Perhaps what distinguishes the historical memory of the Great Famine is a simultaneous two-way traffic between the anonymous and impersonal mass of the dead and the particularized referents of historical discourse. This would involve the condensation of the famine dead as an identifiable historical presence out of a more primordial and undifferentiated being with the dead akin to the "great sea of the dead" evoked in Isidra's explication of the Palo term *Kalunga*, and at the same time the opening out of historical time to a different order of temporality, marked by the indissociable copresence of living and dead.

For Whelan, reading the final paragraphs of Joyce's story in tandem with Mangan's poem "Siberia," this other time is characteristically cold, lifeless, and inhuman; it represents "history's appalled reversion to geological time, into a space and time which precede and follow human geography and human history and which are supremely indifferent to them."[31] For me, however, what Joyce's description, and in particular the figure of the all-pervasive snow, captures so powerfully is not the inassimilable otherness of the time of the dead but rather its inextricable interimplication with that of the living. Indeed, as Elizabeth Grosz has suggested, geological time, like the similarly suprahuman temporality of biological evolution, can be thought of not as the antithesis or negation

146 *Between the Times*

of humanly marked, historical time but as its inescapable precondition. Juxtaposing Bergson's insights with those of Darwin, she suggests that just as living organisms bear the genetic traces of their evolutionary past, so too can the whole of what we are accustomed to think of as "nature" (including the results of evolutionary and geological processes) be understood both as the accumulated past of all life, including that of human society, and as a latent transformative power, coexisting virtually with the present, which at once gives rise to the present and enables its overcoming and displacement in the direction of an unforeseeable future.[32]

It is arguably toward an attempted encompassment of this durational past that Joyce's writing moves through the course of his entire oeuvre. Bergson himself was doubtful that literature, bound as it is to the spatial and sequential arrangement of words on a page, could do more than hint at the possibility of durational time.[33] Joyce's writings, however, evince a greater confidence in literature's powers—a confidence that appears to increase with each successive published work, culminating in the nocturnal linguistic explorations of *Finnegans Wake*. Indeed, is Joyce's final work, his "Book of the Dark" (in critic John Bishop's memorable formulation), not also a Book of the Dead, a work fashioned from a dream idiom in which not only past and present, living and dead, but also multiple languages and semiotic possibilities are afforded a simultaneous coexistence?[34] This ineradicable coexistence is perhaps part of what literature, as a fabulary art of the between, knows about the dead—a knowledge shared, it appears, by many of the people written about by anthropologists (if not always by anthropologists themselves), and one that long predates even Odysseus's and Homer's conjuration of the blood-hungry ghosts beside the sacrificial trench. It is this knowledge that Gabriel confronts as he prepares to set out on his much-debated imaginative journey westward, his envisaged itinerary including not only the physical topography of the west of Ireland, not only the text's multiple infolded mythological, literary, and historical valences (including the spectral yet eerily palpable presence of the famine dead), but also the time of the dead, the time between times, the time of the Winter Ceremonial, the time that encompasses and enables cultural and historical cognition, displacing the present into unforeseen realms of memory and possibility.

thirteen

Anthropology ≠ Ethnography

How might anthropology engage the between without reducing it to such ready-made explanatory formulae as structure, signification, or context? Are there lessons to be learned from literature, the visual arts, and, not least, ritual performance, considered not as objects of knowledge but as possible modes of anthropological engagement? Let us return to Duerr's *Dreamtime* to consider what I take to be one of its most singular and striking features, namely the fact that its evocation of time as a power of difference draws on such an eclectic and heterogeneous range of sources. Duerr's book is likely to disconcert some contemporary anthropological readers, accustomed as they are to a diet of place-specific ethnographies, precisely on account of its unabashedly, even extravagantly comparative scope. Judged by the norms of the fieldwork-based monograph, Duerr's book is apt to seem unwieldy and excessive, recalling Henry James's disapproving characterization of the novels of Tolstoy, Dickens, and other nineteenth-century writers as "large, loose baggy monsters" filled with "queer elements of the accidental and the arbitrary."[1] Duerr does not set out to describe the beliefs about or representations of time current among a particular community. Instead, his account ranges over ancient Near Eastern archaeology, classical and Norse mythology, medieval and early modern European witchcraft, Siberian shamanism, Native American peyote cults, Aboriginal Australian storytelling, Zulu divination ceremonies, Zen Buddhism, and Bushman hunting practices, along with the writings of Wittgenstein, Feyerabend, Lewis Carroll and—more alarming still!—Carlos Castaneda. For anyone schooled in the more recent turns

147

148 Anthropology ≠ Ethnography

taken by the discipline of anthropology, the temptation is to take Duerr to task for his bundling together of historically and geographically disparate materials and his insufficient attention to the specificities of the multiple contexts that his account traverses. This, however, is not the line of argument I intend to pursue here. Instead (and more controversially, no doubt), I wish to propose that the scope of Duerr's study stands as a salutary challenge to the ethnographically oriented particularism that has become not only the default setting for much current anthropological research and writing, including many self-described multisited projects, but also the basis for many arguments concerning the discipline's continued relevance to the understanding of contemporary social processes, some notable dissenting voices notwithstanding.[2]

As a teenager in Britain in the 1980s, my first impressions of anthropology as a discipline were derived not from the reading of ethnographies but from the sprawling, often multivolume comparative works of the late nineteenth and early twentieth centuries—works such as Edward Tylor's *Primitive Culture* (two volumes, 1871), Andrew Lang's *Myth, Ritual and Religion* (1887), and James Frazer's *The Golden Bough* (twelve volumes, 1906–15), those "loose baggy monsters" of an earlier generation of anthropological scholarship. What first drew me to such studies was not only their imposing scale and self-declared ambition but also their expansive referentiality, along with the sometimes disconcerting leaps across space and time that this often seemed to involve. Later, of course, I learned that the current practice of anthropology had little to do with the works that had first captured my teenage imagination. I learned to be suspicious of universalisms and to question the view that societies and cultures had evolved everywhere according to an identical sequence of stages. I learned that comparative anthropological scholarship was now a more cautious affair, confining itself either to an examination of similarities and differences between specific localities or to the elucidation of more narrowly defined problems, such as the dynamics of gift exchange or the logic of pollution restrictions. Above all, I learned that anthropology as a discipline was now identified with its commitment to a method called ethnography, to the detailed, firsthand study of particular localities and populations, to be achieved through painstaking, long-term participant observation. I came to understand, too, that the characteristic genre of anthropological writing was no longer the sprawling, compendious

Anthropology ≠ Ethnography 149

work of large-scale, cross-cultural comparison but rather the more modestly conceived, usually place-specific ethnographic field monograph.

The history of the transition to a fieldwork-based anthropology is a complex one, requiring a more detailed treatment than is possible here, but for the sake of brevity (and in light of my own graduate training at Columbia University), let me consider this disciplinary shift as exemplified in Franz Boas's 1896 essay, "The Limitations of the Comparative Method of Anthropology."[3] Boas's paper, originally delivered in Buffalo, New York, at a meeting of the American Association for the Advancement of Science, self-consciously seeks to reorient anthropological inquiry away from the view that, as he puts it, "there is one grand system according to which mankind has developed everywhere."[4] Specifically, Boas warns against the assumption that the presence of apparently similar cultural traits among geographically scattered populations necessarily indicates the presence of similar causes and a similar sequence of development. Instead, Boas advocates "the careful and slow detailed study of local phenomena."[5] Rather than the explication of ethnographic data on the basis of hypothetical laws claiming universal applicability, he argues that comparison and generalization, if they are to be undertaken at all, must be subordinated to meticulous ethnographic and ethnohistorical research. In contrast to the speculative flights of comparativism, the paradigm of anthropological research and writing that Boas's essay envisions is one premised explicitly on the method of induction, taking always as its starting point the concrete specificity of particular cases.

Today, the commitment to ethnographically grounded particularism staked by Boas's essay has become integral to anthropology's self-image, and such a commitment is routinely cited as proof of the discipline's continuing relevance to the understanding of contemporary social processes. Claims regarding the uniqueness of ethnography as a specifically anthropological way of knowing have been mobilized in support of anthropology's entry into a range of subject areas, including, to name a few, banking and finance, epidemiology, infrastructure and design, and media production. Certainly comparativism has continued to be practiced by anthropologists on both sides of the Atlantic, perhaps most ambitiously under the aegis of Lévi-Straussian structuralism, although more commonly on a more modest and restricted scale. Nonetheless, the recent status of comparativism has tended to be that of a minority pursuit,

engaged in predominantly by senior scholars with an already established record of ethnographic research and publication, recent works by Tim Ingold in Britain and Philippe Descola in France providing notable examples.[6] Nonetheless, it is ethnography as the now-dominant mode of anthropological writing that is most frequently invoked to affirm the identity and distinctiveness of anthropology as an academic discipline.

Why, then, do I find myself increasingly suspicious of this now almost ubiquitously shared vision of anthropology? Certainly not because I doubt the value of ethnography as a method of inquiry, nor because I question the need for anthropology to engage with the contemporary world. My quarrel is not with ethnography per se but rather with what I take to be anthropology's increasing tendency to define its identity and distinctiveness principally on the basis of its deployment of ethnographic methods. Such a move has often resulted, not least, in a distorted view of the discipline's own history, foreclosing many of the intellectual and writerly possibilities that its comparative heritage might offer to the present. By way of illustration, let me turn to a (more or less) randomly chosen paragraph from the second volume of Tylor's *Primitive Culture* (1871). The author is discussing the widespread use of fire by human beings in different times and places to protect themselves against harmful and malevolent spirits, especially those believed to manifest themselves at night. As Tylor writes, "In the dark, especially, harmful spirits swarm." The paragraph begins with a description (taken from the writings of English explorer and colonial administrator George Grey) of the fire sticks carried at night by Aboriginal Australian women to ward off evil spirits. In the following sentence, the scene shifts to South America and the burning brands or torches carried for similar purposes by Indian groups. The next sentence takes us to the Malay peninsula, where protective fires are lit near a mother at the time of childbirth. A little later in the paragraph, a single sentence transports us from Southern India to a wedding in China. We travel onward and backward in time to medieval Iceland, where the early Norse settlers carried fire around the lands they intended to occupy, again to expel indwelling malevolent spirits. Moving forward again into the author's present, we find ourselves in the Hebrides; a sentence later, we are in Bulgaria, where, on the Feast of Saint Demetrius, lighted candles are placed in the stables and woodshed, this time to prevent evil spirits from entering into the domestic animals.[7]

Anthropology ≠ Ethnography 151

What provides the occasion for this whistle-stop tour of continents and centuries is, for Tylor as for many of his contemporaries, a theory of social evolution, asserting that human societies everywhere can be seen to change and develop in accordance with a uniform and predictable sequence of stages. The particular focus of Tylor's study, of course, is on the development of religious conceptions, from animism via polytheism to monotheism, combined with Tylor's signature doctrine of "survivals," which allowed the practices of contemporary Scottish crofters and central European peasants to be understood as vestigial remnants of an otherwise now-vanished animistic sensibility. As a first-time reader of Tylor, however, my attention was caught less by the ordering theoretical framework than by something that the criticisms of Boas and others seem to me to miss: the proliferation of examples and the leaps and juxtapositions that threaten constantly to subvert any appeal to a unifying and totalizing logic, instead swarming uncontainably like the malevolent, nighttime spirits who provide the starting point for Tylor's reflections. If the social evolutionist paradigm invoked by Tylor seeks to contain such superabundance within strictly delimited conceptual bounds, paragraphs like the one cited can sometimes produce a very different effect. They suggest not only a multiplicity of possible human worlds but also the prospect of unpredictable and mutually transformative encounters between spatially and temporally disparate people, things, and places.

For all the apparent rigidity of its intellectual premises, Tylor's prose captured my adolescent imagination because it opened a space for such generative encounters, making it possible for my own Hebridean ancestors to rub shoulders with Aboriginal Australians, Chinese wedding guests, and early Norse settlers in Iceland. What emerges from these collisions, as from those of Lucretian *primordiae*, is a new combination of elements rather than a description of an already existing state of affairs. The absence of an empirically verifiable referent is, of course, exactly what Boas and other critics of the comparative method have objected to. Yet I remain drawn to this speculative world fashioned from descriptive fragments of the existing one, not least because it suggests a different— and, for me at least, compelling—way of conceiving of the current situation of anthropology. I therefore propose, in opposition to Boas (and much of the prevailing *doxa* in anthropology), that the connections generated by anthropological comparativism as practiced on the scale of

Tylor (and more recently Duerr) may be of interest and consequence precisely to the degree that they do indeed appear to be without any directly observable basis outside the texts through which they are made manifest. To make this claim amounts not to a disavowal of the world in the name of self-absorbed textual experimentation, but to a plea for a different kind of worldly engagement. This would demand, however, that the imagining of alternative worlds and their expression through writing be accorded the status of material practices capable of challenging and extending the parameters of what is understood to comprise reality.

QUESTIONING THE REAL

If I am dissatisfied with recent attempts to portray anthropology as synonymous with ethnography, it is precisely because I want an anthropology committed not only to describing and documenting the actuality of the early twenty-first century present but also—quite explicitly—to intervening in and changing it. The current tendency to identify anthropology with ethnography seems to me to risk lapsing into a too-ready acceptance both of the sociopolitical and the ontological status quo. In defining ourselves primarily as ethnographic observers and recorders of the contemporary world, we slide all too easily into a tacit endorsement of a set of externally derived criteria of interest and relevance, usually established by those in positions of economic and political power, including prospective funders of anthropological research, whether these be governments, corporations, independent foundations, or anything else. Arguments for anthropology's continuing relevance within the academy thus come to be elided with arguments for its potential usefulness outside it— whether as a tool of market research or, more ominously, a source of military intelligence, as in the U.S. Army's now-defunct Human Terrain System initiative.[8] It might be objected that ethnography can and frequently has been used to very different political ends—to draw attention to injustice and suffering and to challenge dominant representations of reality. Yet surely such interventions are informed, whether tacitly or overtly, by a sense that reality could, or should, be different. A commitment to the possibility of different worlds immanent to the actuality of the present is found, I would suggest, in the work of scholars as various as David Graeber, Ghassan Hage, Tim Ingold, Elizabeth Povinelli, Kathleen Stewart, Anna Lowenhaupt Tsing, and Eduardo Viveiros de Castro,

Anthropology ≠ Ethnography 153

and it depends, in the most fundamental sense, on a comparative perspective.[9] Ghassan Hage writes that the critical and creative force of comparison consists not simply in opening up edifying vistas of human diversity but in disclosing an alterity, a propensity to become other, that is already present within the self:

> Therefore this critical anthropological thought not only challenges us by telling us that there are people who live differently from the way we live; is also challenges us by telling us that they are relevant to us. The other has, but we can have, different ways of conceiving sexual relations; kinship; our relationship to plants, animals and the landscape; causality; sickness and so on. It can therefore be summarised by the very simple but also paradoxically powerful formulation: we can be radically other than we are. It is paradoxical because in the very idea of "we can be" other than what we are lie the idea that "we already are" other than ourselves. Our otherness is always dwelling within us; there is always more to us than we think, so to speak.[10]

Or, it might be added, comparison shows us that there is more to reality than we previously thought. In contrast, the claim that anthropology equals ethnography risks enshrining a normative empiricism that absolutizes existing actualities as the unchallengeable horizon not only of what might count as reality but also of what might qualify as an accurate or truthful account of it. Descriptive fidelity to the actual is routinely prioritized over poetic invention, which is, in contrast, denied any direct purchase upon the real. Just as fiction making is thus relegated to a human-centered realm of make-believe, so too is the nonhuman world deprived of the power of artistry that Nietzsche's Dionysian vision had affirmed and celebrated. The millennia-old triumph of *logos* over *mythos* continues to cast its shadow, it appears, over much of contemporary academia. But should it? The dangers of this all too fictional separation of truth and fictionality should be readily apparent in the face of ongoing attempts to delimit reality in the name of race, nation, God, the free market, or an imaginatively impoverished political pragmatism. In such circumstances, it becomes imperative to assert that the real exceeds such territorializing claims—that, for example, for all its pretensions to universality, the world of neoliberal capitalism invoked by politicians,

business leaders, and much of the media is but one possible world among many, and as such perpetually haunted not just by the possibility but by the reality of the alternatives it seeks to exclude. Anthropology, no less than art and literature, has an indispensable part to play as a channel for such insurrectionary, real-worldly ghosts of the not yet actual, but this demands an acknowledgment on the part of anthropologists that they are more than ethnographers and that the reality they seek to engage encompasses more than the actuality of any given present. It demands the recognition, in other words, that anthropology's project is both a comparative one and one of *poesis*, understood in the most expansive possible sense.

To restrict ourselves too narrowly to the task of describing the actual is to settle not only for an unnecessarily limited account of reality but for one founded on the preemptive foreclosure of other possibilities of being human—or other than human. To engage these in a nonreductive manner demands not cultural relativism, implying always a quantifiable plurality of culturally bounded perspectives on an already given reality, but rather a willingness to continuously reopen the very question of the real. In the light of recent criticisms of "ontological anthropology," I should add that I see no reason to find the resources needed for doing so exclusively in realms of indigenous alterity framed in opposition to the organizational logics of capitalist techno scientific modernity, or what Lucas Bessire and David Bond have called "extremities beyond the objectivizing modern gaze."[11] Rather, I see them as made manifest through a multiplicity of spaces of encounter, intersection, transition, and transformation, both near at hand and far away—the between spaces that precede any differential ordering of worlds, whether on the basis of culture, ontology, or anything else. Perhaps, as both Bergson and Deleuze suggest, the one and the multiple are false alternatives. Duerr too insists, despite his all too evident attraction to the conventionally primitive and exotic, that what is evoked by his heterogeneous examples is not another reality but another aspect of the same reality, albeit one that exceeds and destabilizes its commonsense enframings. To affirm a commonality predicated explicitly on difference and multiplicity is not to fetishize difference or to seek redemptive significance in visions of the West's colonized and subjugated others but to call attention to hitherto unacknowledged dynamics and potentialities of world making that might (just might—there are

Anthropology ≠ Ethnography 155

no guarantees) enable the making of different—more inclusive, more just, more sustainable—kinds of worlds, worlds in which notions of inclusiveness, justice, and sustainability might themselves be transformed beyond recognition. For this reason, I see fabulation as having nothing in common with the retreat from contemporary engagement into a "speculative futurism" that Bessire and Bond associate with the ontological turn.[12] If the fabulatory enactment of worlds in becoming gestures toward a not-yet-written future, it nonetheless takes place in the present—a present that is, however, never identical to itself insofar as it is constantly displaced from within by a virtual past that exceeds any possible actualization in the present. It is, however, this noncoincidence of the present with itself—and thus the possibilities of making a difference in the present that this affords—that the exclusively ethnographic orientation of much of contemporary anthropology has often threatened to obscure.

fourteen

Fabulatory Comparativism

My appeal to the legacy of anthropological comparativism may seem an odd choice. It is intended, however, to evoke not the resuscitation of a disciplinary history and identity but a minoritarian flight from canonical formulations of the same, past and present. The comparative method (or antimethod) that I envision would appeal not to a closed totality, whether it be the stadial theories of social evolution espoused by Morgan, Tylor, and their contemporaries, the encyclopedic aspirations of Murdoch's Human Relations Area Files, or the sometime structuralist ambition to found a comprehensive science of culture, but rather to an open-ended unity of becoming of the kind evoked by Bergson and Deleuze through their concept of the virtual. If ethnography has often been cited as indicative of anthropology's engagement with the actual, existing world, then perhaps comparativism, in theory if not always in practice, offers one way of combining such a commitment with an acknowledgment and experimental conjuration of an unbounded multiplicity of worlds in becoming. The comparativism I wish to advocate is exploratory and open-ended in character. It juxtaposes diverse scenes not in order to explain them under an already established rubric or with reference to a notional sociohistorical context but rather to manifest a set of associations and connections that need not be assumed to have existed at all prior to the act of comparison itself. I take montage, in other words, to be one of the informing principles of comparativism in an active mode. In this respect, ethnography and comparativism are not, in fact, alternatives to one another, insofar as ethnography is itself a mode of comparison—that

Fabulatory Comparativism

is, a practice of montage. Ethnographic knowledge is produced through the transformative juxtaposition of bodies, languages, sensibilities, and life worlds, just as ethnographic writing, filmmaking, or other modes of presentation are a product and a record of such juxtapositions.[1] Both ethnography and comparativism (which amount, finally, I would suggest, to the same thing) are arts of the between that involve not only the staging of encounters across difference but also the evocation of the limitless potentiality of difference itself. Comparison is a creative act to the extent that rather than accepting the actual as given, it seeks to add to it an intangible (but for all that no less real) dimension of unpredictability and incalculability. It affirms that reality is not exhaustively expressed in the actual but includes within itself the possibility of being otherwise. Such an affirmation, however, cannot, by definition, proceed from any description of the actual alone but rather depends on an artful engagement of the "being of the middle"—of the between as a power to differ from itself immanent to the very substance of reality. If the comparative-ethnographic exploration of coemergent multiple worlds is to ensure that it amounts to more than a rebranding of cultural pluralism, a tabulation of differences within an already presupposed explanatory framework, then it must make manifest through its methods, theoretical reflections, and writing practices its own willingness to pass from description and analysis to an activism grounded in poetic affirmation.

Anthropology needs to grant equal recognition its ethnographic and comparative heritages if it is to assert both its topical relevance and its creative and critical world-shaping potentiality. If ethnography's strength has always consisted in its painstaking and uncompromising adherence to the actual, existing world, comparativism's might be seen to consist, conversely, in its refusal to be confined by any single, currently authorized version of reality. As such, crucially, it holds open the possibility that reality can be not only reimagined but also refashioned, and that anthropological research and writing might play an active role in such refashioning. It allows us, in other words, to conceive of anthropology as a practice of fabulation, as understood by Deleuze. Literary fabulation, as Deleuze reminds us, rather than being the expression of already established positions and identities, is always a matter of transformation, of setting in motion. Fabulation can only be understood as an art of the between—always the invention in the present of what is yet to come. The

same can surely be said of anthropology insofar as it is inescapably involved with fiction and fiction making in Geertz's capaciously defined sense. Anthropology as a fictionalizing enterprise calls attention not only to the contingent and constructed character of existing human arrangements but also to the possibility that the latter might be remade, not through human action and volition alone but through an artful engagement with an other-than-human world that is always a world in becoming—a world that does not consist simply of the givenness of the actual (as the customary reference point of and justification for ethnographic description), but where reality also includes the destabilizing and unquantifiable dimension of the virtual, of which liminality and the image of the massed dead as relayed through art, ritual performance, and storytelling (including anthropological storytelling) have been among humanity's most powerful and ubiquitous reminders. Anthropology, rather than being simply the study and analysis of liminal phenomena, is itself a practice of the between, an interstitial art of making and unmaking carried forward at the interfaces not only between differently constituted human worlds but also between the latter and the other-than-human materialities that are their source and limit—the inhuman earth of Deleuze and Guattari's geophilosophy.[2] Like the irreducibly polysemic night language of Joyce's *Finnegans Wake*, through which the dead, en masse, murmur ceaselessly to the living, anthropology both testifies to and enacts an unbounded multiplicity of worlds that are at the same time one world, ranged on the same plane of existence, without transcendence or hierarchy. Like the mythic world of the Amerindian peoples described by Lévi-Strauss and later Viveiros de Castro, the space-time of the between is one not of homogeneity but of intensive difference.

Duerr's *Dreamtime* is, for this reader at least, one highly suggestive example of what a fabulatory comparativism of the between, a comparativism of multiple worlds in the making, might look like. It is perhaps significant that Duerr's study, which began life as a doctoral dissertation at Oxford under the supervision of Evans-Pritchard, was originally conceived as an ethnography of the ceremonial dances of Pueblo Indians but mutated into its present form via a series of comparative tangents encountered in the course of secondary library research. Drawing on his onetime teacher's celebrated account of Nuer political institutions, Duerr, in the preface to the first (German) edition of the book, describes

the state of his own "soul" in the latter stages of composition as one of "ordered anarchy"—a phrase that seems equally applicable to the organization of the text itself.[3] Duerr's account does not assume an enframing context of social relationships within which stories of magical transformations and otherworld journeys can be seen to "make sense." Instead, he accords priority to his various sources' intuitions of a reality antecedent and irreducible to the organizational logics of any recognizable, knowable social world. Duerr asks us to consider what decisions regarding what to include or exclude are involved in appealing to a social or historical context, and whether different decisions might reveal a different world. He does not seek to provide contextual explanations for his informants' pronouncements; rather, he attempts to take them seriously (in a formulation recently much beloved of ontologically inclined anthropologists) by allowing them to challenge his own received understandings of what reality is. He offers, in effect, an alternative account of reality in which the between is not something to be explained and known but is itself a potential source of knowledge. It is not social relationships that provide the point of reference for approaching liminality and metamorphosis, but vice versa.

Duerr's investigation of the between as a project of comparative philosophical anthropology is able to proceed in this way largely because of its broad, comparative scope, which eschews not only the totalizing schemes of nineteenth-century social evolutionism but equally any prior commitment to the elucidation of a particular social context into which the materials he discusses must be fitted. Duerr can be said to avoid doing explanatory violence to his sources to the extent that he does not seek, for the most part, to explain them at all, allowing his own reflections to take their cue from the resonances established among these juxtaposed elements. It is, in other words, the open-ended and combinatorial organization of his study, its montage character, along with its explicitly transcultural and transhistorical scope of reference, that allows for a thinking and a poetics of the between.

What Difference Does It Make?

What can be said, finally, about a notion that can be personified variously by a geological rift, by Lucretius' *clinamen*, by the dances of the seal people, by the seasonal ribaldries of the Callicantzari, by the ecstatic

transports of Dionysus and his retinue, by the writings of James Joyce, by the extended theatrics of the Kwakwaka'wakw Winter Ceremonial, and by an out-of-print work of comparative anthropological scholarship marking the commencement of an extensive oeuvre that remains, sadly, otherwise untranslated into English? Perhaps nothing—or perhaps everything. Nothing in the sense that the between, by its very nature, eludes the grasp of our analytic lexicon. Try to categorize, define, or explain it, and it inevitably slips away as we find ourselves, as Turner sometimes does, back on the more familiar terrain of social relations and classifications. It is this aspect of the between—its ineffable and ungraspable character—that is so powerfully evoked in Crapanzano's discussion of "imaginative horizons" with reference, among other things, to the elliptical "speaking with names" practiced by the Western Apache and to the *ma*, or interval between forms, of classical Chinese and Japanese aesthetics.[4] Yet there is another aspect to the between that seems equally deserving of consideration: its fecundity, its inexhaustible capacity to dissolve existing forms and generate new ones. If the variegated cast of human and other-than-human characters populating the preceding pages are intended in part to provide a ludic and anarchic alternative to the constitutionalist and social democratic inflections of Latour's *Dingpolitik*, then they are also meant to manifest and embody something of this multifarious generativity. In other words, I have tried not only to call attention to the gaps and indeterminacies that mark the limits of our academic knowledge, but also to evoke an unpredictability lodged at the very heart of the real. It is this that Bergson and later Deleuze would refer to as the virtual, an inexhaustible reservoir of nondetermined potentialities forming a no less real counterpart to the actual, which is continuously produced out of it through an ongoing and open-ended movement of self-differentiation, a movement constitutive of the creativity of being itself and as such demanding to be thought as antecedent to any possible distinction between, for example, nature and culture, structure and antistructure, or reality and its cultural-linguistic representations.[5] It is part of the wager of this book that comparative anthropology, understood as an art of montage or a creative practice of the between, might be particularly suited to evoke such a sense of the real as unfinished and perennially in process, and that this in turn might nurture a variety of cultural, political, and other projects aimed at creatively transforming presently existing actualities.

Fabulatory Comparativism 161

The diverse scenes of encounter and metamorphosis grouped together here should be understood less as case studies or illustrative examples than as conjurations of and with this prodigious yet elusive power of world making. As such, they mark the point at which historical and contextual explanation must acknowledge its own limits, where cultural difference encounters an ontologically prior differential of time and matter. What they invite, I suggest, is not further explanation but a mode of engagement—whether textual, audiovisual, or performative—that is willing to measure itself against them. The articulations born of such encounters demand to be thought in terms not of contextual specificities but of intersectional imaginaries that are willing to engage in the Heraclitean game of becoming by spanning and conjoining disparate times and places to participate in the shaping of new realities. A flag flutters in the breeze of an Icelandic summer's afternoon; magma rises from the earth's depths; continents draw apart; atoms collide and disperse; seal people cast off their skins to dance on a beach at twilight; masked and monstrous figures throng the nights of midwinter; and snow continues to fall throughout the universe on all the living and the dead. What difference does it make? Quite possibly all the difference in the world.

III

Gyro Nights

Inhuman Culture / Inhuman Nature

fifteen

Islands before and after History

Kirkwall Airport, Orkney, 3 PM on a gray, blustery day at the end of February. I am boarding a flight to the island of Papa Westray (or Papay, as it is known locally), lying some nineteen miles to the north. The sky is overcast, and the wind is gusting from offshore. My fellow passengers are a family including two young children, traveling onward and home to the adjacent island of Westray (officially the world's shortest commercial flight, lasting some two minutes in the air) and Dr. Ragnhild (Raggie) Ljösland, a Norwegian researcher in sociolinguistics from the Institute of Nordic Studies here in Kirkwall, who is giving a public lecture in Papay Community Center later that evening. These Britten Norman Islander eight-seater, twin-propeller aircraft are used for all interisland flights in Orkney, and they serve in effect as a school bus for many children from the outlying islands, but both Raggie and I are taking our first trip in one, and we exchange nervous glances as we fasten our safety belts for takeoff. Later in the week I will hear many stories about winter storms and seat-of-the-pants landings in the face of gale-force winds, but this time, becoming airborne is a reassuringly undramatic affair. The noise of the engines fills the cockpit (where the passengers sit directly behind the pilot), and the plane rises—more abruptly than a larger jet, but smoothly. We are flying below cloud level all the way, so one can look down from the narrow window of the plane onto the low, green, undulating landscape of Orkney, made fertile by mud deposited during the last ice age—a contrast to the rockier, glacier-gouged contours of its northerly neighbor, Shetland. And then there's the sea. Even on a cloudy

day at the end of winter, Orkney's coastal waters are an intense, iridescent blue, yet so clear that even from our cruising altitude, we can see directly to the bottom, although these same waters, agitated by storms and fast-running currents, have claimed the lives of countless ships' crews over the centuries.[1] We pass the coast of East Mainland, crossing Inganess Bay and skirting the islands of Shapinsay to the right and Wyre and Egilsay to the left, following the sound between Westray and Eday, then banking sharply as we descend to Papa Westray's narrow airstrip. The wind, which has risen since we left Kirkwall, seems more noticeable on the ground, certainly more audible. Ten minutes later, courtesy of a ride from Jim, a journalist from Glasgow who moved to the island with his family twenty years ago, I find myself sitting in the kitchen of the island's hostel, drinking tea from a mug and waiting for the evening's festivities to begin.

What is it that makes islands good to think, to dream, to imagine with? After all, there are so many kinds of islands: lone rocks, archipelagoes, volcanic islands, coral atolls, treasure islands, prison islands, desert islands, crowded islands (some of them, like Manhattan and Hong Kong, among the most densely populated places on earth), artificial islands (as they tend to be called when the artificers are mostly human, like those of the islands of the Venice lagoon), islands of the imagination (of which

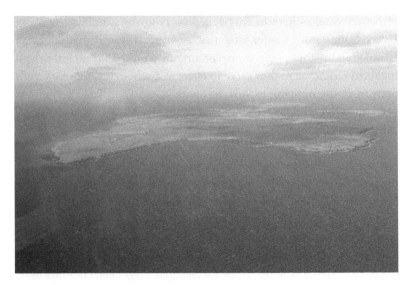

FIGURE 21. Papa Westray from the air. Photograph by author.

Islands before and after History 167

the eponymous no-place of Thomas More's *Utopia* remains perhaps the best-known example)—the list could go on. Then there are the no less various inhabitants of islands, long-term and transient, human and other: pirates, voyagers, castaways, convicts, hermits, holidaymakers, fishermen, farmers, migrating birds, shoals of fish on the move (and the boats that follow them), marine mammals, pulling themselves ashore to give birth (as the seals do every spring here in Orkney), vegetation, sand, and rock in varying combinations, fragments of driftwood, and the continuous action of the sea, resculpting the island's apparently solid contours, year after year, century after century.[2]

Anthropologists, of course, have often written about islands, whether as a quintessential setting for Malinowskian participant-observation fieldwork or as spaces of intercultural contact and exchange—notably between Europeans and the various populations they encountered through voyages of trade, exploration, or colonial expansion.[3] Yet islands, as we shall see, can also be settings for a variety of other encounters: between the living and the dead, between solid and liquid modalities of matter, between humans and a range of other-than-human presences, and not least between human-centered, culturally calibrated time and the more expansive temporalities of environmental and geological change. In 1953, long before he found international fame as a philosopher, a young Gilles Deleuze (who was working at the time as a teacher at Orléans High School) published a short essay called "Desert Islands."[4] Deleuze was interested in islands primarily as a source of creativity and new beginnings, demanding as such a particular kind of attunement to one's environment on part of their human inhabitants. According to Deleuze, there are two principal kinds of islands: continental ones, which are broken-off shards of existing landmasses, and oceanic ones, which are the result of the petrification of coral reefs or of magmic upwellings from beneath the ocean floor, rising, cooling, and solidifying to create new formations. Both kinds of islands testify that the elemental "strife" of land and sea is not yet at an end (much as humans residing in more densely populated localities might like to pretend otherwise) and that the forms of the existing world are not and never will be definitively fixed. The strife of land and water is one that precedes and will continue beyond the limited time span of humans' presence on earth: "Islands are either from before or for after humankind."[5] In this sense, for Deleuze, all islands are in effect desert

168 *Islands before and after History*

islands, belonging to a time at once pre- and posthistorical. The arrival of humans, whether as migrants, colonists, or castaways, does not put an end to the desertedness of desert islands but rather completes it, bringing it to consciousness of itself. Human imaginings about islands participate in and carry forward the movement—the élan—that gives rise to islands themselves. But the individual human imagination is not capable on its own of immersing itself fully in such a movement. To do so requires the engagement of the collective imagination, as revealed most profoundly in the guise of ritual and mythology. For Deleuze, mythology is not an explanatory framework imposed on reality—not something simply willed into existence but a human creative act participating in and giving expression to the other-than-human creative energies that produce islands as privileged sites of new becomings.[6] The creativity exemplified by islands is a matter of re-creation, of beginning again, rather than beginning from scratch. This second creation, the act of re-creation, affirms creativity itself as an ongoing and endlessly open-ended process, a capacity not to create ex nihilo or simply to repeat what has gone before, but to repeat and differ.[7] The beginning anew associated with desert islands in effect usurps the privilege of any single, unique, and self-identical origin: "In the ideal of beginning anew there is something that precedes the beginning itself, that takes it up to deepen and delay it in the passage of time. The desert island is the material of this something immemorial, this something most profound."[8] As such, desert islands (meaning in a sense all islands) evoke a principle of originary difference that remains inassimilable to chronologically marked time.

sixteen

Papay Gyro Nights

No less than the Pacific region that the Tongan-Fijian anthropologist and writer Epeli Hau'ofa describes so evocatively, the North Atlantic is a "sea of islands": Orkney, Fair Isle, Shetland, the Faroe Islands, Iceland, Greenland—stepping-stones for some, final destinations for others; the "lives lived in the shadow of Arctic eschatology" that so captured the imagination of the English writer Sarah Moss.[1] Papa Westray (Papay) is the second smallest and second most northerly of the Orkney Islands, an archipelago lying nine miles north of the coast of Caithness on the mainland of Scotland and comprising about seventy islands, twenty of which are inhabited. In terms of the distinction borrowed by Deleuze from geological science, the islands of Orkney could be said to be of the continental type. Their formation, however, long predates the contours of present-day Europe. They are the remnants of a mountain chain formed between 400 and 600 million years ago by a collision between long since dispersed prehistoric supercontinents—the great southern continent of Gondwanaland and the great northern one of Laurasia—both of which came to form part of the supercontinent of Pangaea, the ongoing breakup of which forms the basis of the current global deposition of continents.[2] Stresses and fractures in the earth's crust after the collision created depressions in the crust that filled with drainage water, forming a giant freshwater lake—Lake Orcadie. Its waters teemed with a multitude of what are now apt to seem bizarre life-forms, like the armored fish (*Pterichthyodes milleri*) whose remains, fossilized by the compaction and hardening of sediments, have been uncovered in vast numbers throughout Orkney

and Shetland and along the adjacent coast of mainland Scotland. Elsewhere, the sediment-trapped remains of these and other marine organisms, geothermally heated and worked on by anaerobic bacteria living below the lake floor, were transformed over millennia into the oil and gas that continue to be pumped so profitably from the North Sea to the terminal built in the 1970s by Occidental Petroleum on the southern Orkney island of Flotta. As the continents were forced apart by magma welling up from the earth's core—Europe separating from North America and the Atlantic Ocean opening up between them—the mountain ranges were eroded by the sea to form the present-day island chains, a process that continues today and that will eventually cause the islands of Orkney and Shetland to disappear beneath the waters from which they first emerged.[3]

The earliest evidence of a human presence in Orkney dates from around 6500 BCE. Successive waves of incomers followed, including the Neolithic builders of Knap of Howar, arguably the oldest surviving house in Europe, here on Papa Westray, of the Skara Brae settlement on Orkney Mainland, and of the stone burial cairns that dot the Orcadian landscape. The Neolithic settlers were in turn followed from the eighth century by the Norse sea raiders, later turned farmers and fishermen, who

FIGURE 22. Papa Westray airport. Photograph by author.

became the dominant presence in Orkney, leading to the islands' annexation to the kingdom of Norway in 875. The earldom of Orkney, comprising Orkney and Shetland, was transferred to the crown of Scotland in 1468 as part of a marriage settlement, and it in turn became part of the British nation-state with the Acts of Union of 1707. Today, the islands of Orkney are home to some 20,000 people, most of them concentrated on Mainland, the largest island. The sea has continued to play an important role in the life of the islands, not only through commercial fishing, which declined sharply over the course of the twentieth century, but also through the onetime involvement of Orcadians in the whaling industry, and more recently through the region's role in pioneering and developing marine energy technologies.[4] Over the centuries, however, the sea has been as much a cause of death as a source of livelihood, as winter storms and fast-running currents have claimed the lives of innumerable ships' crews. The wrecks submerged beneath Orkney's coastal waters were further added to by military vessels sunk during World War I and World War II, when Orkney was the headquarters of British Grand Fleet. Today, these same wrecks are also a lucrative source of tourist revenues, as every summer, parties of divers visit the islands to explore them. While many of the smaller islands have suffered from declining populations in

FIGURE 23. Knap of Howar, Papa Westray, Orkney. Photograph by author.

the twenty-first century, that of Papa Westray was shown by the 2011 U.K. census to have increased during the preceding decade by 35 percent to a total figure of ninety people, comprising a mixture of farmers and farm workers, fishermen, a nurse, a schoolteacher, a number of retirees, and several full- and part-time employees of the island's community-run store.[5]

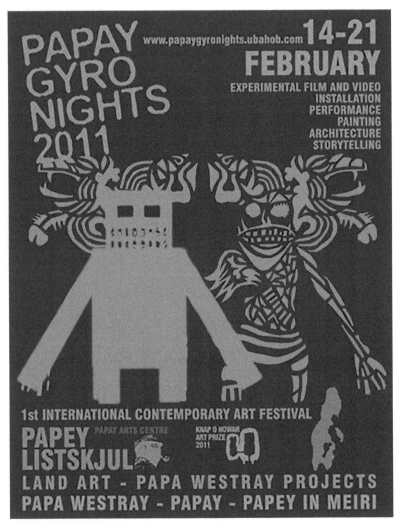

FIGURE 24. Papay Gyro Nights 2011, promotional flyer.

The occasion for my visit to Papa Westray (and for Raggie's lecture) was Papay Gyro Nights, a weeklong festival organized by Sergei Ivanov and Tzs Man Chan (known as Ivanov and Chan), two artists raised in Kyrgyzstan and Hong Kong, respectively, who moved here from London ten years ago. They established a studio and arts center (known as Papey Listskjul) at Tredwall, near the southern end of the island, and since then have contributed a daughter, now seven years old, to Papay's modest population boom of recent years. Beginning with Ragnhild's lecture and a torchlight parade and bonfire, the week's events included exhibitions, installations, film screenings, live music, storytelling, and an ongoing painted record of the proceedings in the form of a series of canvases produced on daily basis by Armando Seijo, a Spanish-born and now London-based artist whose work has also included the live documentation of musical performances and political protests. The name and inspiration for the festival derive from the eponymous figure of a giantess featured in the so-called Gyro Nights once celebrated on the island. The following description appeared in 1923 in the *Proceedings of the Orkney Antiquarian Society*:

Then there were the "Gyro" nights. I wonder if such a thing ever takes place in any other of our islands. . . . Each of the smaller boys got a long bundle of simmons [ropes made from straw, heather, or rushes] and got it lit and so had a torch. This was to entice the "gyros," the hobgoblins. Then we generally kept in pairs. Sometimes we would light a fire and desert it. Then the "gyro" would be drawn away to this fire. Sometimes we formed into a procession, but the procession soon broke up when the "gyro" got after us. The "gyro" was just one of the bigger boys with a mask on. The "gyros" generally went in pairs, and might be dressed simply like two old women. By this disguise we were very often cheated, as it was no unusual thing for one good woman to be visiting another, and one would be accompanying the other part of the way home. But sometimes the disguise of the "gyro" was quite unmistakeable. He might have on some grotesque headgear, then some woman's garment about the body, and about the legs he would have some loose simmons tied round his waist by a piece of rope.

If the "old woman" turned out to be a "gyro" we very soon knew, as each of them had concealed about his person a piece of rope or a tangle, and we very soon felt the weight of it somewhere on our body. Of course

we had to run for dear life, and sometimes when we did run at our best we were caught and just received as many strokes as the "gyro" was pleased to give us.[6]

The author, John Drever, a native of Papa Westray now residing on Orkney Mainland, recalls his own childhood on the island, presumably around the turn of the twentieth century. What Drever describes combines elements of a game of chase and of cross-dressing performance involving the male assumption of a deliberately exaggerated female persona, in this case the figure of the old woman incarnated by the older boys with their masks and improvised costumes. Drever notes that these games took place only in February, toward the end of winter, and that at this otherwise dark time of year it was not unusual to see the fields above his parents' house brightly illuminated by the firebrands carried by the younger boys. Eighty-nine years after the publication of Drever's account, the burning "simmons" used to entice the costumed *gyros* to pursuit were evoked in the torchlight parade and bonfire that marked the opening of the Gyro Nights festival as a group of twenty or so islanders and visitors processed down the narrow road leading from Papay's community center and shop to the old pier. On this occasion, high winds and intermittent rain necessitated repeated relighting of torches and the bonfire had to be fueled with liberal quantities of gasoline to achieve ignition.

The festival, however, was anything but an exercise in revivalism. Rather, it was the deliberate staging of an encounter between a folkloric figure from the island's past and a range of decidedly contemporary artworks in a variety of media. Participating artists were invited to create site-specific works or to display existing works in ways that responded to the singular materiality of the island environment by drawing inspiration from the composite figure of the *gyro*. It seems appropriate, therefore, that my own presence on Papa Westray that week was itself the result of an unexpected encounter. I spent the academic year 2010–11 on sabbatical as a visiting research fellow in the department of anthropology at the University of Edinburgh. I had a long-standing curiosity about Orkney, fueled in part by my reading of the Orcadian poet and novelist George Mackay Brown, and had conceived the idea of developing a new research project based there, but at the time I had no clear sense of what form this might take. Then in January 2011, at the end of a brief visit to

Kirkwall, Orkney's main town, I chanced across a flyer advertising "Papay Gyro Nights 2011: International Contemporary Art Festival." Intrigued, I took note of the details, and on returning to Edinburgh, I looked up the festival's website. I was struck most of all by the use of ostensibly folkloric sources in a decidedly nonantiquarian manner, as a catalyst to produce new artistic engagements with the island environment, or, as Deleuze might put it, an invitation to fabulate:

> Against reconstructing what is gone and almost forgotten, the Festival is a reflection on the folktale, the island's landscape and heritage, as well as an interpretation of tradition and ritual, through new developments in art and architecture. The Festival is a Research lab, learning hub and the place for discussion about the interaction between new media and ideas in relation to tradition, ritual and the island's landscape and heritage. During the Festival the island is transformed into an art space and artworks are screened and exhibited in old farm buildings, the boathouse, workshops, ruins and the open landscape.[7]

I decided immediately that I wanted to attend, made travel and accommodation arrangements, and several weeks later found myself at Kirkwall Airport waiting to board a flight to Papay. What ensued was a remarkable week of exhibitions, film screenings, and performances in various locations around the island; conversations with islanders, artists, fellow visitors, and festival organizers; many hours spent exploring the length and breadth of the island on foot; and weather that ran the gamut from sunshine and clear blue skies to roof-shaking winter storms. On returning to Edinburgh, I began writing a piece about the festival, describing my reactions to some of the featured artworks. I sent a draft of what I had written (on which the present section of this book is based) to Sergei and Tsz Man. We corresponded, and I visited them again during the summer. Since then, we have become friends and regular collaborators. In addition to observing, documenting, and writing about successive Gyro Nights festivals, I have also become a regular participant, presenting lectures and readings based on my ongoing research and contributing articles to *Snæ* (Icelandic for "snow"), a "boogazine" published annually in conjunction with the festival. We have also undertaken a number of collaborative presentations in exhibition spaces and at festivals across the

North Atlantic region and beyond: at Bergen Kjøtt, a gallery and studio space in Bergen, Norway, at the "G!" music festival at Gøta on Esturoy in the Faroe Islands, and most recently in spring 2016 at the Cattle Depot Artists' Village in Kowloon, Hong Kong.

In writing about Papay Gyro Nights, I decided from the outset that my aim was not to produce an ethnography of the festival. I had no wish to frame it as a social scientific object, or to impose my own explanatory framework on it through an appeal to context, community, social relations, culturally mediated perceptions of landscape and environment, or anything else. Such a gesture, I thought, would inevitably amount to a betrayal of the creativity of the participants and organizers and of the island itself as an active and unpredictable presence, as well as of the sense of excitement and possibility that I felt at the time of my first visit and have continued to feel over subsequent ones. Instead, I wanted to enter into the spirit of the invitation that the festival seemed to extend and that seemed to echo Deleuze's (and others') characterization of islands as places of encounter. This was an invitation to open oneself to the possibilities of such encounters—encounters with works of art, with humans and other kinds of beings, with the past as manifested in the form both of stories and of the archeological and geological record, and of course with the materiality of the island and of the ongoing contention of land and sea to which it bears witness. What follows is a series of fabulatory responses to the promptings of artworks, environment, and people—responses that seek not to explain or represent but to embody and carry forward the transformative impetus of the encounters in which they originate. In doing so, I have allowed myself also to pursue a series of comparative tangents inspired both by the festival's appeals to history and folklore and by my own reading—tangents that in some cases carry us far from present-day Orkney.

"HERE COMES GRÝLA"

First, who were the *gyros*, and where did they come from? Taking our lead from an earlier, philologically inclined genealogist, Nietzsche, let's begin with the name. The name *gyro* appears to derive from the word *gyre*, meaning ogre or ogress in the Norn language, a relative of Old Norse formerly spoken in Orkney, Shetland, and Caithness in the far north of the Scottish mainland, and surviving in isolated pockets in

Orkney and Shetland until the nineteenth century.[8] Orcadian linguist and schoolteacher Hugh Marwick, in his 1929 study of Orkney Norn, defines *gyre* as "a fabulous creature, an ogre" or "a powerful and malignant spirit" and traces its derivation to the Old Norse word *gýgr*, meaning "ogress" or "troll woman."[9]

The etymology proposed by Marwick is echoed by the majority of folklore scholarship, including Drever's childhood recollections and Raggie's lecture, as well as by the festival's website. All of them suggest that the antecedents of Papa Westray's Gyro Nights are to be sought in the repertoire of stories and masked and costumed performances documented across the islands of the North Atlantic, and presumably carried by the Norse voyagers who began to settle in Orkney, Shetland, and later the Faroe Islands and Iceland from the seventh century onward. On the islands of Unst and Mainland in Shetland, lying a hundred nautical miles to the north of Orkney, accounts from the early nineteenth century to the early twentieth century describe groups of young men known as *grøleks* going from house to house during the Christmas and New Year period wearing high plaited straw hats, veils, and dresses of plaited straw and black material; one would carry a sheepskin bag to receive offerings of food. On the islands of Yell and Fetlar (also in Shetland), they were known as *skeklers* and would also appear at weddings, where they would demand to dance with the bride and members of her party. Like the term *gyro*, the terms *grølek* and *skekler* have been identified as referring to an ogress or female troll-like creature. In addition to wearing costumes and face coverings, both groups of performers also seek to retain their anonymity by abandoning normal speech patters in favor of animal-like grunts or "reversed speech" (inhaling while speaking).[10]

A Faroese counterpart to the *gyros* of Papa Westray has been identified in the costumed figure of Grýla, a female monster or ogress, again portrayed by a boy or man and combining a variety of animal and human, terrestrial, and marine attributes, including animal skins, horns, one or more tails, seaweed, and fish guts, with store-bought plastic masks a more recent addition. Grýla's appearances, visiting a succession of houses to demand offerings of clothing, food, or drink, are described in accounts from the eighteenth century to the present and are associated in particular with *Grýlukvöld*, the first Tuesday in Lent. An account from the turn of the twentieth century describes the Grýla costume worn by two poor

FIGURE 25. Children from Fetlar, Shetland, dressed as *skeklers*. Photograph by Arthur Nicolson (1909). Shetland Museum and Archive.

children, a brother and sister from Miðvágur. In addition to covering themselves with seaweed, which was hung over their shoulders, tucked in to their belts, wrapped around their heads, and draped behind them like a tail, they also wore animal skins around their necks and fish guts drawn up on their arms "like muffs," along with blackened faces. Thus attired, they would visit houses collecting gifts of food and clothing.[11]

A more detailed but overtly fictionalized account of such a figure, based on contemporary eyewitness descriptions from the island of Svonoy and emphasizing Grýla's physical oddity and prodigality, is to be found in the 1957 short story "Grýlen" by Faroese writer William Heinesen (1900–1991). Here Grýla's costume is described as comprising horns, fur, wood, rags, a doglike snout, and, despite her avowedly feminine gender, a large wooden phallus. She is described as having a "horned head," as being "huge, much like a stack of peats," and dragging a "long rustling tail behind her," which "rattles and bumps like empty pots and kettles." Occasionally she "stretches herself full length with her snout on the ground." At the climax to her tour of the island, she raises herself as high as possible

Papay Gyro Nights

before falling to the ground as if dead. Heinesen's protagonist exhibits another frequently recorded feature of Grýla performers and their Shetlandic counterparts, the *grøleks* and *skeklers*: their use of vocal disguise, eschewing ordinary speech in favor of grunts or guttural monosyllables, suggesting, for many observers, not only a desire to conceal the performers' identity but also a powerful association with forces issuing from beyond the bounds of human society.[12]

In Iceland, grotesque or exaggerated female figures were a feature of the *vikivaki* games associated with Christmas and the New Year and described in accounts from the eighteenth century. These included Háa-Þóra, a giant woman constructed around a large pole carried upright by the (male) performer. Her costume featured a tall woman's headdress, a white scarf, and a long black coat draped across a second pole fixed at right angles to the first, together with a bunch of keys that the performer would shake. She always appeared from outside the room, flanked by two shield maidens (*skaldmeyjar*), accompanied by the singing of mocking and ribald songs. Another female figure impersonated by a male performer featured in the *kerlingarleikur* (old hag game). This involved four characters, the central pair being a mother, known as the old hag (*kellingin*), and a daughter, who, like Háa-Þóra, carried a bunch of keys. According to one mid-eighteenth-century description, the daughter was smartly attired, but the mother resembled an ogress:

> She is dressed up in the following fashion: first of all a hairy dogskin bag is filled with flour, and this is forced onto her head and firmly bound under her chin. She is then clad in a ragged dress of horsehair sacking which reaches down to her backside. Apart from this she is covered in old flour bags, and other rags and tatters. A mask with spectacles on covers her visage. She has a fishskin bag on her back and some tattered seaman's gloves on her hands. Dressed like this she totters along to the living room door.[13]

Although none of the figures featured in these Christmas entertainments is identified as Grýla (and there is no documented tradition of costumed Grýla performances in Iceland), stories continue to be told to the present of a figure named Grýla, who appears not at the beginning of Lent but at Christmas to abduct badly behaved children, carrying them off in her sack. Sometimes she is described as the mother of the *julesveinar* (Yule

180 *Papay Gyro Nights*

lads), who are said to descend from the mountains to visit households at the same time of year, originally to steal and play pranks and more recently (and benignly) as bestowers of Christmas gifts. The name Grýla is recorded also in early written sources, including the saga literature composed in the thirteenth and fourteenth centuries.[14] In the historical *Íslandinga Saga*, dating from the mid-thirteenth century, the character Loftr Pálsson, riding to attack his enemy, Björn Thorvaldson and his followers, recites the following verse: "Here comes Grýla, down into the field, / with fifteen tails on her."[15] Strikingly similar verses have been recorded at much later dates in conjunction with costumed performances in the Faroe Islands and Shetland, which again involve male performers placing themselves in the role of Grýla.[16] Loftr's self-description suggests that Grýla is an intruder into the human realm issuing from the area beyond the cultivated, settled land. It thus recalls the distinction between the "social" and the "wild" that Hastrup and others would later identify as central to medieval Icelandic conceptions of space. The wild here, as Hastrup notes, represented not only the realm beyond human settlement and the reach of law but also the dwelling place of a variety of other than human presences, imagined as predating the arrival of Iceland's earliest human settlers, including the *huldufólk*, one of whose number Hastrup herself would claim to have encountered on a mist-shrouded mountainside in the 1980s. What linked these multifarious outliers (or *útilegumenn*) for Hastrup was a shared identification with "nature" in its untamed, undomesticated state as a presence that could not be controlled, predicted, or otherwise harnessed to human ends.[17] If Hastrup's structuralist-influenced account is concerned primarily with the classificatory ordering of space, the distinction between the social and the wild functioning as a local variant of the Lévi-Straussian core opposition between nature and culture, then it is also striking that in the passage quoted, Grýla's implied association with the realm beyond the bounds of law, home, and farmstead and with a time prior to human settlement is again conjoined with a reference to her extravagant physicality, her fifteen tails suggesting an unruly excess of corporeality that appears no less at odds with the stipulations of legal and social personhood.

If the wayward materiality of Grýla's physical being is underscored both in verbal descriptions like the Grýla verse uttered by Loftr—and its Faroese and Shetlandic variants—and in the details of the costumes

worn by her male impersonators, it is surely worth speculating as to the extent to which this has influenced her subsequent interpretation by folklore scholars as a point of contact between the latter-day folklore record and a pre-Christian Scandinavian past that is otherwise documented only in written sources dating from after Iceland's official adoption of Christianity in 1000 CE. References in the sagas and in later folk performance and poetry have led many commentators to identify Grýla as a counterpart and descendant of the giantesses, ogresses, troll women, and other monstrous female figures so abundantly documented in the folktales of Scandinavia and the North Atlantic, and whose own ancestry has often been traced in turn to the pre-Christian cosmologies of the early Norse voyagers.[18] The fact that in Iceland Grýla (like the *grøleks* and *skeklers* of Shetland) makes her appearance not in February but over Christmas and New Year has led folklorist Terry Gunnell to suggest that the timing of the Faroese Grýla performances and the Gyro Nights of Papa Westray to coincide with the end of winter and the beginning of Lent may be a relatively late development influenced by Christianity and that previously they too may have been associated with year's end.[19] If this is the case, then Grýla and the *gyros* would join the ranks of other masked and costumed performers, often incarnating spirits of the dead or beings of combined human–animal character, making their appearance during the depths of winter, or more specifically in the twelve days between Christmas and Epiphany. Given the seemingly pre-Christian provenance of such midwinter masking practices, Gunnell feels justified in identifying Grýla as a potential "missing link" between the recorded corpus of folk narratives and performances and an otherwise vanished world of pagan Scandinavian ritual and belief in which, he suggests, the wearing of horns, animal skins, and other attributes played a central role.[20]

Nonetheless, many unanswered questions remain. Why does the use of animal disguise combine elements of several species (both marine and terrestrial), along with a number of recognizably human features, and why should such a combination of attributes be so powerfully evocative of a past that is otherwise understood to be accessible only in fragmentary and thoroughly mediated guise—a past that appears moreover to reside on the very cusp of documented history and cosmogonic myth? Why should a female figure, albeit a monstrously distorted one—and one usually represented, furthermore, by a male performer—provide the

privileged vehicle for the persistence of such a past, and thus in effect for modern folklore scholarship's own attempted summoning of mythic prehistory, the pagan dead, and the repertoire of metamorphic, storied beings accompanying them?

It is worth remembering that the twelve days of the Christian liturgical calendar, like the pre-Christian midwinter celebrations on which they were superimposed, appear, as Frazer and Duerr remind us, to have been widely understood as a ritually demarcated rupture in the everyday marking of time and as such falling outside the familiar succession of days, months, and years. For Duerr, such "times between the times" involve the transformative unmaking and remaking of the world as participants not only commune with the dead but also become them through a shared immersion in the metamorphic material substance of creation— an operation that, as Duerr suggests, can only be accomplished by stepping outside conventionally marked time and into something resembling the flux of Bergsonian duration.[21] We need to be cautious, therefore, about assigning to such temporal breaks the status of historical antecedents capable of explaining subsequently occurring events. To do so risks reintegrating them into the familiar order of chronology, whereas their transformative potential consists precisely in their capacity to disrupt this, revealing its own provisional and constructed character by exposing it to the world-altering power of the time of becoming. Is it not just such generative resistance to periodization that we need to bear in mind when considering how the nexus of associations so often posited by folklore scholarship between the pagan past, the dead, the specifically gendered iconography of Grýla, and the hybrid, unstable, and extravagant corporeality that she incarnates?

Back to the early twenty-first century.

MOTHER

Mother is the title of a computer-generated artwork by Genetic Moo, a British group active since 2008, comprising Nicola Schauerman and Tim Pickup. Drawing on a combination of evolutionary science, computers, and myth and fantasy, their work involves the creation of imaginary creatures, or in some cases digital ecosystems, many of them capable of interacting with audiences by evolving, moving, multiplying, or otherwise changing in response to their input: "Since 2008 we have been developing

FIGURE 26. Holland Farm, Papa Westray, Orkney. Photograph by author.

a series of interactive creatures based on imagined future evolutions. In dark spaces audiences engage with fantastical organisms combining elements of the human and the animal."[22] *Mother* consists of close-ups of human body parts, along with animal, plant, and sea-life material. These dissolve, recombine, and mutate in accordance with preprogrammed parameters; no two showings are ever exactly the same. Genetic Moo's website describes the piece as "a swirling mass of ever changing entrails," adding, "During development we imagined that it could contain, and in some way give birth to all our previous creatures and titled it accordingly."[23]

At Papay Gyro Nights, *Mother* is shown in two locations—by day in a disused grain loft above a cattle shed on Holland Farm (the largest farm on Papay and formerly home to the island's onetime landed proprietors) and by night in a former kelp store near the Old Pier at Nauster on the eastern shore. I see it first in the grain loft, a long, narrow space with a gabled roof, often used for community dances. The space is divided in two by a partition wall with a wooden door. On the afternoon in question, the far end of the space is being used to screen a succession of experimental short films, while *Mother*, projected against the partition wall, greets the visitor entering from the external stairs that provide

FIGURE 27. Genetic Moo, *Mother*. Photograph supplied by Genetic Moo (Nicola Schauerman and Tim Pickup).

access from ground level. The space is otherwise in darkness with a continuously playing CD as an accompanying soundtrack—*The Quiet North* (2010)—a far-from-quiet tumult of electronically generated sound by Norwegian noise musician Lasse Marhaug. A further sensory element is provided by the faint, sweetly putrescent, and altogether unmistakable smell of cow shit that drifts upward from the lower level. On the partition wall, a continuously changing amalgam of colors and shapes swirls, pulses, and mutates. Occasionally a recognizable or near recognizable form emerges into visibility—a tentacle, a palpitating organ, what looks briefly like a human face—only to dissolve back into the ongoing flux. All the while, Lasse's sound piece screams and contorts in the darkness.

I stand mesmerized for twenty minutes, maybe more. I move closer, then farther away. I lean into the projector beam so that my shadow falls across the writhing mass—according to Genetic Moo's website, this is a common way for audiences to interact with the piece, especially when it is projected onto the horizontal surface of a gallery floor.[24]

Tim Pickup (half of Genetic Moo) tells me in an e-mail that Sergei, one of the organizers of the festival, described an earlier iteration of *Mother* as a "bowl of flesh soup"—a characterization that I find both apt and appealing.[25] Viewers' reactions to the piece have apparently ranged from entranced fascination to unease, discomfort, or even fear. My own response partakes of all of these. I'm compelled by the strangeness of the shifting shapes and colors, drawn to move closer, to scrutinize the almost (but not quite) recognizable forms that emerge from and fade back into the mass. At the same time (as the title of the piece suggests), there's an undeniable and disconcerting recognition of kinship, of the fact that the pulsing, multifarious, impersonal life revealed here is also what throbs in my veins and arteries, fires in my neurons, and quickens at my fingertips. Tim tells me, "We wanted to make a containing creature that could be imagined to give birth to all our other creations . . . and found a Greek mythological character called Echidna, who was called the 'Mother of all monsters.' So that is how we named it."[26] In the account of the creation of the universe given by the eighth century BCE Greek poet Hesiod in his poem *Theogony*, Echidna is described as a being of dual nature, from the waist up a beautiful nymph but below a monstrous serpent. Immortal, she is confined to a cave beneath the earth, where she mates with her no less monstrous uncle, the hundred-headed Typhaon, to produce a brood of fearsome, hybrid, and extravagantly overendowed progeny, including the fire-breathing chimera, part lion, part goat, and part serpent, and the three-headed dog, Cerberus, who guards the entrance to Hades, the abode of the dead.[27] It seems appropriate that the figure who inspired *Mother* should number among her offspring the guardian of the underworld, the place where, according to later accounts by Homer and others, the dead live out an attenuated but still eerily palpable existence as shades, capable on occasion of meeting and interacting with the living. *Mother* is, after all, as much about death as life. The vision of living matter to which it gives expression is one in which emergence and dissolution are conjoined as moments in a process of becoming that transcends and encompasses the

life span of the individual organism, human or otherwise, and to which distinctions between life and death are, finally, irrelevant. Tim refers to *Mother* as a "containing creature" but to me at least it is evocative of something that escapes containment. The circular perimeter of the projected image suggests less a bounded totality than a partial window on a shifting, metamorphic expanse that can never be apprehended as a unified whole, an impression reinforced by the fact that each screening is different from its predecessor. This surely, as much as anything else, accounts for the documented ambivalence of audience reactions to the piece. *Mother* captivates and disconcerts by affording us an intimation of our immersion as human subjects and as living beings in a life process that both precedes and surpasses our existence as individuals and thus of death not only as the cessation of that existence but as its unacknowledged precondition. As a generative matrix of potential forms, *Mother* is at once all the living and all the dead.

seventeen

The Time of the Ancestors?

Orkney is an environment densely marked not only with the mineralized remains of long-extinct life-forms but also with the archaeological after-traces of now vanished human populations, along with the shipwrecked and the drowned, resting invisibly beneath the waves. It is a setting in which the dead and the material record of their passing appear to merge into a more expansive evolutionary and planetary chronology. The Neolithic settlers who were the builders of Orkney's chambered burial cairns arrived in the islands around five and a half thousand years before the present, probably crossing Pentland Firth in skin boats from the vicinity of Caithness on the Scottish mainland.[1] In addition to farmsteads and dwellings, they also built structures to house their dead. These vary in the details of their construction, but they characteristically take the form of a stone cairn enclosing a rectangular chamber, sometimes subdivided by upright slabs and accessed by a low, narrow passage requiring the visitor to stoop, or in some cases to crawl. Archaeologists have pointed out parallels between the layout of the chambered burial cairns and that of surviving Neolithic dwellings like Knap of Howar on Papa Westray or the houses comprising the village of Skara Brae on Orkney Mainland, suggesting that the tombs were conceived of by their builders as houses for the dead. This in turn has fueled speculation that the Neolithic period in northwest Europe (and elsewhere) marks a shift in attitudes toward the dead, and by extension the emergence of a new conception of time, both of which are materialized in the archaeological record. Alasdair Whittle, for example, writes that the Neolithic ushered in what he calls "the time

187

of the ancestors"—a conception combining a sense of continuity between past and present, living and dead, with a new awareness of lineal descent whereby the living were able to articulate their own ancestry and their own constitution as a descent group by way of a sequence of forebears culminating in the present generation. It was, he suggests, the need to accommodate the remains of these newly differentiated collective ancestors that prompted the building of tombs as houses for the dead, including the chambered cairns that remain such a visible feature of Orkney's present-day landscape.[2]

Nonetheless, if the archeological scholarship of recent decades has sometimes been inclined to find in Neolithic funerary architecture the expression a newly differentiated view of the ancestral dead, coupled with an emergent sense of lineal chronology, then its findings have also demonstrated the extent to which the efforts of Orkney's Neolithic settlers to objectify and commemorate their dead have been effaced or undone by the millennia that have passed between the building of the tombs and latter-day archaeological interpretations of them. For all the

FIGURE 28. Cuween Hill chambered cairn, near Finstown, Orkney Mainland. Photograph by author.

The Time of the Ancestors? 189

sophistication of current techniques of dating and analysis, the dead whose remains were housed in Orkney's chambered cairns remain resolutely anonymous. Indeed, the material record presents an often confusing and uncertain picture with regard even to the deposition of remains. The largest and best known of Orkney's burial cairns, Maes Howe, situated between Kirkwall and Stromness, has not been found to contain any human remains beyond a few skull fragments intermixed with animal bones. In contrast, Mid Howe, on the west coast of the island of Rousay, housed the remains of no fewer than twenty-five individuals, some arranged in crouched burials, others grouped together in a heap of bones at the center of the main chamber. Still other tombs have been found to contain substantial quantities of both animal and human remains, like Cuween Hill, lying southeast of the present-day settlement of Finstown on Orkney Mainland, where the remains of eight human skeletons were found along with twenty-four dog skulls, prompting speculation that the latter represent a sacrificial offering or the expression of a totemic complex.[3] It has therefore proven impossible to arrive at general conclusions as to whether, for example, Orkney's chambered cairns were indeed the final resting place of the dead, whether they afforded a temporary lodging during the process of decay and decomposition, or whether remains were moved in and out of them at intervals in the course of ritual activity. In the case of Orkney's prehistoric inhabitants, one effect of this hindsight-induced uncertainty has been to blur any clear-cut distinction between the collectively recognized ancestral dead and the always prior and undifferentiated mass of the dead.

If archaeological interpretations of sites like Maes Howe have tended to see them as marking a move away from conceptions of an undifferentiated sea of the dead (like the notion of *Kalunga* that plays such a conspicuous role in Ochoa's account of Cuban Palo Monte), then it is nonetheless arguable that the actual sea that washes against Orkney's shores remained a powerful presence in the cosmologies of the region's Neolithic inhabitants. Chris Fowler and Vicki Cummings have suggested that the interplay of water and stone was a central theme in Neolithic cosmological thinking. Although the focus of their discussion is the eastern side of the Irish Sea (south and northwest Wales, the Isle of Man, and southwest Scotland), they argue that a close association between the two substances is to be found throughout the Neolithic world, finding one of its principal

190 *The Time of the Ancestors?*

manifestations in chambered tombs, understood as places of transformation and transition—both between land and sea and between the realms of the living and the dead. They point to the location of many such tombs adjacent to the shoreline or on headlands or promontories to the fact that stone from intertidal zones was often used in their construction, to the frequency of deposits of shells and pebbles, and to the decorative and depositional use of quartz as a material commonly found both in inland, mountainous regions and in close proximity to the sea. For Fowler and Cummings, drawing on analogies with recent ethnographies of Melanesia, the conjunction of water and stone that characterizes the construction and location of many Neolithic chambered tombs is revealing of a conception of personhood and of the human life course as unfolding by way of a series of transformations, finding one of their principal expressions in the transition between solid and liquid modalities of matter and culminating in death, where the sea represents perhaps the final destination of the deceased.[4]

Although some of Orkney's chambered cairns, including Maes Howe, are built at a distance from the surrounding sea, others stand in close proximity to it, including Isibister on South Ronaldsay and Mid Howe, Knowe of Yarso, Blackhammer, and Taversoe Tuick on the south coast of Rousay, while Unstan, near Stromness on the south coast of Mainland, is built on a promontory extending into the Loch of Stenness. References to the sea are also to be found among the grave deposits in many of Orkney's tombs, which include the remains of whales and other marine animals, and in the case of Isbister the bones and talons of sea eagles, giving the site its alternative name, the Tomb of the Eagles.[5]

Even when not explicitly referenced in the archaeological record, the sea is never far away; in fact, it's getting closer all the time! The Neolithic village of Skara Brae, occupied between 3180 BCE and around 2500 BCE, is the best surviving and probably the most extensively researched prehistoric settlement in northern Europe, having attracted the attention of a succession of eminent twentieth-century archaeologists, from V. Gordon Childe to Colin Renfrew.[6] Originally it stood at some distance from the sea, separated from it by sand dunes, which eventually engulfed the settlement after it was abandoned by its inhabitants (for reasons that remain unclear), only to be uncovered in the mid-nineteenth century when much of the sand was dispersed by a violent storm. Today, the remains of the

FIGURE 29. Skara Brae Neolithic village, Orkney Mainland. Photograph by author.

village, comprising a number of houses and other structures interconnected by tunnels, sit precariously at the water's edge. In response, the conservators of the site, Historic Scotland, have closed off access to the dwellings themselves in order that the effects of ongoing marine erosion should not be compounded by the feet of visitors. Nonetheless, given the continuing and unstoppable encroachment of the sea, the future of Skara Brae remains at best uncertain.[7]

The Dead of St. Magnus

Let us turn our attention from the sea to the terra firma of an island graveyard. The one in question adjoins St. Magnus Cathedral in Kirkwall, the principal town of the Orkney, situated on Orkney Mainland. Named after Orkney's patron saint and martyr, the building of the cathedral began in 1137 and was not completed for more than 300 years.[8] Its main entrance on Kirkwall's principal street is framed by two memorials, listing the names of Orcadians killed in World War I and World War II. Inside the cathedral, the remains of St. Magnus himself, originally buried at nearby Birsay, are now interred inside a pillar. Surrounding his remains

192 *The Time of the Ancestors?*

are a number of gravestones and memorials dating from the seventeenth century onward and featuring images of death along with inscriptions commemorating the deceased. More recent memorials include ones to Arctic explorer John Rae (1813–93) and poet and novelist George Mackay Brown (1921–96), arguably Orkney's most celebrated twentieth-century writer.[9]

St. Magnus Cathedral and its grounds seem at first glance far removed from Isidra's vast sea of the dead. What we encounter here are not the anonymous hosts of the dead but rather those whose passing has been marked by funerary rites and whose presence on earth is materialized in the form of inscriptions, headstones, monuments, and memorials— the transitoriness of fleshly substance replaced by an enduring body of stone. It would be a mistake, however, to draw too stark a contrast between the massed and the individuated dead. Indeed, as Sarah Tarlow points out in her archaeological study of Orkney burial practices from the late sixteenth to the twentieth centuries, the degree and manner in which the dead were individuated varies considerably.[10] One obvious contrast is between burials in the churchyard and interments within the walls of the cathedral itself, the latter at one time the exclusive prerogative of the wealthy and powerful. There are also significant variations in the scale and design of the stones themselves (from the cross on a base flanked by a sword that is the earliest surviving monument, dating from the sixteenth century, to the mass-produced gravestones of the late nineteenth century), in the extent of the information given about the deceased (name, dates, details of occupation, relationship to surviving kin), and in whether the same stone commemorates a single individual or multiple family members (husband and wife, parents and children, and so on). The cathedral and churchyard also attest to the impact of the Protestant Reformation on commemorative practices in Orkney. Protestant theology's repudiation of purgatory and the possibility of intercession on behalf of the soul of the deceased led, Tarlow suggests, to a "radical dislocation" of mortuary and commemorative practices. Images of saints and crucifixes were henceforward proscribed (along with other representative religious art). At the same time, and in partial mitigation of the increased distancing of the living from the dead that the Reformation brought about, commemoration came to assume an increasingly didactic function, whereby the deceased could be presented both as a reminder

The Time of the Ancestors?

to survivors of their own mortality and as an example of the virtuous Christian life that the living could emulate. The material record provides evidence of this shift in the seventeenth-century and later bas-relief memorials that are a conspicuous feature of the cathedral interior and that typically include a visual representation of the deceased, heraldic imagery emphasizing his or her social status, an inscription sometimes incorporating a didactic message, and a generic image of death, often a skull or an hourglass.[11] One example, dating from the eighteenth century, commemorates Mary Young (d. 1756), wife of John Riddoch, a magistrate of Kirkwall ("She lived regarded and died regretted").[12]

The image's power is attested by the fact that it continues to attract the attention of present-day visitors to the cathedral: the kneeling figure, her eyes raised heavenward, her hands clasped in prayer, framed by emblems of mortality, the origins of which extend back to the pre-Reformation Middle Ages and beyond. No doubt, as Tarlow's account so eloquently demonstrates, there is much to be learned about and from it by reconstructing the initial circumstances of its production and reception. Yet perhaps there is also something here that escapes or exceeds the explanatory power of context. Doesn't the power of the image derive in part from its lingering at the interface between the particularized deceased and the nameless and numberless hosts of the dead? Perhaps what continues to compel the spectator (the twenty-first-century one as much as the eighteenth-century one) is precisely the fact that in depicting a named individual, it also evokes the still anticipated but nonetheless inevitable death of everyone.

Their differences notwithstanding, it is tempting to see all such acts of commemoration as gestures of solidification intended to push back the sea of the dead, just as the actual sea, which once washed close to the cathedral, has been pushed back over the centuries by a series of land reclamation projects. But is the sea of the dead really so far away? Decades or centuries of Orcadian weather—including persistent rain and winter storms—have rendered many of the inscriptions in St. Magnus churchyard undecipherable. Others have been grown over by moss and lichens, accretions of animate matter transforming incised text into a semiabstract surface of green and gray, out of which there occasionally emerges into legibility a date, name, or term of relatedness—husband, wife, daughter, son. Those able to afford the distinction of an intramural burial have

FIGURE 30. Memorial to Mary Younge (d. 1756), St. Magnus Cathedral, Kirkwall, Orkney. Photograph by author.

often fared little better.[13] Renovations to the cathedral during the late nineteenth and early twentieth centuries resulted in the wholesale removal of many of the remains interred beneath the floor of the nave and their reburial en masse in a pit outside.[14] At the same time, all those who lie in the cathedral and churchyard are underlain by a host of earlier occupants whose presence is no longer recorded, while the Christian burials housed in the vicinity of St. Magnus are surrounded by traces of the now anonymous, pre-Christian dead in the guise of the Neolithic chambered tombs interspersed across the Orcadian landscape, the largest and best known of which, Maes Howe, lies about fifteen miles west of Kirkwall.[15]

Where Do They Come From?

It would seem that from the perspective of the *longue durée*, gravestones and memorials are no more than temporary expedients and that it is the fate of the (more or less) individuated dead to be absorbed back into the undifferentiated mass of their forebears, like the Mongolian shamans described by Caroline Humphrey, who are believed after death to be amalgamated gradually with the anonymous powers animating the landscapes in which they once lived.[16] Where do they come from, then, these

FIGURE 31. Gravestones, St. Magnus Cathedral, Kirkwall, Orkney. Photograph by author.

hosts of the dead, swarming in the depths of the sea, billowing in the air, swirling across the boreal night sky? Are they simply humanity's accumulated past, the aggregate of all those who have lived and died and slipped from the memory of those still living? Many narratives of encounters between the living and the hosts of the dead seem to suggest just such a possibility. Think, for example, of the Europewide repertoire of stories relating to the Wild Hunt, a raucous, nocturnal, sometimes airborne animal–human cavalcade in which spectators have sometimes claimed to identify the figures of recently deceased relatives, new recruits, as it were, to the massed ranks of the dead, who have not yet sunk wholly into the anonymity of forgetting.[17] Do we not find here an explanation of how the invisible crowd of the dead has been constituted and added to over the course of human history by the sum total of individual deaths?

Marcel Granet, writing of the religion of ancient China, suggests a different possibility. Granet argues that the primacy of the collective over the individual—a view that underpinned the sociology of his onetime teacher, Émile Durkheim—applies no less to the relationship between the dead and the living. The vision of the dead as an amorphous and undifferentiated mass was, in other words, prior to any conception of the named and individuated dead. The dead, however, in Granet's account, feature less as a collective representation than as a primordial substance. Granet finds the earliest religious conceptions to be embodied in the ancient beliefs and practices of the Chinese peasantry. A central place in peasant religion was occupied by the earth as a source of fecundity. A bond of consubstantiality linked the earth to its human inhabitants, and a similar bond conjoined the living and the dead. The dead were subject to a double ceremony of burial. Initially they were interred within the family compound for the time it took the flesh to rot, so that "the stuff of the dead entered the domestic Soil," after which their remains were transferred to an ancestral graveyard forbidden to all who were not family members. The view thus arose, Granet suggests, that the conception of new life was the work of fecund powers emanating from the soil where the dead themselves became absorbed into the maternal substance of the earth. The living were understood to be linked to the dead through their shared participation in this amorphous ancestral substance. Unlike the living, however, the dead were not differentiated: "The family was

The Time of the Ancestors? 197

divided into two parts: one was that of the living, strongly united but endowed with the peculiarities inherent in each individual life; the other, that of the dead, formed an indistinct mass." Only at a later time, with the development of feudalism, was the individuated character of the living transferred to the dead as particularized ancestors to whom offerings could be made and acts of worship addressed. Such a conception of specific and identifiable ancestors was, however, distilled out of an older sense of the dead as an undifferentiated ambient presence, "floating confusedly in a corner of the house."[18] If we accept Granet's claim regarding the primacy of the ambient dead, what requires explanation is not the ontogeny of Canetti's invisible crowd but rather the way in which the individualized dead—and perhaps the living themselves—are condensed out of it. Are ancestral cults, death rituals, and practices of memorialization understandable as the means by which a distinguishable presence is solidified out of, and thus disembedded from, the always antecedent throng of the unnamed and undifferentiated dead?

Anthropological literature, at least since Robert Hertz, has frequently emphasized the role of death ritual in effecting a definitive separation between the living and the dead, consigning the latter to their own realm (what Hertz calls a "society of the dead"), where relations with them can be undertaken without risk to the living.[19] It is worth asking, however, whether such differentiation is not as much a material practice as an act of symbolization. In order for relations with them to be regulated and managed, the dead must be produced as something other than an all-pervading and formless substance. Certainly the widely documented practice of exhuming and reburying the remains of the dead once the flesh and other decomposable parts of the body have rotted away can be understood as allowing the liquid indeterminacy of putrefaction to be replaced by the solidity of dry bones, which can then be safely consigned to their final resting place. The multifarious material culture of death practices—including tombs, ossuaries, memorials, and grave goods—needs to be understood as concerned not only with symbolizing the deceased's social status or of the community's beliefs about the afterlife but also with intervening in and modifying states of matter. Hertz's account intimates as much in its extended discussion of the threat of pollution widely ascribed to the remains of the dead during the intermediary period between their initial and final disposal. Hertz writes of the

"impure cloud" that surrounds the deceased, polluting everything it touches, including not only people and objects that have been in physical contact with the corpse but also everything connected with the deceased in the minds of survivors.[20] If Hertz ultimately ascribes these perceived dangers to the threat to the social collective posed by the death of one of its members (particularly an individual such as a chief in whom the power and endurance of the collective is understood to be embodied), his formulation here evokes a pervading and miasmic materiality more akin to Canetti's invisible crowd or Palo's sea of the dead than to his own society of the dead, modeled as the latter is on the institutions and practices of the society of the living, albeit freed from the constraints of mortality. Hertz's mentor, Durkheim, has been criticized by Latour and others for assuming the existence of a kind of "social stuff" as the defining constituent of human collectivities.[21] The taboos and gestures of ritual prophylaxis described by Hertz here seem directed, however, at the powers and dangers of a rather more palpable "stuff"—an other than human materiality that is nonetheless profoundly implicated in the fashioning of bodies, selves, and collective practices, even as it overruns and exceeds their bounds and determinations. Perhaps what is at stake in death practices is not so much the objectification of social relations or values as objectification in and of itself, a process that is at once framed within and staked against the amorphous liquid or vaporous mass of the dead that, as Canetti pointed out, has so ubiquitously haunted the human imagination.

OCEAN, OCEAN

The dead were much in evidence at the second iteration of *Mother*, which took place the same evening in a onetime kelp store at Nouster on the island's eastern shore. The building itself is the material aftertrace of an industry that from the early eighteenth to the mid-nineteenth centuries provided Orkney's landlords with a lucrative source of income: the gathering of seaweed cast up by storms on Orkney's sloping beaches and its rendering down by burning to yield the potash and other alkalis used by glass and soap manufacturers in Britain's developing industrial centers. Falling prices and new industrial methods for the extraction of alkalis eventually consigned the trade to oblivion, but it left behind disused structures like the present one as well as the remains of stone kilns that line the shores of many of Orkney's islands.[22]

The Time of the Ancestors? 199

The showing of *Mother* was followed by the screening of a series of experimental short films, among them *Ocean, Ocean* (2009; https://film video.calarts.edu/showcase/2009), a fourteen-minute film by Icelandic video artist Þorbjörg Jónsdóttir, in which a woman's discovery of a magic chamber in her home triggers a series of encounters between the living and the dead—encounters in which the sea as source of livelihood and taker of lives plays a decisive role. The film's sparse narrative unfolds in an emphatically liminal setting, bounded on the one side by the turbulent waters of the Atlantic, dividing the once linked landmasses of Europe and North America, and on the other by the lava landscape of contemporary Iceland, the solidified aftermath of molten volcanic outpourings from the continental rift that runs beneath.

A lone tent stands in the midst of lava fields. A hooded figure passes against a backdrop of glaciers. A caption announces the wreck of the vessel *Eiríkur Rauði*, March 2, 1927, with no survivors. A young woman, perhaps in her late twenties, lies asleep on her couch. She opens her eyes, looks around the living room of her house, stares into space. Noticing an

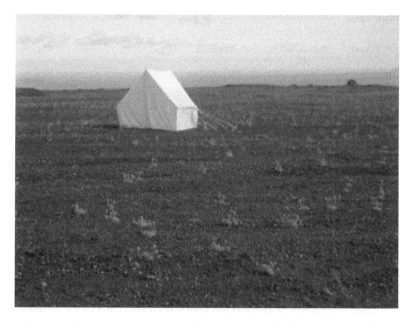

FIGURE 32. A lone tent stands amid lava fields. Þorbjörg Jónsdóttir, *Ocean Ocean* (2009).

FIGURE 33. The young woman stands at the shoreline, looking out to sea. Þorbjörg Jónsdóttir, *Ocean Ocean* (2009).

open door, she glances inside and finds a room she has never seen before, windowless, furnished only with an oil painting showing the stricken vessel capsizing in the high seas. Outside, the figure glimpsed earlier, the hood now cast back to reveal the face of an elderly woman, sits knitting with white wool, often associated (as Þorbjörg later tells me) with impending death in Icelandic dreamlore.[23] The camera pans across the treeless landscape. The young woman is now in her bedroom. She switches off the light to sleep. She wakes to find a man in seaman's attire lying on top of her and whispering inaudibly in her ear as five other figures, three men and two women, dressed in 1920s fashions, stand against the far wall, looking on. Cut back to the painting of the sinking ship. Then we're outside again. The young woman stands at the shoreline, looking out to sea. Low clouds meet the gray water at the horizon line. Inside the house once more, the camera ascends the stairs, then cuts back to the adjacent lava fields, over which it pans. Now the young woman is at a dance in what appears to be the local community center. An accordion plays and

The Time of the Ancestors? 201

people are singing. The floor is filled with dancing couples, all women, again in 1920s dress. The protagonist takes a partner and joins in, singing along to the melody. Who are the living and who are the dead here? As the dance continues, the screen darkens and a caption appears:

Dreams create death
Rain creates flowers
Night creates ghosts

eighteen

In the Beginning
Were the Giants

Young were the years when Ymir made his settlement,
There was no sand, nor sea, nor cool waves;
Earth was nowhere, nor was the sky above,
Chaos yawned, grass was there nowhere.

— POETIC EDDA

In the story of the earth's formation told by geologists, the present-day distribution of continents across the globe's surface is the result of the incremental breakup of the onetime supercontinent of Pangaea, itself the product of the formation and dissolution of a succession of other, earlier supercontinents. In the pre-Christian Norse account of the creation of the world, as preserved fragmentarily in the verses comprising the surviving corpus of Eddic poetry and in the prose summary composed by Snorri Sturluson, the world in its present form is also the result of the dismemberment of a preexisting body—that of the giant Ymir. Vanquished and killed by Odin and his brothers, Ymir's dismembered body provides the building materials of the newly fashioned universe of gods and humans. His flesh becomes the earth, his blood the sea, his bones the mountains, his hair the trees, his skull the sky, and his brain the clouds that pass across it.[1]

As Genetic Moo's invocation of the story of Echidna reminds us, accounts of primordial beings, defeated and dismembered or cast down to the subterranean nether spaces of darkness and the dead, have had an appeal spanning widely different contexts. Hesiod's *Theogony*, to take one example, in which the figures of Echidna, her consort, Typhaon, and their brood of monstrous progeny first appear, also contains an account

of the creation of the universe. It begins with a primordial *Khaos* (Greek for "chasm" or "gap") out of which emerges first Gé or Gaia (Earth), then Erebus, the subterranean realm of darkness, and finally Eros, the deity of sexual love. The union of Gaia and Erebus produces Ouranos, the Sky, and Gaia in turn procreates with her own offspring to give birth, among others, to a monstrous race of Titans, beings of immense physical strength with multiple limbs and heads, who are finally overcome and banished below ground by her grandson, Zeus, in a victory that founds the order of anthropomorphic Olympian gods forming the familiar iconographic basis of Greek religion.[2] A still earlier account is that found in the *Inūma Eliš*, the ancient Mesopotamian epic of creation, preserved on tablets dating from the first millennium BCE but possibly first composed at a considerably earlier date and often cited as a likely antecedent of the Judeo-Christian creation story recounted in the Hebrew Bible and the Old Testament book of Genesis: "In the beginning of Creation, when God made heaven and the earth, the earth was without form and void, with darkness was over the face of the abyss, and a mighty wind swept over the surface of the waters."[3] In the Mesopotamian version, as in the Genesis account, the story of the creation of the world begins with an expanse of waters, in this case personified by Tiamat, a female-identified being whose bodily attributes include a head, a tail, a thigh, and an udder. Mingling her waters with those of Apsu, a male principle, she brings forth out of her vast immemorial body a succession of beings of both sexes, one of whom, Qingu, she takes as her lover. Incited by Qingu, she turns against her other offspring and prepares to make war on them, bringing forth to that end an array of monstrous and composite beings more out-landish than any of the primitive marine denizens of Lake Orcadie—a horned serpent, a fish man, a bull man, a scorpion man, and giant snakes filled with venom instead of blood.[4] Against this threat, the remaining gods, Tiamat's children, unite under the leadership of Marduk (who is described as born of "pure" Apsu, not Tiamat). The battle resolves itself into a single combat between Marduk and Tiamat, from which Marduk emerges victorious. Ensnaring Tiamat in a net, he shoots an arrow that pierces her belly, then slits her down the middle and splits her heart. He makes clouds from her spittle, the Tigris and the Euphrates flow from sockets of her eyes, mountains are fashioned from her udder, her tail is laid across the firmament as a "cosmic bond," and her thigh is set as a

pillar to hold up sky. The blood of her lover, Qingu, is used to fashion men in order that they might labor on behalf of the gods.[5]

Both Tiamat and Ymir appear to belong to the metaphor-saturated mythic discourse—the *mythos*—from which Western philosophy would seek to differentiate its own claim to *logos*. Like Hesiod's *Theogony*, both accounts tell a story of primordial creation out of apparent chaos or undifferentiation—a creation that is subsequently overthrown and a new cosmic order imposed in its place. In both cases, this superseded creation is associated in varying degrees with images of femininity and maternity. For all her multifarious bodily attributes, Tiamat is explicitly identified as a female figure, one who spontaneously gives birth to an assortment of beings, many of them manifestly different in appearance and composition from herself. If Ymir, in contrast, is male identified, "he" is nonetheless shown to be endowed with a combination of male and female characteristics and thus is able also to engender and bring forth other beings out of his own body. In later descriptions of seasonal costumed performances, the giantess or ogress frequently categorized as a folkloric descendent of mythic giants is invariably female, even when endowed with certain conventionally male attributes, such as the wooden phallus carried by Grýla in Heinesen's story. Are the poems and dramatic enactments to be understood simply as victory celebrations on the part of a newly ascendant, male-dominated cosmic order? Do they mark the latter's appropriation of a diminished and domesticated version of a once female-identified power of creation, much as the seemingly preexistent watery depths of the Genesis story would later be subsumed by Christian theologies of creation ex nihilo?[6] Matters are surely complicated by the fact that the architecture of the refashioned universe takes as its building materials the dismembered bodies of the vanquished. Tiamat and Ymir remain present in dispersed form throughout the new order of creation—as the earth, sea, rivers, sky, and clouds—while the blood of Tiamat's consort, Qingu, is the substance from which human beings are fashioned. If the mythic protagonists associated with an earlier dispensation thus remain immanent to the refashioned cosmos that succeeds them, what is their relationship to the verses in which their defeat and overthrow is recounted—or indeed to the costumed performances of Grýla and the *gyros* by which these events are more distantly evoked? Does the self-begetting materiality that is so extravagantly embodied in

these originary beings remain present not only in the physical textures of the universe constructed from their remains but also in the words and gestures that purport to recount their passing?

CHŌRA

How is the matter of bodies, including maternal bodies, implicated in the language we use to talk about them? From where does language draw the materials that it orders according to the dictates of phonology, syntax, and grammar and transmutes into communicable meaning? Perhaps from a place antecedent to discursively instituted distinctions between self and other, subject and object, where signs do not yet stand in for absent things—a place that can't (yet) even be called a place. Julia Kristeva refers to this as the "strange space" of the *chōra*, a term borrowed from that strangest of Plato's dialogues, the *Timaeus*, itself a cosmogonic narrative of sorts, where *chōra* denotes yet another liminal, or third, space between otherwise distinct orders of things, in this case between model and copy, the intelligible and the sensible, an eternal and unchanging realm of being, of ideal forms, and a transitory world of becoming.[7] For Kristeva, too, the term *chōra* designates an in-between space, that of the semiotic—a zone of indistinction between the bodies of mother and child, prior to the acquisition of language and the emergence of a differentiated ego, traversed by drives and primary processes and finding its earliest expressions in the wordless vocalizations and spontaneous laughter of infancy.[8]

But of course it doesn't last. The connection to the mother is broken with the entry into the symbolic—the realm of transmissible meaning and, in psychoanalytic terms, of paternal law. Words take the place of objects. The retrojected maternal body becomes henceforward a source of the "abject," with its attendant "powers of horror," activated by whatever traverses or impinges upon the boundaries of the subject's newly constituted "clean and proper body."[9] Yet the semiotic lives on as an animating pulse within language: the sounds, rhythms, and melodies that form the backdrop to all communication. Sometimes, however, it emerges with greater force, temporarily overwhelming the communicative function, saturating speech or writing with a bodied materiality that refuses recuperation under the auspices of meaning—in states of madness, possession, trance, mystical transports, glossolalia, and, most importantly

for Kristeva, in the linguistic explorations of avant-garde writers like Mallarmé, Lautréamont, Joyce, Céline, and Artaud.[10]

For Kristeva, the semiotic is not straightforwardly chronologically prior to the symbolic, insofar as it can only be imagined as such from within the symbolic, using the terms that the latter provides—or perhaps it depends on what status is accorded to the act of imagining. What the notion of the semiotic alerts us to is the becoming both of language and of the speaking subject, the unruly process that underlies seemingly stable identities and significations and that, in being made manifest, renders them susceptible to contestation and reformulation. But is the submerged life that stirs within language inevitably promised in advance to the regulatory operations of meaning making and subject formation? Can it surface only in the guise of a disruptive negativity, a jamming of signification, only to have the symbolic reconstitute itself, albeit in altered form, until the next upheaval?[11] Might the propulsive materiality that Kristeva identifies as driving the signifying process contribute directly to new linguistic and cultural creation, to new acts of fabulation?

Answers to these questions depend not only on whether language can be construed otherwise than in terms of the interdiction and foreclosure of a henceforward inaccessible Real (a way of understanding Lacan's symbolic order that Kristeva's account is intended in part to contest), but also on whether the bodied vitality of language can be conceived more expansively than in terms of biological reproduction and psychic individuation.[12] Plato's usage of the term *chōra* is, after all, more capacious than Kristeva's. In the *Timaeus*, it refers to the "receptacle" (*hupodochē*) not only of a speaking subject *in potentia* but of all created things. A "strange space" indeed, this *chōra*—a between-space par excellence, falling under the purview neither of the senses nor of the intellect—to be approached, rather, according to the speaker, Timaeus, via "a kind of bastard reasoning." Worse still, those who try to take account of this elusive third space may find themselves prey to "dreamlike illusions" that might prompt them to dispense with transcendence altogether, discounting the eternal truth of the forms in favor of mere appearances, "to claim that every existing thing must surely exist in some particular place and must occupy some place, and that nothing exists except what exists on earth and in the heavens."[13]

The *chōra* poses a danger by virtue of its very definitional slipperiness, threatening to lead thought astray by undoing the hierarchy of being that

underpins Plato's philosophy, proliferating copies that threaten to usurp and take the place of originals, elevating the transitoriness of becoming above the immutability of being. The *chōra* is at once invisible yet affords space to all visible things, distinct from the intelligible realm of eternal forms but nonetheless linked in "some highly obscure fashion" to them. Insofar as it can be defined at all, it is defined by its very absence of defining characteristics: "If it is to be the receptacle of *all* kinds, it must be *altogether* characterless."[14] It receives and copies the qualities of that which enters into it but remains itself unchanged. Continuously shaken by the "dissimilar and imbalanced powers" that appear in it, it exists in a state of perpetual motion and disequilibrium. Yet it is not simply passive. It is capable of erasing the passing impressions left on it in order to retain its own characterless character; it is endowed too with its own, independent motions, likened to the sifting action of a grain sieve, performing a preliminary differentiation of the materials of the visible universe prior to the more orderly creation performed by Plato's Demiurge: "He found everything visible in a state of turmoil, moving in a discordant and chaotic manner, so he led it from chaos to order, which he regarded as in all ways better."[15] The Demiurge's rational and purposive ordering of the universe is, it seems, preceded and facilitated by a different kind of creation, a creation of blind "necessity," of "the wandering cause" that itself necessitates the reopening of the question of beginnings—in Plato's own words, "to start again from the beginning."[16] Like the beginning again to which Deleuze's desert islands call attention, this other beginning, a beginning before the beginning, is also a challenge and affront to the very notion of beginning understood as the definitive imposition of form on inchoate matter—a view that would subsequently find one of its canonical expressions in the *Physics* of Plato's onetime student, Aristotle. The *chōra* is identified not so much with the already formed material things that emerge within the space that it affords as with an unbounded, unscripted potentiality of matter, such that it has sometimes been compared to Hesiod's *khaos*.[17] What we catch a glimpse of is, in John Protevi's words, the possibility of "material self-ordering," a possibility that is, Protevi argues, immediately foreclosed by being subordinated to the ordering and form-bestowing actions of the Demiurge, who is credited with perfecting and carrying to completion the sifting and differentiating work that the *chōra* performs.[18] But if the *chōra* "exists forever and is

indestructible," and if its self-activating motions are prior to and independent of the Demiurge's efforts, can its subjugation ever be more than partial?[19] Does it not rather maintain a wayward and potentially destabilizing presence as an active contributor to the creation of the universe, one that nonetheless remains irreducible to any subsequent process of form-giving or rational ordering?[20]

As the receptacle of all things, the *chōra* is no less a site of linguistic productivity. In attempting to clarify "this difficult and obscure kind of thing," the speaker, Timaeus, has recourse to a multiplicity of terms traversing a range of possible meanings.[21] The term *chōra* can mean not only space, but also place, territory, country, or countryside, as opposed to town.[22] In addition to "receptacle" (*hupodochē*), it is also referred to as a mother, as a nurse (*tithenē*), as the odorless base liquid used in perfumery, and as a plastic material or molding stuff (*ekmageion*) receiving the figures (*eisonta*) that enter and leave it.[23] Yet for all its imputed variousness, the *chōra* appears to retain for Plato a specifically gendered aspect—that of the mother or nurse of all creation.

In Plato's text, the *chōra* is a figure simultaneously of material and semiotic fecundity, spawning a profusion of both things and words, to equally disruptive effect. On the one hand, the *chōra* is credited with capacity to bring forth material copies that have the potential to supplant the primacy of the immaterial forms (at least for those thinkers who allow themselves to fall victim to the "dreamlike illusions" that the *chōra* is capable of inducing). On the other hand, Plato's discourse on the *chōra*, in purporting to speak of that which lies betwixt and between the hierarchically ordered oppositions of the intelligible and the sensible, of eternal being and becoming, generates a proliferation of terms that threatens to trouble or undo the distinctions between *mythos* and *logos* or between figurative and literal meaning that, since Plato's (and Aristotle's) time, have underpinned the authority of philosophical reason and its attempted reigning in of poetry and metaphor.[24]

Kristeva, in contrast, has often been criticized (at least in the Anglophone academy) for taking Plato's metaphors too literally and thus conflating the *chōra* with a heteronormative, reproductively centered, and tradition-bound conception of femininity and maternity. Judith Butler, for example, criticizes Kristeva for "her acceptance of the structuralist assumption that heterosexuality is coextensive with the founding of the

Symbolic" and that the cathexis of homosexual desire can be achieved only through displacements that are sanctioned within the symbolic, such as poetic language or the act of giving birth.[25] But has the *chōra's* more wayward, polyvalent past been altogether left behind in Kristeva's more recent iteration? Could Kristeva's usage—itself arguably a belated instance of the semiotic productivity of Plato's notion—be read back through Plato's account to contest rather than affirm not only the identification of the *chōra* with a sexed and biologized maternal body but also the seeming inevitability of its wholesale subsumption within an anthropocentrically conceived formal system of differentially patterned linguistic signs? Some more recent feminist scholarship has certainly suggested as much. Maria Magaroni, for example, has argued that Kristeva's *chōra* operates according to a "machinic" logic of breaks and flows that may owe more to Deleuze and Guattari's "schizoanalysis" than to the Saussurean structuralist linguistics on which Lacan draws in his account of human subject formation.[26] Emanuela Bianchi has noted that in addition to connotations of maternity and nurturance, the *chōra* in both its Platonic and Kristevan formulations evokes also a vision of an "errant and motile" femininity that resists any attempt at definitional or identitarian fixing, being associated rather with a metamorphic power of "aleatory matter" that persists as an ineradicable and disruptive presence, even within newly ascendant, male-centered, and heteronormatively conceived cosmological and linguistic orders.[27]

ALEATORY MA(T)TER

If anthropology has sometimes sought to recapture such a vision of a universe of matter in motion through the alter worlds of indigenous myth, Bianchi's reading of Plato reminds us that it is to be found too, albeit often in scattered and fragmentary guise, in some of the texts that have come to comprise the canons of Western literature and philosophy. Certainly, as Deleuze, Adriana Cavavero, and others have suggested, it appears easier to catch sight of it in the writings of Plato and his pre-Socratic predecessors than in the more rigidly ordered cosmos of Aristotelian physics.[28] One catches glimpses too in the archaic figures of the Cyclops, the Sirens, and the enchantress Circe encountered by Odysseus (the hero of *metis*, or cunning intelligence) in the course of his homeward journey to Ithaca, or in the precosmology of Gaia, Erebus, and their

extravagantly bodied progeny in Hesiod's *Theogony*, arguably the closest that Greek literature gets to articulating a "mythic world" of the kind described by Lévy-Bruhl, Lévi-Strauss, and later Viveiros de Castro. Consider too the apparent fascination of some late nineteenth- and early twentieth-century European classical scholarship with uncovering the traces of an originary Greek world more ancient than that of the philosophers and Olympian gods.[29] Nietzsche sought it in the tragic Dionysian vision eclipsed by the rise of Socratic reason.[30] His near contemporary, J. J. Bachofen, claimed to have found it in the world of primeval mother right, with its tellurian religion, celebrating the material substance of the earth as the source of all creation, "a cultural stage which was overlaid or totally destroyed by the later development of the ancient world."[31] Decades later, Jane Harrison and other members of the group of classical scholars sometimes referred to as the Cambridge Ritualists, would similarly find the humanlike forms of the gods of Olympus to be late additions, overlaid atop a primordial world of chthonic powers and theriomorphic divinities, evoking a time of "protoplasmic fullness" and "primary fusion" and demanding that "we should think back the 'many' we have so sharply and strenuously divided into the haze of the primitive 'one.'"[32] Around the turn of the twentieth century, at the time of the Ritualists' greatest influence, such a vanished world manifested itself in the more tangible form of the Minoan civilization of Crete, which preceded that of classical Greece and which was made known to the public in large part through the excavations of the Great Palace at Knossos conducted by British archaeologist Arthur Evans.[33] The material culture of Minoan Crete suggested for many early commentators a pre-Olympian world of goddesses, priestesses, snake deities, and sacred bulls, along with the figure of the Minotaur recorded in later stories, a monstrous human–bovine hybrid, born of a Cretan queen's—Pasiphaë's—illicit infatuation with one such bull and confined thereafter to the depths of a purpose-built labyrinth.[34] It was Minoan Crete that would furnish Freud with an image of his own startled recognition of a phase in the development of feminine sexuality prior to the Oedipus complex: "Our insight into this early, pre-Oedipus phase in girls comes to us as a surprise, like the discovery in another field, of the Minoan–Mycenaean civilization behind the civilization of Greece."[35]

FIGURE 34. "Snake Goddess" (woman holding two snakes), smaller of two such figurines found at Knossos, Crete, by Arthur Evans (1903). Heraklion Archaeological Museum. Photograph by C. Messier.

212 *In the Beginning Were the Giants*

Why, though, is it always a matter of excavation or exhumation, of a lost world needing to be painstakingly unearthed and pieced together? Like the spirits evacuating the disenchanted landscapes of modernity, in the stories that the West has told about itself, it seems that the power of metamorphosis is always in retreat, relegated to the oblivion of a chronologically superseded past rather than a durational other time (like that of the Kwakwaka'wakw Winter Ceremonial) that remains capable of intruding on and transforming the present. In Western literature, there is surely no more compendious collection of metamorphosis tales than that to be found in the long poem *Metamorphoses* by the Roman poet known as Ovid (Publius Ovidius Naso, 43 BCE–ca. 18 CE), composed during the early years of the Christian era. Writing at the height of his literary fame in Augustan Rome, Ovid was certainly not afraid to think big. His poetic account of "forms changed / Into new bodies" begins with nothing less than the creation of the universe. (I quote here from a modern verse translation by Charles Martin.) Ovid first describes a precosmological state where disorder reigns:

> Before the seas and lands had been created,
> Before the sky that covers everything,
> Nature displayed a single aspect only
> Throughout the cosmos; Chaos was its name,
> A shapeless, unwrought mass of inert bulk
> And nothing more, with the discordant seeds of disconnected elements all
> heaped
> Together in anarchic disarray.[36]

Then, through an unknown agency—"some god (or kinder nature)"— earth, sea, and sky are separated out. Mountains, valleys, and plains are laid out; plants, birds, fish, and animals spring into life, followed, finally, by humans, fashioned in the image of the gods by Prometheus. The characterization of metamorphosis as a generalized power of creation resurfaces twice more in the poem: at the end, in a summary of Greek philosopher Pythagoras's vision of universal flux and transformation, and in book 3, which retells the story of Dionysus (Bacchus) and Pentheus, in which the god appears both personified in the human form of one of his acolytes and diffused throughout the landscape of mountain

In the Beginning Were the Giants 213

and forest surrounding the city of Thebes. Elsewhere, however, Dionysus's fellow Olympians appear to deploy powers of transformation that are more limited in scope and ambition. Sometimes these take the form of self-gratification, as when Zeus's amorous pursuits lead him to transform himself into a bull in order to abduct Europa or to transform another object of his desires, Io, into a cow in order to avoid the jealous gaze of his spouse, Hera. Sometimes they take the form of punishments inflicted by the gods on uppity mortals like Lycaon, onetime ruler of Arcadia, the first and eponymous lycanthrope, whom Zeus changes into lupine form for having attempted to trick him into partaking of a banquet of human flesh; or Arachne, turned into a spider by the goddess Athena, whom she has challenged—unsuccessfully—to a weaving contest.[37]

If the gods are capable of such feats, humans themselves are unable to change their forms unaided. Instead, they are forced to have recourse to tricks and disguises, like the wooden cow inside which Pasiphaë, mother to be of the Minotaur, hides to couple with the white bull with which she has become besotted. The cow is the work of a human artificer, Daedalus, who would later construct the labyrinth to contain the creature born of the interspecies union he had facilitated, along with the wings used by his son, Icarus, to fly too close to the sun, and who, still later, would lend his name (in the modified form of "Dedalus") to Stephen, the counterpart of Odysseus's son, Telemachus, in Joyce's *Ulysses*. Pasiphaë's coupling with the bull, meanwhile, gives rise to the Minotaur, a hybrid creature but one incapable of altering its form, freakishly caught between species identities that are already codified.[38] From the creation of the universe to the loves and resentments of the gods and, finally, to humans, who are constrained to occupy their given forms unless a god intervenes, the trajectory sketched out appears to be that of a gradual attenuation of metamorphic capability, culminating in a present in which everything is destined to remain what it is.

American novelist William T. Vollmann, reviewing the Norse saga literature, concludes that the ancient Scandinavians, as latecomers to both classical learning and Christianity, have fared little better. First there's Ymir, offspring of contending elements, polymorphously intersexed, the begetter of giants and gods. Then there's Odin, a god in human form but still a magician, shape-shifter, and traveler between worlds. Then there are the human shape-shifters who feature in the later saga literature—

sorcerers who transform themselves into whales, walruses, or swordfish, warriors who wreak havoc on the battlefield in the form of giant bears (*berserkr*, "bear shirts"), often while their human forms lie sleeping at a safe distance from the fray. But somehow a distinction between appearance and reality begins to make itself felt. Vollmann traces a decline in the power of metamorphosis in the sagas: from warriors and kings who were able to transform themselves of their own volition into bears, wolves, or other creatures, to the use of magically endowed animal skins (the bear shirts) to achieve the desired transformation, to the donning of such outer coverings as a simple disguise, beneath which the underlying human form remains unchanged. He tells the story of Norwegian king Harald Fairhair (ca. 870–940), whose father, Halfdan, hid his own (still metamorphically efficacious) bear shirt for fear that his son, gaining possession of it, might become more powerful than he. Years later, Harald, unable to locate the shirt and concerned for his own reputation ("his inability to be ursine was already common gossip") assumed an "imitation" bear shirt, which he wore when he led his warriors into battle.[39] In Harald's case, the bear shirt becomes just that: an outer covering draped over a body that does not change. Eventually we are left with humans who are just . . . well, human. From metamorphosis to metaphor? (But no longer metaphor understood in Nietzsche's sense.)

So how did it happen? Did imagination yield gradually before the implacable demands of reality? Did reality change, or cease to change? Or did humans (at least some of them) simply cease to notice its changefulness? Perhaps we need to remember the giants—the bodies of the bygone and vanquished persisting both as the architecture of a formally stabilized universe and in the verses that retell their stories. Do they not furnish us with a reminder that once upon a time (but which time?) the becomings of matter eluded not only the constraints of fixed form but also the normative overcodings of species, sex, and gender identity?

Ymir, the titularly male twofold being of the Eddic creation narrative, appears to be fashioned from a primordial substance capable of dividing and recombining to produce a variety of other beings without the need for a sexual partner. If Tiamat in the Mesopotamian account appears less equivocally sexed and gendered, her story suggests a femininity unsubordinated to any principle of Oedipal triangulation or lineal descent.

In the Beginning Were the Giants 215

Tiamat gives birth to a multitude of gods and monsters, yet her relation to these progeny appears less as one of filiation, of the familially bounded reproduction of identity and sameness, than of unbounded differentiation and self-othering. Tiamat ain't nobody's mom.

Even after their defeat, death, and dismemberment, the bodily matter of both Ymir and Tiamat appears capable of being remolded by their successors into a variety of new forms—including the earth, sea, and sky, the concentric realms of Ásgarð, Miðgarð, and Útgarð, home to gods, humans, and giants, and the great rivers Tigris and Euphrates that supply the Fertile Crescent with its fertilizing waters. These cosmogonic bodies are, it seems, a gift that keeps on giving—even posthumously. Rather than simply marking hylomorphism's decisive subordination of matter to form as an epochal transition in the history of being, might they not alert us instead to the persistently polymorphous life of the materials of creation, a life that no humanly conceived ideology of creation as form giving can ever definitively still?

Giant bodies were also a preoccupation of Russian critic and linguist Mikhail Bakhtin, whose work Kristeva first encountered as a student in her native Bulgaria and on whose theories of linguistic heteroglossia and the carnivalesque she draws in her own reflections on literary language.[40] Bakhtin's study of sixteenth-century French writer François Rabelais attached great importance to the "grotesque image of the body" that features prominently in the latter's pentalogy of novels, *Gargantua et Pantagruel* (1532–64), recounting the adventures of its two eponymous giant protagonists. The grotesque body, in Bakhtin's words, is "a body in the act of becoming. It is never finished, never completed; it is continually built, created, and builds and creates another body."[41] Characteristically described with an emphasis on bodily protuberances and cavities— bulging eyes, erect phallus, bowels, anus—the grotesque body is marked by its openness to the world, to swallowing or being swallowed by it, by prodigious feats of drinking and gluttony, followed by similarly spectacular regurgitations of what has been consumed via urination, shitting, or vomiting. The grotesque for Bakhtin is associated in particular with times of upheaval and revolutionary transformation, like the disintegration of the hierarchical medieval conception of the universe that accompanied the beginnings of modern capitalism, the first European voyages

to the Americas, the Protestant Reformation, and the wars of religion that followed in its wake. Yet it also mobilized a repertoire of images that was common to "all languages, all literatures" and that was, in its scope, "cosmic and universal," evoking a primordial life force indifferent to the mortality of the individual organism or even the life of entire species. In seeking constantly to join itself with other bodies and with the world, the grotesque body was capable of breaching conventional distinctions between the organic and the inorganic. This could manifest itself not only in the conflation of images of the "lower bodily stratum" with those of the underworld—entrances to the latter being widely portrayed in literature and folklore as bodily orifices—but also in a more widespread identification between the bodily attributes of giants and features of the physical landscape. Rabelais, Bakhtin notes, drew extensively on stories of giants in classical and medieval literature and European folklore, as well as on the figure of giants who featured in popular celebrations such as the pre-Lenten Carnival: "Most local legends connect such local phenomena as mountains, rivers, rocks and islands with the bodies of giants or with their different organs; these bodies are, therefore, not separated from the world or from nature."[42]

If Kristeva, drawing in part on Bakhtin's ideas, calls attention to the infolding of the material substance of the disavowed maternal body into language in the guise of sonic effects and rhythmic pulsions capable on occasion of derailing the meaning-bearing functions of signification, Bakhtin (like Rabelais) invites us, arguably, to entertain the possibility not only of a more direct and conspicuous involvement of the matter of bodies in the fashioning of linguistic and cultural artifacts—whether they be novels, carnival processions, or anything else—but also a more capacious understanding of bodied materiality, whereby flesh, text, artworks, and physical geography are involved in a continuous interchange of material substance. The "cosmic" or "ancestral" body that Bakhtin identifies with the grotesque and the figure of the giant, like the bodies of those other cosmic ancestral figures Tiamat and Ymir described in Mesopotamian and Norse creation stories, suggests the possibility of imagining the body as a generative site not only beyond conventionally sexed and gendered understandings of maternity and reproduction but also beyond the conventionally human—and indeed the conventionally organic. Considering each of these accounts, together with Plato's alongside Kristeva's, allows

us to bypass the psychoanalytic trajectories of subject formation and psychic individuation in pursuit of an engagement with the inhuman earth of Deleuze and Guattari's geophilosophy. It allows us to think of the materiality that infiltrates both literary language and (for Bakhtin at least) performative and visual culture as not only biological but geological, planetary, cosmic.[43]

nineteen

Tiamaterialism

What would it take to affirm the disavowed and dispersed body of Tiamat, or of her Eddic counterpart, Ymir, as a presence manifest within but not exhaustively defined by the humanly fashioned cultural artifacts through which it finds contemporary expression? The term "Tiamaterialism" was coined by Reza Negarestani in his remarkable book *Cyclonopedia: Complicity with Anonymous Materials* (2008). Splicing together elements of detective fiction, archaeology, geology, science fiction, speculative philosophy, Mesopotamian myth, Islamic monotheism, and Zoroastrian dualism, Negarestani propels us into an unclassifiable world of "inorganic pestilence," "petropolitical undercurrents," agentive decay, and global conspiracies of inhuman forces waging relentless war against the wholeness and integrity of any imaginable order of creation. It asks us to picture the Middle East (as the region from which the story of Tiamat and Marduk originates, and one theater of contemporary global conflict) not only as a material entity but as an animate, sentient one. Such life and sentience, however, are far from being anthropomorphic projections or metaphorical displacements from human society to physical geography, understood as discrete and distinguishable domains. This is a vitality and intelligence of an inhuman, alien kind, that Negarestani likens to H. P. Lovecraft's Cthulhu and the Great Old Ones, monstrous, gelid, tentacled, bloblike beings of extraterrestrial origin ("eldritch contradictions of all matter, force and cosmic order"), originating among the stars and now confined beneath the earth or under the sea in a dream state, waiting until such time as the stars are right for them to return and resume their

lawless rule over the planet. Such a time, Lovecraft writes, will be easy to know: "For then mankind would have become as the Great Old Ones; free and wild and beyond good and evil, with laws and morals thrown aside and all men shouting and killing and reveling in joy. Then the liberated Old Ones would teach them new ways to shout and kill and revel and enjoy themselves, and all the earth would flame with a holocaust of ecstasy and freedom."[1] Certainly Lovecraft's fantasies of telluric extraterrestrials are conspicuously tinged with xenophobia and racial and sexual paranoia, to the extent that Donna Haraway's coinage of the term "Chthulcene" (note the difference of spelling) explicitly repudiates any connection to Lovecraft's "misogynist racial nightmare monster," preferring instead to invoke a genealogy that "entangles myriad temporalities and spatialities and myriad intra-active entities-in-assemblages—including the more-than-human, other-than-human, inhuman and human-as-humus."[2] The fostering of collaboration and comaking across species and other divides has of course been an enduring concern of Haraway's work. Both Lovecraft and Negarestani raise, however, a very different possibility that is surely no less worth taking seriously—namely, that the other than human might manifest itself in malign or terrifying guise.

What Tiamaterialism names for Negarestani is a wayward, inhuman, anorganic potentiality of matter prior to discursive intelligibility, one that subsists within histories of capital and modernity both as a disruptive force and as the disavowed condition of their unfolding, a potentiality finding one of its most potent manifestations in the oil or petroleum that flows from beneath both the Middle East and the North Sea. Formed between subterranean strata under immense pressure and in the absence of oxygen, petroleum is seen as developing a "satanic intelligence" that impels it to surge upward from the between places of its formation and initial confinement and to become the unseen operator—the "lubricant" or "Tellurian Lube"—of history and geopolitics, infiltrating and co-opting what human actors assume, mistakenly, to be their own projects and agendas.[3] Both Western technocapitalism and what the media like to call radical Islam are conscripted as unwitting helpers in creating the conditions propitious to the manifestation of such an alien–terrestrial life: a globalized "desert," or in Deleuze and Guattari's phrase a "plane of immanence," where all ontological hierarchies are leveled, all traces of transcendence expunged. In the United States' self-described war on terror, both the

late Osama bin Laden and the administration of George W. Bush become "petropolitical puppets convulsing along chthonic strings of the blob."[4]

If such an inhumanly animate earth appears sometimes as a hidden agentive cause ("the arch-puppeteer and occult manipulator of planetary events"), it is not to be confused with a solid ground or stable presence. It offers no guarantees of coherence or closure in the guise, for example, of a totalizing biospheric ecology. It resembles Hesiod's Gaia more than James Lovelock's—a begetter of monsters rather than a self-regulating system.[5] Rather than a ground, Negarestani's is a "holey" earth, engaged in a continuous operation of ungrounding. It is an earth hollowed out by caverns, threaded by subterranean wormholes, tunnels, and pathways. These undermine the integrity and stability of solid forms by perforating them, rendering them porous, bringing surfaces and depths into communication and in the process dissolving their oppositional hierarchy:

> For a solid body, the vermiculation of holes undermines the coherency between the circumferential surfaces and its solidity. The process of degenerating a solid body by corrupting the coherency of its surfaces is called

FIGURE 35. "Petropolitical puppets convulsing along chthonic strings of the blob." President George W. Bush and Defense Secretary Donald H. Rumsfeld. Image courtesy of Tech. Sgt. Cedric H. Rudisill, U.S. Air Force.

ungrounding. In other words, the process of ungrounding degenerates the whole into an endless hollow body—irreducible to nothingness—and damages the coherency between the surfaces and the solid body itself. To talk about holey spaces and Earth is to insinuate the Earth as the Unground.[6]

In its undermining of solid bodies, porosity is linked also to fluidity, for which it becomes an enabling conduit. Twisting, vermiculating, oozing across borders and from below to above (in a reversal of the logic of trickle-down economics), once mentioned, it seems that holeyness is everywhere, refusing to be confined to any preordained set of spacetime coordinates. Here, for example, are a few of the occasions when the (w)holey inhuman earth could be said to have insinuated itself into the present text:

- The volcanic ruptures in the earth's crust, through which its molten core erupts periodically to the surface in Iceland and elsewhere.
- The tunnels, sunken cities, and non-Euclidean underground spaces that in Lovecraft's fiction afford the resting place and eventual route of return for Cthulhu and his retinue of Great Old Ones.
- Artaud's characterization of the plague as turbulent, lavalike body fluids rising beneath the skin, trying to escape through blisters and lesions.
- Bakhtin's account of the grotesque body, its openness to the world revealed through cavities and gaping orifices, plunging from exteriority to interiority and back again.

Like Bakhtin, Negarestani makes a series of connections between motherhood, metamorphosis, and these chthonic depths, but again, motherhood is radically divested of any reassuring connotations of care, nurturance, and familial order.[7] Birthing partakes here of a minoritarian or deviant creativity that has nothing to do with principles of filiation or lineage but rather obeys a logic of seepage and contamination—the gradual but unstoppable advance of putrefaction, the contagious spread of disease, the lugubrious expansion of an oil slick, the shifting of desert sands, or their wind-borne dispersal. This is the gratuitous and antiutilitarian proliferation embodied in Hesiod's Khaos, in Plato's *chōra*, in Tiamat, in Ymir—and still hinted at in the giant and giantess figures of North

Atlantic storytelling and performance traditions that inspired Papay Gyro Nights.

Such nonlocalizable ubiquity (never reducible to straightforward, unambiguous presence) demands perhaps an unashamedly universalizing (and no doubt empirically unverifiable) assertion: that all poetry—indeed all art—is, wittingly or unwittingly, Tiamaterialist. Poetry accesses not only a psychic or subjective prehistory of not-yet-individuation (as Kristeva suggests) but a cosmic pre- and posthistory extending far beyond any witnessing, authenticating human presence. The porosity of the present to a before time of primordial flux and unfixity given linguistic expression in cosmogonic poetry from Mesopotamia, Greece, Iceland, and elsewhere affirms that newness and becoming are indissolubly linked to unmaking and dissolution, a linkage pertaining not only to the transforming contours of the physical universe—the subterranean magmic surgings that conjoin and sunder continents, the sea's ongoing decomposition of Orkney's rocky shores—but also to human acts of artistic creation as exercises less in the imposition of form on inert matter than in active engagement with transformations of material substances that are, finally, indifferent to the ends to which humans attempt to shape them, an engagement that, as humans, carries us beyond ourselves and into an other-than-human, metamorphic materiality that is at once our indispensable precursor and our inevitable successor.

New media theorist Jussi Parikka writes, "The world of thought, senses, sensation, perception, customs, practices, habits and human embodiment is not unrelated to the world of geological strata, climates, the earth, and the massive durations of change that seem to mock the timescales of our petty affairs."[8] Clearly such entanglements between human practice, climate, and geology have much to do with the early twenty-first-century present, including labor relations, global capital, the politics of resource extraction, and the ever-increasing ecological impact of humans (or at least some populations of humans). Yet Parikka insists that they challenge us also to think beyond anthropocentric notions of context, forcing us to remember that many of the materials from which our various communicational media are fashioned (for example, the chemicals, metals, and minerals used in the manufacture of computer batteries, hard drives, screens, liquid crystal displays, and miniaturized circuits) are themselves the products of geological processes extending across millions or billions

of years. To take seriously the materiality of media is not only to engage the suprahuman planetary and cosmic timescales opened up by fields such as geology and astrophysics but also to refuse to assume the transparent legibility of humanly wrought artifacts, to acknowledge that human signifying intentions are inevitably subject to inflection and disruption by material presences that humans neither create nor fully control. Tiamaterialism subsists, not least in an age of information technology.

If Parikka's focus is on the geologic underpinnings of contemporary digital media, verbal art, as old perhaps as the human species, has been no less a conduit for chthonic disturbances and wayward materialities. At issue, however, is not the promise of a restored holism, of humanity's reintegration into an all-encompassing terrestrial web of life, a view still encountered in various forms in avowedly posthumanist scholarship, but rather the radical ungrounding of any possible claim to a transcendent vantage point, including that of an ecosystemic subject.[9] As Bakhtin and Negarestani, no less than the *Inūma Eliš*, Hesiod, and the Norse Edda demonstrate, what pulses through the language of poetry (or of any artistic medium) is not the nurturing feminine, maternal body as a precondition of linguistic and social subjectification but an altogether more expansive and unruly body, resistant to any attempt at objectification or totalization, capable of tearing asunder humanly contrived orders of signification to effect an opening to a devouring and eviscerating outside. Language does not only re-present the world; language *is* the world speaking. If our narrowly human-centered preoccupation with meaning making tends to render us forgetful of this fundamental fact, then the overwhelming and enduring importance of poetry (and art) lies in its capacity to remind us of it, endlessly but always differently.

twenty

Blubberbomb

I am still dead. I am flowing.

—AASE BERG, *Transfer Fat*

A darkened room. Four walls, four projectors, four talking heads. And what heads they are! A seventeenth-century ruff; ears of corn, butterflies, and a lobster; an octopus; a mask of prawns (cooked); a whitened face sprouting thornlike protuberances, resembling an arrow-studded Saint Sebastian or a Christ fused with his own mocking crown of thorns. Lobster-head, Octopus-head, Prawn-head, Thorn-head. A Babel of voices: four monologues fused into a multilingual polylogue; a melody by Brahms—*Feldeinsamkeit*; a torrent of semiaudible lyrics delivered in a Tom Waits–like growl; a speech from Shakespeare; and, from Thorn-head, the following:

Eat and die
Touch and die
Fuck and die
Smile and die
Spit and die
Dream and die . . .

The Madrigal of the Explosion of the Wise Whale is a four-channel installation by the Greek-born and now London-based artist Filippos Tsitsopoulos, who plays each of the four characters. The piece was conceived in part as a tribute to the artist's father, a well-known theatrical actor, who on one occasion went on stage to perform the role of Polonius in

Shakespeare's *Hamlet* after having attended the funeral of his wife, the artist's mother, earlier in the day. The performance, dedicated to his deceased wife, came to an unexpected halt with Polonius's reading aloud of Hamlet's love letter to Polonius's daughter, Ophelia:

Doubt thou the stars are fire
Doubt that the sun doth move
Doubt truth to be a liar
But never doubt I love.[1]

Rather than continuing, he began to repeat the final line, over and over: "Never doubt I love, never doubt I love, never doubt I love . . ." Filippos, who was in the audience, describes the scene: "The other actors on stage were astonished, looking at one another. The crowd starts clapping . . . and they had to stop the performance because people were clapping hands without understanding why. It was a kind of hysteria, an enormous wave attacking their nervous system."[2]

It all appears to start with a dead father. Behind him, however, offstage somewhere, is a dead mother, unseen, but still, it seems, very much present—sufficiently so to stop even Shakespeare in his tracks. How does one begin to speak to them? How does one move amid the liquid turbulence of the dead? What does one have to become in order to do so? Years later, it was the stalled performance of Hamlet that provided the catalyst for Filippos's own work, with its cast of marine, metamorphic characters:

I started performing Polonius for him. I transform myself and my head with living elements creating a flexible mask with prawns, imitating the red beard of the Danish Polonius. I read that in the old Pacific traditions people thought that men in another life became fishes, prawns, calamari, whales, returning to their habitat the sea, so I transformed myself into a creature able to communicate with my deceased father, dedicated to him these words, the conclusion of a lifetime, the starting point or ending point to his philosophy—and my philosophy too—about life, religion, death and love. Doubt that the stars are fire / Doubt that the sun doth move / Doubt truth to be a liar / But never doubt I love. Art itself is the reason to create art.[3]

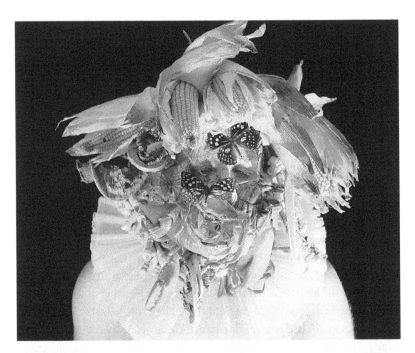

FIGURE 36. Filippos Tsitsopoulos, *The Madrigal of the Explosion of the Wise Whale*. Four-channel video installation (2010). Photographs supplied by the artist.

The Madrigal of the Explosion of the Wise Whale was first shown in 2010 at the Freies Museum, in Berlin's Potsdamer Strasse. I first saw it, however, two years later, in the very different setting of Papay Gyro Nights 2012, in the onetime kelp store on the island's eastern shore. It was here, on a storm-lashed night at the end of winter, that Lobster-face, Prawn-face, Octopus-face, and Thorn-face now addressed their monologues to an audience of islanders and visitors.

The transposition from urban to island setting offered a reminder of the economic importance of whales in the life of North Atlantic maritime communities like those of Orkney and its northerly neighbors, Shetland, the Faroe Islands, and Iceland, as well as for many of the coastal regions of the eastern Canadian Arctic of which Rasmussen wrote. From the mid-eighteenth century, whaling ships bound for Greenland and the Davis Straight would call regularly at the port of Stromness on Orkney Mainland to trim ship and take on stores and additional crew, and Orcadians continued to serve as crew members on whaling vessels until the international moratorium on whaling of 1986.[4] The importance of whales in the North Atlantic region, however, long predates the growth of commercial whaling. Whalebones and tools fashioned from them have been

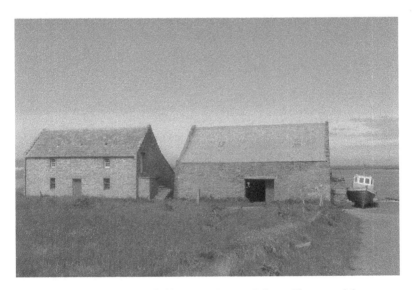

FIGURE 37. Old Kelp Store (left), Papa Westray, Orkney. Photograph by author.

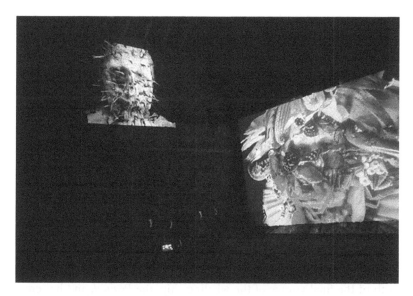

FIGURE 38. *The Madrigal of the Explosion of the Wise Whale* at Papay Gyro Nights, 2012. Old Kelp Store, Papa Westray, Orkney. Photograph by Tsz Man Chan.

found at Neolithic and Bronze Age archaeological sites around the North Sea (including Skara Brae in Orkney), while Stone Age rock carvings from northern and southern Norway depict whales alongside other animals known to have been hunted at the time.[5] For millennia, stranded whales have been scavenged onshore, or in some cases driven by teams of small boats to beach themselves during their seasonal migrations (a practice that continues, controversially, to the present with pilot whales in the Faroe Islands). From a later date, they were hunted at sea, at increasing distances from land. Once captured, killed, and dismembered, their uses were many. Their meat provided food, their blubber oil for lamps, and in the absence of timber, their giant rib cages furnished the structural support for human dwellings. Smaller bones were fashioned into household furnishings and tools; whale skin was used to make purses, belts, and ropes for church bells. Ambergris, a by-product of digestion consisting of a darkish mass of oils, fats, and undigested matter excreted or vomited by the whale, was used as a fixative in perfumery. Spermaceti, an odorless, clear liquid found in the head cases of sperm

whales, was used in the manufacture of candles and cosmetics and in leatherworking. The industrial revolution and the urbanization that accompanied it provided a range of new uses for whale products. Whale oil was used in increasing quantities in street lamps (five thousand of them in London in the first half of the nineteenth century), as an industrial lubricant in workshops and mills, in the manufacture of varnishes, paints, ropes, and soap, and in the preparation of leather and wool. With the decline in whale oil prices after the discovery of petroleum, new applications were found for the meat and bones of whales in the manufacture of glycerine, fertilizers, paint, medications, cosmetics, margarine, and animal feed. In the words of historian Jean-Pierre Proulx, "Few animals have occupied as important a place as the whale in the economy of the Atlantic nations."[6]

Time perhaps to consult what remains the greatest example of whaling literature, Melville's *Moby-Dick*. Melville's whale of a novel tells the story both of the final voyage of the whaling ship, the *Pequod*, and her crew from the Massachusetts whaling ports of New Bedford and Nantucket to the South Pacific, and of Captain Ahab's obsession with the white whale, Moby-Dick, whom he pursues across three oceans. Ahab's pursuit of Moby-Dick is not simply a quest for revenge (for the lower leg of which the white whale had deprived him on a previous voyage), but also, as Deleuze and Guattari note, a metamorphic flight from the conventionally human. This is not a matter of imitation, imaginative empathy, or the exchange of one species identity for another. Ahab and the whale form an alliance across difference, a "block of becoming," a between zone of indiscernibility whereby in striking at the whale, Ahab is striking at himself. Ahab's obsession assumes planetary dimensions as he swears his willingness to dive to the center of the globe in order to have his revenge. His becoming-whale leads him, ultimately, like Filippos, to the realm of the dead, but without the possibility of return—except of course through the words of the novel's narrator and the sole survivor of the *Pequod*: "Call me Ishmael."[7] At the same time, *Moby-Dick* is itself a work distended to whalelike proportions with an abundance of nautical and cetological detail. Individual chapters include discussions of natural history, zoological classification, and the technicalities of whaling, along with extended reflections on the majesty and mythopoeic grandeur of whales:

Blubberbomb

Wherefore, for all these things, we account the whale immortal in his species, however perishable in his individuality. He swam the seas before the continents broke water' he once swam over the site of the Tuileries and Windsor Castle and the Kremlin. In Noah's flood he despised Noah's Ark; and if ever the world is again flooded, like the Netherlands, to kill off its rats, then the eternal whale will survive, and, rearing upon the top-most crest of the equatorial flood, spout his frothed defiance to the skies.[8]

More than a century and a half later, however, with numerous whale species hunted to the point of extinction, Melville's optimism may seem far less plausible. Are whales simply another example of a nature that is thoroughly historical, thoroughly socialized, thoroughly entangled, for better or worse, with human projects and purposes? Is it only possible to tell the story of the intervening years as one of cumulative human destructiveness and belatedly dawning ecological responsibility? After all, as Vicky Szabo reminds us, whales were never just resources; they were also monsters, prodigies, and creatures of wild nature and the open sea beyond the sway of human governance—a source of terror and wonder in life as much as of subsistence or, occasionally, superabundance in death. Medieval and early modern accounts of whales from Northern Europe, including clerical sources and the Icelandic saga literature, draw on a combination of classical, Christian, and pagan Scandinavian influences to evoke a panoply of associations, among them sea serpents, weather magic, shape-shifting sorcerers, and the biblical figures of Leviathan and Jonah's great fish.[9] Need these be understood simply as further human acts of appropriation, as the human bestowal of meaning on a realm only ostensibly beyond human habitation and influence? Might they be rather seen as establishing thoroughly provisional and precarious linkages—"partial connections," perhaps, to borrow a phrase from Marilyn Strathern—with powers and presences that resist or disrupt such wholesale encompassment?[10]

The mundane and practical, the monstrous and magical, are present in equal measure in one of the most comprehensive early modern accounts of whaling, the multivolume *Description of the Northern Peoples*, written by Swedish cleric Olaus Magnus (1490–1557) and first published in 1555. Drawing on written authorities and the author's firsthand observations, Olaus's narrative includes detailed descriptions both of whales and of the methods used in killing and processing them. It also includes copious

details of regional customs and traditions concerning whales and their uses, such as the following, relating to the whalebone houses that were a widely reported feature of North Atlantic communities.[11] Olaus cites the belief, allegedly current among the Arctic Norwegians, that the whales whose bones were incorporated into such dwellings continued to influence the dreams of those who slept within: "Those who sleep inside these ribs are forever dreaming that they are rolling incessantly on the ocean waves or, harassed by storms, are in perpetual danger of shipwreck."[12] Here, strikingly, it is not the whales themselves but rather the bones that are their physical residue that retain the capacity to trouble the sleep of their human exploiters, providing the conduit for a tempestuous fluidity to infiltrate the seeming solidity of architectonic form via the dreams of the land dwellers who lie within. Indeed, it is precisely the human appropriation of the whale's physical remains that renders the inhabitants of such dwellings vulnerable to these oneiric incursions from beyond the settled realm of terra firma.

What about blubber, the layer of veined fatty tissue found under the skin of whales and extending over almost the whole body to a thickness

FIGURE 39. Whalebone houses, Norway. From Olaus Magnus, *Description of the Northern Peoples* (1555). Published by the Hakluyt Society. Reproduced by permission of David Higham Associates.

of, in some cases, up to twelve inches? Of all the substances wrested by human effort from dead whales, blubber, consumed as a food by many peoples of the Arctic and also a source of oil burned in lamps and used in the manufacture of leather, soap, cosmetics, and candles, was at once the most abundant and the most potentially lucrative—to the extent that one especially profitable seventeenth-century Dutch whaling colony on the Arctic island of Spitsbergen earned the nickname of *Smeerenburg* (blubber town).[13] Yet if blubber was a prized resource, and latterly a commodity, it also imposed its own imperatives on the humans who sought it out. The swift decomposition of whale carcasses—within twenty-four to forty-eight hours—necessitated their rapid processing on shore, usually a community-wide effort, or, at a later point, the construction of specialized whaling vessels with onboard facilities for stripping, boiling, and rendering down the blubber obtained from the kill.[14] Alongside a recognizably human-centered history of predation and production, might one not detect here the insinuation into human practice of a different logic—a blubbery agency and temporality to which human projects were obliged accommodate themselves?

Carry my smelt
across hard lakes
carry my way of
pouring my runny body[15]

Transfer Fat is the title of a collection, originally published in 2002, by contemporary Swedish poet Aase Berg, a former member and cofounder of the Surrealist Group in Stockholm (1986–), a collective of artists, writers, and activists drawing part of its inspiration from figures on the fringes of the French Surrealist movement of the 1920s, like Georges Bataille.[16] The poems draw on a variety of influences and sources, including two classic science fiction films, Stanley Kubrick's *2001: A Space Odyssey* (1968) and Andrei Tarkovsky's *Solaris* (1972), along with the vibrational materialism of string theory, the viscous liquid–solid materiality of whale blubber, and the author's own experience of pregnancy, of which she would later say in an interview, "I was afraid of everything physical. . . . Then I gave birth to kids and suddenly realized that my body was a monster, but working together with me."[17] *Transfer Fat* marks a significant

departure from Berg's earlier work, the prose poems that predominate in her first two volumes giving way to short, sparse stanzas in which individual words are at once densely charged with meaning and continuously call attention to their own material presence on the page. Then there are the titles—"Unborn Fat," "Smelt," "The Shimmering Inside of Tunnels," "Crawlfish," "Quantum Tunneling," "Hole Whale," "Birth Rubber," "Blubber Biter," "Open the Voter," "Mom Choice," "Umbilical String"—enigmatic outriders that seem simultaneously to invite and impede readerly access to the verses appended to them. Reviewing the English translation of *Transfer Fat* at the time of its initial publication, poet and critic Joyelle Macsweeney writes of Berg's titles in terms that are powerfully reminiscent both of Filippos's descriptions of his own work and of the mutational pulsions of Genetic Moo's *Mother*:

> The titles act like membranes; they catch your attention; your attention becomes a little prod or probe. You push at the membrane of the title and move through it into the shell meat of the poem, carrying gummy traces of the title with you, covering your eyes, nose, mouth, changing your vision and your breathing. You're now half-digesting, half-gestating the poem, which, by the sci-fi logic by which the book operates, means that you might now be destined to supernova in a slickly bloody birth.[18]

Berg's verses render language into what she calls a "deformation zone," in which words shed their conventional significations and interpenetrate and mutate to form new realities:

Blubber biter—

Here hangs the bite
Waiting for blubber
For many thousand years
Of slowness[19]

Like the dream language of Joyce's *Finnegans Wake*, the poems of *Transfer Fat* hold multiple signifying possibilities in a state of suspension, without requiring the reader to settle decisively for one at the expense of another. Berg's English translator, Johannes Göransson, writes, "In the

Blubberbomb

blubberiness of the whale we get a blubbery language that refuses to coalesce: every choice is and isn't a choice, is and isn't a whale."[20] In Swedish, the word *val* can mean "whale," "election," or "choice," depending on context. It also rhymes with *hal*, "slippery," which is also the name of the increasingly erratic computer in Kubrick's film, references to which are scattered throughout the text. Compound words and neologisms are also a recurrent feature of the Swedish language, but Berg's writing carries this to extremes with formulations like *valyngeskal* (whalebroodshell) and *fittsela rullbandsfettflod* (cunststiff looptrack fatflood). This practice also has a defamiliarizing effect on familiar compound words, focusing renewed attention on their constituent elements, as in the Swedish term for killer whale—*späckhuggaren*—which Göransson is led to render directly into English as "blubber biter." The oozing, forming, dissolving, self-sculpting ambience of the text is one that stages language as a material practice, a metamorphic and inherently unstable stuff continuously overrunning lexical definitions and semantic intelligibility. Of his own role as translator, Göransson has the following to say: "Rather than writing a 'faithful' translation of a text so unfaithful to its own native language, I hope to bring into English this unfaithful translation ambience, this language fat."[21]

Lightness in fatness
Flight in blubber[22]

If the maternal or birthing body is a reiterative presence in these verses, then the body in question is by no means a normatively gendered one— no more so than Tiamat, Ymir, or Negarestani's bloblike petrochemical puppeteer. Rather, it appears decidedly queer in its fluctuations, slippages, and animal, vegetable, and mineral metamorphoses. It is worth comparing *Transfer Fat* briefly with the work of another famously blubber-besotted artist, Matthew Barney. Barney's 2005 feature-length film *Drawing Restraint 9* is set on board a Japanese whaling vessel bound for the Antarctic. During the course of the voyage, a quantity of petroleum jelly, set in a mold and deposited on deck, gradually liquifies and spreads. At the same time, the ship's two passengers, a man and a woman played by Barney and his then partner, Icelandic singer Björk, take part in a series of elaborate costumed ceremonies, fall in love, and end by shedding their

human forms, using flensing knives, designed for the stripping of blubber from whale carcasses, to carve each other into the shapes of whales that finally swim away from the ship. If Barney's film recounts parallel trajectories from human to nonhuman and from semisolid form to fluid deliquescence, then Berg's verses conjure a realm of linguistic-material becoming that is always already impersonal and asubjectival, already other than human. As such, it represents not a telos or a lost object to be regained through purposive human striving but a subliminal contemporaneity, a literally other time:

In granite gains fat
In slow veins' years
Of patience in a way of
Being another time than
Human[23]

What might we understand by "another time than / Human"? A blubbery time? A whale of a time? A Fat Time? "Fat Time" was, of course, another name for Carnival, the period of license and celebration traditionally preceding the beginning of Lent in the liturgical calendar of medieval and early modern Europe, and later its colonial outposts in the Americas and elsewhere, Fat Tuesday being the literal (whatever that is) translation of "Mardi Gras." It was with Carnival too that Bakhtin, another celebrant of linguistic and discursive heterogeneity, famously associated the "grotesque image of the body." The grotesque body for Bakhtin was a body in process, emphatically and unabashedly material, a constantly bursting out of itself, overflowing its own bounds to conjoin with other bodies and the world, partaking as such of an unruly, preindividual, impersonal life force akin to what Deleuze would later refer to as "A Life."[24] A body then at once blubbery and explosive?

Here's Tsitsopoulos again (this time referencing a study of the concept of the soul by his compatriot, independent scholar of comparative religion Penagis Lekatsas):

Also in the Pacific there takes place a ritual of hanging up pictures of deceased loved ones along with images of living persons, newspaper clippings and flowers also, in the body of a lifeless whale that the sea dragged

Blubberbomb

dead on shore. Lead away, was the idea and the symbolism of this action, all these messages through the stomach of the animal, to the marine world that all humans come from.[25]

Sometimes, though, he notes, the proceedings were interrupted by an explosion, caused by the buildup of gases as a result of the ongoing process of decomposition. Such occurrences have been widely reported—for example, in Tainan City, Taiwan, in January 2004, when the carcass of a sperm whale, washed up on the adjacent coast, exploded while being transported by truck to the Sutsao Wildlife Reservation Area, showering spectators and passersby (not to mention the sidewalk) with quantities of putrescent blubber and entrails in a body burst that, as contemporary news footage attests, was no less a burst of color, as the dark brownish gray outer form of the dead whale disintegrated in a cascade of crimson.[26]

Filippos, however, thought of the exploding whale less as a traffic incident than as a sanctified cetacean suicide bomber: "The new Saint Whale bomber—a weird whale-saint that explodes in all directions, accompanied by bomb-laden animals."[27] Echoing both the corporeal exuberances of Bakhtinian Carnival and the baroque predilection for implicatory self-elaboration that so impressed both art historian Henri Focillon and later Deleuze, Tsitsopoulos envisaged the installation's four video projections as scenes from inside the whale's belly, envisioned as a matrixial space-time of dissolution, metamorphosis, and communication with the dead.[28] Here the accumulated debris of Nature and Culture as conventionally designated—fragments of terrestrial and marine life, outdated costumes, and musical forms, like the madrigal of the title—would be rendered down, transformed, and recombined to yield an explosion of new life. Like Aase Berg's poetry, this is not a realm of axioms and definitions, seeking to limn the contours of an assumed to be given real, but one generative of realities yet to come. The whale belly is a field of co-existence—of pasts, presents, and futures, the human and the other than human, the raw and the cooked, not so much a zone of undifferentiation as one of intensive difference, ready to erupt from the screen in novel and unforeseen configurations. For Filippos, the resultant explosion amounted, despite the titularly male gender of the protagonists, to a self-dissipatory act of birthing:

238 *Blubberbomb*

San Whale the Bomber, representing a new version of San Sebastian . . .
just about to burst after receiving a barrage of arrows. In the images we
find fragments of a universe made of flowers, fruits, lobsters, faces etc. . . .
without apparent order . . . a non-place, timeless, but in which there is
action slowed down by the photographic moment, a sort of Big Bang view-
ing, giving birth to this other reality.[29]

What such a slow-motion bursting or opening reveals is a thoroughly
real and thoroughly inhuman presence manifest within but ultimately
irreducible to what we have become accustomed to think of as culture
and history. It is a presence that art and literature are able to evoke pre-
cisely to the degree that they acknowledge and affirm the materiality of
their media as a force capable of displacing from within their own pur-
ported signifying intentions. It is a presence that academic discourse
has often missed precisely by its failure to do the same. This is less a mat-
ter of accurately representing nature, whether as human construct or as
radical exteriority, than of translation in Göransson's sense, of allowing
oneself to be powerfully affected by the metamorphic oozings of an inas-
similable yet inalienable alien matter. Taking seriously the density, the
opacity, the inhuman life of the materials with which we work, including
texts, images, and their reciprocal interferences, demands perhaps the
questioning not only of anthropology's sometime self-identification as a
social science but of the very possibility of a social science, along with its
habitual recourse to "context," "history," and the relationality of discretely
conceived bodies as the supposedly definitive arbiters of explanation, as
well as the countervailing embrace of a truth that can only find acknowl-
edgment through the suspension of accredited distinctions between truth
and fiction, between what science knows and what poetry and art can
claim, differently but no less persuasively, to know.[30]

Like the faltering Shakespearean speech of the artist's actor father, and
like the whaleblubbery ambient flux of Aase Berg's poetry, the end of
Thorn-face's monologue is marked by a disturbance of language. Sud-
denly the verbal recitation issuing from the realm of death, dissolution,
metamorphosis, and explosive potentiality is punctuated by irregular,
ducklike quacks, each quack causing the performer's head to twitch as
though convulsed by an involuntary spasm—"Quack! Quack!" At the
same time, this most chromatically somber of the work's four protagonists

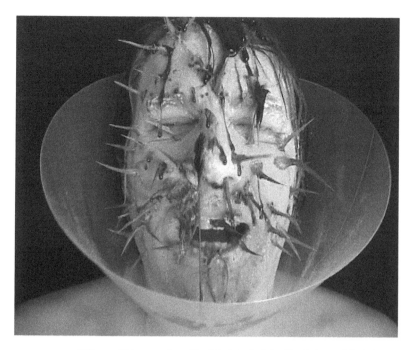

FIGURE 40. Filippos Tsitsopoulos, *The Madrigal of the Explosion of the Wise Whale*. Photograph supplied by the artist.

undergoes a startling transformation as red, bloodlike fluid begins to seep from the base of the thornlike protuberances that cover the face: a quacking, bleeding vegetable Christ or a perforated Sebastian leaking liquid life from his accumulated puncture wounds. But the strange, misshapen, oozing talking head keeps talking, talking from an elsewhere and an elsewhen that seize and contort the habituated space-time of the viewer's familiar here and now as humanly intelligible discourse dissipates into an inhuman and asemic force of sound and vision:

> Go and die!
> Quack!
> Laugh and die!
> Quack! Quack!
> Cry and die!
> Quack!

Fight and die!
Quack! Quack!
Fuck and die!
Quack!
Quack!
Quack!
Quack!
Quack!

BOOM!!!!!

twenty-one

A Globe of Fire

An explosion on an altogether larger scale was envisioned by Walter Traill Dennison (1825–94), probably Orkney's best-known and most prolific nineteenth-century folklorist, addressing a meeting of the Orkney Natural History Society in the town of Stromness on Orkney Mainland. Dennison was the son of a well-to-do farming family from Sanday, the largest of Orkney's northern isles, lying around twenty miles northeast of Orkney Mainland. His lecture, published in 1893 in the journal *Scottish Antiquary*, is devoted to the effects of marine erosion on Orkney's landscape and archaeological heritage, including graves and memorials to the dead, and it draws repeatedly on examples from his native island. He begins, however, not with burials of deceased humans but with the remnants of submerged prehistoric forests. On the west side of the bay of Otterswick, in Sanday, an area now accessible only at the low water line during the spring tide in March, it is possible, he points out, to dig through the overlying layer of sand to reach a bed of moss "in which the decaying skeletons of trees lie in every conceivable position." Such submerged forests, Dennison notes, can also be found on many of the other islands: at Storehouse Bay on the island of North Ronaldsay; at Pierowall on Westray; at Millbay on Stronsay; and on Orkney Mainland and the south isles, affording proof that the land on which the trees once grew was formerly above sea level and that the islands of the Orkney archipelago have been undergoing a gradual process of subsistence. Dennison offers a brief imaginative reconstruction of these now vanished landscapes—the tree trunks and spreading leaves, the animals that once

241

242 *A Globe of Fire*

roamed there, the birds that sang in the branches—before going on to enumerate the traces of human habitation that are in the process of being effaced by the encroachments of the sea. These include the fragmentary ruins of houses and kelp stores at Swarthammer and Hamness, the side walls and seaward gables of which have now disappeared beneath the waters.[1]

Halfway through the lecture, though, the perspective abruptly shifts. Dennison asks his audience to reflect on the transitoriness of all terrestrial forms, considered from the vantage point of geological time:

> In our "talk, talk," we speak of the firm, stable, immovable earth. No words can be more fallacious when applied to our world. The truth is, we live on a globe of fire, ready at any moment, from many causes, to be hurled into terrific destruction. Imagine a huge chasm opening longitudinally in that part of the abysmal sea on which the two Atlantic oceans rest or roll. Those oceans would at once be precipitated on a tremendous mass of igneous matter, whereby an amount of steam would be generated sufficient to explode the world, making the earth like a bursting bombshell. . . . And while we talk of the immutable laws of nature, we should remember that all these laws must succumb to the inexorable law of exhaustion.[2]

From an account of transformations of the familiar landscape, we are catapulted into a vision of planetary destruction, in which the earth's solid mantle is cracked asunder by the outpouring of its molten core—the same core that bubbles upward through Iceland's vermicular, volcanic lavascape and to which Captain Ahab had threatened to dive in pursuit of Moby-Dick. Dennison's description evokes the obliteration not only of humanity but also of the terrestrial globe itself as the ecological support of all life.

It is striking that Dennison should be propelled toward such a vision precisely by consideration of the interplay—the "strife"—between land and sea in an island setting. Islands appear here as sites not only of new beginnings, or beginnings anew—as they were for Deleuze—but also of violent and catastrophic endings. Concrete instances of death—the demise of prehistoric forests and of the human inhabitants of the ruined houses scattered along Sanday's shoreline—are absorbed first of all into the encroaching waters of the North Sea and finally into a speculative

conjuration of cosmic flux and dissolution capable of eradicating all vestiges of a human presence.

Deleuze and Guattari would later rearticulate the elemental strife of land and sea in terms of a geophilosophy situated in relation to the earth as the inhuman ground of human thought and action, and tracing a continuous two-way traffic between the territorializing inscription of the earth by history, language, and politics, and the deterritorializing impetus of the earth itself as the undoing and the virtual limit of any possible actualization of territory—and thus of any humanly conceivable project of world making.[3] More recently, the philosophical imperative to envision a cosmic reality from which humanity is radically absent has been reasserted by Quentin Meillasoux, who refers to such a reality as the realm of the "ancestral" (or the "Great Outdoors"), referring not to the human ancestors documented in archaeological and folklore scholarship but to that which pre- or postdates humanity and that demands as such to be thought as existing independently of its being given to a knowing, perceiving human subject. For Meillasoux, it is preeminently modern science, notably evolutionary biology and geology, that has provided access to ancestral realities such as the nucleation of the earth and the beginnings of terrestrial life, in the process throwing down a challenge to post-Kantian philosophy's frequent insistence on the inescapable mediation of all knowledge by context, language, or subjectivity.[4] Yet to suggest, as Meillasoux often appears to, that knowledge of the ancestral is the exclusive prerogative of a self-sufficient philosophical or scientific rationality risks obscuring the ways in which the antecedent inhumanity (or posthumanity) of the ancestral remains implicated in human thought and language, no less than in the perhaps more self-evident materiality of bodies and perceptions. If the disavowal of any possibility of direct knowledge of reality in itself has been a defining gesture of modern, self-styled critical philosophies, it is surely worth asking whether intimations of a reality existing independently of our capacity as humans to think or perceive it have not previously found expression through other genres and media—whether, indeed, such expressions might not be as old as humanity, as old as culture. Might not what has sometimes been referred to as culture be nothing more or less than the human appropriation and encoding of an inhuman, anorganic force of matter that forever exceeds and displaces the humanly constructed orders fashioned from it? If so,

244 *A Globe of Fire*

might it not be the case that this displacement from within and without has attained one of its most potent manifestations in the immemorial and unresolved strife of land and sea and its associated imaginaries?

"THE SEA IS THE LAND'S EDGE ALSO"

"The sea is the land's edge also," writes T. S. Eliot in his poem "The Dry Salvages" (the third of his *Four Quartets*, published in 1941), which takes its title from a group of rocks off Cape Ann on the Massachusetts coast— the same coast from which Captain Ahab and the crew of the *Pequod* set sail in their ill-fated pursuit of Moby-Dick. Eliot's poem pictures the sea beating continuously against the New England shore, casting up as it does so "hints of earlier and other creation," including starfish, horseshoe crabs, and the algae and sea anemones found in rock pools, along with the backbones of dead whales deposited by the tide.[5] Perhaps unsurprisingly, the continuous encroachment of the sea upon Orkney's islands has been a persistent theme of Orcadian imaginaries of place and was an abiding preoccupation of Dennison's output as a folklorist. Dennison's writings on the Orcadian folklore of the sea first appeared as a series of articles in *Scottish Antiquary* between 1890 and 1893. Here the sea appears not only as a constant presence in the life of the islands, and the resting place of countless dead of past generations, but also as the abode of a variety of other-than-human powers and agencies. These included: the benign and maternal Sea Mother ("Mither of the Sea"), who each spring fought and subdued her antagonist, Teran (the bringer of winter storms, "whose name means furious anger"), to ensure calm weather during the summer months; the Stoor Worm, a variety of sea serpent; the Nuckelavee, or Devil of the Sea, whose venomous breath blighted crops and caused animals to sicken; the misshapen Sea Trow; the Fin Folk, a race of beings usually described as human in outward appearance but living beneath the waves and occasionally abducting humans to join them as spouses; and, perhaps best known, the selkies, or seal people, beings residing in the sea in the guise of seals but sometimes venturing ashore at twilight to cast off their sealskins and dance naked in human form on the sand. For Dennison, the repertoire of stories about these and other denizens of the sea that he collected from his native island of Sanday and elsewhere represented a series of cultural strata (or "survivals," in Edward Tylor's influential phrase) extending back to the

A *Globe of Fire* 245

earliest human conceptions. Like Tylor, Dennison suggested that in these vestigial traces could be read a history of the evolution of human thought and imagination. Beginning with the Sea Mother ("answering to all the purposes of protoplasm"), he traced a progression through Teran and the Stoor Worm, via Nuckelavee ("half man and half beast"), the Sea Trow ("in the form of a man, with the mind of a beast"), the selkie ("a beast, yet able to assume the form of a man") to the Fin Folk ("with astute mind, and well developed human form, yet with all the conveniences of a fish for aqueous existence and locomotion"), a progression tending, as he suggested, toward the increasingly anthropomorphizing personification of elemental forces.[6] Dennison's descriptions suggest, however, the possibility of considering the folklore of the sea as something more than the projection of human-identified traits onto an inanimate nature. The contemporaneous coexistence (at least until the late nineteenth century) of the various storied beings inventoried by Dennison could be understood as indexing not the linear temporality underpinning Victorian stadial theories of social evolution (of the kind that informed Tylor's speculations about primitive animism) but rather a time more akin to that of Deleuze's pre- and posthistorical strife of land and sea, of the self-differentiating potentiality of time and matter, to which folkloric imaginings of elemental powers continuously refer us. The Orcadian folklore of the sea, to which Dennison devoted a lifetime of scholarly labors, might thus be approached not as the evidential scaffolding on which to hang a unidirectional account of human progress but as an exemplification of what the young Deleuze identified as the mythic imagination, a collectively exercised power of fabulation that appropriates, condenses, and elaborates the other-than-human forces and materials out of which human worlds are at once formed and carried beyond themselves.

"Seaweeds and Limpets Will Grow on Our Gravestones"

It is worth setting the reiterative presencing of the sea in the guise of folklore, material culture, and marine erosion against, on the one hand, the sometimes voiced archeological interpretation of Neolithic tombs as marking the differentiation of the dead as a linearly unfolding sequence of group ancestors, and on the other hand the more varied technologies of particularization (gravestones, memorials, and so on) in evidence in

the churchyard of St. Magnus Cathedral. As the unevenness and variability of the intervening archaeological record reminds us, we should be wary of locating such divergent expressions in a single trajectory of progressive individuation extending from the prehistoric past to the early twenty-first-century present. What is evoked by Dennison's anticipated cataclysm, by the fate of sites such as Skara Brae and by the material record itself, is not a linear narrative of historical progress but a persistent and unresolved two-way movement between differentiation and dedifferentiation—between, on the one hand, the solidification of collective, individual, or sometimes named presences through the construction of houses for the dead, the ritual processing of remains, the erection of gravestones and monuments, and the carving of inscriptions, and on the other hand, the continuing and finally unstoppable dissolution of the same back into the amorphous, all-pervasive, and always prior backdrop so powerfully evoked in Isidra's exposition of the Palo term *Kalunga* as "the great indifferent sea of the dead."[7] Further, are not the sea of the dead, the more familiar terrestrial sea, from which the former borrows its name, and Canetti's invisible crowd themselves condensations out of the immense, indifferent, and always antecedent matter of the universe— of planets and stars, solar systems and galaxies that were born and died long before the appearance of life on earth? If the cultural death work performed by funerary rites, inhumation practices, and acts of memorialization is apt to appear always as an attempt to resist or slow the dissolution of the deceased into the generative and untotalizable mass of what came before (and will come after), then these death practices nonetheless affirm and make visible at the same time the inevitability of such dissolution. What such gestures produce, then, is arguably a transitional space between differentiation and assimilation, one in which the striving toward commemoration or perpetuation becomes at the same time the disclosure of ephemerality, of our participation as humans and culture makers in a materiality that at once constitutes and dispossesses us. Our bodies will liquify, our stone monuments will crumble, our inscriptions will fade. Are not we who call ourselves the living, along with our tombs, memorials, funerary rites, and prayers for the dead, no more than a passing hesitation, a transitory holding back in the face of the summons that murmurs continuously and irresistibly from the vast sea of the dead? Perhaps indeed it is the privileged role of the dead, the anonymous and

A Globe of Fire

mythic dead as much as our deceased loved ones, friends, and family members, to remind us continuously of this. Dennison concludes his address to the Orkney Natural History Society by returning to a human timescale, albeit one poised precariously on the brink of its own dissolution. In a paragraph recalling Melville's paean to the "immortal" whale, he reminds his audience that their own memorials to the dead, the solid ground on which they stand, and indeed they themselves are likewise no more than a fleeting presence, fated to be reclaimed by the sea that beats continuously against Orkney's shores:

> Our island home is doomed. In a few short ages the lobster and crab will crawl on our cold hearthstones; whales and fishes will disport above where our chimney tops now reach; seaweeds and limpets will grow on our gravestones, and our graves will be nowhere. But our dust will be safe in that most glorious of all sepulchers—the mighty ocean—on which "time writes no wrinkle"[8]

For the sea is the land's edge also.

twenty-two

Nighttime

How does one begin to imagine the radical absence of an imagining human subject—if indeed imagination is to be understood as an exclusively human faculty? Like the primordial waters of the Mesopotamian and Judeo-Christian creation narratives, darkness has also served diverse human communities as an imaginative placeholder for that which is understood to precede the very possibility of imagining. Think, for example, of the darkness that lies upon the face of the deep before divine intervention in the biblical account of creation. Distilled out of the originary elements of fire and ice, and belonging to an earlier order of creation than the gods who supplant them, Ymir and his fellow giants are also creatures of darkness, understood both as the primordial condition of the universe, prior to the emergence of intelligible, specularly legible form, and as the state to which everything will return, at least temporarily, when the existing order is overthrown. In the words of the Voluspa, or seeress, who narrates this story of creation and destruction: "The sun turns black, earth sinks into the sea / The bright stars vanish from the sky."[1] Many stories suggest that night is the time in which giants are most active and powerful and that they have a marked antipathy toward daylight and diurnal clarity. Another Eddic poem describes a giantess called Rimgjerd who is turned to stone when struck by the rays of the rising sun.[2] The giants who appear in folktales from Orkney and Shetland are in many ways diminished versions of their Eddic counterparts—malevolent, clumsy, frequently stupid. They nonetheless share their precursors' nocturnal character. Some stories explain features of the local landscape such as

standing stones and stone circles as the petrified bodies of such giants. Reverend John Bryden, in his *New Statistical Account of Shetland* of 1841, mentions two standing stones in the vicinity of Wester Skeld said to be the metamorphosis of two giants who were on their way to plunder and murder the local inhabitants but miscalculated the time and were struck and transformed by the first light of day. The transformation, however, is not always a permanent one; some stories tell of petrified giants reawakening during the hours of darkness. A standing stone known as the Yetna-steen on the southern Orkney island of Rousay is described as descending to the Loch of Stockness for a drink immediately after midnight on New Year's Day, while in the Parish of Birsay on Orkney Mainland, stories have been recorded about the stone of Quoyboon going down each New Year's morning to the Loch of Boardhouse, but always being back in its usual place by dawn. Of these stories, Orcadian folklorist Ernest Marwick notes, "Possibly we can see in these local tales a dim memory of the giant Ymir, out of whose body, according to Scandinavian myth, Odin and his brothers built the world, making the seas and lakes out of his blood, earth of his flesh, and the sky of his skull."[3]

Surely the appeal of such accounts consists again in their insinuating of a generative recursivity into what appears otherwise to be a logic of linear supercession: the race of giants overcome by the ascendant gods, the body of the individual giant (or giantess) transfixed and rigidified by the dawn light. Perhaps one of the roles of such narrative recapitulations is to do just that, even as they appear to recount the definitive overcoming of an earlier order by its self-designated successor. If nighttime is the time of the giants, then perhaps night here is not simply the night that follows day, but a more enduring, enveloping, and tactile night. Gaston Bachelard writes of such a night as a "pervading," "active," or "penetrating" night: "Night is *made of night*. Night is a substance, is nocturnal matter."[4] Yet if Bachelard's point of reference is the human imagination—specifically the material imagination—in its capacity to conceive of such a vision of night, what is evoked here seems equally to be the possibility of subjectivity's outward unraveling into the anonymous and impersonal life of the material universe. This, then, is the night that precedes all differentiations—including that of subject and object—and that precedes the creation of the world itself in the Eddic account. If this night returns—

250 *Nighttime*

and will always return—it is as the all-pervasive night of not-yet-formed matter, not waiting to be formed by an outside hand but, like Plato's *chōra*, animated by its own motions, stirred by its own powers and potentialities. It is the night in which the rigidity of stone reawakens to life and movement—the night of the giants.

THE MIRRIE DANCERS

As a visitor to the island, it is difficult not to be struck by the often enveloping character of Papa Westray's nights. The island has only eight streetlights, all of them grouped along the short stretch of road running east to west between the community shop and the island school. (The airstrip has no landing lights, so the timing of interisland flights varies throughout the year in accordance with the hours of daylight.) To move downhill from the street-lit area in the direction of the old pier and kelp store, or uphill in the direction of Holland Farm is to pass from the familiar glow of an illuminated human settlement into impenetrable darkness— a darkness that in shutting out visibility magnifies every ambient sound, such as the moaning of the wind, often a more or less constant presence, or the variegated nighttime calls of the many bird species that nest in the northerly part of the island. Only when you arrive at the southern or western shore is the obscurity pierced by the tightly grouped lights of the village of Pierowall on the adjacent island of Westray, lying less than two miles away across the sound. Yet under the right conditions, the absence of electric light can also be conducive to visibility. On cloudless nights on the cusp of spring, the constellations of the night sky appear with a clarity of definition not to be experienced in more densely populated localities. Sometimes at the same time of year, on particularly clear nights, a more unusual sight presents itself—the aurora borealis, known locally— and more evocatively—as the Merry Dancers—red, blue, green, yellow, or pink, in varying combinations, and emitted, according to astronomers, by collisions occurring high in the ionosphere between charged particles, agitated by a combination of solar wind and the pull of the earth's magnetic field. For many of the peoples of the circumpolar region, however, the aurora has been associated also with en masse appearances of the dead. Canetti, for example, notes that for the Tlingit of Alaska and the Sami of northern Europe, the lights are the massed souls of warriors killed

in battle, in some cases continuing their fight in the upper regions of the air, while the Cree of northwest Canada refer to them, more benignly, as the Dance of the Spirits, again evoking a crowd or plurality rather than particular, named individuals.[5]

Mirrie Dancers was also the title of a Shetland-based community art project, documented for the duration of the festival in a digital photographic display in the entrance to Ivanov and Chan's home-cum-studio space. Conceived by the artists Nayan Kulkarni and Roxane Permar and commissioned by Shetland Arts (an arts organization founded in 2006 and based in Lerwick, Shetland's main town), the project invited Shetland residents to collaborate in creating light-based artworks for their locality.[6] Many of these involved projections onto the sides of buildings and other surfaces emulating the shifting colors of the celestial Merry Dancers. Among the sites chosen was Da Giant's Grave, two large standing stones at the foot of a hill known as the Björgs, to the west of Lochend in Northmavine, the most northerly parish on Shetland Mainland. In this case, archaeological investigation of the site has indicated that the standing stones are the remains not of petrified giants caught unawares by the break of day but of a human burial—one of the many Neolithic chambered cairns distributed across the landscape of Orkney and Shetland. Films made by members of the local community were translated using specialized software into "color light scores," which were then projected onto the stones between dusk and 11 o'clock at night.[7] The images on the screen at Tredwall were a pictorial record of the display, which had ended on November 30 of the previous year. Nonetheless, even at such a remove, it was impossible (for this viewer at least) not to register the power of the associations set in motion by the coming together of a prehistoric structure built to house the dead, the folkloric figures of petrified giants, and the light projection emulating the colors of the aurora—itself formerly understood as the spirits of the dead disporting, festively or violently, in the night sky. What the superimposition of these registers evoked so forcefully was not only the many-layered cultural stratigraphy of Orkney and Shetland's long settlement history but also an interface between a humanly elaborated semiotics of landscape and the no less generative materialities of light and stone, histories of death and remembrance emerging from and receding into the more expansive temporalities of matter, of geological, evolutionary, and cosmic time.

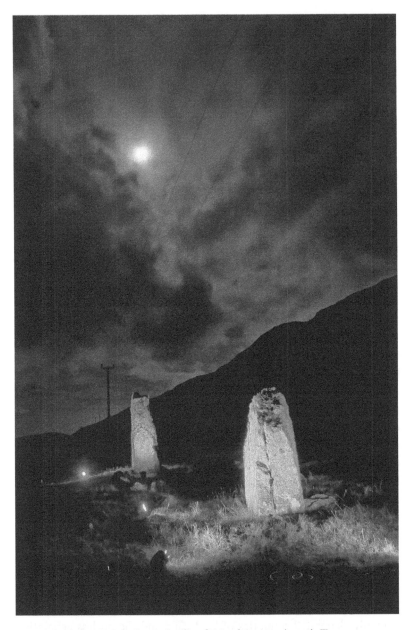

FIGURE 41. Da Giant's Grave, Lochend, Northmavine (2009). Temporary illumination for *Mirrie Dancers*, a community-based art project conceived by Nayan Kulkarni and Roxane Permar, commissioned by Shetland Arts (2009–12). Photograph by Mark Sinclair; supplied by Roxane Permar.

BACK TO "NATURE"?

"Back to nature, back to somewhere else" is a line from the song "Back to Nature" by English postpunk band Magazine (from their album *Secondhand Daylight*, released in 1979). What kind of nature might it be that one could come back to not in the manner of a homecoming but as a different, unfamiliar place, an elsewhere? What would it take to experience a return to nature in these terms? It has, after all, been a characteristic gesture of much recent scholarship to proclaim the "end of nature," and with it of the latter's contrastive opposition to society or culture, and to assert that what was once referred under the rubric of nature is in fact inextricably entangled with the lives and projects of humans. Environments— all environments—so the argument goes, should be understood as the reciprocal co-creation of a variety of human and nonhuman agents, what Donna Haraway has famously termed "naturecultures," or the "material-semiotic."[8] One might ask, however, whether idioms of mutuality, reciprocity, and co-constitution apply so readily to, say, a meteorite strike, an earthquake, a tsunami, an erupting volcano? Much as the devastation these wreak has the capacity to reveal, sometimes shockingly, the ways in which vulnerability and risk are unequally distributed among and within human communities, is their capacity to affect us not in many cases massively, spectacularly disproportionate to our capacity to influence or act on them? Or consider the unseen subterranean processes of sedimentation and compaction involved in the formation of oil, a substance that is by this point an indispensable resource for many humans, and a highly profitable one for the few who control its production and distribution.

It is worth remembering that by no means all of the variegated presences that surround humans and that play a role in constituting their worlds are readily accessible to or manipulable by them. Hugh Raffles, for example, begins his alphabetized *Insectopedia* of insect–human interactions by describing the tens of millions of tiny airborne insects, some of them wingless, carried across oceans and continents by wind currents, sometimes at heights of up to 15,000 feet. This teeming, multifarious life remains largely unseen by humans, yet is on occasion spectacularly capable of impinging on them by destroying crops or spreading diseases.[9] Are such sporadic and fleeting interspecies encounters adequately characterized as social relationships? Do the tiny insects not manifest rather an

elusive, unquantifiable, ambient presence that might seem to have more in common with Palo's ambient dead or Canetti's invisible crowd than with the interspecies relationalities and mutual becomings of Haraway's companion animals?

Do hyphenated and portmanteau terms run the risk of confining the other than human within an all-encompassing social relationality that remains tacitly human centered even in its purportedly greater inclusiveness? Naturecultures, after all, seem always to presuppose a human component, along with a human vantage point from which interactions with entities of other kinds can be observed and explicated. Has the metaphysical dualism of nature and culture been replaced by the tacit but no less metaphysically laden subsumption of what was once called nature by history, society, and subjectivity? Claire Colebrook suggests that much self-described posthumanities scholarship amounts in effect to an "ultrahumanism," whereby many of the characteristics formerly associated with a disavowed human exceptionalism are reconstituted at the level of ecosystems, the biosphere, or an all-encompassing web of life. Qualities such as (embodied) mindfulness, connectedness, and self-organizing dynamism are thus transposed from a human, social realm to living systems figured in terms of "self-maintaining organicism and autopoesis."[10] In being ostensibly cut down to size as but one element in a ubiquitous web of interrelatedness, humans nonetheless retain a unique and privileged position as interpreters of the systems from which they themselves are understood to emerge.[11] Colebrook writes:

> When man is destroyed to yield a posthuman world it is the same world minus humans, a world of meaning, sociality and readability yet without any sense of the disjunction, gap or limits of the human. Like nihilism, the logic is metaleptic: the figure of man is originally posited in order to yield a sense or meaning of life, and yet when man is done away with as an external power what is left is an anthropomorphic life of meaning and readability."[12]

Certainly there are those, like Timothy Morton, who have argued that an "ecology without nature" is precisely one that is able to dispense with any sort of appeal to a unifying ground. Yet alternative formulations like "mesh" seem always to prioritize interconnectedness over difference and

Nighttime 255

disjuncture, much as the contemporary turn toward "life" has tended to emphasize boundedness and self-maintenance at the expense of death and dissolution (although the latter are, as Genetic Moo's *Mother* reminds us, no less a part of life).[13] In jettisoning nature so readily, do we risk dimming our appreciation of a universe that exists independently of our capacity to relate to it? Ymir, Tiamat, and the rest, as well as the not-yet-territorialized expanses of darkness, water, fire, and ice from which they emerge, remind us that it doesn't have to be that way. Far from being anthropomorphic projections, these unruly bodies—fragmentary, dispersed, anarchically procreative—articulate a cosmogonic vision of a pre- (and post-) human world that refuses definitional closure, just as the wayward vitality of Lispector's "It" and Deleuze's "A Life" evokes a power of difference at once generative and dissipative, and as such not bounded by an organicist logic of adaptation, efficiency, and self-maintenance. Rather than reinscribing a titularly posthuman humanity as the self-knowledge of living systems, they remind us of the inescapable immanence of human imagining and practice to a material universe that always both precedes and outstrips them.

What if nature, rather than being a social construct on the one hand or a simple exteriority to be subjugated or fetishized on the other, were more like an intimate stranger, an *unheimlich* presence in Freud's sense?[14] Or, more provocatively, perhaps, following Lovecraft and Negarestani, an indwelling alien, a capricious, monstrously embodied, extraterrestrial intelligence lurking inscrutably in the tellurian depths? It is appropriate here perhaps to invoke the distinction borrowed by Spinoza from medieval philosophy between *natura naturata* (nature natured—that is, as the passive product of a chain of causes) and *natura naturans* (nature naturing—or nature in an active, generative mode).[15] It is the latter that Deleuze would identify with virtuality and Bergsonian duration, or, more precisely, with the movement of actualization through which a world came into existence and was continuously carried beyond itself in the direction of the new and unforeseen.[16] Jean-Luc Nancy argues that what is ultimately at stake in Freud's concept of the id is "what links us together . . . not only us humans but the totality of beings—the animal within us, and even the vegetable, the mineral."[17] Such commonality, traversing the boundaries of the conventionally organic and inorganic, is, however, not reducible to sameness. Rather, it marks a scene of originary

self-estrangement, of a difference prior to the very possibility of identity. Might such a propensity for becoming other be no less characteristic of what has been called nature? Another philosopher, Robert Corrington, suggests that Plato's and Kristeva's *chōra*, that "strange space" of "bastard reasoning," suspended between the intelligible and the sensible, where images proliferate and threaten to usurp the priority of their purported originals, should be understood as nothing less than the "Unconscious of Nature," out of which humanly legible signs emerge and into which they recede.[18] Or, to speculate further, might one speak of nature as a planetary or cosmic unconscious, generative rather than repressive, one that necessarily includes all the dead, human or other? Talk of an unconscious might seem to restore the ascendancy of history, society and the subject, via a humanism reconstituted on the level of an entified and self-bounding totality of "life." We should remember, however, that for Freud himself, one of the principal lessons of the unconscious was, precisely, that "the ego is not master in its own house."[19] To consider nature in such terms would be to acknowledge that it is always already other to itself and thus incapable of serving as a ground or unified whole, appearing rather as an unquantifiable play of differences in which humans variously participate but which is never exhausted by their participations.

Instead of rushing to substitute a no less totalizing relationality for the now abundantly criticized nature/culture binary, might we consider instead the differences internal to the latter's constituent terms? What, then, of culture as nature's long-standing definitional counterpart? Nigel Clark has issued a forceful statement of the need for humans, as sojourners on a "volatile planet," to acknowledge and respect the wayward potentialities and unpredictability of the multifarious other presences by which they are surrounded and on which they depend for their continued survival.[20] But perhaps humans in most times and places have indeed recognized this. Whatever else culture is or is not, might it not include, among other things, an engagement, whether in the mode of affirmation or disavowal, with impersonal, inhuman life of matter that is the condition for the making and unmaking of human worlds? It is perhaps in this respect that academic discourse stands to learn most from literature and from the performing and visual arts insofar as each of them engages more or less explicitly with the interface between the materiality of a medium, whether it be paint, stone, celluloid, the body of the performer, or—most

strikingly in the case of poetry—the rhythmic and phonic substance of language, and the production of discursively redeemable cultural meaning. In doing so, they index and creatively exploit culture's complicity with and displacement from within by the other-than-human materials from which it is fashioned. At issue here is neither the cultural construction of nature nor actor network theory's concatenations of humans and nonhumans under the rubric of an expanded sociality, but rather the enactment of an inescapable human involvement with forces that can never be exhaustively encompassed by human projects and understandings. Not everything is available to be scrutinized, analyzed, annotated, and explained; there remains, in Mathijs van de Port's words, "the rest of what is."[21] This, surely, is the darkness in which the primordial giants move, a darkness no less impenetrable for being the precondition of any possible enlightenment. Deleuze's concept of fabulation alerts us precisely to the fact that this excess, this beyond, this between, perennially disruptive of intelligibility and explanatory closure, is what must be engaged in the making, unmaking, and remaking of worlds. Might it not be the universe's very obliviousness to human purposes that guarantees the possibility of what anthropologist Elizabeth Povinelli and poet Myung Mi Kim have both referred to as "the otherwise"?[22]

What links the artworks featured in the Gyro Nights festival, the figures of Grýla and the *gyros,* their Nordic, Greek, and Mesopotamian counterparts, and the geological and cosmogonic prehistory toward which they gesture is not only a specific and traceable history of influences and appropriations but also, more profoundly, the affirmation of a shared consubstantiality with what (without lapsing back into discredited dualisms) we should perhaps be unembarrassed to call nature—a nature that, for all our varied entanglements with it, nonetheless retains a reserve of ungraspability and incalculability that is constitutive of nature's own becoming rather than simply a function of the limitations of human knowledge—a nature, therefore, that is never simply for us.[23]

The night of the *Mirrie Dancers* screening at Tredwall was an exceptionally clear one—so clear, in fact that BBC Radio Orkney had earlier alerted listeners to the possibility of seeing the dancers, the aurora borealis, firsthand. Thus encouraged, at around 2 AM, I ventured out alone in search of the lights in the sky, following the road past the airstrip toward the northern end of the island. The moon—not quite full—and the stars

stood out clearly against the cloudless, inky blue of the night sky with the lights of nearby Westray visible across the sound as a dim glow to the southwest. The road climbed, flanked on either side by stone walls, behind which stretched a patchwork of small fields, now cloaked in darkness. The wind, which had dropped since earlier in the day, stirred the grasses and hedgerows, and intermittent birdcalls resounded invisibly in the distance. For more than an hour I walked, scanning the sky at intervals. Sometimes, convinced that I had caught sight of a glimmer in the direction of the barely perceptible north horizon, I would stop in the middle of the road and look up, waiting, concentrating—but nothing. The dancers were elsewhere.

Afterword
Anthropology Is Art Is Frog

In February 2013, I participated in Frogtopia. At once no place and multiple places, Frogtopia is the creation of Frog King, who in turn is the creation, or the costumed alter ego, of Kwok Mang-ho. Born in Guandong province in 1947 and educated in Hong Kong, where he now lives, Kwok is recognized today as one of the pioneers of multimedia and performance art in China.[1] Frog King's output consists of a proliferation of works in a variety of media: video, photography, ink on paper, costumed performance, and found materials such as plastic bags. His approach is typically to fill his canvases and his exhibition and performance spaces with characteristic motifs, including calligraphy, inflated plastic bags suspended from strings, and the frog image that has played an increasingly conspicuous part in his work.[2] Kwok has stated in interviews that he was drawn to the figure of the frog because of its metamorphic life cycle and its capacity to move between land and water. At the same time, the image is meant to evoke a range of other associations, with its bulging eyes embodying watchfulness and suggesting a bridge for exchange and communication between Chinese and Western artistic influences and a sailboat for journeying to new places.[3] The title Frog King, meanwhile, alludes to a parable attributed to fourth-century BCE Taoist philosopher Zhuang-zi, which tells of a frog living at the bottom of an abandoned well who considers himself the king of his narrow domain until a passing turtle draws his attention to a world extending far beyond its confines.[4]

Unlike his namesake, however, Frog King is well traveled, having toured mainland China, Korea, the United States, and Europe and represented

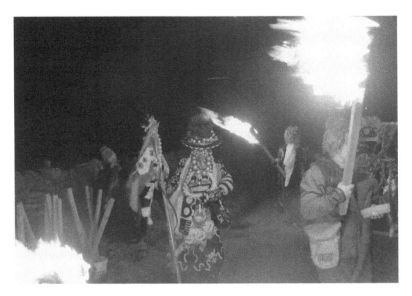

FIGURE 42. Papay Gyro Nights, 2013: opening torchlight parade, led by Frog King. Photograph by author.

Hong Kong in the appropriately amphibious setting of the Venice Biennale. Wherever he goes, he carries with him the characteristic trappings of Frogtopia, incorporating found objects, along with photographs and photocopies of previous projects to produce new works, many of which are distributed free to audience members, who are in turn invited to participate in the creative process through drawing, painting, paper folding, dressing up in improvised costumes, or wearing his signature "Froggy Glasses."[5] Artist and audience are thus collaboratively engaged in transforming an exhibition or performance space into a version of Frogtopia, from which the exchange practices of the capitalist art market are—at least temporarily—excluded and where, in his own words, the principle "Art is Life, Life is Art" holds sway.

Frog King's densely packed canvases and installations have been interpreted by some commentators as evoking, among other things, the crowded living environment of contemporary Hong Kong, where humans, consumer goods, automobiles, and garbage jostle for space. I first met him, however, far from his familiar habitat, at Papay Gyro Nights in 2013. The festival's lineup for that year also included a philosopher in residence

(Rick Dolphijn of Utrecht University, a specialist in contemporary continental philosophy) and an anthropologist in residence (me). The festival began, as usual, with a torchlight parade, culminating in a bonfire celebration. That year, costumes were supplied by Frog King, including an assortment of conventionally male and female clothing, colored wigs, hats, and of course froggy sunglasses. Thus attired, a procession of islanders of all ages, artists, and visitors (plus a philosopher and an anthropologist), led by Frog King, made its way toward the Old Pier on the eastern shore of the island, where the bonfire was to be lit. A strong wind blowing from offshore sent showers of sparks flying from the flaming torches as we left behind the island's six street lamps and advanced into the surrounding darkness. Arriving at the pier, Frog King put his torch to the bonfire. As the flames climbed, swept upward and outward by the wind, he shouted: "Papay Gyro Nights Art Festival 2013! Heat it up! Fire action! We are making energy! Hot Beauty!" and was joined by a chorus of "Gyro! Gyro! Gyro!"

For the remainder of the festival, Frog King established himself in a vacant room in the island's school, which he bedecked with a variety of frog regalia, covering every inch of the walls, turning it into a Frogtopia-cum-workspace. Here he held open studio throughout the week, and on the final Saturday afternoon, he hosted a gathering of artists, audience members, parents, and children, who talked, dressed up, played, and made art while Frog King distributed a selection of previously produced works to everyone present. Reactions to the afternoon were varied. One visitor, a retiree from London, now living in Stromness on Orkney Mainland and a regular festival attendee, was skeptical about taking part in what he took to be children's entertainment. Others, including the Papay's oldest resident, a sprightly octogenarian and the author of a recently published memoir of life on the island, seemed more appreciative.[6] Several people remarked on the fact that, for several hours, children and adults, islanders and outsiders, had played together and in doing so produced an assortment of artworks in a range of media. But what sort of play were we engaged in? If Frog King's performances seem intended to draw audiences from a variety of backgrounds into a participatory practice of collaborative making, many of the materials they draw on—discarded clothing, scraps of paper, plastic bags—serve as a reminder that such play is inevitably an engagement with a world that, even when it is

composed of humanly manufactured objects, nonetheless exists independently of us and as such is always in excess of the meanings we ascribe to it or the forms that we seek to impose upon it. Take the assertion "Art is Life, Life is Art." This can be read as affirming simultaneously a generalized human creativity (as evoked by Frog King's frequently and unabashedly universalizing rhetoric) and the artistry of an other-than-human life, an aesthetic drive—at once creative and destructive—immanent to the material substance of the universe. Such a drive, akin to Serres's third person or Nietzsche's Dionysian vision of the world as artist, or Heraclitus' image of the universe as a child at play, is, finally, indifferent to humans, who are, by comparison, like Zhuang-zi's frog, ensconced in his well with his kingly delusions, an insignificant speck amid the vastness of a universe of which he knows nothing. To experience a Frog King performance in Papay was to be made aware continuously of the unstoppable encroachment of this other-than-human world—not only through the assembled materials of Frogtopia, but also through the cries of seabirds, the wind that blew continuously throughout the week and sometimes made walking out of doors difficult, the waves beating on the island's rocky shores, and, less conspicuously but no less tellingly, the marine erosion to which the islands of Orkney and its northerly neighbor, Shetland, have been subject since their formation between 400 and 600 million years ago and that will eventually lead to both island chains disappearing beneath the waters. By that time, of course, it is entirely possible that all traces of Orkney's more than eight-millennia-long human presence will have disappeared too.

If anthropology is an art, what kind of art is it? An amphibious and metamorphic one, to be sure, an art that plays—with great absurdity and seriousness—at the interface between differentiated human worlds and at the thresholds of their making and undoing. Far from being the holistically conceived study of "our" humanity—as some textbooks and four field adherents would continue to have it—anthropology as a creative practice is marked by a constitutive inhumanity. Like Frog King's art and Hastrup's man of the *huldfólk*, in their very different ways, anthropology's encounters with other humans and other than humans remind us that what we may refer to as "our" experience is never exclusively and unequivocally ours but is always also the medium of a desubjectification and dispossession at once individual and collective. I propose that

anthropology is nothing more or less than the performative enactment—through writing or other media—of this simultaneous grounding and ungrounding of human worlds in the elusive commonality of their non-coincidence both with themselves and with one another, a commonality of participation in difference rather than identity. Every document of an anthropological encounter is therefore also wittingly or unwittingly the transcript of a becoming inhuman, of the unraveling of observer and observed into the untotalizable whole of what came before and will come after.

As Saturday afternoon drew to a close, Rick Dolphijn, the festival's philosopher in residence (whom I had met two summers previously in Copenhagen at a conference on the work of Deleuze), asked Frog King whether he still subscribed to the view that art is life, life is art. Frog King—or was it Kwok Mang-ho, or both?—answered that he had once considered that to be the case, "But now I realize, Art is Frog." Creation. Metamorphosis. Creation as metamorphosis. Art is Frog. I can currently think of no better or more timely answer to the question: what is anthropology?

FIGURE 43. The philosopher and the Frog King. Rick Dolphijn (left) and Kwok Mang Ho (right) with Armando Seijo (center). Photograph by author.

Acknowledgments

This book has been many years in the making, during which time it has amassed many debts of gratitude. At the University of Minnesota I have been blessed with a remarkable group of colleagues, among whom I must single out Bill Beeman, Bruce Braun, Tony Brown, Cesare Casarino, Maria Damon, Vinay Gidwani, Karen Ho, John Ingham, Jean Langford, Sonali Pahwa, Gloria Raheja, Arun Saldanha, Jenny Schmid, Hoon Song, Karen-Sue Tassig, David Valentine, Peter Wells, and Thomas Wolfe. I have also been fortunate to learn from and be inspired by an exceptional group of graduate students (past and present), including Murat Altun, Lalit Batra, Kai Bosworth, Danielle Carr, Ursula Dahlinghaus, Daniel Dean, Avigdor Edminster, Beverly Fok, Megan Gette, Mia Hassoun, Susie Hatmaker, Jen Hughes, Elizabeth Johnson, Peter Johnson, Garnet and Kate Kindervater, Jessi Lehman, Carrie Lorig, George McConnell, Bridget Mendel, Laurie Moberg, Lindsay Montgomery, Harlan Morehouse, Arif Hayat Nairang, Kevin Obsatz, Harshit Rathi, Stephen Savignano, Britt Vanpaepeghem, Amber White, Elisabeth Workman (to whom additional thanks are due for introducing me to the extraordinary poetry of Aase Berg), and Joanne Zerdy. It has been my privilege to share ideas, questions, and provocations with a more geographically scattered group of interlocutors and sometime collaborators, including Gretchen Bakke, Richard Baxstrom, Craig Campbell, Nigel Clark, Marisol de la Cadena, Robert Desjarlais, Rick Dolphijn, Rebecca Empson, Daniella Gandolfo, Angela Garcia, Barbara Glowczewski, Brian Goldstone, John Hartigan, Joe Hughes, Tim Ingold, Naveeda Khan, Eduardo Kohn, Jake Kosek,

266 *Acknowledgments*

Chris Lamping, Natasha Myers, Juan Obarrio, Todd Ochoa, Anand Pandian, Stephania Pandolfo, Marina Peterson, Hugh Raffles, Peter Skafish, Lisa Stephenson, Katie Stewart, Mick Taussig, Rane Willerslev, Helena Wulff, and Erin Yerby.

Research and writing began in earnest during a sabbatical year spent as a visiting research fellow in the department of anthropology at the University of Edinburgh. Thanks are due to Richard Baxstrom (again) for helping to arrange my visit, to Jonathan Spencer for welcoming me to the department, and to Don Dupres, Julia Lungu, and Izidor Kresnik for helping to make Edinburgh feel like the home away from home that it has since become.

Above all, this book could not have been written without the Papay Gyro Nights Art Festival, held annually on the island of Papa Westray ("Papay") in Orkney. No words are sufficient to thank the festival's organizers, Sergei Ivanov and Tsz Man Chan, and their daughter, Snaedis, now aged seven, for their friendship, generosity, and hospitality over the past six years, for their exuberantly experimental vision, and for reminding me and everyone else that art can indeed change the world. I owe a debt of gratitude also to the participating artists who shared their work, ideas, and time with me: Genetic Moo (Tim Pickup and Nicola Schauerman), Filippos Tsitsopoulos, Þorbjörg Jónsdóttir, Signe Liden, Bertrand Mandico, Elina Löwenson, Roxane Permar, Armando Seijo, Makino Takashi, Tom Muir (who shared not only his stories but also his encyclopedic knowledge of Orkney's archaeology, folklore, and history), and the one and only Frog King (aka Kwok Mang Ho, whom I have since had the privilege of meeting twice more on his home ground of Hong Kong).

I presented versions of what would eventually become this book in several venues: Aarhus University; University of Aberdeen; Banff Center for the Arts; University of California at Berkeley; Cattle Depot Artists' Village, Kowloon, Hong Kong; University of Chicago; Duke University; University of Edinburgh; Irish Museum of Modern Art; Maynooth University; Stockholm University; and University of Texas at Austin. I thank each of my audiences for their generosity and for prompting me through their questions and comments to think more deeply about many of the issues I explore in my work.

Eduardo Kohn and an anonymous reader reviewed the manuscript for the University of Minnesota Press. I thank both of them for their

Acknowledgments 267

close readings, encouragement, and helpful suggestions. I hope that subsequent revisions have gone some way toward doing them justice. My editor, Jason Weidemann, championed the project from the outset and was instrumental in bringing it to contract and guiding it though the publication process. Thanks are due also to Ana Bichanich and Mike Stoffel as well as to my meticulous and ever patient copy editor.

Finally, I would like to thank my mother, Margaret McLean, my friends and family in the United States, Britain, Ireland, and elsewhere, and especially Emily Ewen, who shared my life during the process of writing this book (not always an easy thing to do, I suspect).

As I was drafting these acknowledgments, I received word that my friend Sergei Ivanov, who provided part of the inspiration for this book, had disappeared, having been last seen on the island of Papa Westray. It now seems likely that he fell while photographing along the shoreline and was swept into the sea. Like everyone who knew Sergei, I still struggle to come to terms with the resulting sense of confusion and loss. Knowing him has had a profound effect on both my life and my work. It is with a heavy heart but with much love and gratitude that I dedicate this book to him and to Tsz Man and Snaedis.

Notes

PROLOGUE

1. Davidson, *Myths and Symbols*, 173.
2. Larrington, *Poetic Edda*, 57.
3. O'Donoghue, *From Asgard to Valhalla*, 11–22; Turville-Petre, *Myth and Religion*, 1–34.
4. Näsström notes also the association of the Norse giants with "wild nature" in its most untamed and threatening manifestations, especially winter and cold. Näsström, *Freyja*, 186–87. See also Davidson, *Myths and Symbols*, 173–74; Turville-Petre, *Myth and Religion*, 275–78; and Orchard, *Dictionary of Norse Myth and Legend*, 55.
5. Larrington, *Poetic Edda*, 11.
6. Weisman, *World without Us*, 21–38, 129–44.
7. Ibid., 5.
8. On this point, see Meillasoux, *After Finitude*, 11–27.
9. See, e.g., Bennett, *Vibrant Matter*; Coole and Frost, *New Materialisms*; Dolphijn and van der Tuin, *New Materialism*.
10. See Bogue, *Deleuzian Fabulation*, and chapter 3 below.
11. The phrase "alternative facts" was used, famously and controversially, by Kellyanne Conway, counselor to the president, in a *Meet the Press* interview with Chuck Todd on January 22, 2017. Conway used the phrase in response to Todd's observation that White House press secretary Sean Spicer's claim that President Donald's Trump's inaugural ceremony had drawn the largest crowds ever to attend a presidential inauguration was disproved by available data and photographic evidence.

1. AN ENCOUNTER IN THE MIST

1. Hastrup, "Challenge of the Unreal," 52.
2. Hastrup, *Place Apart*, 69.

3. Simpson and Árnason, *Icelandic Folktales and Legends*.

4. Hastrup, *Place Apart*, 121.

5. Huldufólk, *Facebook*, August 14, 2014, https://www.facebook.com/verborge nesvolk?fref=nf.

6. See, e.g., Schneider, "Spirits and the Spirit of Capitalism."

7. Pálsson, *Textual Life of Savants*, 64; see also Einarsson, "From the Native's Point of View," and Stefánsson's review of Hastrup's *Island of Anthropology*.

8. Hastrup, "Challenge of the Unreal," 53.

9. The *Landnámabók* (*Book of Settlements*), recounting the early settlement of Iceland (the earliest versions of which date from the thirteenth century), mentions that Irish monks were formerly present in Iceland but that they left (or had already left) when the first Norse settlers arrived. Pálsson and Edwards, *Book of Settlements*, 15. Terry Gunnell has suggested elsewhere that the popular image of the *huldufólk* combines conceptions of elves or land spirits (*landvættir*) imported from Scandinavia and traditions relating to fairies carried by Irish and Scottish slaves. Qtd. in Marc Vincenz, "To Be or Not to Be," *Reykjavik Grapevine*, May 27, 2009, http://grapevine.is/mag/articles/2009/05/27/article-to-be-or-not-to-be/.

10. Meletinskij, "Scandinavian Mythology," 46–57.

11. Davidson notes that there is considerable confusion in the surviving Christian-era sources as to the precise geography of the pre-Christian Norse cosmos. In the Eddic poem *Grímnismál* (Sayings of Grímnir), for example, the roots of Yggdrasil are said to extend into the abode of the dead (*Hel*), the realm of giants (*Jotunheim*), and the world of humans, implying that the realm of the gods is situated in the sky. Davidson, *Myths and Symbols*, 170–71. In Snorri Sturluson's prose summary, however, the home of the gods (where the gods "hold their tribunal") is also situated under one of Yggdrasil's roots, but he then adds that this root is situated in the sky. Sturluson, *Prose Edda*, 27–28. See also Turville-Petre, *Myth and Religion*, 279.

12. Hastrup, *Culture and History*, 136–37; Turville-Petre, *Myth and Religion*, 276.

13. Icelandic law recognized a distinction between lesser and greater outlawry. The former, *fjörbaugsgarðr*, involved banishment for a period of three years, while *skóggangr* (forest-going) involved the permanent loss of civil rights. Hastrup, *Culture and History*, 137.

14. Ibid., 142–43. "In Icelandic popular legends, the inland deserts of the island are represented as having hidden valleys, peopled by an older race of men, indeed a kind of outlaws called *útilegumenn*. The tales referring to them have a special name, *útilegumanna-sögur*." Cleasby, *Icelandic–English Dictionary*, 671.

15. Hastrup suggests that the *ódáðahraun* may have been understood in direct opposition to the Althing, or general assembly, which formed a recognized center of the domains of society and law. In contrast, she argues, the *ódáðahraun* constituted an "anti-center" metonymically related to the "wild" as "the spatial expression of the anti-social forces threatening the country." Hastrup, *Culture and History*, 145, 136–54.

Notes to Chapter 1 271

16. Scudder, *Saga of Grettir the Strong*, 140–53.

17. Scherman, *Iceland*, 343.

18. Durrenberger, "Sitting Buddha," 91; see also Einarsson, "From the Native's Point of View," and Miller's review of Hastrup's *Culture and History*.

19. Hastrup, *Culture and History*, 136. Lévi-Strauss's own formulation of the relationship of nature to culture, in his preface to the second edition of *The Elementary Structures of Kinship*, of which Hastrup quotes only the initial sentences, is more complex, allowing for the possibility that the differentiating mechanisms associated with culture might represent a "synthetic duplication" of mechanisms already present in nature: "Ultimately we shall perhaps discover that the relationship between nature and culture does not favor culture to the extent of being hierarchically imposed on nature and irreducible to it. Rather it takes the form of a synthetic duplication of mechanisms already in existence but which the animal kingdom shows only in disjointed form and dispersed among its members—a duplication, moreover, permitted by the emergence of certain cerebral structures which themselves belong to nature." Lévi-Strauss, *Elementary Structures*, xxix–xxx.

20. Favret-Saada, *Deadly Words*, 3–5.

21. Favret-Saada writes of the role of language in witchcraft: "A set of words spoken in a crisis situation by someone who will later be designated a witch are afterwards interpreted as having taken effect on the body and belongings of the person spoken to, who will on that ground say he is bewitched. The unwitcher takes upon himself the words originally spoken to his client, and turns them back on to their initial sender, the witch. Always the 'abnormal' is said to have settled in after certain words have been uttered and the situation persists until the unwitcher places himself like a screen between the sender and the receiver." Ibid., 9.

22. Hastrup, "Challenge of the Unreal," 52–56. The distinction between "life" and "genre" is one that Hastrup borrows from her former teacher, Oxford anthropologist Edwin Ardener. See Ardener, "Social Anthropology," 52.

23. Stoller, "Eye, Mind, and Word," 3–4, qtd. in Hastrup, "Challenge of the Unreal," 55.

24. Hastrup, writing in the late 1980s, aligns herself with what she describes as "a relatively recent trend of self-refection in social anthropology." Hastrup, "Challenge of the Unreal," 50. For many readers, at least in the Anglophone academy, such a trend would come to be seen as exemplified by the volume *Writing Culture* (1986), whose contributors seek to explore both the rhetorical construction of anthropological texts and their embeddedness in what its editors, James Clifford and George Marcus, refer to as "larger contexts of systematic power inequality, world systems constraints, and institutional foundations that could only partly be accounted for by a focus on textual production." Clifford and Marcus, preface to *Writing Culture*, vii–viii. Hastrup makes no mention of *Writing Culture* in the account of her encounter with the *huldumaður* (although she does cite other works by Clifford and another contributor, Paul Rabinow), but her stated concern with "the nature of the anthropological discourse and/or the ethnographic texts" might seem to place her unequivocally within its thematic orbit. Nonetheless, in contrast

272 *Notes to Chapter 1*

to many of the contributors to *Writing Culture*, Hastrup appears, at least with hindsight, to be less concerned with the critical analysis of how others have written than with exploring the implications of her own practice of writing as an integral part of her role as an anthropologist. On the legacies of *Writing Culture* in contemporary anthropology, see Starn, *Writing Culture*. On the question of writing in contemporary anthropology, see Pandian and McLean, *Crumpled Paper Boat*.

25. Barthes, "Authors and Writers," qtd. in Hastrup, "Challenge of the Unreal," 57; see also Rabinow, "Discourse and Power."

26. Hastrup, "Challenge of the Unreal," 58. Hastrup's assertion of coevalness as a condition of the fieldwork encounter draws on Fabian's critique of anthropology's frequent denial of such coevalness. Fabian, *Time and the Other*, 37–70.

27. Nancy, *Birth to Presence*, 1.

28. Foucault traces the shift from a sixteenth-century regime of knowledge founded on a web of resemblances and similitudes linking human beings, the natural world, and the various superlunary planetary bodies to one based on a logic of representation as exemplified by the new disciplines of biology, philology, and political economy. In Foucault's account, this involves also a transition from a ternary system of signs, comprising sign, signified, and the "conjuncture" between them, to a binary one, comprising only sign and signified. This shift is seen as raising the question of how a sign might to be linked to what it signified, a question that the classical period (beginning in the seventeenth century) answered in terms of representation and that the modern period (from the beginning of the nineteenth century) answered via the analysis of meaning and signification. Foucault, *Order of Things*, 42–43.

29. Gayatri Spivak, notably, has criticized both Foucault and Deleuze for conflating representation in the sense of re-presentation or standing-for (German *Darstellung*) with representation in the sense of "speaking for" (*Vertretung*). Spivak, "Can the Subaltern Speak?," 68.

30. Ingold, *Perception of the Environment*, 14–15.

31. Kohn, *How Forests Think*, 15, 50–51; Viveiros de Castro, *Cannibal Metaphysics*, 10. See also Deacon, *Symbolic Species*; and Peirce, *Philosophical Writings*, 98–120.

32. Nancy, *Birth to Presence*, 1–2.

33. Moss, *Names for the Sea*, 3–4.

34. Ibid., 221–22.

35. Ibid., 226, 229.

36. Ibid., 229, 333–34.

37. Clark, *Inhuman Nature*.

38. For an overview of debates in the humanities concerning the Anthropocene, see Colebrook, *Death of the Posthuman*.

39. See Brassier, *Nihil Unbound*, 48.

40. Hastrup, "Challenge of the Unreal," 53.

41. Serres, *Troubadour of Knowledge*, 57–62.

Notes to Chapter 2 273

42. Benveniste, *Problems of General Linguistics*, 199. Serres's account echoes, but does not cite, Benveniste's.

43. See, e.g., Silverstein, "Shifters, Linguistic Categories."

44. Serres, *Troubadour of Knowledge*, 46.

2. TALABOT

1. Shoemaker, "Report from Holstebro," 314.

2. Barba was born in 1936, the son of a general in the Italian army, and grew up in Gallipoli. In 1954 he settled in Norway, where he worked as a welder and merchant sailor and attended university. In 1960 he moved to Warsaw, initially to attend the State Theater School, but he left to work instead with experimental director Jerzy Grotowski, interrupting his studies to visit India in 1963, where he first encountered Kathakali dance drama, which became an important influence and point of reference in his own theatrical productions and theoretical writings. Barba returned in 1964 to Oslo, where he founded Odin Teatret, before relocating to Holstebro, a small town (33,000 people) in northeastern Denmark. Taviani, "Postscript," 238–41.

3. Of the article, Barba wrote: "For me, this article's fascination sprang from the evident contrast between the scientific discourse and the experience of seduction, perceived as reality by the senses of the anthropologist and with scepticism by her intellect." Barba, *On Directing and Dramaturgy*, 128.

4. Ibid. Italian theater scholar Fernando Taviani writes, "The whole of Barba's research and activity could be interpreted as a continuous striving to remain a foreigner," suggesting that Barba's preoccupation with movement, displacement, and diasporic figures is directly informed by his own experiences of travel between countries and continents. Taviani, "Postscript," 274.

5. Barba first developed the notion of a Third Theater in a short text composed in 1976 for the Belgrade International Theater Festival (BITEF): "The Third Theater lives on the fringe, often outside or on the outskirts of the centers and capitals of culture. It is a theater created by people who define themselves as actors, directors, theater workers, although they have seldom undergone a traditional theatrical education and therefore are not recognized as professionals." Barba, "Third Theater," 193. This conception owed much to observation of new theater groups encountered earlier the same year when Odin Teatret toured Latin America, where Barba has since spent increasing amounts of time and where his work has exercised a powerful influence. Watson, "Introduction: Contexting Barba," 170–71. In a more recent interview with Serbian director Dijana Milošević, Barba associated the Third Theater explicitly with the themes of exile, diaspora, and dissidence: "A new generation of young people comes to the theater and sees it as a no man's land. . . . In this land live those who don't share the common ideas, superstitions and values of the people around them, but at the same time they are able to establish the praxis of how they can live by doing so through making art. Theater can represent this kind of freedom. It can represent this island of dissidents even in the heart of the civilized world, whether it is in big cities or small villages." Milošević, "Big Dreams," 294.

274 *Notes to Chapter 2*

6. Barba describes theater anthropology as drawing selectively on a variety of disciplines without straightforwardly applying the approach of any of them: "Let us avoid equivocation. Theater Anthropology is not concerned with applying the paradigms of cultural anthropology to theater and dance. It is not the study of the performative phenomena in those cultures which are traditionally studied by anthropologists. Nor should theater anthropology be confused with the anthropology of performance." Barba, *Paper Canoe*, 10.

7. Barba, *Paper Canoe*, 9; Hastrup, "Out of Anthropology," 328. Hastrup would go on to explore affinities between the anthropologist and the theatrical performer in an ethnographic study of Britain's Royal Shakespeare Company. Hastrup, *Action*, 313–38.

8. Shoemaker, "Report from Holstebro," 308–11.

9. Barba, *On Directing and Dramaturgy*, 101; Eisenstein, "Cinematic Principle"; Pound, *Cantos*. Pound's understanding of ideograms was based largely on the writings of American scholar Ernest Francisco Fellonosa (1853–1908), whose insistence on the predominantly pictorial origins of Chinese and Japanese written characters has been challenged by many later commentators: "Pound believed that almost all the characters are ideograms, that is, composed of two or more pictures which when put together create a new word; to choose a real ideogram as an example, 'sun' and 'moon' together mean 'bright.'" Kimpel and Eaves, "Pound's 'Ideogrammatic Method,'" 205.

10. Barba, *On Directing and Dramaturgy*, 102.

11. Artaud, *Theater and Its Double*, 31.

12. Shoemaker, "Report from Holstebro," 312.

13. Ibid., 316.

14. Barba would later draw an explicit link between the figure of the trickster and the montagelike construction of the scenes: "The estranging yet enticing effect of such a figure was not a consequence of the explicit narrative events: it was the contiguity which engendered unexpected meeting points and interferences." Barba, *On Directing and Dramaturgy*, 104.

15. Qtd. in Shoemaker, "Report from Holstebro," 314.

16. Qtd. in Odin Teatret, *Talabot*, http://www.odinteatret.dk/productions/past -productions/talabot.aspx.

17. Hastrup, *Passage to Anthropology*, 138.

18. Hyde, *Trickster Makes This World*.

19. Hastrup, "Out of Anthropology," 332–35. Varley's own account of the production can be found in a memoir of her thirty-year career at Odin Teatret. Varley, *Notes from an Odin Actress*, 133–56.

20. Hastrup, *Passage to Anthropology*, 143.

21. Hastrup, "Out of Anthropology," 335–36. For Hastrup, the effectiveness of the stage presentation of *Talabot* was illustrative of Richard Schechner's reflections on "restored behavior" as a key element in theatrical performance. Restored behavior, as characterized by Schechner, seeks to recover sequences of events,

Notes to Chapter 2 275

scripted actions, known texts, and so on, understood as existing separately from the performers yet simultaneously endowed with its own reality and efficacy: "Performance is not merely a selection from data arranged and interpreted; it is behavior itself and carries with it a kernel of originality, making it the subject for further interpretation, the source of further history." Schechner, "Collective Reflexivity," 43.

22. Hastrup, *Passage to Anthropology*, 144–45.

23. Artaud, *Theater and Its Double*, 19.

24. Nin, *Diary*, 191–92.

25. Ibid., 192.

26. In addition to *Talabot,* the trickster features in *Great Cities under the Moon* (first performed 2003), *Ode to Progress* (1997), *The Whispering Winds* (1996), *Itsi Bitsi* (1991), and a number of street performances. Ledger, *Odin Teatret*, 16, 27–28.

27. Hyde, *Trickster Makes This World*, 256.

28. In addition to the trickster, who recurs in several of Odin Teatret's productions, Barba identifies a number of other such figures. These include Doña Musica (played by Julia Varley) in *Kaosmos* (1993–96), who dances around the other characters, and an unidentified character (played by Jan Ferslev) in *Salt* (2002), who sits outside the clearly delimited performance space and acts independently of the main protagonist (Roberta Carreri): "He looked like her prompter or her shadow, yet his music songs and humming as well as his actions didn't correspond to those of the protagonist in the center of the space." Barba, *On Directing and Dramaturgy*, 104.

29. Hyde argues that the category of trickster includes not only the familiar Native American figures of Raven and Coyote but also the West African figures of Eshu and Legba, the Norse Loki, and the Greek Hermes, along with a variety of writers and artists, among them Frederick Douglass, Allen Ginsberg, Marcel Duchamp, and John Cage. Hyde, *Trickster Makes This World*, 226–80. Crapanzano, notably, has likened the ethnographer in certain respects to the figure of Hermes, at once a messenger and intermediary, a tutelary god of speech and writing and a practitioner of tricks and cunning: "He [the ethnographer] presents languages, cultures and societies in all their opacity, their foreignness, their meaninglessness; then, like the magician, the hermeneut, Hermes himself, he clarifies the opaque, renders the foreign familiar, and gives meaning to the meaningless. He decodes the message. He interprets." Crapanzano, "Hermes' Dilemma," 51. The identification of Hermes as a trickster is, however, challenged by Hungarian classical scholar Karl Kerényi, who distinguishes between Hermes ("the trickster god") and Native American and other trickster figures on the basis that Hermes, although an intermediary and boundary crosser (whose functions include conducting the souls of the dead to the underworld), is not a spirit of disorder: "To be a god means to be the creator of a world, and a world means order." Kerényi, "Trickster in Relation to Greek Mythology," 190.

30. For example, Wagner, *Coyote Anthropology*.

31. Radin, *Trickster*, 168–69.

32. Ibid., 22–23.

276 *Notes to Chapter 3*

3. FAKE

1. Nietzsche, *On the Genealogy of Morals*, 44–46, 148–56.

2. Deleuze, *Cinema 2*, 137.

3. The first volume of Deleuze's study of cinema is devoted to what he calls the "movement image"—that is, the indirect, spatialized representation of time in terms of movement. This involved, among other things, a chronological ordering of events (such that flashbacks and other devices might interrupt but never fundamentally challenge), a clear distinction between subjective states and objective realities, and an appeal to a reality assumed to be already given prior to and independently of its cinematic depictions. Deleuze, *Cinema 1*.

4. Deleuze, *Cinema 2*, 146–47.

5. Deleuze, *Negotiations*, 123.

6. Flaxman, *Deleuze*, xvii.

7. According to the Robert *Dictionnaire*, Bergson was the first to use the term "fabulation" in a "philosophical" sense as referring to an "activity of the imagination." Bogue, *Deleuzian Fabulation*, 14. Donna Haraway's discussion of "speculative fabulation" as a form of activist storytelling, drawing on science fiction and other genres, makes no reference to either Bergson's or Deleuze's use of the term. Haraway, *Staying with the Trouble*, 8, 81, 105.

8. Bergson, *Two Sources*, 109, 158.

9. Deleuze, *Negotiations*, 174.

10. Deleuze and Guattari, *Kafka*, 16–27.

11. Deleuze and Guattari, *What Is Philosophy?*, 230. Deleuze finds an example of the creation of "giants" in the writings of T. E. Lawrence: "One of the great portrayers of landscapes in literature." Contrary to many of Lawrence's critics, Deleuze sees Lawrence's images of desert landscapes (and of himself) not as "some sort of contemptible individual mythomania" but as a "projection machine" aimed at providing a heroic and empowering self-image for the protagonists of the Arab revolt. Deleuze, *Essays Critical and Clinical*, 118.

12. Deleuze, Essays Critical and Clinical, 4.

13. Qtd. in Bogue, *Deleuzian Fabulation*, 18.

14. Deleuze, *Cinema 2*, 223.

15. Deleuze, *Negotiations*, 174.

16. Biehl and Locke, "Deleuze and the Anthropology of Becoming," 337.

17. Grosz, *Chaos, Territory, Art*, 1–24. It is for this reason, as Grosz notes, that Deleuze identifies architecture as the first art: "Art is, for Deleuze, the extension of the architectural imperative to organize the space of the earth . . . This roots art not in the creativity of mankind but rather in a superfluousness of nature, in the capacity of the earth to render the sensory superabundant, in the bird's courtship song and dance, or in the field of lilies swaying in the breeze under the blue sky." Grosz argues that Deleuze understands art too as being, from the outset, sexual, drawing upon evolutionary accomplishments and survival instincts and diverting them into avenues of expression that no longer bear any direct relation to the imperatives of survival: "Art is the sexualization of survival, or, equally,

Notes to Chapter 5 277

sexuality is the rendering artistic, the sexualization of the excessiveness of nature." Ibid., 10–11.

18. Deleuze and Guattari, *What Is Philosophy?*, 85–113.

19. Ibid., 167, 169.

20. Ibid., 171.

21. Deleuze, *Essays Critical and Clinical*, 3.

22. Ibid. Deleuze finds an exemplary use of the third person in the work of Kafka. According to Maurice Blanchot (whom Deleuze cites): "What Kafka teaches us—even if this formulation cannot be directly attributed to him—is that story-telling brings the neutral into play.... The narrative 'he' or 'it' unseats every subject just as it disappropriates all transitive action and all objective possibility. This takes two forms: (1) the speech of the narrative always lets us feel that what is being recounted is not being recounted by anyone: it speaks in the neutral; (2) in the neutral space of the narrative, the bearers of speech, the subjects of the action—those who once stood in the place of characters—fall into a relation of self-nonidentification. Something happens to them that they can only recapture by relinquishing their power to say 'I.' And what happens has always already happened: they can only indirectly account for it as a sort of self-forgetting, the forgetting that introduces them into the present without memory that is the present of narrating speech." Blanchot, *Infinite Conversation*, 384; cited in Deleuze, *Essays Critical and Clinical*, 3. Deleuze comments: "Literature here seems to refute the linguistic conception, which finds in shifters, and notably in the first two persons, the very condition of enunciation." Ibid., 185.

23. Deleuze, *Pure Immanence*.

24. Deleuze, *Expressionism in Philosophy*; Spinoza, *Ethics*.

25. Deleuze, *Pure Immanence*, 31.

26. Colebrook, *Deleuze and the Meaning of Life*, 99–108.

27. Lispector, *Agua Viva*, 28.

28. Dickens, *Our Mutual Friend*, 443.

29. Ibid., 446.

30. Deleuze, *Pure Immanence*, 28–29.

31. Taussig, *Mimesis and Alterity*, vxii.

4. ANTHROPOLOGIES AND FICTIONS

1. Lorig, *Pulp vs. the Throne*, 91.

2. Geertz, *Interpretation of Cultures*, 29.

3. Fassin, "True Life," 52.

4. Debaene, *Far Afield*, 141–47; Leiris, *L'Afrique fantôme*; Lévi-Strauss, *Tristes Tropiques*.

5. Geertz, *Works and Lives*, 25–48.

6. Favret-Saada, *Deadly Words*, 3–12, 97–109; Taussig, *I Swear I Saw This*, 1.

5. KNUD RASMUSSEN

1. Rasmussen himself and many of his subsequent biographers would attribute his success as an ethnographer of the Arctic—including his linguistic abilities

278 *Notes to Chapter 5*

and his much remarked upon prowess in activities such as hunting and sledging—
to his background as what Lila Abu-Lughod has termed a "halfie." Abu-Lughod,
"Writing against Culture," 138–43. Kaj Birket-Smith, a participant in Rasmussen's
Fifth Thule Expedition and later one of the founders of university education in
anthropology in Denmark, wrote in his biography of Rasmussen that "in the
entanglement between the best qualities of the eskimo and the white man lay the
grandness and enchantment that emanated from him." Qtd. in Hastrup, "Knud
Rasmussen," 158.

2. Gilberg, "Profile: Knud Rasmussen," 169; Cruwys, "Profile: Knud Rasmussen," 27.

3. Rasmussen, *Across Arctic America*, vii.

4. Rasmussen's companions were Birket-Smith (ethnographer), Therkel Mathiassen (archaeologist and cartographer), Helge Bagsted (writer), Peter Freuchen (anthropologist and journalist), Jacob Olsen (interpreter), Leo Hansen (photographer), and six Inuit assistants: Arqioq, Arnanguaq, "Bosun," Aqatsaq, Qavigarssuaq, and Arnarulunguak (the latter the only woman in the party). The party later split into several groups to collect specialist data. Rasmussen, Birket-Smith, and Bangsted set out to study the inland Inuit living on the "barren grounds" west of Chesterfield Inlet. Freuchen and Mathiassen traveled north to Baffin Island to collect geological and ethnographic data from the Igloolik region. Mathiassen and Olsen later left for Repulse Bay and Southampton Island to conduct archaeological research. Birket-Smith, Olsen, Mathiassen, and others left the Arctic during spring 1923, but Rasmussen remained to undertake a journey across Arctic Canada to Alaska with Qavigarssuaq and Arnarulunguak and two twelve-dog sledges. The sledge journey ended on June 30, 1925, at Icy Cape. From there, Rasmussen traveled by boat to Kotzebue and onward to Nome, from where he attempted to cross to Siberia. Cruwys, "Profile: Knud Rasmussen," 30–31.

5. Shoemaker, "Report from Holstebro," 310.

6. Rasmussen, *Across Arctic America*, 136.

7. Ibid., 182.

8. Ibid., 184–87.

9. In this respect, Rasmussen's refusal to entertain the possibility that the amulets might indeed be materially efficacious seems exemplary of the modernist, purificatory "semiotic ideology," intent on denying the agentive power of material things in favor of an exclusively human-centered view of agency that Webb Keane describes with reference to the mission encounter in Indonesia. Keane, *Christian Moderns*, 1–6.

10. Shoemaker, "Report from Holstebro," 316.

11. Hastrup, *Place Apart*, 50.

12. Hastrup, "Out of Anthropology," 337. The Danish title of the popular account of Fifth Thule Expedition is *Den store sladerrejse* (The long sled journey).

13. Hastrup, "Knud Rasmussen," 168–69.

14. I have adopted the spelling "Avva" as used in Zacharias Kukuk's film *The Journals of Knud Rasmussen* (2006), based in part on Rasmussen's account. The spelling "Aua" appears in Rasmussen's published text.

Notes to Chapter 5 279

15. Igloolik, Nunavut (3,400 kilometers north of Montreal), has established a reputation among ethnographers and travelers as a particularly remote location—a fact sometimes explained with reference to its relatively recent history of contact. Pack ice in the Northern Fox Basin kept European explorers and whalers from reaching the region, with the result that the first recorded contact did not take place until the early nineteenth century, when captains William Parry and George Lyon plus 150 members of a British naval expedition passed the winters of 1822–23 and 1823–24 there on Iglulingmiut lands. Parry's and Lyon's accounts emphasize the isolation of the community among whom they wintered, although Igloolik Island was a much frequented site by Inuit groups in the late eighteenth and nineteenth centuries. Metal utensils and meat trays were already in use when Parry and Lyon arrived and trade in meat, furs, wood, and metals quickly developed between Inuit and Europeans. The early twentieth century witnessed further changes, including the arrival of non-Inuit traders, Christian missionaries, and the Royal Canadian Mounted Police. Rasmussen's report makes little reference to these developments, although his popular account includes passing mention of Hudson Bay Company representatives and other outsiders to the region. Wachowich, "Cultural Survival and Trade," 123–26.

16. Rasmussen, *Across Arctic America*, 21.

17. Rasmussen, *Intellectual Culture of the Iglulik Eskimos*, 119.

18. Rasmussen, *Across Arctic America*, 118–19.

19. Ibid., 127.

20. Pasolini, "Cinema of Poetry," 175–78; Deleuze, *Cinema 2*, 147–49.

21. Evans, *Isuma*, 15–26.

22. In his published accounts, Rasmussen finds out only afterward about the conversion of Avva's family, and in Kunuk's film, he is absent when the events shown on screen take place.

23. Qtd. in Sidimus, *Reflections*, 261.

24. Evans, *Isuma*, 27.

25. Rasmussen, *Intellectual Culture of the Iglulik Eskimos*, 43.

26. Boas and his Kwakwaka'wakw collaborator and coauthor, George Hunt, write: "It is perfectly well-known by all concerned that a great part of the shamanistic procedure is based on fraud; still it is believed in by the shaman as well as by his patients and their friends. Exposures do not weaken the belief in the 'true' power of shamanism." Boas, *Kwakiutl Ethnography*, 121. Reviewing a range of literature on shamanism and witchcraft, Michael Taussig suggests that the coexistence of belief in the power of shamans and the knowledge that they routinely have recourse to trickery is an instance of the "public secret," whereby what is at stake is not simply concealment but the revelation of concealment: "Magic is efficacious not despite the trick but on account of its exposure. The mystery is heightened, not dissipated, by unmasking and in various ways, direct and oblique, ritual serves as a stage for so many unmaskings." Taussig, "Viscerality," 273.

27. Rasmussen, *Intellectual Culture of the Iglulik Eskimos*, 44.

28. Ibid., 160.

280 *Notes to Chapter 5*

29. Ibid., 192.
30. Ibid., 177.
31. Ibid., 44.
32. Rasmussen, *Intellectual Culture of the Copper Eskimos*, 54.
33. Rasmussen, *Across Arctic America*, 271.
34. Rasmussen, *Intellectual Culture of the Copper Eskimos*, 57.
35. Ibid., 58–59.
36. Ibid., 59
37. Rasmussen, *Across Arctic America*, 276.
38. Rasmussen, *Intellectual Culture of the Copper Eskimos*, 60.
39. Ibid., 60–61.
40. Ibid., 61. The account in Rasmussen's popular narrative is somewhat differently phrased, but it too suggests a slippage between the perspectives of shaman and ethnographic observer. Again, much depends on the weight accorded to terms like "almost": "And so great was the suggestive power of what had passed, in this wild place too near to the elemental forces, that we could almost see it all; the air alive with hurrying spirit forms, the race of the storm across the sky, hosts of the dead whirled past in the whirling snow; wild visions attended by that same rushing of mighty wings of which the wizards had spoken." Rasmussen, *Across Arctic America*, 278.

6. The Voice of the Thunder

1. Vico, *New Science*, 129.
2. Aristotle, *Poetics*, 43.
3. Vico, *New Science*, 129.
4. Ibid., 424.
5. Fernandez, "Persuasions and Performances," 58, 43.
6. Lakoff and Johnson, *Metaphors We Live By*, 6, 160.
7. Sonne, "In Love," 23. See also Otto, *Idea of the Holy*, and Söderblom, *Living God*.
8. Marrett, "Pre-Animistic Religion," 164–68; Codrington, *Melanesians*, 117–27, 191–217; Mauss, *General Theory of Magic*, 133–73.
9. Marrett, "Pre-Animistic Religion," 169–70.
10. Ibid., 170.
11. With regard to the origins and subsequent diffusion of Inuit religion, Rasmussen came to share the view of his fellow ethnographer and sometime traveling companion, Kaj Birket-Smith, that the "Caribou Eskimos" represented a proto-inland Inuit culture that coastal Inuit groups too had once shared. Sonne, "In Love," 23.
12. Rasmussen, *Alaskan Eskimos*, 133; qtd. in Merkur, *Powers*, 59.
13. Najagneq adds that Sila, so often associated with the fury of the elements, is also portrayed on occasion as having a gentler, feminine aspect: "But he also has another way of utterance, by sunlight, and calm of the sea, and little children innocently at play, themselves understanding nothing. Children hear a soft and gentle

Notes to Chapter 7 281

voice, almost like that of a woman. It comes to them in a mysterious way, but so gently they are not afraid; they only hear that some danger threatens. And the children mention it casually when they come home, and it is then the business of the angakoq to take such measures as shall guard against the peril." Rasmussen, *Across Arctic America*, 385–86.

14. Merkur, *Powers*, 62–63; Rasmussen, *Intellectual Culture of the Iglulik Eskimos*, 71–72. Shamanism involving Narsuk has been documented only in the Northwest Passage and on the western shores on Hudson Bay, among some Copper bands, the Netsilik Inuit and some Iglulik bands. Further to the east, the concept of Narsuk disappears. Merkur, *Powers*, 66.

15. Merkur, *Powers*, 63. The first anthropological description of Sedna, also referred to as the Sea Mother or the Mother of the Sea Animals, is to be found in Boas's *Central Eskimo*, 175–83. Sometimes (e.g., among the Mackenzie, Netsilik, and some Iglulik and Baffin Island bands), she is described as controlling land animals as well as sea animals. In other cases, her power also extends to soil and rocks. Merkur, *Powers*, 107. Merkur summarizes her role in the following terms: "In popular religious thought, the Sea Mother is an indweller. She indwells in the sea and all of its animals. . . . When the observances are kept, she is treated as she desires, and she responds by providing abundant game and fish to humankind. Conversely, when the observances are neglected, she herself is abused, and she removes the game and fish from the reach of the Inuit." Merkur, *Powers*, 136.

16. Rasmussen, *Intellectual Culture of the Copper Eskimos*, 56–61.

17. Joyce, *Finnegans Wake*, 3. Joyce's thunder outbursts have been the subject of extensive critical commentary, notably by Eric McLuhan (son of celebrated media theorist Marshall McLuhan), who argues that the thunders are not only "macroscopic puns" including terms from all of the various languages used in *Finnegans Wake* but also articulate words and themes from their immediate contexts. McLuhan, *Role of Thunder*, x.

7. METAPHOR AND/OR METAMORPHOSIS

1. Deleuze and Guattari, *Kafka*, 22.

2. Jakobson, "Two Aspects of Language," 132. Jakobson's discussion of metaphor and metonymy makes reference, famously, to Freud's distinction between the principles of "displacement" or "condensation" and "identification and symbolism" operative in dreams and to Frazer's distinction between "imitative" or "homeopathic" and "contagious" magic. Freud, *Interpretation of Dreams*, 260–402; Frazer, *Golden Bough*, part 1.

3. Kafka, *Complete Stories*, 89.

4. Kofman, *Nietzsche and Metaphor*, 20–21.

5. Aristotle, *Rhetoric*, 125.

6. Vernant, *Origins of Greek Thought*, 102–18; Vernant, *Myth and Society in Ancient Greece*, 203–60.

7. Kofman, *Freud and Fiction*, 10.

8. Aristotle, *Physics*; Protevi, *Political Physics*, 7–11.

Notes to Chapter 7

9. Kofman, *Freud and Fiction*, 10–12.

10. Ibid., 19.

11. France's essay, "The Garden of Epicurus" (1895), includes a short dialogue between Aristos and Polyphilos on the language of metaphysics, in which Polyphilos says, "Any expression of an abstract idea can only be an analogy. By an odd fate, the very metaphysicians who think to escape the world of appearances are constrained to live perpetually in allegory. A sorry lot of poets, they dim the colors of the ancient fables, and are themselves but gatherers of fables. They produce white mythology." Qtd. in Derrida, "White Mythology," 11. Derrida adds: "What is white mythology? It is a metaphysics which has effaced in itself that fabulous scene which brought it into being, and which yet remains, active and stirring, inscribed in white ink, an invisible drawing covered over in the palimpsest." Ibid.

12. Nietzsche, "On Truth and Lie," 84.

13. Kofman, *Nietzsche and Metaphor*, 7, 16–17.

14. Ibid., 151n14. Kofman makes repeated use of the term "proper" (*le propre*), implying propriety (appropriateness), decency, distinctiveness, and (self-)ownership, the latter being the sense in which Nietzsche sometimes makes use of the Latin term *proprium*.

15. Nietzsche, *On the Genealogy of Morals*, 152–53.

16. Kofman, *Nietzsche and Metaphor*, 75; Nietzsche, "On Truth and Lie," 89.

17. Nietzsche, "On Truth and Lie," 88. Aristotle writes: "The other animals live by nature above all, but in some slight respects by habit as well, while man lives also by reason (for he alone has reason)." Aristotle, *Politics*, book 7, chapter 13, 210.

18. Kofman, *Nietzsche and Metaphor*, 20. Heraclitus lived during the period spanning the end of the sixth and the beginning of the fifth century BCE. His surviving works are in the form of cross-referring, aphoristic fragments. Hornblower and Spawforth, *Oxford Classical Dictionary*, 687.

19. Nietzsche, "On Truth and Lie," 86.

20. Ibid., 89.

21. Ibid., 79.

22. Nietzsche, *On the Genealogy of Morals*, 162.

23. Irigaray, *Marine Lover*, 46.

24. Otto, for example notes that water is a characteristically Dionysian element—the element of becoming and transformation, as well as being frequently identified as a feminine element. Otto, *Dionysus*, 56, 62–64, 171, 182. A number of other commentators have noted Dionysus' association with depths of sea: he throws himself into sea when pursued by Lycurgus (a ruler who, like Pentheus, attempted to suppress his cult); at festivals in Dionysus' honor, his image appears mounted on a ship drawn on wheels; Ariadne, his sometime mortal consort, is a seawoman, an island dweller, who is later carried away over the sea by Theseus, son of Poseidon, a sea divinity. Forbes Irving, *Metamorphosis in Greek Myths*, 193; Kerényi, *Dionysus*, 179.

25. Marcel Detienne writes: "Dionysos is more complex and polymorphous than any other divinity in the pantheon—by his rare prestige as a magician as much as

by his affinity for displaying or manifesting in the *beyond*. His *beyond* with respect to the human condition between gods and beasts does not only take the form of the state of cruel bestiality omophagy imposes. For the very same Dionysiac indistinctness between men and beasts likewise leads to the disappearance of any distance between men and gods. The extreme savagery the god's possession demands actually takes the form of a golden age made present by the absence of any difference between man, god and animal." Detienne, *Dionysos Slain*, 90.

26. Deleuze and Guattari, *What Is Philosophy?* 85–113; Flaxman, *Deleuze*, 72–115.

27. Malinowski, *Argonauts*, 301–2; Fortune, *Sorcerers of Dobu*, 94–95; Wirz, *Die Marind-anim von Holländisch-Süd-Neu-Guinea*.

28. Lévy-Bruhl, *Primitive Mythology*, 57.

29. Evans-Pritchard, "Lévy-Bruhl's Theory of Primitive Mentality"; Mousalmas, "Concept of Participation."

30. Lévy-Bruhl, *Primitive Mythology*, 252–57; on the figure of metamorphosis in European folklore, see Vaz da Silva, *Metamorphosis*.

31. Lévi-Strauss and Eribon, *Conversations with Claude Lévi-Strauss*.

32. Descola, *Beyond Nature and Culture*, 163. Descola elaborates the proposed contrast in the following terms: "Dream beings are thus not plants or animals that undergo metamorphosis and change into humans, nor are they humans that change into plants or animals. Rather, they are original and originating hybrids, concrete hypostases of physical and moral properties that can thus transmit those attributes to entities all with their own individual forms but each of which is regarded as a legitimate representative of the prototype from which it came. . . . Far from mutually apprehending each other as subjects engaged in a social relationship, humans and non-humans are merely particularized materializations of classes of properties that transcend their own existences." Ibid., 164–65.

33. Viveiros de Castro, "Cosmological Deixis," 469–70.

34. Ibid., 478.

35. Ibid., 482.

36. Viveiros de Castro writes: "We must remember, above all, that if there is a virtually universal Amerindian notion, it is that of an original state of undifferentiation between humans and animals, described in mythology. . . . The differentiation between 'culture' and 'nature,' which Lévi-Strauss showed to be the central theme of Amerindian mythology, is not a process of differentiating the human from the animal, as in our own evolutionist mythology. The original common condition of both humans and animals is not animality but rather humanity. The great mythical separation reveals not so much culture distinguishing itself from nature but rather nature distancing itself from culture: the myths tell how animals lost the qualities inherited or retained by humans." Ibid., 471–72.

37. Eliade, *Myth of Eternal Return*, 88. Eliade's (and others') identification of myth with a condition of originary undifferentiation is reiterated with reference to European folklore by Francisco Vaz da Silva, who argues that folktales and fairy tales express a "monist" ontology emphasizing the primordial unity underlying superficial differences. Vaz da Silva, *Metamorphosis*, 214–15.

284 *Notes to Chapter 7*

38. Viveiros de Castro, *Cannibal Metaphysics*, 65–66.

39. Ibid., 66.

40. "Ontology Is Just Another Word for Culture" was a motion tabled at the 2008 meeting of the Group for Debates in Anthropological Theory at the University of Manchester. Proposing the motion were Michael Carrithers and Matei Candea. Opposing were Karen Sykes and Martin Holbraad. Venkatesan, "Ontology." For a discussion of the political implications of the ontological turn, see Martin Holbraad and Morten Axel Pedersen, eds., "The Politics of Ontology," *Cultural Anthropology*, January 13, 2014, https://culanth.org/fieldsights/461-the-politics-of -ontology.

41. See Latour, "Perspectivism," 2.

42. Holbraad, *Truth in Motion*, xv–xxiii.

43. Viveiros de Castro, *Cannibal Metaphysics*, 173. Viveiros de Castro characterizes such an approach as a "thought experiment" or "fiction" that "consists in treating indigenous ideas as concepts and then following the consequences of this decision: defining the preconceptual ground or plane of immanence the concepts presuppose, the conceptual persona they conjure into existence, and the matter of the real that they suppose." Ibid., 187.

44. Vernant, *Myth and Society*, 204.

45. Skafish, "Introduction," 25. Viveiros de Castro himself suggests that this might involve displacing the foundational assumptions of Western thought by engaging the "non-philosophy" or the "life" of the various other peoples inhabiting the planet. His phrasing here echoes (but does not explicitly cite) François Laruelle's account of "non-philosophy" as characterized by its refusal of what Laruelle takes to be the founding gesture of Western philosophy—that of "autopositioning," or setting itself apart from the world in order to represent and comment upon it. Viveiros de Castro, *Cannibal Metaphysics*, 192; Laruelle, *A Dictionary of Non-Philosophy*, 56–57.

46. Lévi-Strauss, *Story of Lynx*, 43–54, 225–42; Viveiros de Castro, *Cannibal Metaphysics*, 213.

47. Taussig, "Sun Gives without Receiving," 398.

8. "They Aren't Symbols—They're Real"

1. West, *Ethnographic Sorcery*, 1–5. For a more extended account of sorcery practices on the Mueda plateau, see West's ethnography, *Kupilikula*, based on his dissertation research.

2. West, *Ethnographic Sorcery*, 24; see also Comaroff, *Body of Power*, 9; Jackson, *Paths toward a Clearing*, 91; White, *Speaking with Vampires*, 14.

3. Stoller, *Fusion of the Worlds*; Stoller and Olkes, *In Sorcery's Shadow*. Such claims have often met with skepticism or dismissal from other anthropologists: Beidelman, review of *In Sorcery's Shadow*, by Paul Stoller and Cheryl Olkes; Baum, "Reflections"; Denzin, "Writing the Interpretive, Postmodern Ethnography"; Jackson, review of *In Sorcery's Shadow*.

4. West, *Ethnographic Sorcery*, 25.

Notes to Chapter 9 285

5. Ibid., 70.

6. Paul Ricoeur, a defender of Aristotle, suggests that a rigid distinction between literal and figurative meanings is not explicitly formulated in Aristotle's writings but is introduced at a later point by his successors. Nonetheless, Kofman argues persuasively that such a distinction is at the very least strongly implied in Aristotle's own criticisms of what he takes to be inappropriate metaphors. Ricoeur, *Rule of Metaphor*, 21; Kofman, *Nietzsche and Metaphor*, 174, n.5.

7. West, *Ethnographic Sorcery*, 86–93. Significantly, this is one of the moments too when West experiences his own role as an ethnographer as most closely akin to that of a sorcerer.

8. Ibid., 31–33.

9. Ibid., 32.

10. Ibid., 27.

11. Ibid., 28.

12. Ibid., 27.

13. Artaud, *Theater and Its Double*, 19.

14. Nin, *Diary*, 191–92.

9. Liminality

1. Serres, *Troubadour of Knowledge*, 5, 47.

2. Karlsson, *Iceland's 1100 Years*, 83–86.

3. Latour, "From Realpolitik to Dingpolitik," 23. Heidegger had previously drawn attention to the same etymology in "Building, Dwelling Thinking," 331.

4. Scherman, *Iceland*, 129–30.

5. Taussig, *Shamanism*; Marcus, "Modernist Sensibility." On montage as a cinematic technique, see Rohdie, *Montage*. For a discussion of montage in relation to social scientific accounts of modernity (with specific reference to Sweden), see Pred, *Recognizing European Modernities*.

6. Heraclitus, *Fragments*, 37.

7. Douglas, *Purity and Danger*.

8. Van Gennep, *Rites of Passage*.

9. Lucretius, *On the Nature of the Universe*.

10. Serres and Latour, *Conversations*, 70.

11. Lucretius, *On the Nature of the Universe*, 43. The elusive temporality of the *clinamen*—taking place in "a minimum of time"—is described by Deleuze: "The *clinamen* or swerve has nothing to do with an oblique movement which would come accidentally to modify a vertical fall." Rather, the *clinamen* has always been present as "a differential of matter and, by the same token, a differential of thought." Deleuze, *Logic of Sense*, 269.

12. Lucretius, *On the Nature of the Universe*, 63–64, 137.

13. Bergson, *Philosophy of Poetry*; Prigogine and Stengers, *Order Out of Chaos*, 141, 302–5; Stengers, *Power and Invention*, 47–49.

14. Serres, *Birth of Physics*, 82. Serres's insight is applauded by Deleuze and Guattari, who write that "the atom of the ancients, from Democritus to Lucretius,

286 *Notes to Chapter 9*

was always inseparable from a hydraulics, or generalized theory of swells and flows. The ancient atom is entirely misunderstood if it is overlooked that its essence is to course and flow." Deleuze and Guattari, *Thousand Plateaus*, 489.

15. Serres, *Birth of Physics*, 123.

16. Kapferer argues that Turner's approach moves beyond, on the one hand, van Gennep's more narrowly conceived view of ritual as a sequence of actions and, on the other, the static orientation toward symbols and collective representations characteristic of self-identified neo-Durkheimians like Douglas. Kapferer, "Ritual Dynamics," 37.

17. Turner, *Forest of Symbols*, 93–94, 97.

18. Ibid., 96.

19. Turner, *Ritual Process*, 131–32.

20. Ibid., 119; Evans-Pritchard, *Nuer Religion*, 290, 293.

21. Turner, *Ritual Process*, 128.

22. Ibid., 119. Evans-Pritchard notes, for example, that the leopard-skin priest will not approach people making pots lest the pots crack; if anything goes wrong with the standing crops, he may be asked to anoint the earth with butter; he may also be asked to anoint seeds or digging sticks before sowing; when a priest dies, his body is placed between hides on a light platform in the grave to prevent it from coming into direct contact with the earth. Evans-Pritchard writes that such associations come initially as a surprise, given that the Nuer do not have a cult of the earth of the kind found in parts of West Africa. He concludes, however, that "the association of priesthood with the earth is a representation which accords with the general idea of man being identified with the earth and God with the sky, the priest being essentially a person who sacrifices on behalf of man to God above." Evans-Pritchard, *Nuer Religion*, 290–91.

23. Turner, *Forest of Symbols*, 106.

24. West, *Ethnographic Sorcery*, 5.

25. Massumi writes, invoking Deleuze: "What would it mean to give logical consistency to the in-between? It would mean realigning with a logic of relation. For the in-between, as such, is not a middling being but rather the being *of* the middle—the being of a relation. A positioned being, central, middling or marginal, is a *term* of a relation. It may seem odd to insist that a relation has an ontological status separate from the terms of the relation. But, as the work of Deleuze repeatedly emphasizes, it is in fact an indispensable step toward conceptualizing change as anything more or other than a negation, deviation, rupture or subversion." Massumi, *Parables for the Virtual*, 70.

26. Crapanzano, *Imaginative Horizons*, 64.

27. Hamilton-Paterson, *Seven Tenths*.

28. Morris, "Viking Orkney," 210–13.

29. Brown, *Beside the Ocean of Time*, 1994

30. Puhvel, "Seal in the Folklore of Northern Europe"; Marwick, *Folklore of Orkney and Shetland*; Williamson, *Tales of the Seal People*.

31. Brown, *Beside the Ocean of Time*, 164.

Notes to Chapter 10 287

32. August 1, or Lammas Day, marked the festival of the wheat harvest in Britain. The name "Lammas" derives from the Old English *hlæf mæsse* (loaf mass), referring to the custom of bringing to church on that day a loaf made from the new crop. Banks, *British Calendar Customs*, 45.

33. Brown, *Beside the Ocean of Time*, 172–75.

34. Turner, *Forest of Symbols*, 110.

35. Dennison, *Orkney Folklore and Sea Legends*; Ferguson, *Shipwrecks of Orkney*.

10. THE DEAD HAVE NEVER BEEN MODERN

1. Weber, "Science as a Vocation" and *Protestant Ethic*; Baudrillard, *Symbolic Exchange*.

2. Ariès, *Hour of Our Death*, 5–28, 559–601.

3. Benjamin, "Storyteller," 94.

4. Detienne and Vernant, *Cunning Intelligence*, 22–23, 227–29; Horkheimer and Adorno, *Dialectic of Enlightenment*, 35–62.

5. Horkheimer and Adorno, *Dialectic of Enlightenment*, 35–62.

6. Homer, *Odyssey*, 128–29.

7. Joyce, *Ulysses*.

8. Spenser writes: "For yt is in the manner of all *Pagans. And Infidells*, to be yntemperate in there waylinges, of theire dead, for that they had no faith nor hope of salvacion." Spenser, *View of the Present State of Ireland*, 72–73. See also McLean, *Event and Its Terrors*, 40, 100.

9. Witoszek and Sheeran, *Talking to the Dead*.

10. Latour, *We Have Never Been Modern*.

11. Seremetakis, *Last Word*, 14.

12. Hechter, *Internal Colonialism*, 3–14.

13. Torchiana, *Backgrounds*.

14. Joyce, *Dubliners*, 211.

15. Ibid., 222–23.

16. Ibid., 251–54.

17. Ibid., 255–56.

18. Canetti, *Crowds and Power*, 47.

19. Ibid., 47–49.

20. Ochoa, "Versions of the Dead," 482. Ochoa explains his preference for the term "inspiration" over the more familiar "religion" in the following terms: "Religion is, for me, overladen with European assumptions of form, doctrine and homogeneity, in short, with a static sense of belief and practice. Inspiration seems less defined; it is a more mobile term that has nonreligious usages important to my description of Palo's overflowing creativity." Ochoa, *Society of the Dead*, 8.

21. Danaher, *Year in Ireland*, 228.

22. Joyce, *Recollections of James Joyce*, 20.

23. Hole, *Christmas and Its Customs*, 8–12; Simpson and Roud, *Dictionary of English Folklore*, 61–63.

288 *Notes to Chapter 10*

24. A remarkable visual record of such masking practices in contemporary Europe has been compiled by French photographer Charles Fréger in *Wilder Mann*. For a study of Kukeri masquerade practices in present-day Bulgaria, see Creed, *Masquerade and Postsocialism*.

25. Alford, "Hobby Horse," 122.

26. Dumézil, *Problème des centaures*, 170–72.

27. Alford, "Hobby Horse," 124; Lawson, *Modern Greek Folklore*, 222.

28. Marwick, *Folklore of Orkney and Shetland*, 32–39.

29. Senn, "Romanian Werewolves," 206.

30. Abbott, *Macedonian Folklore*, 73–75; Lawson, *Modern Greek Folklore*, 190–255.

31. Lawson, *Modern Greek Folklore*, 190–91.

32. Ibid., 191–92.

11. THE GOD WHO COMES

1. Euripides, *Bacchae*, 191–224.

2. Harrison, *Forests*, 34.

3. Otto, *Dionysus*, 59.

4. Detienne, *Dionysos Slain*, 68.

5. Nietzsche, *Birth of Tragedy*, 17–19. In fact, Nietzsche considered Euripides to be the least Dionysian of the Greek tragedians, espousing instead a rational, Socratic aesthetic, whereby "in order to be beautiful, everything must be reasonable." *The Bacchae*, written toward the end of Euripides's life and first performed posthumously, was, Nietzsche thought, a belated and partial recantation on Euripides's part, born of the recognition that Dionysus was too powerful a presence to be expunged definitively from the life of the city and that, "in the face of such wonderful powers, it is proper to evince at least some diplomatically cautious sympathy." Ibid., 62, 60.

6. Kerényi, *Dionysus*, 238. More recent classical scholarship has often been critical of the interpretations of Dionysus proposed by Nietzsche and some of his successors. Some recent commentators have questioned both the identification of Dionysus with suffering, violence, and loss of self and his association, in the writings of Nietzsche and others, with the origins of tragedy, pointing out that such interpretations have often obscured his more obvious and better-documented role as a god of wine. Henrichs, "Loss of Self"; Scullion, "Nothing to Do with Dionysus." An interpretation of the god more in keeping with that of Nietzsche is provided, however, by Detienne, *Dionysos Slain*. For a summary of debates surrounding the figure of Dionysus and his cult, see Parker, *Polytheism and Society*, 138–39.

7. Otto, *Dionysus*, 56; Forbes Irving, *Metamorphosis in Greek Myths*, 193; Parker, *Polytheism and Society*, 290–326.

8. Lawson, *Modern Greek Folklore*, 190–255. In Macedonia, Karkantzari (or Shatsantzari) are similarly associated with the Twelve Days but are not thought to be denizens of the underworld but rather human beings, especially those who have a "light" guardian angel, who are transformed by night into monsters: "Their nails suddenly grow to an abnormal length, they turn red in the face, their eyes become

bloodshot and wild, their noses and mouths excrete." In this hideous guise, they roam each night from house to house, knocking on doors and demanding admittance. If they are refused, they climb down through chimneys and torment the inhabitants by pinching or otherwise harassing them in their sleep. At daybreak, they resume their human form until nightfall. Abbott, *Macedonian Folklore*, 73–74.

9. Parker, *Polytheism and Society*, 14–15.

10. Ibid., 294.

11. Ibid., 290.

12. Harrison, *Prologomena*, 32–76; Parker, *Polytheism and Society*, 290–327.

13. Parker notes, for example, that the cult of Dionysus was not otherwise associated with the summoning of the dead: "He [Dionysus] is in no sense a lord of the nameless dead such as roamed at the festival." Parker, *Polytheism and Society*, 315.

14. Ibid., 290–316; Burkert, *Greek Religion*, 237–42.

15. The frogs ("children of the water marsh"), who act as a chorus in Aristophanes' play, refer to a song they were accustomed to sing: "For Zeus's son, the god of Nysa, / Dionysus in the Marsh, / when every year a crowd / of drunken revelers at the festival / came to our sanctuary." Aristophanes, *Frogs*, 172; Pickard-Cambridge, *Dramatic Festival of Athens*, 25; Simon, *Festivals of Attica*, 93.

16. Burkert, *Greek Religion*, 232.

12. BETWEEN THE TIMES

1. There is, of course, as British historian Ronald Hutton has noted, a danger in assuming a too straightforward continuity between the masked performances condemned in early Christian writings and those described in the much later folklore record, particularly in the absence of documentation from the intervening centuries. Hutton, *Stations of the Sun*, vii.

2. Frazer, *Golden Bough*, part 6, 328–29.

3. Duerr suggests that such caves were regarded as the uterus of the earth goddess, into which initiates would be conducted in order that they might "die" and then be born again to a new life: "There is sufficient evidence to assume further that rituals were carried out in these uteri in which the initiate participated in 'separating' the animals from the cave wall, thus aiding in their birth from the womb of the earth." He adds, "Cults of this nature can be traced through the millennia almost to the present." Duerr, *Dreamtime*, 21.

The view that cave painting was a ritual act intended to entice animals to show themselves through the surface of the cave wall is put forward by South African archaeologist David Lewis-Williams. Drawing both on his own researches on the San rock art of Southern Africa and on comparative material from southwest Europe, Lewis-Williams proposes, controversially, that these images of animals and of theriomorphic animal–human hybrid beings that feature in both contexts correspond to hallucinations experienced by shamans in trance states and that such visions were understood by those who painted them as emanating from another world that could be accessed from the depths of caves and other subterranean spaces. The cave walls on which images of animal–human hybrid beings

are depicted thus become at once a boundary and a point of interface between worlds. Lewis-Williams notes that many painted images appear to incorporate features of the cave wall so that irregularities in the rock's surface come to double as anatomical features such as ears or eyes, or else figures are positioned in such a way that they appear to emerge directly out of a fissure or cleft in the rock. He argues, therefore, that the wall should be understood not simply as an inert surface to which pigments are applied to create images but rather as a membrane—literally a "painted veil"—through which the images are forcing their way from another world, lured precisely by the ritual act of painting. Lewis-Williams and Dowson, "Through the Veil," 14–15.

4. Duerr, *Dreamtime*, 35.

5. Ibid., 104; Castaneda, *Separate Reality*.

6. Duerr, *Dreamtime*, 66.

7. Ibid., 69.

8. Ibid., 45.

9. The same concerns would later lead Bergson to express reservations about the four-dimensional space-time continuum proposed by the theory of relativity, which he viewed as a recent and particular instance of a much longer standing tendency to spatialize time: "Minkowski's and Einstein's space-time remains a species of which the ordinary spatialization of time in a four dimensional space is the genus." Bergson, *Duration and Simultaneity*, 134.

10. Bergson, *Matter and Memory*, 133–77, 225–49. Elizabeth Grosz writes: "Bergson is one of the few theorists to affirm the continual dynamism, not of the present, but of the past, its endless capacity for reviving and regenerating itself in an unknown and unpredictable future." Grosz, *Nick of Time*, 178.

11. Bergson, *Time and Free Will*.

12. Bergson, *Duration and Simultaneity*, 47, qtd. in Deleuze, *Bergsonism*, 82

13. Bergson's rejection of the One and the Many as a "false problem" would later inform Deleuze's insistence on what he calls the "univocity" of being. Univocity of being designates a simple presence in which individuating differences are distributed not according to the laws of genus or species but according to a "nomadic" logic of "crowned anarchy" whereby everything is at once irreducibly different and yet nothing can be said to participate more or less in being. Deleuze writes: "Being is said in the same sense of everything of which it is said, but that of which it is said differs: it is said of difference itself." Deleuze, *Bergsonism*, 117; *Difference and Repetition*, 36–37.

14. Bergson, *Time and Free Will*, 76–77.

15. Deleuze, *Nietzsche and Philosophy*, 72. Harrison writes of Dionysus as "an instinctive attempt to express what professor Bergson calls *durée*, that life which is one, indivisible and yet ceaselessly changing." Harrison, *Themis*, xii.

16. See, for example, Badiou, *Deleuze*; Hallward, *Out of This World*.

17. Deleuze, *Difference and Repetition*, 82.

18. Beplate, "Joyce, Bergson," 300–301.

Notes to Chapter 13 291

19. It seems appropriate that during the potlatch prohibition instituted by the Canadian government between 1885 and 1951 (directed against the ceremonial distributions, or in some cases the destruction of property, that often took place during the same season), a visual record of many of the dances and masked performances associated with the Winter Ceremonial should have been preserved in a work that is itself ambivalently poised between documentary and fiction: Edward Curtis's 1914 film, *In the Land of the Head Hunters*. Shot in the vicinity of Fort Rupert, British Columbia, and featuring a Kwakwaka'wakw cast acting out a fictional narrative based on a local legend, Curtis's film is itself a remarkable document of an encounter between worlds. For a discussion of the film's significance both as a work collaboratively fashioned by Curtis and the Kwakwaka'wakw and as a landmark in the history of cinema, see the essays collected in Evans and Glass, *Return to the Land of the Headhunters*. On the Canadian government's efforts to outlaw potlatches, see Bracken, *Potlatch Papers*.

20. Boas, *Kwakiutl Ethnography*, 171–298; Goldman, *Mouth of Heaven*, 86–121.

21. Boas, *Kwakiutl Ethnography*, 42–45.

22. Walens, *Feasting with Cannibals*, 138.

23. Ibid., 139.

24. Joyce, *Dubliners*, 219–20, 233, 239, 240–41, 255, 256.

25. Ellmann, *James Joyce*, 243.

26. Kelleher, "Irish History and Mythology," 419–23. James MacKillop defines a *geis* (Old Irish, plural *gessa*) as "the idiosyncratic taboo or prohibition placed upon heroes and prominent personages in Irish narratives. The breaking of a *geis* often results in instant death and sometimes also brings bad luck or destruction upon the culprit's people. *Gessa* (especially ones that prove impossible to comply with) are frequently imposed upon male protagonists by female figures identified as personifications of land or sovereignty." MacKillop, *Dictionary of Celtic Mythology*, 257.

27. Muldoon, *To Ireland, I*, 50–66.

28. Whelan, "Memory of 'The Dead,'" 62–64, 87.

29. Ibid., 65, 69–70, 71, 72.

30. MacNeill, "Wayside Death Cairns"; see also McLean, *Event and Its Terrors*, 101–9.

31. Whelan, "Memory of 'The Dead,'" 72.

32. Grosz, *Nick of Time*, 255–57.

33. Beplate, "Joyce, Bergson," 305.

34. Bishop, *Joyce's Book of the Dark*.

13. ANTHROPOLOGY ≠ ETHNOGRAPHY

1. Henry James, preface to vol. 7 of the New York edition of "The Tragic Muse," http://www.henryjames.org.uk/prefaces/home.htm.

2. See, e.g., Ingold, "That's Enough about Ethnography."

3. For an extended account of the emergence of fieldwork in British and American anthropology, see Stocking, *Ethnographer's Magic*, and *After Tylor*.

4. Boas, "Limitations," 904.

Notes to Chapter 13

5. Ibid., 906.

6. Descola, *Beyond Nature and Culture*; Ingold, *Being Alive*.

7. Tylor, *Primitive Culture*, 194–96.

8. The U.S. Army's Human Terrain System program, which ended operations in 2014, is explored in the 2010 documentary film *Human Terrain: War Becomes Academic*, written and directed by James Der Derian, David Udris, and Michael Udris.

9. Graeber, *Debt*; Hage, *Alter-Politics*; Ingold, *Life of Lines*; Povinelli, *Geontologies*; Stewart, *Ordinary Affects*; Tsing, *Mushroom*; Viveiros de Castro, *Cannibal Metaphysics*.

10. Hage, *Alter-Politics*, 54.

11. Bessire and Bond, "Ontological Anthropology," 445.

12. Ibid., 441.

14. Fabulatory Comparativism

1. The view that ethnographic research and writing can be understood in terms of uncertain and unpredictable encounters has been widely articulated in recent decades. See, e.g., Clifford, "On Ethnographic Surrealism"; Faubion and Marcus, *Fieldwork Is Not What It Used To Be*; McLean and Liebling, *Shadow Side of Fieldwork*; Stewart, *Ordinary Affects*; Tsing, *Friction*. It is striking, however, that the contemporary situation of ethnography has rarely (if ever) been discussed in relation to anthropology's other, comparative heritage.

2. Deleuze and Guattari, *What Is Philosophy?*, 85–113.

3. Duerr, *Dreamtime*, xi; Evans-Pritchard, *Nuer*, 6.

4. Crapanzano, *Imaginative Horizons*, 39–46, 51–56.

5. Bergson, *Creative Evolution*; Deleuze, *Bergsonism*; McLean, "Stories and Cosmogonies"; Ansell-Pearson, *Philosophy and the Adventure of the Virtual*. Kapferer too has recourse to the concept of the virtual, which he derives both from the writings of Deleuze and Guattari (1987) and those of Suzanne Langer (1942, 1953), in order to extend Turner's theorizations of liminality and ritual. For Kapferer, the virtual becomes a key term for understanding the transformative power of ritual dynamics without subordinating them to a logic of social causation: "The phantasmagoric space of ritual virtuality may be conceived not only as a space whose dynamic interrupts prior determining processes but also as a space in which participants can reimagine (and redirect or reorient themselves) into the everyday circumstances of life." The liminal thus becomes "a descent into the ground of reality rather than a making and a marking of a stage in a linear progression." Kapferer, "Ritual Dynamics," 47, 50. See also Deleuze and Guattari, *Thousand Plateaus*; Langer, *Philosophy in a New Key*; Langer, *Feeling and Form*.

15. Islands before and after History

1. See Ferguson, *Shipwrecks of Orkney, Shetland*.

2. On the variousness of islands and their inhabitants, see Lowenthal, "Islands, Lovers, and Others."

Notes to Chapter 16

3. See, e.g., Malinowski, *Argonauts*; Dening, *Islands and Beaches*; Sahlins, *Islands of History*. On islands as metaphors in anthropology, see Eriksen, "In Which Sense Do Cultural Islands Exist?"

4. Dosse, *Gilles Deleuze and Félix Guattari*, 102.

5. Deleuze, *Desert Islands*, 9.

6. Ibid., 10–12.

7. *Difference and Repetition* is, of course, the title of one of the best known of Deleuze's later philosophical works.

8. The notion of such a second beginning finds one of its most forceful expressions, for Deleuze, in the myth of the Flood, in which the Ark, as the crucible of a new beginning, finds its resting place on a de facto island, a solitary mountain peak protruding above the otherwise ubiquitous waters. In order to begin anew, Deleuze suggests, it is necessary, at least provisionally, to separate oneself from whatever, according to the logic of chronological time reckoning, came before. It is the water, the ocean, or the sea surrounding the island that embodies a principle of segregation necessary for such second creation to begin: "as though the island had pushed its desert outside." Deleuze, *Desert Islands*, 11, 13–14.

16. Papay Gyro Nights

1. Hau'ofa, "Our Sea of Islands"; Moss, *Names for the Sea*, 3–4.

2. Auton, Fletcher, and Gould, *Orkney and Shetland*, 4; Nance, Worsley, and Moody, "Supercontinent Cycle."

3. Auton, Fletcher, and Gould, *Orkney and Shetland*, 10–15.

4. The European Marine Energy Center (EMEC) was established in Orkney in 2003 to provide testing facilities for developers of wave and tidal energy converters and currently operates fourteen full-scale test berths, along with two nursery test sites for smaller devices or ones at an earlier stage of development. According to EMEC, Orkney was chosen as a base because of "its excellent oceanic wave regime, strong tidal currents, grid connection, sheltered harbour facilities and the renewable, maritime and environmental expertise that exists within the local community." In July 2012, the Pentland Firth and Orkney Waters were designated a Marine Energy Park (http://www.emec.org.uk).

5. Childe and Clarke, *Skara Brae*; Davidson, *Chambered Cairns*; Hacquebord, "There She Blows"; Renfrew, *Prehistory of Orkney*; Thomson, *New History of Orkney*; Towsey, *Orkney and the Sea*; Watts, "OrkneyLab."

6. Drever, "Papa Westray Games," 70.

7. *Papay Gyro Nights*, http://www.papaygyronights.papawestray.org/ (2011).

8. The Norn language (the term *Norn* derives from the Old Norse *norræn*, "Norwegian" or "Norse") was first introduced to Orkney and Shetland by Scandinavian settlers around 800 CE. It quickly became the dominant language in the islands and remained so in Orkney until the succession to the earldom of the Scots-speaking Sinclairs in in 1379 and in Shetland until the transfer of the islands to Scotland in 1468. The decline of Norn has been attributed to various factors, including immigration from the Scottish mainland, declining contacts with Norway, and

294 *Notes to Chapter 16*

the increasing use of Scots as the language of the ruling class, administration, courts, and, after the Reformation, religion. By the late seventeenth century, there were few monoglot speakers of Norn remaining in the islands, and those who continued to use the language in the late eighteenth and early nineteenth centuries appear to have shown the increasing influence of Scots on its phonology and grammar. Walter Sutherland, from Skaw in Unst, Shetland, who died around 1850, has often been cited as the last speaker of Norn, although individual Norn words continued in use. The two principal latter-day collections of Norn terms are those compiled by the Faroese linguist Jakob Jakobsen (1864–1918) and the Orcadian scholar Hugh Marwick (1881–1965). Jakobsen's *Etymological Dictionary of the Norn Language in Shetland* is based on fieldwork carried out in Shetland in 1893–95. It was first published in Danish in four volumes between 1908 and 1921 and in English in two volumes in 1928 and 1932. Marwick's study, *The Orkney Norn*, was based on his doctoral thesis at the University of Edinburgh and drew on fieldwork conducted in Orkney in the early decades of the twentieth century. Barnes, "Orkney and Shetland Norn," 352–55; Barnes, "Norse and Norn," 179–83; Jakobsen, *Etymological Dictionary*; Marwick, *Orkney Norn*.

9. Ibid., 65.

10. Gunnell, *Origins of Drama*, 168–72; Jakobsen, *Etymological Dictionary*, 271–75; Marwick, *Folklore of Orkney and Shetland*, 91, 116.

11. Gunnell, *Origins of Drama*, 160–79; Gunnell, "Masks and Mumming," 298–301, 309, 318–19; Williamson, *Atlantic Islands*, 247–49.

12. Faroese television interviews with older inhabitants of Svonoy in the 1990s confirmed that on the island, Grýla was impersonated by a single performer, usually the same man, who dressed in animal skins, kept a bag for offerings under his costume, and wore a wooden mask. Gunnell, *Origins of Drama*, 164; Gunnell, "Masks and Mumming," 299–300.

13. Gunnell, *Origins of Drama*, 153.

14. Grýla is explicitly identified as an ogress figure in a fourteenth-century manuscript of *Skáldskaparmál* (the second part of Snorri Sturluson's *Prose Edda*), where her name is listed alongside those of three other ogresses, or *trollkvinna*. Gunnell, *Origins of Drama*, 161.

15. Gunnell, "Grýla, Grýlur," 35.

16. One such Grýla verse is featured in Heinesen's story, "Grylen," this time invoking Grýla's later, Lenten associations: "Down comes Grýla from the outer fields / With forty tails / A bag on her back, a sword / knife in her hand / Coming to carve out the stomachs of the children / Who cry for meat during Lent." Qtd. in Gunnell, *Origins of Drama*, 165. Jakobsen, meanwhile, records a verse from the island of Foula in Shetland in which the name Grýla (or the related Shetlandic term *grølek*) is replaced by the locally more familiar *Skekla*: "Skekela (an ogress) rides into the homefield / On a black horse with a white patch on its brow / With fifteen tails / And fifteen children on each tail." Ibid., 173.

17. Hastrup, *Culture and History in Medieval Iceland*, 136–45.

Notes to Chapter 17 295

18. Jennings, "Giantess as Metaphor"; Marwick, "Creatures"; Motz, "Giants in Folklore and Mythology"; Puhvel, "Mighty She-Trolls"; Smith, "Perchta the Belly-Slitter."

19. Gunnell, *Origins of Drama*, 167.

20. Gunnell, "Grýla, Grýlur," 34.

21. Duerr, *Dreamtime*, 35.

22. "About Genetic Moo," *Genetic Moo,* http://www.geneticmoo.com/about.php.

23. *Mother* (artwork), *Genetic Moo*, http://www.geneticmoo.com/Cmother.php.

24. Ibid.

25. E-mail communication, March 1, 2011.

26. Ibid.

27. Hesiod, *Theogony*, 12–13.

17. THE TIME OF THE ANCESTORS?

1. Ritchie, "First Settlers," 36–37.

2. Henshall, "Chambered Cairns"; Whittle, *Europe in the Neolithic*, 1, 355, 365–66.

3. Davidson, *Chambered Cairns*; Henshall, "Chambered Cairns," 99–107.

4. Fowler and Cummings, "Places of Transformation," 16.

5. Hedges, *Tomb of the Eagles*, 145–59.

6. Childe, *Skara Brae*; Renfrew, *Prehistory of Orkney*.

7. Childe and Clarke, *Skara Brae*.

8. Magnus was killed by his cousin, Haakon Paulsson, in or around 1115 in a dispute over succession to the earldom of Orkney. The story of his martyrdom is told in the *Orkneyinga Saga*, written in the early thirteenth century by an unknown Icelandic author. Between 1154 and 1472, Orkney was part of the Norwegian archbishopric of Trondheim, after which it became part of the Scottish province of St. Andrews. The cathedral was assigned to the people of Kirkwall by King James III of Scotland in a charter of 1486 and is owned today by the Royal Burgh of Kirkwall. Pálsson and Edwards, *Orkneyinga Saga*; "St. Magnus Cathedral—History," *St. Magnus Cathedral, Kirkwell, Orkney*, http://www.stmagnus.org/history.html.

9. Mooney, *Cathedral and Royal Burgh*.

10. Tarlow, *Bereavement and Commemoration*, 50–51. Tarlow's study is based on records produced by the Orkney Graveyard Project, available for consultation in the form of a database in the Orkney Archive Office in Kirkwall.

11. The Reformed Church of Scotland also introduced a formal ban on intramural burials (on pain of excommunication) in 1579. Although this was strictly observed in many parts of Scotland, burials within the walls of St. Magnus Cathedral appear to have continued until the early nineteenth century. Tarlow, *Bereavement and Commemoration*, 79–94.

12. An adjacent memorial, commemorating George Liddell of Hamner (d. October 1681, aged forty-eight) contains a more overtly didactic message (along with a family crest and skull): "Death hastens no flight avails to pay the tribute of mortality man is bound by nature's law all things go back to where they came and

seek their mother and what has been returns again to nothingness But I lament the loss of time material damage everyone can make good no one can make good the loss of time."

13. The practice of interments inside the cathedral continued until the early decades of the nineteenth century, causing the level of the floor in the nave to be continuously raised. One description from 1847 refers to the "effluvia" unleashed by the opening of these graves to facilitate restoration works. Tarlow, *Bereavement and Commemoration*, 93.

14. Albert Thomson, who served as curator of St. Magnus Cathedral for thirty-two years, recalls a conversation with an eyewitness to the reburial of the intramural dead, an elderly Kirkwall man ("with several drinks taken") who looked into the hole before it was filled in and remarked, "Good God, boys, there'll be some scramble here at the Resurrection!" Recording available at the Orkney Library and Archive.

15. Ashmore, *Maes Howe*.

16. Humphrey, "Chiefly and Shamanist Landscapes," 153.

17. Davidson, "Wild Hunt."

18. Granet, *Religion of the Chinese People*, 52.

19. Hertz, *Death and the Right Hand*, 58.

20. Ibid., 38. Hertz's examples here (and throughout his study) are drawn predominantly from the Olo Ngaju, a grouping of riverine peoples in southeastern Borneo.

21. Latour, *Reassembling the Social*, 43, 46–47, 64, 66, 75.

22. Thomson, *New History of Orkney*, 349–62.

23. Þorbjörg Jónsdóttir, personal communication, 2012.

18. IN THE BEGINNING WERE THE GIANTS

1. Larrington, *Poetic Edda*, 57.

2. Hesiod, *Theogony*.

3. *New English Bible*, Genesis 1:1–2, 1.

4. Daley, *Myths from Mesopotamia*, 245, 247.

5. Ibid., 244–61. See also Barton, "Tiamat"; Jakobsen, "Battle between Marduk and Tiamat."

6. Feminist theologian Catherine Keller argues that the doctrine of creation ex nihilo began to gain influence from the second century onward as a response to the seeming challenge to godly omnipotence presented by descriptions in written sources of the deep (*tehom*) as existing—apparently—prior to the divine act of creation. In a comparative rereading of the Genesis account alongside other ancient Near Eastern creation narratives, Keller draws attention to what she sees as the retroactive gendering of a notionally precosmological substance of creation. It is such a gesture, she suggests, that allows for the subsequent disenfranchisement of a feminine-identified creative power of matter, whether through a contrastively formulated doctrine of creation out of nothingness or through the

Notes to Chapter 18 297

restrictive identification of such a feminized material creativity with a superseded, mythic past rather than with the present. Keller, *Face of the Deep*, 43–64.

7. Kristeva, *Powers of Horror*, 14; Plato, *Timaeus*, 39–46.

8. Kristeva, *Desire in Language*, 124–47; Kristeva, *Revolution in Poetic Language*, 25–30.

9. Kristeva, *Powers of Horror*, 1–31.

10. Tsing has criticized Kristeva's later study of abjection, *Powers of Horror*, for its ethnocentric reliance on a now discredited account of unilineal social evolution: "Kristeva . . . follows an insulting evolutionary track from Africans and Indians to Judaism, Christianity, and, at last, to French poets. In addition, she assumes an epistemological dichotomy between European 'theory' and global 'empirical' variation in which, by definition, the Third World can never be a source of theoretical insight." Tsing, *In the Realm of the Diamond Queen*, 180–81.

11. Bracha Ettinger criticizes Kristeva for confining expressions of the feminine to moments of "rupture and negativity." Instead, she suggests, "we can free ourselves from the compulsion to disqualify as mystical or psychotic whatever lies beyond the phallic border, but also . . . grasp that the borderline itself can become transgressive and should not be perceived only as a castration, as a split, and as a bounding limit." Ettinger's own work as a theorist and visual artist is concerned with articulating what she calls the "matrixial boderspace" as one that will not allow itself to be reduced to either a social construct or a biological given. Ettinger, *Matrixial Borderspace*, 177, 184.

12. Philosopher Robert Corrington writes: "While she [Kristeva] confines the *chōra* to the human process and its unconscious, maternal and bodily dimensions, it is actually a structure that obtains in nature as a whole." Corrington's understanding of the *chōra* is informed by Peircean semeiotics rather than Saussurean linguistics (which he characterizes as "the mediating tradition")—*chōra* is not the object of a founding interdiction but a presemiotic "ground" that "gives birth" to signs but is always in excess of any attempt to give linguistic or semeiotic expression to it. Corrington, *Ecstatic Naturalism*, 27. The possibility of a semeiosis beyond the human is one that Eduardo Kohn, also drawing on the theories Peirce, has recently explored to great effect in his ethnography of the Ecuadorian Upper Amazon. Kohn, *How Forests Think*.

13. Plato, *Timaeus*, 45.

14. Ibid., 43.

15. Ibid., 18; Bianchi, *Feminine Symptom*, 90–91.

16. Plato, *Timaeus*, 39. John Sallis writes, "In the *Timaeus* nothing is more vigorously interrogated than the question of beginning," although, as Emanuela Bianchi notes, Sallis's own interrogation of Plato's dialogue pays only cursory attention to the ways in which the question of beginnings is interwoven with figures of femininity and sexual difference. Sallis, *Chorology*, 5; Bianchi, *Feminine Symptom*, 89.

17. El-Bizri, "*Qui Etes-vous Chōra?*," 275.

18. Protevi, *Political Physics*, 147.

19. Plato, *Timaeus*, 45.

298 *Notes to Chapter 18*

20. Raphael Demos, for example, writes: "The flux, which Plato decries, is the display of the endless creativity of being. In short, it is possible, departing from Plato, to construe the receptacle as a contribution to reality, not as a diminution of it." Demos, "Receptacle," 557.

21. The other speakers include Critias (who features in an unfinished companion dialogue of the same name), Hermocrates, and, as always, Plato's own teacher, Socrates. Timaeus is entrusted with the task of expounding the origins of the universe because, in Critias's words, he "knows more than the rest of us about the heavenly bodies and has specialized in natural science." Plato, *Timaeus*, 15.

22. Bianchi, *Feminine Symptom*, 97.

23. Ibid., 90–91. Timaeus mentions gold as one particular example of such a material: "Imagine someone who moulds out of gold all the shapes there are, but never stops remoulding each form and changing it into another. If you point at one of the shapes and ask him what it is, by far the safest reply, so far as truth is concerned, is for him to say 'gold'; he should never say that it's 'a triangle' or any of the other shapes he's in the process of making, because that would imply that these shapes are what they are, when in fact they're changing even while they're being identified." Plato, *Timaeus*, 42.

24. Derrida, "Khōra," 113.

25. Butler, *Gender Trouble*, 84. See also Butler, *Bodies That Matter*, 15; Fraser, *Revaluing French Feminism*, 190.

26. Margaroni, "Lost Foundation," 88.

27. Bianchi, *Feminine Symptom*, 113.

28. Bianchi notes that in Aristotle's *Physics* the status of aleatory matter is downgraded by being identified with the illusory motion of the automaton, a sophisticated technology, the apparent self-motion of which is in fact the product of (masculine) *technē*. Bianchi, *Feminine Symptom*, 113. In contrast, Deleuze writes that in Plato's work, "an obscure debate was raging in the depths of things, in the depths of the earth, between that which undergoes the action of the Idea and that which eludes this action." Deleuze, *Desert Islands*, 6. Cavarero argues that although it is in Plato's writings that a "matricidal" impulse at work in Western thought achieves its philosophical "completion," this has "not yet hardened into a system," allowing traces of an earlier, prephilosophical, and prepatriarchal moment to become apparent through "rips and tears." Cavarero, *In Spite of Plato*, 9.

29. Roberto Calasso writes that the Greek gods of Olympus, no less than those of the much later documented Norse pantheon, represent a decisive break with an earlier world of mythic metamorphosis: "The twelve gods of Olympus agreed to appear as entirely human. This was the first time a group of divinities had renounced abstraction and animal heads. No more the unrepresentable behind the flower or the swastika, no more the monstrous creature, the stone fallen from heaven, the whirlpool. Now the gods took on a cool, polished skin, or an unreal warmth, and a body where you could see the ripple of muscles, the long veins." Calasso, *Marriage*, 54.

Notes to Chapter 18

30. Nietzsche, *Birth of Tragedy, Philosophy in the Tragic Age,* and *Dionysian Vision.*

31. Bachofen, *Myth, Religion,* 70.

32. Harrison, *Prolegomena,* 164. In a study of the group (which also included F. M. Cornford, A. B. Cook, and the Oxford-based Gilbert Murray), Robert Ackerman characterizes their project as a search for "a deeper, more primitive layer of gods underlying the Homeric stratum of the Olympians." Ackerman, *Cambridge Myth,* 86.

33. Burkert, *Greek Religion,* 20, 39.

34. Ibid., 19–47.

35. Freud, "Female Sexuality," 226. The Bronze Age civilization that preceded that of classical Greece was brought to light through the excavations carried out from 1871 by Heinrich Schliemann at Mycenae (which gave its name to the period of Greek history stretching from roughly 1600 BCE to about 1100 BCE) and by Arthur Evans's early twentieth-century discovery of the older Minoan civilization of Crete. Later discoveries and the decipherment of Linear B tablets from Knossos, Mycenae, and Phylos contributed to a clearer and more differentiated view of the Minoan and Mycenaean periods. Burkert, *Greek Religion,* 19–20.

36. Ovid, *Metamorphoses,* 15.

37. Ibid.

38. Calasso, *Marriage,* 11–12. Medieval historian Carolyn Walker Bynum makes a case for understanding hybridity and metamorphosis as "fundamentally different": "The hybrid expresses a world of natures, essences, or substances (often diverse or contradictory to each other), encountered through paradox; it resists change. Metamorphosis expresses a labile world of flux and transformation, encountered through story." Bynum, *Metamorphosis and Identity,* 29–30.

39. Vollmann, *Ice Shirt,* 36. Hilda Ellis Davidson refers to warriors known as "berserks" who are described in the saga literature as followers of Odin and who were known for exhibiting the ferocity of bears or wolves on the battlefield, and in some cases for being impervious to blows from swords or other weapons. She writes: "The term *berserk* may have been based on the wearing of a bear skin (*serkr* = shirt), and this is suggested by the alternate name given to them: *úlfheðnar,* 'wolf coats.'" Davidson, "Shape Changing," 149.

40. McAfee, *Julia Kristeva,* 4; Schippers, *Julia Kristeva and Feminist Thought,* 27.

41. Bakhtin, *Rabelais,* 317.

42. Ibid., 318–19, 328. On the subject of giants in medieval European literature, see Cohen, *Of Giants.*

43. Noelle McAfee suggests such a possibility when she links the concept of *chōra* to a history of cosmogonic speculation extending to the present: "Plato's musings about the origins of the universe are ones we might adopt today, using a more modern vocabulary. In addition to asking 'What was there before the big bang?' and 'Where did the universe come from?' we might ask 'Where is this universe?' or 'In what space did the universe come to be?'" McAfee, *Julia Kristeva,* 19–20.

19. TIAMATERIALISM

1. Lovecraft, *Best Supernatural Stories*, 145.
2. Haraway, *Staying with the Trouble*, 101.
3. Negarestani, *Cyclonopedia*, 19, 42, 65–67.
4. Ibid., 20. Negarestani sometimes appears to be more attracted to the alternative and highly controversial account of the formation of oil proposed by astrophysicist Thomas Gold. Gold's theory of "Deep Hot Biosphere" proposes that the formation of petroleum results from colonies of bacteria feeding on hydrocarbon deposits trapped close to the earth's core and that this is a continuous and mobile process, such that earth might possess a virtually endless supply of oil. Negarestani writes: "Thomas Gold's theory of Deep Hot Biosphere suggests that petroleum is not a fossil fuel, and that oil has its origin in natural gas flows, which feed bacteria living in the bowels of the earth. Therefore, the demonarchy of oil is not subjected to the laws of the dead (i.e. the preserved corpses of prehistoric organisms) but rather is animated by a Plutonic vitalism (abiogenic petroleum generated by the nether biosphere of the earth). Petroleum surfaces from primordial origins—thus, it is not of the earth but of the Outside, planted here as a xeno-chemical Insider. Oil is produced by Plutonic forces and the nether biosphere, rather than from the decomposition of fossils and organic body counts. Consequently, oil is far more substantial and follows a different, autonomous logic of planetary distribution." Ibid., 72.
5. The vision of earth ("Gaia") as a self-regulating system comprising the biosphere, atmosphere, hydrosphere, and pedosphere was first set out by Lovelock in the 1970s in a series of works aimed at academic and wider audiences, including *Gaia: A New Look at Life on Earth*, first published in 1979.
6. Ibid., 43.
7. American poet Clayton Eshleman, writing about the Paleolithic cave art of southwestern Europe, refers to such a figure as a "transpersonal cosmogonic Mother"—personified by caves and other subterranean apertures as sacred or ritual spaces from which initiates emerge "reborn." Eshleman, *Juniper Fuse*, xxi.
8. Parikka, *Geology of Media*, vii.
9. Claire Colebrook notes that the turn toward ecology and "life" in much recent "posthumanities" discourse has often entailed an unquestioned adherence to notions of self-maintaining organicism and autopoesis: "If man as a particular and exceptional being has been vanquished, what is saved is nevertheless a highly normative (theological-organic) logic of life in which the bounded and self-separating body with a world of its own is affirmed against various calculative reductivisms." Colebrook, *Death of the Posthuman*, 169.

20. BLUBBERBOMB

1. Shakespeare, *Hamlet*, 31.
2. Tsitsopoulos, "Feldeinsamkeit Tonight Theater Stage Statement" (2011), http://4art.com/profile/filippostsitsopoulos.

Notes to Chapter 20 301

3. Ibid.

4. Towsey, *Orkney and the Sea*, 59.

5. Hacquebord, "There She Blows," 11; Proulx, *Whaling in the North Atlantic*, 5–7.

6. Proulx, *Whaling in the North Atlantic*, 30–35, 63, 77.

7. Melville, *Moby-Dick*; Deleuze and Guattari, *Thousand Plateaus*, 243–45.

8. Melville, *Moby-Dick*, 354.

9. Szabo, *Monstrous Fishes*, 177–210.

10. Strathern, *Partial Connections*.

11. Olaus interprets the occurrence of whales in Arctic Norway as evidence of divine providence, given that the harsh climate does not allow trees to grow there to provide timber, although his description of such whalebone houses does not state whether they are permanent dwellings or temporary shelters used by hunting and fishing parties. The use of the jawbones of whales in the construction of houses is supported by a range of classical and medieval sources with reference to Europe, Asia, Africa, and the Middle East. Greek geographer Strabo, for instance, refers to the use of whales' jawbones in house construction by peoples living adjacent to the Indian Ocean. Szabo, *Monstrous Fishes*, 205–7.

12. Olaus describes the construction of these whalebone houses in the following terms: "After the skeleton has eventually been cleansed by rains and fresh air, strong men are enlisted to erect it in the form of a house. The one who is supervising its construction exerts himself to put windows at the top of the building or in the monster's sides, and divides the interior into several comfortable living quarters. The doors are made from the creature's hide. . . . Inside this boat shaped dwelling are rooms set apart for pigs and other animals, as in the same way in ordinary wooden houses." Magnus, *Description of the Northern Peoples*, 3:1107.

13. The foundation of "Blubbertown" coincided with the emergence of the Netherlands as a leading whaling nation. The settlement consisted of a fort, a church, inns, taverns, and shops, with merchants and craftsmen catering to a population of between 18,000 and 20,000 whalers. Proulx, *Whaling in the North Atlantic*, 55.

14. Ibid., 31–92.

15. Berg, *Transfer Fat*, 15.

16. The group's website states that it was founded at a waterfall called Ristafallet in Jämtland in northwest Sweden on Midsummer's Eve 1986 and describes its founding members as "a dynamic collective eager to question everything, stir up scandal, develop automatist behaviour, poetic revelations, rigorous revolutionary morality and enraptured self-confidence, all in a spirit of furious defiance of consensus in the then still existent social democratic idyll." "Experience of the Surrealist group in Stockholm," http://www.surrealistgruppen.org/experienceof.html. Aase Berg would later say of her own involvement in the group: "We were completely asocial. We mixed the philosophy and methods of the French Surrealists with drug experiments and political happenings. After a while we started to take interest in contemporary natural science, or, we interpreted it poetically, I should say, since we didn't understand much in a proper way. But nowadays I look back and realize that

302 *Notes to Chapter 20*

we lacked the feministic perspective. The surrealist group of Stockholm as it was in those days, and also the original surrealist movement, are almost the opposite of my feministic point of view today." "An interview with Aase Berg by S. J. Fowler." *3: AM Magazine,* http://www.3ammagazine.com/3am/maintenant-42-aase-berg/.

17. Aase Berg, Johannes Göransson, and Garth Graeper, "The Rumpus Poetry Book Club Chat with Aase Berg, Johannes Göransson, and Garth Graeper," *Rumpus,* March 2, 2012, http://therumpus.net/2012/03/the-rumpus-poetry-book-club-chat -with-aase-berg-johannes-goransson-and-garth-graeper/. Berg's description of the experience of pregnancy is worth comparing with Kristeva's: "Cells fuse, split and proliferate; volumes grow, tissues stretch, and body fluids change rhythm. . . . Within the body, growing as a graft, indomitable, there is an other. And no one is present, within that simultaneously dual and alien space, to signify what is going on. 'It happens, but I'm not there.'" Kristeva, *Desire in Language,* 237.

18. Joyelle McSweeney, "Forest of Flinches: *Transfer Fat* by Aase Berg: Now Available from Ugly Duckling," *Montevidayo,* February 20, 2012, http://montevidayo .com/2012/02/forest-of-flinches-transfer-fat-by-aase-berg-now-available-from-ugly -duckling/.

19. Berg, *Transfer Fat,* 45.

20. Göransson, "Ambient Translations," 116.

21. Ibid., 116, 118.

22. Berg, *Transfer Fat,* 41.

23. Ibid., 87.

24. Bakhtin, *Rabelais,* 316–20; Deleuze, *Pure Immanence,* 27–30.

25. Filippos Tsitsopoulos, *The Madrigal of the Explosion of the Wise Whale,* seven-part exhibition project, 2010, https://whalebomber.files.wordpress.com/2010/ 10/the-madrigal-of-the-explosion-of-the-wise-whale.pdf. Penagis Lekatsas was an independent philologist and newspaper columnist in the decades after World War II, who wrote on ancient Greek and comparative religion, among other topics. His writings were influenced by George Thomason's Marxist interpretations of ancient Greek society, as well as by the social evolutionist theories of Johann Jacob Bachofen and Lewis Henry Morgan, and earned him a considerable following on the Greek left during the 1960s. Papataxiarchis, "From 'National' to 'Social' Science," 43; Agelopoulos, "Multiple Encounters," 69.

26. "Whale Explodes in Taiwanese City," *BBC News,* January 29, 2004, http:// news.bbc.co.uk/2/hi/science/nature/3437455.stm.

27. Tsitsopoulos, *Madrigal.*

28. Focillon, *Life of Forms*; Deleuze, *Fold.*

29. Tsitsopoulos, *Madrigal.*

30. On this point, see Serres, *Troubadour of Knowledge,* 37–111.

21. A GLOBE OF FIRE

1. Dennison, *Orkney Folklore,* 171–72.

2. Ibid., 173.

3. Deleuze and Guattari, *What Is Philosophy?,* 85–113; Flaxman, *Deleuze,* 72–114.

Notes to Chapter 22

4. Meillasoux, *After Finitude*, 1–27.
5. Eliot, *Four Quartets*, 21.
6. Dennison, *Orkney Folklore*, 30.
7. Ochoa, "Versions of the Dead," 482.
8. Dennison, *Orkney Folklore*, 186.

22. NIGHTTIME

1. Larrington, *Poetic Edda*, 11.
2. Marwick, "Creatures," 257.
3. Ibid., 258–59.
4. Bachelard, *Water and Dreams*, 101.
5. Canetti, *Crowds and Power*, 49; Falck-Yatter, *Aurora*, 29–44.
6. *Mirrie Dancers* (art project), *Papay Gyro Nights 2011*, http://www.papay gyronights.papawestray.org/html/gyro2011/mirrie_dancers.html.
7. *Mirrie Dancers*, http://www.shetlandarts.org/our-work/past-projects/mirrie -dancers.
8. McKibben, *End of Nature*; Haraway, *When Species Meet*, 4, 16.
9. Among the examples cited by Raffles are anthrax-transmitting horseflies and cucumber beetles, notorious pests of agricultural crops, found at heights of 200 and 3,000 feet, respectively. Raffles, *Insectopedia*, 7.
10. Colebrook, *Death of the Posthuman*, 166.
11. In addition to underpinning many contemporary arguments about the continued relevance of humanities disciplines, such a conception bears obvious affinities with the managerialist idioms of efficiency, preparedness, and resilience that have dominated much public debate about possible responses to climate change. See Wakefield and Braun, "New Apparatus."
12. Colebrook, *Death of the Posthuman*, 164.
13. Morton, *Ecology without Nature*, 1–28; Morton, *Ecological Thought*, 28–38.
14. On the *Unheimlich* (uncanny), see Freud, "Uncanny."
15. Spinoza, *Ethics*, 51–52.
16. Deleuze, *Bergsonism*, 93.
17. Nancy, *Adoration*, 91.
18. Plato, *Timaeus*, 45; Corrington, *Ecstatic Naturalism*, 48.
19. Freud, "Difficulty," 143.
20. Clark, *Inhuman Nature*, 27–54.
21. Van de Port, *Ecstatic Encounters*, 11–46.
22. Povinelli, *Economies of Abandonment*, 10; Myung Mi Kim and Charles Bernstein, "Ear Turned toward the Emergent: Close Listening with Myung Mi Kim," *Jacket*, February 19, 2012, http://jacket2.org/interviews/ear-turned-toward-emergent.
23. I see a parallel attempt to rehabilitate the concept of nature in the recent renewal of interest in the *Naturphilosophie* of F. W. J. Schelling. See, e.g., Grant, *Philosophies of Nature*, and Tritten and Whistler's "Editorial Introduction" to a special issue of the journal *Angelaki*.

AFTERWORD

1. Kwok, "Artistic Concept and Artist Biography," 6; Wong, "Message from the Commissioner," 4.

2. Chia, "Frogtopia–Hongkornucopia," 10.

3. Lippard, *Mixed Blessings*, 102; Ming, "Tadpole to Frog King," 31.

4. Cooper, *Symbolic and Mythological Animals*, 17.

5. Chia, "Frogtopia–Hongkornucopia," 3–10; Tsang, "Art Is Life," 22–23.

6. See Rendall, *Papay Life.*

Bibliography

Abbott, G. F. *Macedonian Folklore.* 1903. Reprint, Chicago: Argonaut, 1969.

Abu-Lughod, Lila. "Writing against Culture." In *Recapturing Anthropology: Working in the Present,* edited by Richard G. Fox, 137–62. Santa Fe, N.M.: School of American Research Press, 1991.

Ackerman, Robert. *The Cambridge Myth and Ritual School: J. G. Frazer and the Cambridge Ritualists.* New York: Garland, 1991.

Agelopoulos, Georgios. "Multiple Encounters: Attempts to Introduce Anthropology in Greece during the 1940s–1960s." In *The Anthropological Field on the Margins of Europe,* edited by Aleksander Bošković and Chris Hann, 65–84. Zurich: Lit Verlag, 2013.

Alford, Violet. "The Hobby Horse and Other Animal Masks." *Folklore* 79, no. 2 (1968): 122–34.

Ansell-Pearson, Keith. *Philosophy and the Adventure of the Virtual: Bergson and the Time of Life.* New York: Routledge, 2002.

Ardener, Edwin. "Social Anthropology and the Decline of Modernism." In *Reason and Morality,* edited by Joanna Overing, 46–69. London: Tavistock, 1985.

Ariès, Philippe. *The Hour of Our Death.* Translated by Helen Weaver. London: Penguin, 1982.

Aristophanes. *Frogs.* In *"Lysistrata," "The Women's Festival," and "Frogs."* Translated by Michael Ewans, 159–223. Norman: University of Oklahoma Press, 2010.

Aristotle. *Physics.* Translated by Robin Waterfield. Oxford: Oxford University Press, 1996.

———. *Poetics.* Translated by Malcolm Heath. London: Penguin Classics, 1997.

———. *Politics.* Translated by Carnes Lord. Chicago: University of Chicago Press, 2010.

———. *Rhetoric.* Translated by W. Rhys Roberts. New York: Dover, 2004.

Artaud, Antonin. *The Theater and Its Double.* Translated by Mary Caroline Richards. New York: Grove Press, 1958.

Bibliography

Ashmore, Patrick. *Maes Howe*. Edinburgh: Historic Buildings and Monuments, HMSO, 1988.

Auton, Clive, Terry Fletcher, and David Gould. *Orkney and Shetland: A Landscape Fashioned by Geology*. Redgorton: Scottish Natural Heritage/Edinburgh: British Geology Survey, 1996.

Bachelard, Gaston. *Water and Dreams: An Essay on the Imagination of Matter*. Translated by R. Farrell. Dallas, Tex.: Pegasus Foundation/Dallas Institute of Humanities and Culture, 2006.

Bachofen, J. J. *Myth, Religion, and Mother Right: Selected Writings of J. J. Bachofen*. Translated by Ralph Mannheim. Princeton, N.J.: Princeton University Press, 1992.

Badiou, Alain. *Deleuze: The Clamor of Being*. Translated by Louise Burchill. Minneapolis: University of Minnesota Press, 2000.

Bakhtin, Mikhail. *Rabelais and His World*. Translated by Hélène Iswolsky. Bloomington: Indiana University Press, 1984.

Banks, Mary Macleod. *British Calendar Customs: Scotland*. Volume 3. London: W. Glaischer for the Folklore Society, 1941.

Barba, Eugenio. *On Directing and Dramaturgy: Burning the House*. Translated by Judy Barba. London: Routledge, 2010.

———. *The Paper Canoe: A Guide to Theater Anthropology*. Translated by Richard Fowler. London: Routledge, 1995.

———. "Third Theater." In *Beyond the Floating Island*. Translated by Judy Barba, Richard Fowler, Jerrald C. Rodesch, and Saul Shapiro, 193–94. New York: Performing Arts Journal Publications, 1986.

Barnes, Michael. "Norse and Norn." In *Languages in Britain and Ireland*, edited by Glanville Proce, 171–83. Oxford: Blackwell, 2000.

———. "Orkney and Shetland Norn." In *Language in the British Isles*, edited by Peter Trudgill, 352–66. Cambridge: Cambridge University Press, 1984.

Barthes, Roland. "Authors and Writers." In *A Barthes Reader*, edited by Susan Sontag, 185–93. New York: Hill & Wang, 1982.

Barton, George A. "Tiamat." *Journal of the American Oriental Society* 15 (1893): 1–27.

Baudrillard, Jean. *Symbolic Exchange and Death*. Translated by Iain Hamilton Grant. London: Sage, 1993.

Baum, Robert M. "Reflections on a Sorcerer's Apprentice." *History of Religions* 29, no. 3 (1990): 297–99.

Beidelman, Thomas O. Review of *In Sorcery's Shadow: A Memoir of an Apprenticeship among the Songhay of Niger*, by Paul Stoller and Cheryl Olkes. *Ethnohistory* 36, no. 4 (1989): 438–40.

Benjamin, Walter. "The Storyteller: Reflections on the Works of Nikolai Leskov." In *Illuminations*, translated by Harry Zohn, edited by Hannah Arendt, 83–109. New York: Schocken Books, 1968.

Bennett, Jane. *Vibrant Matter: A Political Ecology of Things*. Durham, N.C.: Duke University Press, 2010.

Benveniste, Émile. *Problems of General Linguistics*. Translated by Mary Elizabeth Meek. Miami, Fla.: University of Miami Press, 1973.

Beplate, Justin. "Joyce, Bergson, and the Memory of Words." *Modern Language Review* 100, no. 2 (2005): 298–312.

Berg, Aase. *Transfer Fat*. Translated by Johannes Göransson. New York: Ugly Duckling Presse, 2012.

Bergson, Henri. *Creative Evolution*. Translated by Arthur Mitchell. Westport, Conn.: Greenwood Press, 1975.

———. *Duration and Simultaneity*. Translated by L. Jacobson. Indianapolis, Ind.: Bobbs-Merrill, 1965.

———. *Matter and Memory*. Translated by N. M. Paul and W. S. Palmer. New York: Zone Books, 1991.

———. *Philosophy of Poetry: The Genius of Lucretius*. Translated by Wade Baskin. New York: Philosophical Library, 1959.

———. *Time and Free Will*. Translated by F. L. Pogson. Eastford, Conn.: Martino Fine Books, 2015.

———. *The Two Sources of Morality and Religion*. Translated by R. Ashley Audra and Cloudesley Brereton. Notre Dame: University of Notre Dame Press, 1977.

Bessire, Lucas, and David Bond. "Ontological Anthropology and the Deferral of Critique." *American Ethnologist* 41, no. 3 (2014): 440–56.

Bianchi, Emanuela. *The Feminine Symptom: Aleatory Matter in the Aristotelian Cosmos*. New York: Fordham University Press, 2014.

Biehl, Joao, and Peter Locke. "Deleuze and the Anthropology of Becoming." *Current Anthropology* 51, no. 3 (2010): 317–51.

Bishop, John. *Joyce's Book of the Dark: "Finnegans Wake."* Madison: University of Wisconsin Press, 1993.

Blanchot, Maurice. *The Infinite Conversation*. Translated by Susan Hanson. Minneapolis: University of Minnesota Press, 1993.

Boas, Franz. *The Central Eskimo*. Lincoln: University of Nebraska Press, 1964.

———. *Kwakiutl Ethnography*. Edited by Helen Codere. Chicago: University of Chicago Press, 1966.

———. "The Limitations of the Comparative Method of Anthropology." *Science*, n.s., 4 (1896): 901–8.

Bogue, Ronald. *Deleuzian Fabulation and the Scars of History*. Edinburgh: Edinburgh University Press, 2010.

Bracken, Christopher. *The Potlatch Papers: A Colonial Case History*. Chicago: University of Chicago Press, 1997.

Brassier, Ray. *Nihil Unbound: Enlightenment and Extinction*. Basingstoke: Palgrave Macmillan, 2007.

Brown, George Mackay. *Beside the Ocean of Time*. 1994. Reprint, Edinburgh: Polygon, 2005.

Burkert, Walter. *Greek Religion: Archaic and Classical*. Translated by John Raffan. Oxford: Wiley Blackwell, 1985.

308 *Bibliography*

Butler, Judith. *Bodies That Matter: On the Discursive Limits of "Sex."* 1993. Reprint, New York: Routledge, 2011.

———. *Gender Trouble: Feminism and the Subversion of Identity.* New York: Routledge, 1990.

Bynum, Caroline Walker. *Metamorphosis and Identity.* New York: Zone Books, 2001.

Calasso, Roberto. *The Marriage of Cadmus and Harmony.* Translated by Tim Parks. London: Vintage Books, 1994.

Canetti, Elias. *Crowds and Power.* Translated by Carol Stewart. London: Penguin, 1992.

Castaneda, Carlos. *A Separate Reality: Further Conversatons with Don Juan.* New York: Washington Square Press, 1991.

Cavarero, Adriana. *In Spite of Plato: A Feminist Rewriting of Ancient Philosophy.* Translated by Anderlini D'Onofrio and Áine O'Healy. New York: Routledge, 1995.

Chia, Benny. "Frogtopia–Hongkornucopia: Reading Frog King Kwok." In Frog King Kwok and Hong Kong Arts Development Council, *Frogtopia Hongkornucopia*, 10–13.

Childe, V. Gordon. *Skara Brae: A Pictish Village in Orkney.* London: Kegan Paul, Trench, Trubner, 1931.

Childe, V. Gordon, and D. V. Clarke. *Skara Brae.* Edinburgh: HMSO, 1983.

Clark, Nigel. *Inhuman Nature: Sociable Life on a Dynamic Planet.* London: Sage, 2011.

Cleasby, Richard. *An Icelandic–English Dictionary. Initiated by Richard Cleasby, subsequently revised, enlarged, and completed by Gudbrand Vigfusson, M.A. Second Edition, with a supplement by Sir William A. Craigie, containing many additional words and references.* Oxford: Clarendon Press, 1957.

Clifford, James. "On Ethnographic Surrealism." In *The Predicament of Culture: Twentieth Century Ethnography, Literature and Art*, 117–51. Cambridge, Mass.: Harvard University Press, 1988.

Clifford, James, and George Marcus, eds. Preface to *Writing Culture: The Poetics and Politics of Ethnography*, vii–ix. Berkeley: University of California Press, 1986.

Codrington, R. H. *The Melanesians: Studies in their Anthropology and Folklore.* 1891. Reprint, New York: Dover, 1972.

Cohen, Jeffrey Jerome. *Of Giants: Sex, Monsters, and the Middle Ages.* Minneapolis: University of Minnesota Press, 1999.

Colebrook, Claire. *Death of the Posthuman: Essays on Extinction.* Ann Arbor, Mich.: Open Humanities Press, 2015.

———. *Deleuze and the Meaning of Life.* London: Continuum, 2010.

Comaroff, Jean. *Body of Power, Spirit of Resistance: The Culture and History of a South African People.* Chicago: University of Chicago Press, 1985.

Coole, Diana, and Samantha Frost, eds. *New Materialisms: Ontology, Agency, Politics.* Durham, N.C.: Duke University Press, 2010.

Cooper, J. C. *Symbolic and Mythological Animals.* London: Aquarian Press, 1992.

Bibliography

Corrington, Robert. *Ecstatic Naturalism: Signs of the World*. Bloomington: Indiana University Press, 1994.

Crapanzano, Vincent. "Hermes' Dilemma: The Masking of Subversion in Ethnographic Description." In *Writing Culture: The Poetics and Politics of Ethnography*, edited by James Clifford and George Marcus, 51–76. Berkeley: University of California Press, 1986.

———. *Imaginative Horizons: An Essay in Literary-Philsophical Anthropology*. Chicago: University of Chicago Press, 2004.

Creed, Gerald W. *Masquerade and Postsocialism: Ritual and Cultural Dispossession in Bulgaria*. Bloomington: Indiana University Press, 2011.

Cruwys, E. "Profile: Knud Rasmussen." *Polar Record* 26, no. 156 (1990): 27–33.

Daley, Stephanie, ed. and trans. *Myths from Mesopotamia*. Oxford: Oxford University Press, 1989.

Danaher, Kevin. *The Year in Ireland*. Cork: Mercier Press, 1972.

Davidson, Hilda R. Ellis. *Myths and Symbols in Pagan Europe: Early Scandinavian and Celtic Religions*. Syracuse, N.Y.: Syracuse University Press, 1988.

———. "Shape Changing in the Old Norse Sagas." In *A Lycanthropy Reader: Werewolves in Western Culture*, edited by Charlotte Otten, 142–60. Syracuse, N.Y.: Syracuse University Press, 1986.

———. "The Wild Hunt." In *Supernatural Enemies*, edited by Hilda Ellis Davidson and Anna Chaudhri, 163–76. Durham: University of North Carolina Press, 2001.

Davidson, James L. *The Chambered Cairns of Orkney: An Inventory of the Structures and Their Contents*. Edinburgh: Edinburgh University Press, 1989.

Deacon, Terrence W. *The Symbolic Species: The Co-evolution of Language and the Brain*. New York: Norton, 1998.

Debaene, Vincent. *Far Afield: French Anthropology between Science and Literature*. Translated by Justin Izzo. Chicago: University of Chicago Press, 2014.

Deleuze, Gilles. *Bergsonism*. Translated by Hugh Tomlinson and Barbera Hammerjam. New York: Zone Books, 1991.

———. *Cinema 1: The Movement Image*. Translated by Hugh Tomlinson and Barbara Habberjam. London: Athlone Press, 1986.

———. *Cinema 2: The Time Image*. Translated by Hugh Tomlinson and Robert Galeta. Minneapolis: University of Minnesota Press, 1989.

———. *Desert Islands and Other Texts, 1953–1974*. Translated by Mike Taomina. Edited by David Lapoujarde. Cambridge, Mass.: MIT Press, 2004.

———. *Difference and Repetition*. Translated by Paul Patton. New York: Columbia University Press, 1995.

———. *Essays Critical and Clinical*. Translated by Daniel W. Smith and Michael A. Gresco. Minneapolis: University of Minnesota Press, 1997.

———. *Expressionism in Philosophy: Spinoza*. Translated by Martin Joughin. New York: Zone Books, 1990.

———. *The Fold: Leibniz and the Baroque*. Translated by Tom Conley. New York: Continuum, 2006.

310 *Bibliography*

———. *The Logic of Sense*. Translated by Mark Lester. New York: Columbia University Press, 1990.

———. *Negotiations: 1972–1990*. Translated by Martin Joughin. New York: Columbia University Press, 1995.

———. *Nietzsche and Philosophy*. Translated by Hugh Tomlinson. London: Continuum, 1986.

———. *Pure Immanence: Essays on a Life*. Translated by Anne Boyman. New York: Zone Books, 2001.

Deleuze, Gilles, and Félix Guattari. *Kafka: Toward a Minor Literature*. Translated by Dana Polan. Minneapolis: University of Minnesota Press, 1986.

———. *A Thousand Plateaus: Capitalism and Schizophrenia*. Translated by Brian Massumi. Minneapolis: University of Minnesota Press, 1987.

———. *What Is Philosophy?* Translated by Graham Burchell and Hugh Tomlinson. London: Verso, 1994.

Demos, Raphael. "The Receptacle." *Philosophical Review* 45, no. 6 (1936): 535–57.

Dening, Greg. *Islands and Beaches: Discourse on a Silent Land: Marquesas, 1774–1880*. Honolulu: University of Hawaii Press, 1980.

Dennison, Walter Traill. *Orkney Folklore and Sea Legends: Studies of Traditional Life and Folklore*. Kirkwall, Scotland: Orkney Press, 1995.

Denzin, Norman. "Writing the Interpretive, Postmodern Ethnography" (review essay). *Journal of Contemporary Ethnography* 19, no. 2 (1990): 231–36.

Derrida, Jacques. "Khōra." In *On the Name*, 88–127. Translated by David Wood, John P. Leavey Jr., and Ian MacLeod. Stanford, Calif.: Stanford University Press, 1995.

———. "White Mythology: Metaphor in the Text of Philosophy." Translated by F. C. T. Moore. *New Literary History* 6, no. 1 (1974): 5–74.

Descola, Philippe. *Beyond Nature and Culture*. Translated by Janet Lloyd. Chicago: University of Chicago Press, 2013.

Detienne, Marcel. *Dionysos Slain*. Translated by Mireille Mueller and Leonard Mueller. Baltimore, Md.: Johns Hopkins University Press, 1979.

Detienne, Marcel, and Jean-Pierre Vernant. *Cunning Intelligence in Greek Culture and Society*. Translated by Janet Lloyd. Hassocks, Sussex: Harvester Press, 1978.

Dickens, Charles. *Our Mutual Friend*. New York: Oxford University Press, 2008.

Dolphijn, Rick, and Iris van der Tuin. *New Materialism: Interviews and Cartographies*. Ann Arbor, Mich.: Open Humanities Press, 2012.

Dosse, François. *Gilles Deleuze and Félix Guattari: Intersecting Lives*. Translated by Deborah Glassman. New York: Columbia University Press, 2010.

Douglas, Mary. *Purity and Danger: An Analysis of the Concepts of Pollution and Taboo*. London: Routledge and Keegan Paul, 1966.

Drever, John. "Papa Westray Games." *Proceedings of the Orkney Antiquarian Society* 1 (1922–23): 69–70.

Bibliography

Duerr, Hans Peter. *Dreamtime: Concerning the Boundary between Wilderness and Civilization*. Translated by Felicitas Goodman. Oxford: Basil Blackwell, 1985.

Dumézil, Georges. *Le problème des centaures: Étude de mythologie comparée indo-européenne*. Paris: P. Geuthner, 1929.

Durrenberger, E. Paul. "Sitting Buddha in a Mississippi Golf Course: Constructing Anthropology in Exotic and Familiar Settings." *Anthropology and Humanism* 16, no. 3 (1991): 88–94.

Einarsson, Niels. "From the Native's Point of View: Some Comments on the Anthropology of Iceland." *Antropologiska Studier* 46–47 (1990): 69–77.

Eisenstein, Sergei. "The Cinematic Principle and the Ideogram." In *Film Form: Essays in Film Theory*. Translated by Jay Leyda, 28–44. New York: Harcourt Brace, 1949.

El-Bizri, Nader. "*Qui Etes-vous Chōra?* Receiving Plato's *Timaeus*." *Existentia* 11 (2001): 473–90.

Eliade, Mircea. *The Myth of the Eternal Return*. Translated by Willard R. Trask. Princeton, N.J.: Princeton University Press, 1971.

Ellmann, Richard. *James Joyce*. New and rev. ed. New York: Oxford University Press, 1982.

Eriksen, Thomas Hylland. "In Which Sense Do Cultural Islands Exist?" *Social Anthropology* 1, no. 1b (1993): 132–47.

Eshleman, Clayton. *Juniper Fuse: Upper Paleolithic Imagination and the Construction of the Underworld*. Middletown, Conn.: Wesleyan University Press, 2003.

Ettinger, Bracha. *The Matrixial Borderspace*. Minneapolis: University of Minnesota Press, 2006.

Euripides. *The Bacchae and Other Plays*. Translated by Phillip Vellacott. London: Penguin, 1973.

Evans, Brad, and Aaron Glass, eds. *Return to the Land of the Headhunters: Edward S. Curtis, The Kwakwaka'wakw and the Making of Modern Cinema*. Seattle: Bill Holm Center for the Study of Northwest Coast Art, in collaboration with the University of Washington Press, 2014.

Evans, Michael Robert. *Isuma: Inuit Video Art*. Montreal: McGill–Queens University Press, 2008.

Evans-Pritchard, E. E. "Lévy-Bruhl's Theory of Primitive Mentality." 1934. Reprint, *Journal of the Anthropological Society of Oxford* 1, no. 2 (1970): 9–60.

———. *The Nuer: A Description of the Modes of Livelihood and Political Institutions of a Nilotic People*. 1940. Reprint, New York: Oxford University Press, 1969.

———. *Nuer Religion*. Oxford: Clarendon Press, 1956.

Fabian, Johannes. *Time and the Other: How Anthropology Makes Its Object*. New York: Columbia University Press, 1983.

Falck-Yatter, Harald. *Aurora: The Northern Lights in Mythology, History, and Science*. Translated by Robin Alexander. Edinburgh: Floris Books, 1999.

Fassin, Didier. "True Life, Real Lives: Revisiting the Boundaries between Etnography and Fiction." *American Ethnologist* 41, no. 1 (2014): 40–55.

Bibliography

Faubion, James D., and George E. Marcus, eds. *Fieldwork Is Not What It Used to Be: Learning Anthropology's Method in a Time of Transition.* Ithaca, N.Y.: Cornell University Press, 2009.

Favret-Saada, Jeanne. *Deadly Words: Witchcraft in the Bocage.* Translated by Catherine Cullen. Cambridge: Cambridge University Press, 1980.

Ferguson, David. *Shipwrecks of Orkney, Shetland, and the Pentland Firth.* Newton Abbot: David & Charles, 1988.

Fernandez, James. "Persuausions and Performances: Of the Beast in Every Body . . . And the Metaphors of Everyman." *Daedalus: Journal of the American Academy of Arts and Sciences* 101, no. 1 (1972): 39–60.

F for Fake. Orson Welles. France, Iran, West Germany, 1974.

Flaxman, Gregory. *Deleuze and the Fabulation of Philosophy. Powers of the False, Volume 1.* Minneapolis: University of Minnesota Press, 2012.

Focillon, Henri. *The Life of Forms in Art.* Translated by George Kubler. New York: Zone Books, 1992.

Forbes Irving, P. M. C. *Metamorphosis in Greek Myths.* 1990. Reprint, Oxford: Clarendon Press, 2002.

Fortune, R. F. *Sorcerers of Dobu: The Social Anthropology of the Dobu Islanders of the Western Pacific.* 1932. Reprint, London: Routledge, 2004.

Foucault, Michel. *The Order of Things: An Archaeology of the Human Sciences.* New York: Vintage Books, 1994.

Fowler, Chris, and Vicky Cummings. "Places of Transformation: Building Monuments from Water and Stone in the Neolithic of the Irish Sea." *Journal of the Royal Anthropological Institute* 9, no. 1 (2003): 1–20.

Fraser, Nancy. *Revaluing French Feminism: Essays on Difference, Gender, and Culture.* Bloomington: Indiana University Press, 1992.

Frazer, James George. *The Golden Bough.* 3rd edition. Part 6. *The Scapegoat.* London: Macmillan, 1980.

———. *The Golden Bough: A Study in Magic and Religion, Part 1.* New York: Macmillan, 1950.

Fréger, Charles. *Wilder Mann: The Image of the Savage.* Stockport: Dewi Lewis, 2014.

Freud, Sigmund. "A Difficulty in the Path of Psychoanalysis." In *The Standard Edition of the Complete Psychological Works of Sigmund Freud,* edited by James Strachey, 17:135–44. New York: Penguin, 2001.

———. "Female Sexuality." In *The Standard Edition of the Complete Psychological Works of Sigmund Freud,* edited by James Strachey and Anna Freud, 21:223–43. London: Hogarth Press, 1961.

———. *The Interpretation of Dreams.* Oxford: Oxford University Press, 1999.

———. "The Uncanny." In *The Standard Edition of the Complete Psychological Works of Sigmund Freud,* edited by James Strachey, 17:217–56. London: Hogarth Press, 1955.

Frog King Kwok and Hong Kong Arts Development Council. *Frogtopia Hongkornucopia: Kwok Mang-ho (a.k.a. Frog King).* La Biennale di Venezia 54th International Art Exhibition. Hong Kong: Hong Kong Arts Development Council, 2011.

Bibliography

Geertz, Clifford. *The Interpretation of Cultures*. New York: Basic Books, 1973.

———. *Works and Lives: The Anthropologist as Author*. Stanford, Calif.: Stanford University Press, 1988.

Gilberg, Rolf. "Profile: Knud Rasmussen, 1879–1933." *Polar Record* 22, no. 137 (1984): 169–71.

Goldman, Irving. *The Mouth of Heaven: An Introduction to Kwakiutl Religious Thought*. New York: Wiley, 1975.

Göransson, Johannes. "Ambient Translations: Transferring Aase Berg's Fat." Translated by Johannes Göransson. In Asse Berg, *Transfer Fat*. New York: Ugly Duckling Presse, 2012.

Graeber, David. *Debt: The First 5000 Years*. New York: Melville House, 2014.

Granet, Marcel. *The Religion of the Chinese People*. Translated by Maurice Freedman. 1922. Reprint, New York: Harper & Row, 1975.

Grant, Iain Hamilton. *Philosophies of Nature after Schelling*. London: Continuum, 2006.

Grosz, Elizabeth. *Chaos, Territory, Art: Deleuze and the Framing of the Earth*. New York: Columbia University Press, 2008.

———. *The Nick of Time: Politics, Evolution and the Untimely*. Durham, N.C.: Duke University Press, 2004

Gunnell, Terry. "Grýla, Grýlur, 'Grøleks,' and Skeklers." *Arv: Nordic Yearbook of Folklore* 57 (2001): 33–54.

———. "Masks and Mumming Traditions in the North Atlantic." In *Masks and Mumming in the Nordic Area*, edited by Terry Gunnell, 275–326. Uppsala: Kungl. Gustav Adolfs Akademien för svensk folkkultur, 2007.

———. *The Origins of Drama in Scandinavia*. Cambridge: D. S. Brewer, 1995.

Hacquebord, Louwrens. "'There She Blows': A Brief History of Whaling." In *Whaling Communities*, edited by Elizabeth Verstergaard. *North Atlantic Studies* 2, no. 1–2 (1989): 11–20.

Hage, Ghassan. *Alter-Politics: Critical Anthropology and the Radical Imagination*. Melbourne: Melbourne University Press, 2015.

Hallward, Peter. *Out of This World: Deleuze and the Philosophy of Creation*. London: Verso, 2006.

Hamilton-Paterson, James. *Seven Tenths: The Sea and Its Thresholds*. London: Faber & Faber, 2007.

Haraway, Donna. *Staying with the Trouble: Making Kin in the Chthulucene*. Durham, N.C.: Duke University Press, 2016.

———. *When Species Meet*. Minneapolis: University of Minnesota Press, 2008.

Harrison, Jane Ellen. *Prolegomena to the Study of Greek Religion*. 3rd ed. Princeton, N.J.: Princeton University Press, 1989.

———. *Themis: A Study of the Social Origins of Greek Religion*. Cambridge: Cambridge University Press, 1927.

Harrison, Robert Pogue. *Forests: The Shadow of Civilization*. Chicago: University of Chicago Press, 1994.

Hastrup, Kirsten. *Action: Anthropology in the Company of Shakespeare*. Copenhagen: Museum Tusculanum Press, 2004.

———. "The Challenge of the Unreal, or How Anthropology Comes to Terms with Life." *Culture and History* 1 (1987): 50–62.

———. *Culture and History in Medieval Iceland*. Oxford: Clarendon Press, 1985.

———. "Knud Rasmussen (1879–1933): The Anthropologist as Explorer, Hunter and Narrator." *Folk: The Journal of the Danish Ethnographic Society* 46, no. 7 (2004–5): 159–80.

———. "Out of Anthropology: The Anthropologist as Object of Dramatic Representation." *Cultural Anthropology* 7, no. 3 (1992): 327–45.

———. *A Passage to Anthropology: Between Experience and Theory*. London: Routledge, 1995.

———. *A Place Apart: An Anthropological Study of the Icelandic World*. Oxford: Clarendon Press, 1998.

Hechter, Michael. *Internal Colonialism: The Celtic Fringe in British National Development*. Berkeley: University of California Press, 1975.

Hedges, John W. *Tomb of the Eagles: A Window on Stone Age Tribal Britain*. London: John Murray, 1984.

Heidegger, Martin. "Building, Dwelling, Thinking." In *Basic Writings: From Being and Time* (1927) *to The Task of Thinking* (1964), edited by David Farrell Krell, 323–39. New York: Harper & Row, 1977.

Henrichs, Albert. "Loss of Self, Suffering, Violence: The Modern View of Dionysus from Nietzsche to Girard." *Harvard Studies in Classical Philology* 88 (1984): 205–40.

Henshall, Audrey. "The Chambered Cairns." In *The Prehistory of Orkney*, edited by Colin Renfrew, 83–117. Edinburgh: Edinburgh University Press, 1984.

Heraclitus. *Fragments*. Translated by T. M. Robinson. Toronto: University of Toronto Press, 1974.

Hertz, Robert. *Death and the Right Hand*. Translated by Rodney and Claudia Needham. 1907. Reprint, Glencoe, Ill.: Free Press, 1960.

Hesiod. *Theogony/Works and Days*. Translated by M. L. West. Oxford: Oxford University Press, 1988.

Holbraad, Martin. *Truth in Motion: The Recursive Anthropology of Cuban Divination*. Chicago: University of Chicago Press, 2012.

Hole, Christina. *Christmas and Its Customs*. London: Richard Bell, 1958.

Homer. *The Odyssey*. Translated by Walter Shewring. Oxford: Oxford University Press, 1998.

Horkheimer, Max, and Theodor W. Adorno. *Dialectic of Enlightenment*. Translated by Elmund Jephcott. Stanford, Calif.: Stanford University Press, 2002.

Hornblower, Simon, and Antony Spawforth. *The Oxford Classical Dictionary*. 3rd rev. ed. Oxford: Oxford University Press, 2003.

Huldufólk 102. Film. Directed by Nisha Inalsingh. Iceland/United States, 2006.

Humphrey, Caroline. "Chiefly and Shamanist Landscapes in Mongolia." In *The Anthropology of Landscape: Perspectives on Space and Place*, edited by Eric Hirsch and Michael O'Hanlon, 135–62. Oxford: Clarendon Press, 1995.

Hutton, Ronald. *Stations of the Sun: A History of the Ritual Year in Britain*. Oxford: Oxford University Press, 1995.

Hyde, Lewis. *Trickster Makes This World: Mischief, Myth and Art*. New York: Farrar, Straus and Giroux, 1995.

Ingold, Tim. *Being Alive: Essays on Movement, Knowledge, and Description*. London: Routledge, 2011.

———. *The Life of Lines*. London: Routledge, 2015.

———. "That's Enough about Ethnography." *Hau: A Journal of Ethnographic Theory* 4, no. 1 (2014): 383–95.

Irigaray, Luce. *Marine Lover of Friedrich Nietzsche*. Translated by Gillain C. Gill. New York: Columbia University Press, 1991.

Jackson, Michael. *Paths toward a Clearing: Radical Empiricism and Ethnographic Inquiry* Bloomington: Indiana University Press, 1989.

———. Review of *In Sorcery's Shadow: A Memoir of an Apprenticeship among the Songhay of Niger*, by Paul Stoller and Cheryl Olkes. *American Ethnologist* 15, no. 2 (1988): 390–91.

Jakobsen, Jakob. *An Etymological Dictionary of the Norn Language in Shetland*. 1928–32. Reprint, Lerwick: Shetland Folk Society, 1985.

Jakobsen, Thorkild. "The Battle between Marduk and Tiamat." *Journal of the American Oriental Society* 88, no. 1 (1966): 104–8.

Jakobson, Roman. "Two Aspects of Language and Two Types of Aphasic Disturbances." In *On Language*, edited by Linda R. Waugh and Monique Monville-Burson, 115–33. Cambridge, Mass.: Harvard University Press, 1989.

Jennings, Andrew. "The Giantess as Metaphor for Shetland's Cultural History." *Shima: The International Journal for Research into Island Cultures* 4, no. 2 (2010): 1–14.

Journals of Knud Rasmussen, The. Norman Cohn, Zacharias Kunuk. Canada, Denmark, and Greenland, 2006.

Joyce, James. *Dubliners*. Dublin: Lilliput Press, 1992.

———. *Finnegans Wake*. London: Faber & Faber, 1975.

———. *Ulysses*. Dublin: Lilliput Press, 1997.

Joyce, Stanislaus. *Recollections of James Joyce*. New York: James Joyce Society, 1950.

Kafka, Franz. *The Complete Stories*. Translated by Nahum N. Glatzer. New York: Schocken Books, 1983.

Kapferer, Bruce. "Ritual Dynamics and Virtual Practice: Beyond Representation and Meaning." In *Ritual in Its Own Right: Exploring the Dynamics of Transformation*, edited by Don Handelman and Galina Lindquist, 35–54. Oxford: Berghahn Books, 2005.

Karlsson, Gunnar. *Iceland's 1100 Years: The History of a Marginal Society*. London: C. Hurst, 2000.

Keane, Webb. *Christian Moderns: Freedom and Fetish in the Mission Encounter*. Berkeley: University of California Press, 2007.

Kelleher, John V. "Irish History and Mythology in James Joyce's "The Dead." *Review of Politics* 27, no. 3 (1965): 414–33.

Keller, Catherine. *The Face of the Deep: A Theology of Becoming*. New York: Routledge, 2003.

Kerényi, Karl. *Dionysus: Archetypal Image of Indestructible Life*. Translated by Ralph Mannheim. Princeton, N.J.: Princeton University Press, 1996.

———. "The Trickster in Relation to Greek Mythology." In *The Trickster: A Study in American Indian Mythology*, edited by Paul Radin, 173–91. New York: Schocken Books, 1972.

Kimpel, Ben D., and T. C. Duncan Eaves. "Pound's 'Ideogrammatic Method' as Illustrated in Canto XCIX." *American Literature* 5, no. 2 (1979): 205–37.

Kofman, Sarah. *Freud and Fiction*. Translated by Sarah Wykes. Boston: Northeastern University Press, 1990.

———. *Nietzsche and Metaphor*. Translated by Duncan Large. Stanford, Calif.: Stanford University Press, 1989.

Kohn, Eduardo. *How Forests Think: Toward an Anthropology beyond the Human*. Berkeley: University of California Press, 2013.

Kristeva, Julia. *Desire in Language: A Semiotic Approach to Literature and Art*. Translated by Leon S. Roudiez. New York: Columbia University Press, 1980.

———. *Powers of Horror: An Essay on Abjection*. Translated by Leon S. Roudiez. New York: Columbia University Press, 1982.

———. *Revolution in Poetic Language*. Translated by Leon S. Roudiez. New York: Columbia University Press, 1984.

Kwok, Mang-ho. "Artistic Concept and Artist Biography." In Frog King Kwok and Hong Kong Arts Development Council, *Frogtopia Hongkornucopia*, 6–8.

Lakoff, George, and Mark Johnson. *Metaphors We Live By*. 1980. Reprint, Chicago: University of Chicago Press, 2003.

Langer, Susanne. *Feeling and Form*. London: Routledge and Keegan Paul, 1951.

———. *Philosophy in a New Key*. Cambridge, Mass.: Harvard University Press, 1942.

Larrington, Carolyne, trans. and ed. *The Poetic Edda*. Oxford: Oxford University Press, 1966.

Latour, Bruno. "From Realpolitik to Dingpolitik: How to Make Things Public." In *Making Things Public: Atmospheres of Democracy*, edited by Bruno Latour and Peter Weibel, 4–30. Cambridge, Mass.: MIT Press, 2005.

———. "Perspectivism: 'Type' or 'Bomb'?" *Anthropology Today* 25, no. 2 (2009): 1–3.

———. *Reassembling the Social: An Introduction to Actor-Network Theory*. New York: Oxford University Press, 2005.

———. *We Have Never Been Modern*. Translated by Catherine Porter. Cambridge, Mass.: Harvard University Press, 1993.

Lawson, John Cuthbert. *Modern Greek Folklore and Ancient Greek Religion*. Cambridge: Cambridge University Press, 1910.

Ledger, Adam J. *Odin Teatret: Theater in a New Century*. New York: Palgrave Macmillan, 2012.

Leiris, Michel. *L'Afrique fantôme*. Paris: Gallimard, 1988.

Bibliography

Lévi-Strauss, Claude. *The Elementary Structures of Kinship*. Translated by James Harle Bell and John Richard von Sturmer. Boston: Beacon Press, 1969.

———. *Tristes Tropiques*. Translated by John Weightman and Doreen Weightman. London: Penguin, 2012.

Lévi-Strauss, Claude, and Didier Eribon. *Conversations with Claude Lévi-Strauss*. Translated by Paula Wissing. Chicago: University of Chicago Press, 1991.

Lévy-Bruhl, Lucien. *Primitive Mythology: The Mythic World of the Australian and Papuan Natives*. Translated by Brian Elliott. 1935. Reprint, St. Lucia: Queensland University Press, 1983.

Lewis-Williams, David, and Thomas A. Dowson. "Through the Veil: San Rock Paintings and the Rock Face." *South African Archaeological Bulletin* 45, no. 151 (1990): 5–16.

Lippard, Lucy R. *Mixed Blessings: New Art in a Multicultural America*. New York: Pantheon Books, 1989.

Lispector, Clarice. *Agua Viva*. Translated by Stefan Tobler. New York: New Directions, 2010.

Lorig, Carrie. *The Pulp vs. the Throne*. Chicago: Artifice Books. 2015.

Lovecraft, H. P. *Best Supernatural Stories of H. P. Lovecraft*. New York: World, 1945.

Lovelock, James. *Gaia: A New Look at Life on Earth*. Oxford: Oxford University Press, 2016.

Lowenthal, David. "Islands, Lovers and Others." *Geographical Review* 97, no. 2 (2007): 202–29.

Lucretius. *On the Nature of the Universe*. Translated by R. E. Latham. London: Penguin, 2005.

MacKillop, James. *A Dictionary of Celtic Mythology*. Oxford: Oxford University Press, 2004.

MacNeill, Maire. "Wayside Death Cairns in Ireland." *Béaloideas* 16 (1946): 49–63.

The Madrigal of the Explosion of the Wise Whale. Filippos Tsitsopoulos. Four-channel video installation. Germany, Greece, Spain, United Kingdom, 2010.

Magnus, Olaus. *Description of the Northern Peoples*. Vol. 3. Translated by Peter Fischer and Humphrey Higgens. Edited by Peter Foote. London: Hakluyt Society, 1998.

Malinowski, Bronislaw. *Argonauts of the Western Pacific: An Account of Native Enterprise and Adventure in the Archipelagoes of Melanesian New Guinea*. 1922. Reprint, Prospect Heights: Waveland Press, 1984.

Marcus, George E. "The Modernist Sensibility in Recent Ethnographic Writing and the Cinematic Metaphor of Montage." In *Visualising Theory: Selected Essays from V.A.R., 1990–1994*, edited by Lucien Taylor, 37–53. London: Routledge, 1994.

Margaroni, Maria. "'The Lost Foundation': Kristeva's Semiotic Chora and Its Ambiguous Legacy." *Hypatia* 20, no. 1 (2005): 78–98.

Marrett, R. R. "Pre-Animistic Religion." *Folklore* 11, no. 2 (1900): 162–84.

Bibliography

Marwick, Ernest. "Creatures of Orkney Legend and Their Norse Ancestry." In *An Orkney Anthology: The Selected Works of Ernest Walker Marwick*, edited by John D. M. Robertson, 257–78. Edinburgh: Scottish Academic Press.

———. *The Folklore of Orkney and Shetland.* 1975. Reprint, Edinburgh: Birlinn, 2000.

Marwick, Hugh. *The Orkney Norn.* Oxford: Oxford University Press, 1929.

Massumi, Brian. *Parables for the Virtual: Movement, Affect, Sensation.* Durham, N.C.: Duke University Press, 2002.

Mauss, Marcel. *A General Theory of Magic.* Translated by Robert Brain. New York: Routledge, 2001.

McAfee, Nöelle. *Julia Kristeva.* London: Routledge, 2004.

McKibben, Bill. *The End of Nature.* New York: Random House, 1989.

McLean, Athena, and Annette Liebling, eds. *The Shadow Side of Fieldwork: Exploring the Blurred Borders between Ethnography and Life.* Oxford: Wiley Blackwell, 2007.

McLean, Stuart. *The Event and Its Terrors: Ireland, Famine, Modernity.* Stanford, Calif.: Stanford University Press, 2004.

———. "Stories and Cosmogonies: Imagining Creativity beyond 'Nature' and 'Culture.'" *Cultural Anthropology* 24, no. 2 (2009): 213–45.

McLuhan, Eric. *The Role of Thunder in "Finnegans Wake."* Toronto: University of Toronto Press, 1997.

Meillasoux, Quentin. *After Finitude: An Essay on the Necessity of Contingency.* Translated by Ray Brassier. London: Continuum, 2008.

Meletinskij, Eleazar. "Scandinavian Mythology as a System (1)." *Journal of Symbolic Anthropology* 1 (1973): 45–57.

Melville, Herman. *Moby-Dick.* New York: Norton, 2002.

Merkur, Daniel. *Powers Which We Do Not Know: The Gods and Spirits of the Inuit.* Moscow: University of Idaho Pres, 1991.

Miller, William. Review of Kirsten Hastrup's *Culture and History in Medieval Iceland: An Anthropological Analysis of Structure and Change. Scandinavian Studies* 58, no. 2 (1986): 183–86.

Milošević, Dijana. "'Big Dreams': An Interview with Eugenio Barba." *Contemporary Theater Review* 16, no. 3 (2006): 291–95.

Ming, Fay. "Tadpole to Frog King." In Frog King Kwok and Hong Kong Arts Development Council, *Frogtopia Hongkornucopia*, 30–33.

Mirrie Dancers. Nayan Kulkarni, Roxane Permar, Shetland Community Arts. Community artwork involving light projections onto buildings and archeological monuments. United Kingdom, 2010.

Mooney, James. *The Cathedral and Royal Burgh of Kirkwall.* Kirkwall, Scotland: W. R. Mackintosh, 1947.

Morris, Christopher. "Viking Orkney: A Survey." In *The Prehistory of Orkney: BC 4000–1000 AD*, edited by Colin Renfrew, 210–42. Edinburgh: Edinburgh University Press, 1985.

Morton, Timothy. *The Ecological Thought*. Cambridge, Mass.: Harvard University Press, 2010.

———. *Ecology without Nature: Rethinking Environmental Aesthetics*. Cambridge, Mass.: Harvard University Press, 2007.

Moss, Sarah. *Names for the Sea: Strangers in Iceland*. Berkeley, Calif.: Counterpoint, 2012.

Mother. Genetic Moo. Code-driven, generative video installation, using digital photographs and video. United Kingdom, 2011.

Motz, Lotte. "Giants in Folklore and Mythology: A New Approach." *Folklore* 93, no 1 (1982): 70–84.

Mousalmas, S. A. "The Concept of Participation in Lévy-Bruhl's 'Primitive Mentality.'" *Journal of the Anthropological Society of Oxford* 21, no. 1 (1990): 33–46.

Muldoon, Paul. *To Ireland, I: An Abecdiary of Irish Literature*. London: Faber & Faber, 2000.

Nance, R. D., T. R. Worsley, and J. B. Moody. "The Supercontinent Cycle." *Scientific American* 259, no. 1 (1988): 72–79.

Nancy, Jean-Luc. *Adoration: The Deconstruction of Christianity II*. Translated by John McKeane. New York: Fordham University Press, 2013.

———. *The Birth to Presence*. Translated by Brian Holmes. Stanford, Calif.: Stanford University Press, 1993.

Näsström, Britt-Mari. *Freyja: The Great Goddess of the North*. Lund: Department of History of Religions, University of Lund, 1995.

Negarestani, Reza. *Cyclonopedia: Complicity with Anonymous Materials*. Melbourne: re.press, 2008.

The New English Bible with the Apocrypha. New York: Oxford University Press, 1971.

Nietzsche, Friedrich. *"The Birth of Tragedy" and Other Writings*. Translated by Ronald Speiers. Cambridge: Cambridge University Press, 1999.

———. *The Dionysian Vision of the World*. Translated by Ira J. Allen. Minneapolis, Minn.: Univocal, 2013.

———. *On the Genealogy of Morals*. Translated by Walter Kaurfmann. New York: Vintage Books, 1989.

———. "On Truth and Lie in a Nonmoral Sense." In *Philosophy and Truth: Selections from Nietzsche's Notebooks of the Early 1870s*, edited by Daniel Breazeale, 79–97. Hassocks, Sussex: Harvester Press, 1979.

———. *Philosophy in the Tragic Age of the Greeks*. Translated by Marianne Cowan. Washington, D.C.: Regenery, 1998.

Nin, Anaïs. *The Diary of Anaïs Nin. Volume 1: 1931–1934*. New York: Swallow Press and Harcourt, Brace and World, 1966.

Ocean, Ocean. Þorbjörg Jónsdóttir. Film/Video MFA, California Institute for the Arts, 2009.

Ochoa, Todd Ramón. *Society of the Dead: Quita Manaquita and Palo Praise in Cuba*. Berkeley: University of California Press, 2010.

320 *Bibliography*

———. "Versions of the Dead: Kalunga, Cuban-Kongo Materiality and Ethnography." *Cultural Anthropology* 22, no. 4 (2007): 473–500.

O'Donoghue, Heather. *From Asgard to Valhalla: The Remarkable History of the Norse Myths.* London: I. B. Tauris, 2007.

Orchard, Andy. *Dictionary of Norse Myth and Legend.* London: Cassell, 1995.

Otto, Rudolf. *The Idea of the Holy.* Translated by John W. Harvey. Oxford: Oxford University Press, 1950.

Otto, Walter. *Dionysus: Myth and Cult.* Translated by Robert B. Palmer. Bloomington: Indiana University Press, 1965.

Ovid. *Metamorphoses.* Translated by Charles Martin. New York: Norton, 2005.

Pálsson, Gísli. *The Textual Life of Savants: Ethnography, Iceland, and the Linguistic Turn.* Chur, Switzerland: Harwood Academic, 1995.

Pálsson, Hermann, and Paul Edwards. *The Book of Settlements: Landnámabók.* Translated by Hermann Pálsson and Paul Edwards. Winnipeg: University of Manitoba Press, 2007.

———. *Orkneyinga Saga: The History of the Earls of Orkney.* Translated by Hermann Pálsson and Paul Edwards. London: Penguin, 1981.

Pandian, Anand, and Stuart McLean eds. *Crumpled Paper Boat: Experiments in Ethnographic Writing.* Durham, N.C.: Duke University Press.

Papataxiarchis, Evthymios. "From 'National' to 'Social' Science: Politics, Ideology, and Disciplinary Formation in Greek Anthropology from the 1940s till the 1980s." In *The Anthropological Field on the Margins of Europe*, edited by Aleksander Bošković and Chris Hann, 30–63. Zurich: Lit Verlag, 2013.

Parikka, Jussi. *A Geology of Media.* Minneapolis: University of Minnesota Press, 2015.

Parker, Robert. *Polytheism and Society at Athens.* Oxford: Oxford University Press, 2007.

Pasolini, Pier Paolo. "The 'Cinema of Poetry.'" In *Heretical Empiricism.* Translated by Ben Lawton and Louise K. Barnett, 167–86. Washington, D.C.: New Academic, 2005.

Peirce, Charles Sanders. *Philosophical Writings of Peirce.* Edited by Justus Buchler. New York: Dover, 2011.

Pickard-Cambridge, Arthur W. *The Dramatic Festival of Athens.* Oxford: Clarendon Press, 1968.

Plato. *"Timaeus" and "Critias."* Translated by Robin Waterfield. Oxford: Oxford University Press, 2008.

Pound, Ezra. *The Cantos of Ezra Pound.* New York: New Directions, 1990.

Povinelli, Elizabeth A. *Economies of Abandonment: Social Belonging and Endurance in Late Liberalism.* Durham, N.C.: Duke University Press, 2011.

———. *Geontologies: A Requiem to Late Liberalism.* Durham, N.C.: Duke University Press, 2016.

Pred, Allan. *Recognizing European Modernities: A Montage of the Present.* London: Routledge, 1995.

Bibliography

Prigogine, Ilya, and Isabelle Stengers. *Order Out of Chaos: Man's New Dialogue with Nature.* London: Heinemann, 1984.

Protevi, John. *Political Physics: Deleuze, Derrida and the Body Politic.* New York: Athlone Press, 2001.

Proulx, Jean Pierre. *Whaling in the North Atlantic: From Earliest Times to the Mid 19th Century.* Ottawa: National Historic Parks and Sites Branch, Parks Canada, Environment Canada, 1986.

Puhvel, Martin. "The Mighty She-Trolls of Icelandic Saga and Folktale." *Folklore* 98, no. 2 (1987): 175–79.

———. "The Seal in the Folklore of Northern Europe." *Folklore* 74, no. 1 (1963): 326–33.

Rabinow, Paul. "Discourse and Power: On the Limits of Ethnographic Texts." *Dialectical Anthropology* 10, no. 1/2 (1985): 113.

Radin, Paul. *The Trickster: A Study in American Indian Mythology.* 1956. Reprint, New York: Schocken Books, 1988.

Raffles, Hugh. *Insectopedia.* New York: Vintage Books, 2010.

Rasmussen, Knud. *Across Arctic America: Narrative of the Fifth Thule Exhibition.* 1927. Reprint, Fairbanks: University of Alaska Press, 1999.

———. *The Alaskan Eskimos: As Described in the Posthumous Notes of Dr. Knud Ramsussen. Report of the Fiftth Thule Expedition, 1921–1924.* Edited by H. Ostermann. New York: AMS Press, 1952.

———. *Intellectual Culture of the Copper Eskimos. Report of the Fifth Thule Expedition, 1921–14.* Vol. 9. Copenhagen: Gyldendalske Boghandel, Nordisk Forlag, 1932.

———. *Intellectual Culture of the Iglulik Eskimos: Report of the Fifth Thule Expedition, 1921–1924.* Vol. 7, no. 2. Copenhagen: Gyldendalske Boghandel, Nordisk Forlag, 1929.

Rendall, Jim. *A Papay Life.* Peterborough: Remus House.

Renfrew, Colin, ed. *The Prehistory of Orkney.* Edinburgh: Edinburgh University Press, 1993.

Ricoeur, Paul. *The Rule of Metaphor: The Creation of Meaning in Language.* Translated by Robert Czerny with Kathleen McLaughlin and John Costello. New York: Routledge, 2003.

Ritchie, Anna. "First Settlers." In *The Prehistory of Orkney,* edited by Colin Renfrew, 36–53. Edinburgh: Edinburgh University Press, 1984.

Rohdie, Sam. *Montage: Cinema Aesthetics.* Manchester: Manchester University Press, 2007.

Sahlins, Marshall. *Islands of History.* Chicago: University of Chicago Press, 1985.

Sallis, John. *Chorology: Of Beginning in Plato's "Timaeus."* Bloomington: Indiana University Press, 1999.

Schechner, Richard. "Collective Reflexivity: Restoration of Behavior." In *A Crack in the Mirror: Reflexive Perspectives in Anthropology,* edited by Jay Ruby, 39–82. Philadelphia: University of Pennsylvania Press, 1982.

Scherman, Katharine. *Iceland: Daughter of Fire.* London: Gollancz, 1976.

Bibliography

Schippers, Birgit. *Julia Kristeva and Feminist Thought*. Edinburgh: Edinburgh University Press, 2011.

Schneider, Jane. "Spirits and the Spirit of Capitalism." In *Religious Regimes and State Formation: Perspectives from European Ethnology*, edited by Eric R. Wolf. 181–220. Albany: State University of New York Press, 1991.

Scudder, Bernard. *The Saga of Grettir the Strong*. London: Penguin, 2005.

Scullion, Scott. "Nothing to Do with Dionysus: Tragedy Misconceived as Ritual." *Classical Quarterly* 52 (2002): 102–37.

Senn, Harry A. "Romanian Werewolves: Seasons, Ritual, Cycles." *Folklore* 93, no. 2 (1982): 206–15.

Seremetakis, C. Nadia. *The Last Word: Women, Death, and Divination in Inner Death, and Mani*. Chicago: University of Chicago Press, 1991.

Serres, Michel. *The Birth of Physics*. Translated by Jack Hawkes. Edited by David Webb. Manchester: Clinamen Press, 2000.

———. *The Troubadour of Knowledge*. Translated by Sheila Faria Glaser and William Paulson. Ann Arbor: University of Michigan Press, 1997.

Serres, Michel, and Bruno Latour. *Conversations on Science, Culture, and Time*. Translated by R. Lapidus. Ann Arbor: University of Michigan Press, 1995.

Shakespeare, William. *Hamlet*. New York: Norton, 1963.

Shoemaker, David. "Report from Holstebro: Odin Teatret's 'Talabot.'" *New Theater Quarterly* 6, no. 24 (1990): 307–17.

Sidimus, Joysanne. *Reflections in a Dancing Eye: Investigating the Artist's Role in Canadian Society*. Banff: Banff Center Press, 2004.

Silverstein, Michael. "Shifters, Linguistic Categories, and Cultural Description." In *Meaning in Anthropology*, edited by Keith Basso and Henry A. Selby, 11–53. Albuquerque: University of New Mexico Press, 1979.

Simon, Erika. *Festivals of Attica: An Archaeological Commentary*. Madison: University of Wisconsin Press, 1983.

Simpson, Jacqueline, and Jón Árnason. *Icelandic Folktales and Legends*. Berkeley: University of California Press, 1972.

Simpson, Jacqueline, and Steve Roud. *A Dictionary of English Folklore*. Oxford: Oxford University Press, 2000.

Smith, John B. "Perchta the Belly-Slitter and Her Kin: A View of Some Traditional Threatening Figures." *Folklore* 115, no. 2 (2004): 167–86.

Söderblom, Nathan. *The Living God: Basal Forms of Personal Religion 1. Gifford Lectures, 1931*. Oxford: Oxford University Press, 1933.

Sonne, Birgitte. "In Love with Eskimo Imagination and Intelligence." *Études/Inuit/Studies* 12, no. 1–2 (1988): 21–44.

Spenser, Edmund. *A View of the Present State of Ireland*. London: E. Partridge at the Scholartis Press, 1934.

Spinoza, Baruch. *The Ethics. Treatise on the Emendation of the Intellect. Selected Letters*. Translated by Samuel Shirley. Indianapolis, Ind.: Hackett, 1992.

Spivak, Gayatri. "Can the Subaltern Speak?" In *Colonial Discourse and Postcolonial Theory: A Reader*, edited by Patrick Williams and Laura Chrisman, 66–111. New York: Columbia University Press.

Bibliography

Starn, Orin, ed. *Writing Culture and the Life of Anthropology*. Durham, N.C.: Duke University Press, 2015.

Stefánsson, Halldór. Review of Kirsten Hastrup's *Island of Anthropology*. *Ethnos* 3–4 (1992): 345–68.

Stengers, Isabelle. *Power and Invention: Situating Science*. Translated by Paul Bains. Minneapolis: University of Minnesota Press, 1997.

Stewart, Kathleen. *Ordinary Affects*. Durham, N.C.: Duke University Press, 2007.

Stocking, George W. *After Tylor: British Social Anthropology, 1855–1951*. Madison: University of Wisconsin Press, 1966.

————. *The Ethnographer's Magic and Other Essays in the History of Anthropology*. Madison: University of Wisconsin Press, 1992.

Stoller, Paul. "Eye, Mind, and Word in Anthropology." *L'Homme* 24, no. 3–4 (1984): 91–114.

————. *Fusion of the Worlds: An Ethnography of Possession among the Songhay of Niger*. Chicago: University of Chicago Press, 1989.

Stoller, Paul, and Cheryl Olkes. *In Sorcery's Shadow: A Memoir of an Apprenticeship among the Songhay of Nigeria*. Chicago: University of Chicago Press, 1987.

Strathern, Marilyn. *Partial Connections*. 1991. Reprint, Berkeley, Calif.: Altamira Press, 2004.

Sturluson, Snorri. *Prose Edda: Tales from Norse Mythology*. Translated by Arthur Gilchrist Brodeur. New York: Dover, 2004.

Szabo, Vicki Ellen. *Monstrous Fishes and the Mead-Dark Sea: Whaling in the Medieval North Atlantic*. Leiden: Brill, 2008.

Talabot. Eugenio Barba, Odin Teatret. Theatrical production. Austria, Chile, Denmark, France, Germany, Hungary, Italy, Norway, Peru, Poland, Sweden, Switzerland, Wales, Yugoslavia; 279 performances from August 1988 to October 1991.

Tarlow, Sarah. *Bereavement and Commemoration: An Archaeology of Mortality*. Oxford: Blackwell, 1999.

Taussig, Michael. *I Swear I Saw This: Drawings in Fieldwork Notebooks, Namely My Own*. Chicago: University of Chicago Press, 2011.

————. *Mimesis and Alterity: A Partcular History of the Senses*. London: Routledge, 1993.

————. *Shamanism, Colonialism, and the Wild Man: A Study in Terror and Healing*. Chicago: University of Chicago Press, 1987.

————. "The Sun Gives without Receiving: An Old Story." *Comparative Studies in Society and History* 37, no. 2 (1995): 368–98.

————. "Viscerality, Faith, and Scepticism: Another Theory of Magic." In *Magic and Modernity: Interfaces of Revelation and Concealment*, edited by Birgit Meyer and Peter Pels, 272–306. Stanford, Calif.: Stanford University Press, 2003.

Taviani, Fernando. "Postscript." In *Beyond the Floating Island*. Translated by Judy Barba, Richard Fowler, Jerrald C. Rodesch, and Saul Shapiro, 236–74. New York: Performing Arts Journal Publications, 1986.

Thomson, William P. L. *The New History of Orkney.* 1987. Reprint, Edinburgh: Birlinn, 2008.

Torchiana, Donald T. *Backgrounds for Joyce's "Dubliners."* Boston: Allen & Unwin, 1986.

Towsey, Kate, ed. *Orkney and the Sea: An Oral History.* Kirkwall, Scotland: Orkney Heritage, 2002.

Tritten, Tyler, and Daniel Whistler. "Editorial Introduction: Schellingian Experiments in Speculation." In "Nature, Speculation, and the Return to Schelling," edited by Tyler Tritten and Daniel Whistler, 1–8. Special issue, *Angelaki: Journal of the Theoretical Humanities* 21, no. 4 (2016).

Tsang, Tak-ping. "'Art Is Life, Life Is Art': Frog King's Art and Life as a Secular Pilgrimage of Illumination." In Frog King Kwok and Hong Kong Arts Development Council, *Frogtopia Hongkornucopia*, 20–29.

Tsing, Anna Lowenhaupt. *Friction: An Ethnography of Global Connection.* Princeton, N.J.: Princeton University Press, 2005.

———. *In the Realm of the Diamond Queen.* Princeton, N.J.: Princeton University Press, 1993.

———. *The Mushroom at the End of the World: On the Possibility of Life in Capitalist Ruins.* Princeton, N.J.: Princeton University Press, 2015.

Turner, Victor. *The Forest of Symbols: Asects of Ndembu Ritual.* Ithaca, N.Y.: Cornell University Press, 1967.

———. *The Ritual Process: Structure and Anti-structure.* Ithaca, N.Y.: Cornell University Press, 1969.

Turville-Petre, E. O. G. *Myth and Religion of the North.* 1964. Reprint, Westport, Conn.: Greenwood Press, 1975.

Tylor, Edward Burnett. *Primitive Culture: Researches into the Development of Mythology, Philosophy, Religion, Language Art, and Custom.* 2 vols. 1871. Reprint, London: John Murray, 1903.

Van de Port, Mathijs. *Ecstatic Encounters: Bahian Candomblé and the Quest for the Really Real.* Amsterdam: Amsterdam University Press, 2011.

Van Gennep, Arnold. *The Rites of Passage.* Translated by Monika B. Vizedom and Garbrielle L. Caffee. Chicago: University of Chicago Press, 1960.

Varley, Julia. *Notes from an Odin Actress: Stones of Water.* London: Routledge, 2010.

Vaz da Silva, Francisco. *Metamorphosis: The Dynamics of Symbolism in European Fairy Tales.* New York: Peter Lang, 2002.

Venkatesan, Soumhya, ed. "Ontology Is Just Another Word for Culture: Motion Tabled at the 2008 Meeting of the Group for Debates in Anthropological Theory, University of Manchster." *Critique of Anthropology* 30, no. 2 (2010): 152–200.

Vernant, Jean-Pierre. *Myth and Society in Ancient Greece.* Translated by Janet Lloyd. New York: Zone Books, 1990.

———. *The Origins of Greek Thought.* Translated from the French. Ithaca, N.Y.: Cornell University Press, 1982.

Vico, Giambattista. *The New Science of Giambattista Vico. Unabridged translation of the third edition (1744) with the addition of the "Practic of the New Science."* Translated by Thomas Goddard Bergin and Max Harold Frisch. Ithaca, N.Y.: Cornell University Press, 1948.

Viveiros de Castro, Eduardo. *Cannibal Metaphysics.* Translated by Peter Skafish. Minneapolis, Minn.: Univocal, 2014.

———. "Cosmological Deixis and Amerindian Perspectivism." *Journal of the Royal Anthropological Institute* 4, no. 3 (1995): 469–88.

Vollmann, William T. *The Ice Shirt.* New York: Penguin, 1993.

Wachowich, Nancy. "Cultural Survival and Trade in Iglulingmiut Traditions." In *Critical Inuit Studies: An Anthology of Contemporary Arctic Ethnography*, edited by Pamela Stern and Lisa Stevenson, 119–38. Lincoln: University of Nebraska Press, 2006.

Wagner, Roy. *Coyote Anthropology.* Lincoln: University of Nebraska Press, 2010.

Wakefield, Stephanie, and Bruce Braun, eds. "A New Apparatus: Technology, Government and the Efficient City." Special issue, *Society and Space* 32, no. 1 (2014).

Walens, Stanley. *Feasting with Cannibals: An Essay on Kwakiutl Cosmology.* Princeton, N.J.: Princeton University Press, 1981.

Watson, Ian. "Introduction: Contexting Barba." In *Negotiating Cultures: Eugenio Barba and the Intercultural Debate*, edited by Ian Watson, 1–17. Manchester: Manchester University Press, 2002.

Watts, Laura. "OrkneyLab: An Archipelago Experiment in Futures." In *Imagining Landscapes: Past, Present, and Future*, edited by Monica Janowski and Tim Ingold, 59–76. London: Ashgate, 2012.

Weber, Max. *The Protestant Ethic and the Spirit of Capitalism.* Translated by Talcott Parsons. London: Harper & Collins, 1991.

———. "Science as a Vocation." In *From Max Weber: Essays in Sociology*, edited by H. H. Gerth and C. Wright Mills, 129–56. New York: Oxford University Press, 1949.

Weisman, Alan. *The World without Us.* New York: St. Martin's Press, 2007.

West, Harry G. *Ethnographic Sorcery.* Chicago: University of Chicago Press, 2007.

———. *Kupilikula: Governance and the Invisible Realm in Mozambique.* Chicago: University of Chicago Press, 2005.

Whelan, Kevin. "The Memory of 'The Dead.'" *Yale Journal of Criticism* 15, no. 1 (2002): 59–97.

White, Luise. *Speaking with Vampires: Rumor and History in Colonial Africa.* Berkeley: University of California Press, 2000.

Whittle, Alasdair. *Europe in the Neolithic: The Creation of New Worlds.* Cambridge: Cambridge University Press, 1996.

Williamson, Duncan. *Tales of the Seal People: Scottish Folk Tales.* Northampton, Mass.: Interlink, 1998.

Williamson, Kenneth. *The Atlantic Islands: A Study of the Faeroe Life and Scene.* London: Collins, 1948.

Bibliography

Wirz, Paul. *Die Marind-anim von Holländisch-Süd-Neu-Guinea*. 2 vols. Hamburg: L. Friederichsen, 1922.

Witoszek, Nina, and Pat Sheeran. *Talking to the Dead: A Study of Irish Funerary Traditions*. Amsterdam: Rodopi, 1998.

Wong, Wilfred Ying-wai. "Message from the Commissioner." In Frog King Kwok and Hong Kong Arts Development Council, *Frogtopia Hongkornucopia*, 4–5.

Index

abjection. *See under* Kristeva, Julia
actual and virtual. *See under* Bergson,
 Henri; Deleuze, Gilles
Adorno, Theodor W., 115–16
Agua Viva, 42–43, 95, 255
aleatory matter, 209, 298n28
Alford, Violet, 124
amulets (Inuit), 50–52, 278n9
Anarqâq, 58–63. *See also* Rasmussen,
 Knud: on Inuit shamanism;
 shamanism: Canadian Arctic
animal disguise, 124–25, 139, 181,
 288n24, 299n39
animatism. *See* Marett, Robert Ranulph
animism, 82–85, 151, 245
Anthesteria, 130–31, 289n13, 289n15
Anthropocene, ix, 17, 272n38
architecture as "first art," 276n17
Ardener, Edwin, 271n22
Ariès, Philippe, 114–15
Aristophanes, 131, 289n15
Aristotle: criticisms of Heraclitus, 78;
 form and matter, 74–75, 207, 298n28;
 humans as political animals, 75;
 metaphor, 68–69, 74–76; metaphori-
 cal versus literal meaning, 74–75, 90,
 208, 285n6; reason as distinctively
 human faculty, 78, 282n17; *zoë* and
 bios, 129–30

Árnason, Jón, 6
Artaud, Antonin: in *Talabot*, 21, 22, 23;
 "The Theater and the Plague," 23,
 28–30; theater as collective reawak-
 ening, 31, 33
Atanarjuat (film), 54. *See also*
 Isuma Productions; Kunuk,
 Zacharias
atomism (classical), 103–6, 285n14
aurora borealis: scientific explanations
 of, 250; as spirits of the dead, 121,
 250–51
Avva, 53–56, 134, 278n14, 279n22. *See
 also* Rasmussen, Knud: on Inuit
 shamanism; shamanism: Canadian
 Arctic

Bachelard, Gaston, 249
Bachofen, Johann Jakob: influence on
 Lekatsas, 302n25; tellurian religion
 and mother-right, 210
Badiou, Alain, 290n16
Bakhtin, Mikhail, 215–17, 221, 223, 236,
 237
Barba, Eugenio: biography, 273n2; on
 exile, 22, 273n4; on montage, 23; role
 of trickster in *Talabot*, 31, 274n14;
 theater anthropology, 22, 274n6;
 "Third Theater," 273n5; West's

Index

destruction of indigenous cultures, 50
Barney, Matthew, 235–36
Barthes, Roland, 11
Bataille, Georges, 233
Baudrillard, Jean, 114
Benjamin, Walter, 24, 115
Benveniste, Émile, 18
Berg, Aase, 224, 233–36, 238, 301n16
Bergson, Henri: actual and virtual, 136–37, 156, 160; criticisms of theory of relativity, 290n9; durational time, 135–38, 154, 290n10, 290n15; *élan vital*, 107; memory, 136; myth-making, x, 38–39, 41, 276n7. *See also* fabulation
berserks, 214, 299n39
Bianchi, Emanuela: aleatory matter in classical philosophy, 209, 297n16; sexual difference and origins, 298n28
Biehl, Joao, 40
Blanchot, Maurice, 277n22
Boas, Franz: criticisms of comparative method, 149, 151; description of Sedna, 281n15; Kwakwaka'wakw Winter Ceremonial, 138–39; shamans' use of trickery, 279n26
Brown, George Mackay, 111–12, 174, 192
Burckert, Walter, 131
burial practices, Orkney, 170, 187–95, 245–47, 251
Butler, Judith, 208–9
Bynum, Carolyn Walker, 299n38

Calasso, Roberto, 298n29
callicantzaros, 125–26, 130, 159, 288n8
Cambridge Ritualists, 210, 299n32. *See also* Harrison, Jane
Canetti, Elias: aurora borealis as spirits of the dead, 250–51, 254; invisible crowd (of the dead), 121, 197, 198, 246
Carmen, 18

carnival, 215–16, 236–37
Castaneda, Carlos, 133–34, 147
Cavarero, Adriana, 209, 298n28
Cave, Nick, 114
cave art: caves as initiatory spaces, 133, 300n7; painting as ritual act, 289n3
chambered cairns (Orkney): deposi-tions of human and animal remains in, 189; as feature of Orcadian land-scape, 170, 187, 195; as houses for the dead, 187–88; relationship to Neolithic cosmological thinking, 189–90
Childe, V. Gordon, 190
chōra: Kristeva, 205–6, 208–9, 216–17, 256, 297n12; Plato, 205–8, 221, 250, 256, 299n43
cinema of poetry, 54
Clark, Nigel, 17, 256
Colebrook, Claire: on Deleuze's "A Life," 42; on the limitations of post-humanism, 254, 300n9
communitas. *See under* Turner, Victor
comparativism (anthropology): criti-cisms of, 149–50; fabulatory, 156–62; nineteenth century, 147–49, 150–52; relationship to ethnography, 152–57
Corrington, Robert, 256, 297n12
Crapanzano, Vincent: criticisms of Turner, 110; ethnographer as Hermes, 275n29; imaginative horizons, 110, 160
Cthulhu. *See* Lovecraft, H. P.
Curtis, Edward, 140, 291n19

darkness: association with Dionysus, 130; giants and, 257, 258; as pre-cosmological condition, vii, 19, 203, 248; relationship to vision, 250, 257; as tactile experience, 249–50
"Dead, The" (short story): allusions to Great Irish Famine, 143–44; depictions of the dead in, 120–21, 142–43, 146; as ghost story, 123–24;

Index

literary and mythological references in, 143–44; plot summary, 118–20

death: attenuated presence of in modernity, 114–15; dead as undifferentiated mass, 121–24, 195–98, 245–47, 254; death practices on peripheries of Europe, 117–18; Hertz on death ritual, 197–98; impact of Reformation on death practices, 192–94; Neolithic attitudes toward, 187–91. *See also* burial practices, Orkney; Canetti, Elias

Debaene, Vincent, 47

Deleuze, Gilles: actual and virtual, 137–38, 156, 160, 292n5; affects and percepts, 41; art and architecture, 276n17; cinema, 36–40, 54, 276n3; desert islands, 167–69, 176, 207, 242, 293n8; "A Life," 42–44, 87, 95, 236, 255; literature and the impersonal, 42, 44, 87, 277n22; metaphor, 73–74, 80–81, 86–87; movement image, 276n3; Plato, 298n28; powers of the false, 36–38, 44, 47, 57; time image, 36–38, 54; univocity of being, 290n13. *See also* fabulation; geophilosophy

Dennison, Walter Traill: effects of marine erosion on landscape and archaeology, 241–42, 247; Orkney folklore of the sea, 244–45; visions of planetary catastrophe, 242

Derrida, Jacques, 76, 282n11

Descola, Philippe: animism versus totemism, 82, 283n32; as comparativist, 150; typology of "modes of relation," 84–85

Detienne, Marcel: Dionysus and alterity, 129, 282n25, 288n6; *metis,* 115

Dickens, Charles, 43, 147

Dionysus: birth of, 129; breaking down boundaries between human, animal, and divine, 80, 282n25; and

darkness, 130; and the dead, 130, 289n13; disruption of order, 127–28, 130–31; duration personified, 137, 160, 290n15; modern interpretations of, 129, 288n6; and Pentheus, 127–28, 212; as primordial matter, 128; simultaneously one and many, 137; stranger god, 127–29; tragedy and, 78–79, 288n5; and water, 80, 130, 282n24, 289n15; worship in winter, 130. *See also* Anthesteria; Euripides; Nietzsche, Friedrich: on Dionysus; tragedy, Greek

Dolphijn, Rick, 261, 263

Douglas, Mary, 102, 109, 286n16

Duerr, Hans Peter: on caves as ritual spaces, 289n3; as comparativist, 147–48, 152, 158–60; times between the times, 133–35, 142, 154, 182

Dumézil, Georges, 288n26

Durkheim, Émile, 196, 198, 286n16

Echidna, 185, 202. *See also* Genetic Moo; Hesiod; *Mother*

Eisenstein, Sergei, 23

Eliot, T. S., 244

Epicurus, 103

Eshleman, Clayton, 300n7

ethnography: denial of coevalness, 272n26; limitations of, 152–55; as paradigm of anthropological research, 148–50, 152; as practice of montage, 157; relationship to literary fiction, 45–48; writing and, 10–11, 271n24. *See also* comparativism; Geertz, Clifford

Ettinger, Bracha, 297n11

Euripides, 128, 288n5

European Marine Energy Center, 293n4

Evans, Arthur, 210–11, 299n35

Evans-Pritchard, E. E.: criticisms of Lévy-Bruhl, 81; Nuer leopard-skin priest, 107, 286n22; "ordered

330 *Index*

anarchy" of Nuer political institutions, 158

Eyjafjallajökull volcano eruption, 15–16

Fabian, Johannes, 272n26

fabulation: anthropology as art of, 95, 110, 156–61, 176, 262–63; Bergson on, 38–39, 138, 276n7; collapsing of representational distance, x–xi; creation of giants, 39, 276n11; creation of "minor" language, 39; Deleuze on, 39–42, 44, 138, 245, 257, 276n11; engagement with other-than-human becomings, 40–42, 80, 95, 257; in Kunuk's *The Journals of Knud Rasmussen,* 57; myth and, 87, 245; poetic language and, 206; relationship to virtual past, 146, 155

Fassin, Didier, 46–47

Favret-Saada, Jeanne: "getting caught," 9–10, 14, 48; language of witchcraft, 109, 271n21

Fernandez, James, 69, 94

F for Fake (film), 34–36. *See also* Welles, Orson

Fifth Thule Expedition. *See under* Rasmussen, Knud

Finnegans Wake: the dead in, 143, 146, 158; dream language of, 146, 158, 234; Vico and, 69, 72; voice of thunder in, 72, 281n17. *See also* Joyce, James

Flaxman, Gregory, 38, 80

Fortune, R. F., 81

Foucault, Michel, 12, 272n28

Four Quartets. See Eliot, T. S.

France, Anatole, 76, 282n11

Frazer, James George: on *The Golden Bough,* 148; "imitative" versus "contagious" magic, 281n2; on Twelve Days as intercalary period, 132–33, 182

Freud, Sigmund: on Minoan civilization, 210, 299n35; uncanny

(unheimliche), 303n14; unconscious *(id),* 255–56

Frog King (Kwok Mang-ho), 259–63. *See also* Papay Gyro Nights

Frogs, The. See Aristophanes

Gaia hypothesis. *See* Lovelock, James

Gargantua et Pantagruel, 215–16

Geertz, Clifford: criticisms of *Tristes Tropiques,* 47; ethnography and fiction, 45–46, 158

Genetic Moo (Pickup and Schauerman), 182–86, 202, 234, 255. See also *Mother;* Papay Gyro Nights

geology of media. *See* Parikka, Jussi

geophilosophy, 41, 42, 80, 158, 217, 243

giants: associations with "wild nature," 269n4; features of landscape as petrified bodies of, 216, 249, 251; in folklore and literature, vii–viii, 7–9, 104, 175–82, 202, 215–16, 248–49, 251, 299n42; nocturnal character, vii, 248, 257; in Norse creation narrative, vii–viii, 9, 19, 202, 204, 213, 215, 248–49, 257; in Vico's *New Science,* 67–69, 72

Gold, Thomas, 300n4

Göransson, Johannes, 235, 238

Graeber, David, 152, 292n9

Granet, Marcel, 196–97

Great Famine (Ireland), 144–46

Grosz, Elizabeth: art as channeling other-than-human becomings, 40, 276n17; dynamism of past in Bergson, 290n10; relationship of history to evolutionary and geological time, 145. *See also* Bergson, Henri: durational time; Deleuze, Gilles: art and architecture

grotesque image of body, 215–17, 221, 236

Grýla: in Faroe Islands, 177–79; in Iceland, 179–81

Index 331

Gunnell, Terry: Celtic and Scandinavian influences on *huldufólk* traditions, 270n9; elves in popular culture, 6; pre-Christian origins of North Atlantic masking traditions, 181

Gyro, 176–77. *See also* Grýla

Hage, Ghassan, 152–53

Hamlet. See Shakespeare, William

Haraway, Donna: Chthulucene, 219; naturecultures, 253–54; speculative fabulation, 276n7

Harrison, Jane: on Dionysus, 137, 290n15; on pre-Olympian stratum of Greek religion, 210

Hastrup, Kirsten: the challenge of the unreal, 10–11, 17–18, 44; on coevalness, 272n26; criticisms of, 7, 9, 270n7, 271n18; encounter with man of *huldufólk*, 3–7, 87, 94, 180, 262; ethnography of Royal Shakespeare Company, 274n6; on Knud Rasmussen, 52–53; on life and genre, 271n22; medieval Icelandic conceptions of space, 7–8, 180, 270n15; on *Talabot*, 21–22, 25–28, 274n21; on writing, 11, 271n24. *See also* Barba, Eugenio; *Talabot*

Hau'ofa, Epeli, 169

Heidegger, Martin, 99, 285n3

Heinesen, William, 178–79, 204, 294n16

Heraclitus: Aristotle's criticisms of, 78, 282n18; universe as child at play, 78, 102, 262

Hertz, Robert, 197–98, 296n20

Hesiod: account of creation of universe, 202–3, 204, 220, 223; compared to Amerindian myth, 210; Echidna, 185; *khaos* compared to Plato's *chōra*, 207, 220–21

Homer, 115–16, 120, 146, 185, 299n32

Horkheimer, Max, 115–16

huldufólk, 5–11, 14–17, 19–20, 21, 25, 28, 33, 87, 94–95, 180, 270n9

Huldufólk 102 (film), 5, 9

Humphrey, Caroline, 195

Hutton, Ronald, 289n1

Hyde, Lewis, 25, 30–31

hylomorphism, 75, 215. *See also* Aristotle: form and matter

Iceland: geology, 8, 15, 20, 41, 94, 99–101, 199–200; settlement history, 3–4, 7–8, 270n9

Igloolik (Nunavut, Canada): contact history and location, 53, 279n15; cult of Sedna, 281n15; shamanism, 281n14; visited by Fifth Thule Expedition, 278n4. *See also* Isuma Productions; Kunuk, Zacharias; Rasmussen, Knud: Fifth Thule Expedition; shamanism: Canadian Arctic

Inalsingh, Nisha, 5, 9

Ingold, Tim, 12, 150, 152, 291n2

In the Land of the Headhunters (film). *See* Curtis, Edward

Inūma Eliš, 203–4, 223. *See also* Tiamat

invisible crowd. *See under* Canetti, Elias

Irigaray, Luce, 80

Isuma Productions, 54, 57. *See also* Kunuk, Zacharias

Ivanov, Sergei, 173, 175, 185, 251. *See also* Papay Gyro Nights

Jakobsen, Jakob, 294nn8–9. *See also* Norn language

Jakobson, Roman, 73–74, 281n2

Jónsdóttir, Þorbjörg, 199–201. *See also* Papay Gyro Nights

Journals of Knud Rasmussen, The (film): blurring of subjective and objective viewpoints, 54–56, 134; divergences from Rasmussen's published accounts, 54–57, 134,

278n14, 279n22; fabulatory remaking of colonial past, 56–57. *See also* Igloolik; Kunuk, Zacharias; Rasmussen, Knud
Joyce, James: *Finnegans Wake*, 69, 72, 234, 281n17; Kristeva on, 206; *Ulysses*, 116–17. *See also* "Dead, The"

Kafka, Franz: destruction of metaphor, 73–74; as example of "minor" literature, 39; film adaptation of *The Trial*, 37; use of third person, 277n22
Kalunga, 122, 145, 189, 246. *See also* Palo Monte, Cuba
Kapferer, Bruce, 286n16
Keller, Catherine, 296n6
kelp, 198
Knap of Howar, 170–71, 187
Knossos, Palace of, 210, 299n35
Kofman, Sarah, 74–76, 282n14, 285n6
Kohn, Eduardo, 12–13, 287n12
Kristeva, Julia: abjection, 205, 297n10; compared to Peirce, 297n12; criticisms of, 208–9, 297nn10–11; influence of Bakhtin on, 215–16; on motherhood, 302n17; semiotic versus symbolic, 205–6. *See also* *chōra*
Kulkarni, Nayan, 251–52. *See also* Papay Gyro Nights
Kunuk, Zacharias: *Atanarjuat*, 54; *The Journals of Knud Rasmussen*, 54–57, 292n22; reality of spirits, 56, 134
Kwakwaka'wakw (Kwakiutl). *See* Winter Ceremonial

Lacan, Jacques, 206, 209
Landnámabók, 270n9
Laruelle, François, 284n45
Latour, Bruno: criticisms of Durkheim, 198; *Dingpolitik*, 160; "thing" as assembly, 99–101; *We Have Never Been Modern*, 117. *See also* Heidegger, Martin

Lawrence, T. E., 276n11
Leiris, Michel, 47
Lekatsas, Penagis, 236, 302n25
Lévi-Strauss, Claude: as comparativist, 149; on myth, 82–83, 85, 158, 210, 283n36; on nature and culture, 9, 180, 271n19; *Tristes Tropiques* as experimental work, 47; understanding of structure in later writings, 86
Lévy-Bruhl, Lucien: Evans-Pritchards's criticisms of, 81, 283n29; fluidity of mythic world, 81; "participations," 81–82; universality of "primitive" thought, 81–82, 84
Lewis-Williams, 289n3
Lispector, Clarice, 42–43, 95, 255
Locke, Peter, 40
Lovecraft, H. P., 218–19, 221, 255
Lovelock, James, 220, 300n5
Lucretius: atoms and letters, 105, 108; *clinamen*, 103–6, 159, 285n11; physics as hydraulics, 104, 285n14; as poet and physicist, 103, 105; role and status of gods, 104

Madrigal of the Explosion of the Wise Whale, The (video installation), 224–28, 236–40. *See also* Papay Gyro Nights
Magaroni, Maria, 209
Magazine (band), 253
Magnus, Olaus, 231–32, 301n11
Malinowski, Bronislaw, 81, 167
Mardi Gras, 236. *See also* carnival
Marett, Robert Ranulph, 70–71, 72
Marhaug, Lasse, 184. See also *Mother*; Papay Gyro Nights
Marwick, Ernest, 249
Marwick, Hugh, 177, 294n8. *See also* Norn language
Massumi, Brian, 110, 286n25
McAfee, Noelle, 299n43
Meillasoux, Quentin, 243, 269n8

Index

Melville, Herman, 41, 230–31, 247. See also *Moby Dick*
Mérimée, Prosper, 18
Merkur, Daniel, 281n15
Metamorphoses. See Ovid
metamorphosis: as characteristic of mythic world, 81–87; as cosmic principle, 212–13; creation and, 263; distinguished from hybridity, 299n38; in European folklore, 112, 283n30; and Greek Olympian gods, 298n29, 299n38; in midwinter season, 132–33; perceived decline of, 212–14; relationship to truth, 38; tricksters and, 33; as undoing of metaphor, 73–74, 80, 81, 93, 113, 126
metaphor: anthropological theories of, 69–70, 94; Aristotle on, 68, 74–76, 86–87, 208, 285n6; contrasted with metamorphosis, 73–74; Derrida on, 76, 282n11; Nietzsche on, 76–81; sorcery as metaphor, 88–92, 94; subordination to literal meaning, 285n6; Vico on, 68–69, 72
metonymy, 73–74, 281n2
midwinter celebrations, Europe, 120, 132, 138, 161, 181–82. See also animal disguise; Twelve Days
Minoan civilization: archaeology and material culture, 210–11, 299n35; Freud on, 210; story of Minotaur, 210, 213
Mirrie Dancers (community art project), 251–52, 257–58. See also Papay Gyro Nights
Moby Dick, 41, 230, 242, 244
montage: comparative anthropology and, 156–57, 159–60; as compositional principle, 101–2, 110, 274n14; in modernist cinema and literature, 23, 31, 274n14, 285n5
Morton, Timothy, 254
Moss, Sarah, 14–16, 169

Mother (digital artwork), 182–86, 198–99, 234, 255. See also Genetic Moo; Papay Gyro Nights
movement image. See under Deleuze, Gilles
Mozambican Civil War, 88, 91
Mrs. Dalloway. See Woolf, Virginia
multiplicity (Riemann), 137
myth: association with metaphor, 74–76, 85, 204; Greek differentiation of *logos* from *mythos*, 74–76, 85, 153, 204, 208; metamorphosis and, 81–87; nondistinction between humans and animals, 81–82; precosmological condition of intensive difference, 83–84
Myung Mi Kim, 257

Names for the Sea, 14–16. See also Moss, Sarah
Nancy, Jean-Luc: on representation, 11, 13; on the unconscious, 255
Narsuk, 63, 65, 70–72, 94, 95, 281n14
nature: beyond relationality, 256–58; as cosmic Unconscious, 256; rejection of in recent social theory, 253–54
Naturphilosophie. See Schelling, F. W.
Negarestani, Reza, 218–23, 255, 300n4
Nietzsche, Friedrich: on Dionysus, 129, 210, 262, 288nn5–6; metaphor, 76–81, 90, 94, 282n14; will to truth, 36
Nin, Anaïs, 29–30
non-philosophy. See Laruelle, François
Norn language, 176–77, 293n8
Norse mythology: cosmology, 7–8, 270n11; creation of universe, vii–viii, ix, 8–9, 19, 202, 204, 213–14, 216, 248–49; gods as latecomers, viii, 104, 115; *Ragnarok,* viii

Ocean, Ocean (film), 199–201. See also Papay Gyro Nights

Index

Ochoa, Todd Ramón, 122, 287n20
Odin Teatret (theater company), 21–29, 32, 273n2, 274n19, 275n26. *See also* Barba, Eugenio; *Talabot*
Odyssey, 115–16, 120, 146, 185, 299n32
ontological turn, 84–86, 159, 284n40; criticisms of, 154–55; experimental writing and, 86–87
Orkney Islands: archaeology, 170–71, 187–95, 241–42, 245–47, 251; folklore, 111–13, 173–75, 177, 244–47; geology, 165–66, 169–70; history, 170–72, 187, 191–92, 295n8; marine energy, 171, 293n4; marine erosion, 170, 190–91, 241–42, 244, 246–47, 262; shipwrecks, 113, 166, 187
Our Mutual Friend, 43. *See also* Dickens, Charles
Ovid, 128, 212–13

Palo Monte, Cuba, 121–22, 145, 189, 198, 246, 254, 287n20
Pálsson, Gísli, 7, 270n7
Papa Westray island, 165–66, 169–72, 174, 183, 187
Papay Gyro Nights: description and origin of name, 173–76; Frogtopia, 259–63; *The Madrigal of the Explosion of the Wise Whale*, 224–29, 236–40; *Mirrie Dancers*, 251–52, 257–58; *Mother*, 182–86; *Ocean, Ocean*, 198–201. *See also* Genetic Moo
Parikka, Jussi, 222–23
Pasolini, Pier Paolo, 54
Peirce, Charles Sanders: icon, index, and symbol, 12–13; Peircean semiotics versus Saussurean linguistics, 297n12
Permar, Roxanne, 251–52. *See also* Papay Gyro Nights
Perrault, Pierre, 39–40
perspectivism. *See under* Viveiros de Castro, Eduardo

Plato: *logos* and *mythos*, 85; prepatriarchal traces in work of, 298n28; *Timaeus*, 205–9, 216, 221, 250, 256, 297n16, 298nn20–21, 298n23, 299n43; truth and representation, 11, 36. *See also chōra*
Poetic Edda, vii–viii, 103, 202, 214, 218, 223, 248, 270n11
potlatch, 291n19. *See also* Winter Ceremonial
Pound, Ezra, 23, 274n9
Pour la suite du monde (film), 39–40
Povinelli, Elizabeth, 152, 257
powers of the false. *See under* Deleuze, Gilles
Protestant Reformation: decline of Norn language and, 293n8; influence on Orkney burial practices, 192–93
Proulx, Jean-Pierre, 230

Rabelais, François: *Gargantua et Pantagruel*, 215–16. *See also* Bakhtin, Mikhail
Rabinow, Paul, 271n24
Radin, Paul, 31–33
Raffles, Hugh, 253, 303n9
Rasmussen, Iben Nagel, 24, 26, 30, 32
Rasmussen, Knud: as collector of Inuit amulets, 50–52, 278n9; Danish-Inuit background, 277n1; Fifth Thule Expedition, 49–66, 278n4; on Inuit shamanism, 53–54, 57–66, 70–72, 280n11, 280n13; in *The Journals of Knud Rasmussen*, 54–57, 134, 279n22; in *Talabot*, 21–22, 50, 52. *See also* shamanism: Canadian Arctic; *Talabot*
Renfrew, Colin, 190
representation: critiques of 11–14; Foucault on, 272n28; Nancy on, 11–12, 13; and nature/culture distinction, 12; and Peircean semiotics,

12–13; standing-for versus speaking-for, 272n29
Ricoeur, Paul, 285n6

Saint Magnus, 191, 295n8
Saint Magnus Cathedral, 191–95, 246, 295n8, 295n11, 296nn13–14
Schechner, Richard, 274n21
Schelling, F. W., 303n23
Sedna, 53, 65, 72, 281n15
selkies, 111–13, 159, 161, 244–45
Seremetakis, C. Nadia, 117
Serres, Michel: arts and sciences, 103, 302n30; on Lucretius, 104–5; third spaces, 18–19, 95, 262, 273n42
Shakespeare, William, 224–25
shamanism: Amazonia, 82–83; Canadian Arctic, 53–66, 71–72, 280n40, 281n14; Mongolia, 195; Pacific Northwest, 279n26; Paleolithic, 289n3; Siberia, 121, 133, 147. *See also* Anarqâq; Rasmussen, Knud: on Inuit shamanism
Shetland Arts, 251
Sila, 71–71, 280n13
Skafish, Peter, 85–86
Skara Brae, 170, 187, 190–91
snake goddesses (Minoan), 210–11. *See also* Minoan civilization
Söderblom, Nathan, 70, 72
sorcery (Mozambique), 88–95
Spinoza, Baruch, 42, 255
spirit drawings, 58–63. *See also* Rasmussen, Knud: on Inuit shamanism; shamanism: Canadian Arctic
Spivak, Gayatri, 272n29
Stoller, Paul, 10, 284n3
Strathern, Marilyn, 231
Sturluson, Snorri, vii, 9, 202, 270n11, 294n14
Surrealist Group in Stockholm, 233, 301n16. *See also* Berg, Aase

survivals. *See under* Tylor, Edward Burnett
Szabo, Vicki Ellen, 231, 301n11

Talabot: Hastrup's reactions to, 25–27, 274n21; making of, 21–23; montage-like construction of, 23–24, 31, 274n14; Rasmussen in, 50, 52; trickster in, 24–25, 30–32, 274n14, 275n26. *See also* Barba, Eugenio; Hastrup, Kirsten; Odin Teatret
Taussig, Michael: literal basis to metaphor, 87; shamanic trickery as "public secret," 279n26; uncertainty of witnessing, 48
Theogony, 185, 202, 204, 210. *See also* Hesiod
Thingvellir, Iceland, 99–103, 110
third person, 17–20, 42, 44, 95, 262, 277n22. *See also* Benveniste, Émile; Serres, Michel: third spaces
Þórðarson, Þórbergur, 3, 5
Tiamat, 204, 214–16, 218, 221, 235, 255
Tiamaterialism, 218–23. *See also* Negarestani, Reza
Timaeus. See under Plato
time image. *See under* Deleuze, Gilles
totemism, 82, 84–85, 283n32
tragedy, Greek, 76–77, 288nn5–6. *See also* Dionysus: tragedy and; Euripides
trickster: examples of, 275n29; liminality and, 112; in *Talabot,* 21, 24–26, 30–32, 274n15, 275n26; undoing distinctions between reality and representation, 31–33, 47, 95; Winnebago trickster cycle, 31–33
trolls, 4, 8, 17, 125, 177, 181, 294n14
Tsing, Anna, 152, 297n10
Tsitsopoulos, Filippos, 224–28, 236–40. *See also* Papay Gyro Nights
Tsz Man Chan, 173, 251. *See also* Papay Gyro Nights

336 Index

Turner, Victor: communitas, 107; Crapanzano's criticisms of, 110; liminality as interstructural situation, 106–9; on *nkang'a* girls' puberty ritual, 88

Twelve Days (Christmas to Epiphany): appearances of the dead, 123–24; as intercalary period, 132, 182; masked performances associated with, 123–26, 181

Tylor, Edward Burnett: on animism, 70, 151; as comparativist, 148, 150–52; as social evolutionist, 151, 245; on "survivals," 151, 244–45; on fire as protection against harmful spirits, 15

Ulysses, 116–17. See also Joyce, James

uncanny. *See under* Freud, Sigmund

unconscious, 135, 256, 297n12. *See also* Freud, Sigmund; Nancy, Jean-Luc

ungrounding, 220–23, 263. *See also* Negarestani, Reza

univocity of being. *See under* Deleuze, Gilles

vampires, 89, 125

Van Gennep, Arnold, 102, 286n16

Varley, Julia, 25, 274n19, 275n28

Vaz da Silva, Francisco: metamorphosis in European folk tales; 283n30; monist ontology of folktales, 283n37

vermiculation. *See* ungrounding

Vernant, Jean-Pierre: Greek *mythos* versus *logos,* 85; Odysseus as epitome of *metis,* 115

Vico, Giambattista: giants and thunder, 67–68; influence on *Finnegans Wake,* 69, 72; metaphorical origins of human thought, 68, 72

Viveiros de Castro, Eduardo: as comparativist, 152; on decolonization of thought, 13; on indigenous ideas as concepts, 284n43, 284n45; on myth, 83–84, 158, 210, 283n36; on perspectivism, 82–86

Vollmann, William T., 213–14

Voluspa, viii, 248. See also *Poetic Edda*

Wagner, Roy, 275n30

"War on Terror," 219–20

Weber, Max, 114

Welles, Orson, 34–38, 44, 47, 52

werewolves, 125

West, Harry: ethnography as sorcery, 285n7; healing and sorcery, 88–94, 284n1; sorcery as metaphor, 88–90, 109; undoing of metaphor, 92–95

whales: economic importance in North Atlantic, 228–30; exploding whale carcasses, 237; literary associations, 230–32, 234–35; use of whale bone in construction of houses, 229, 232; whale blubber, 229, 232–33, 236. *See also* Magnus, Olaus; *Moby Dick*

Whelan, Kevin, 144–45

white mythology. *See* Derrida, Jacques

Wild Hunt (European folklore), 196

will to truth. *See under* Nietzsche, Friedrich

Winter Ceremonial (Kwakwaka'wakw), 138–42, 160, 212, 279n26, 291n19; adoption of different names by participants, 139, 142; suspension of chronologically marked time, 140–42, 146, 212; theatricality, 139, 141, 160; tribal ancestors of human-animal character, 139–42. See also Curtis, Edward

Wirz, Paul, 81

Woolf, Virginia, 41

Writing Culture, 271n24

Ymir, vii–x, 202–4, 215–16, 221, 235, 255. *See also* giants: in Norse creation narrative; Norse mythology: creation of universe; *Poetic Edda*

STUART McLEAN is professor of anthropology and global studies at the University of Minnesota. His publications include *The Event and Its Terrors: Ireland, Famine, Modernity* and *Crumpled Paper Boat: Experiments in Ethnographic Writing* (edited with Anand Pandian).

Lightning Source UK Ltd.
Milton Keynes UK
UKHW02f1526080918
328553UK00007B/313/P